IMAGES
of Rail

THE LONG ISLAND
RAIL ROAD
1925–1975

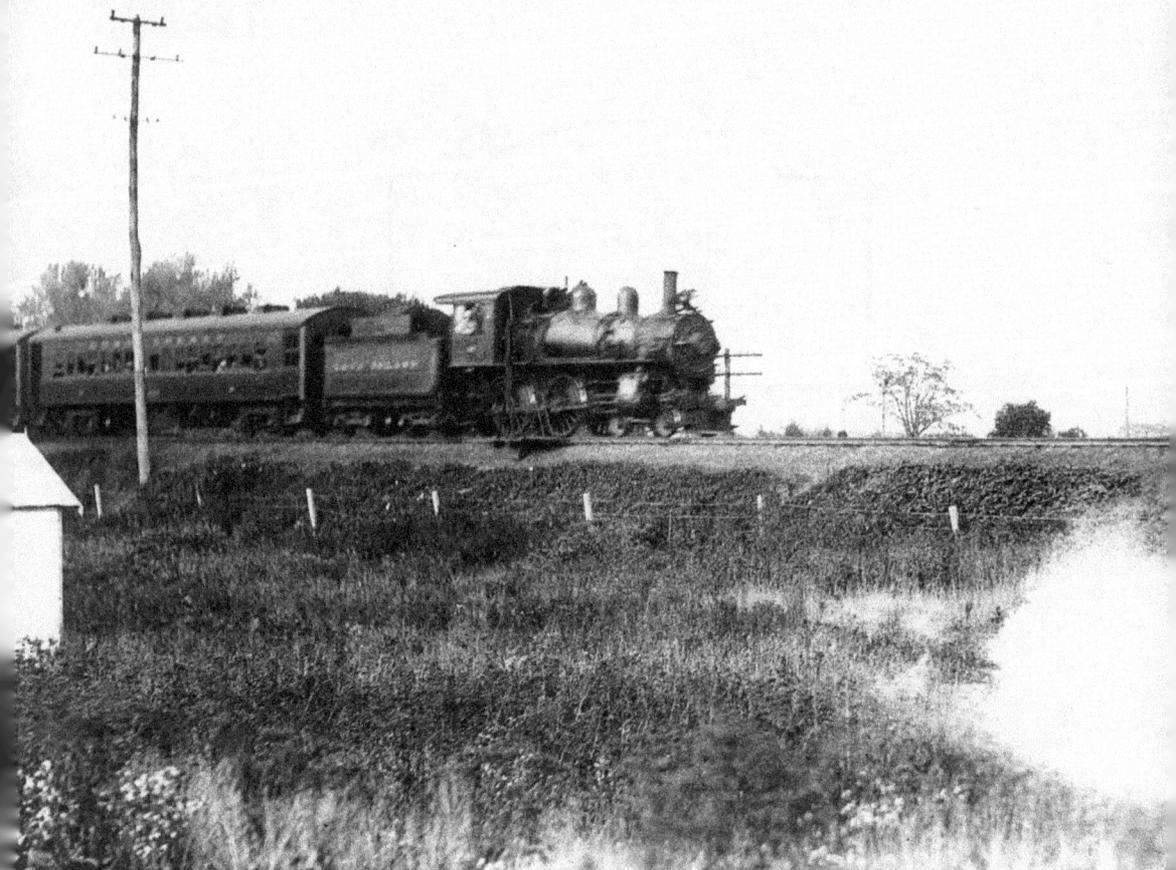

A D56s American class (4-4-0) makes a nice clip pulling another commuter run out on the island in this 1920s action shot. A product of Baldwin Locomotive Works in 1904, this little workhorse had 68-inch drivers and pulled trains for many years on the LIRR, both in passenger service and, years later, in freight service, until its retirement c. 1929–1930. (David Keller collection.)

IMAGES
of Rail

THE LONG ISLAND RAIL ROAD
1925–1975

David Keller and Steven Lynch

ARCADIA
PUBLISHING

Published by Arcadia Publishing
Charleston, South Carolina

Library of Congress Catalog Card Number: 2004106341

For all general information contact Arcadia Publishing at:
Telephone 843-853-2070
Fax 843-853-0044
E-mail sales@arcadiapublishing.com
For customer service and orders:
Toll-Free 1-888-313-2665

Visit us on the Internet at www.arcadiapublishing.com

*Dedicated to the memories of the many Long Island Rail Road
veterans I have known, without whose friendship and generosity my
interest in the LIRR, and eventually this book, would never have existed.*

—David Keller

*Dedicated to my wife and family, who have always supported my
railroading interests. In addition, a special thanks to my father,
Frederick A. Lindauer, for his lifelong enthusiasm and encouragement in
photographic pursuits, from which this book's genesis owes it creation.*

—Steven Lynch

CONTENTS

Acknowledgments 6

Introduction 7

1. The Steam Era 11

2. Carrying the Passengers 27

3. Carrying the Freight 37

4. The Dieselization of Long Island 49

5. Service in Electrified Territory 61

6. Signal Towers 73

7. The People Who Made It Work 85

8. Maintenance of Way 103

9. Structures and Scenes along the Right of Way 115

ACKNOWLEDGMENTS

I am very lucky that I was able to count as my friends and acquaintances such men as George Ayling, Jeff Skinner, Dan Whaley, Charlie Jackson, George DePiazzy, Tom Bayles, and many others. I owe a major debt of gratitude to Matty Roeblin, who started the whole thing off by giving me his trainman's hat and vest upon his retirement, when I was a budding railfan of five years of age. I also wish to credit my father, Henry Keller, who spent lots of his time driving me all over the island to take railroad photographs when I was a young teenager. Additional credit goes to the intensive research of Vincent F. Seyfried and the photographic skills of such prolific railroad photographers as George E. Votava and William Lichtenstern, as well as to the classic photography of James V. Osborne and Jules Krzenski, and to the kindness and great generosity of Edward Hermanns. Thanks also go to my partner, Steve Lynch, who had the idea for this book and thankfully pushed me off the fence to get it done. Last, but not least, I thank my wife, Susan, for putting up with my hobby during all the years we have been together.

—David Keller

I would like to thank the following individuals for their unselfish sharing of maps, photographs, knowledge, and information in the pursuit of Long Island Rail Road history: Robert Andersen, David Brinkmoeller, Steve Hoskins, Henry Maywald, David Morrison, and Stephen Rothaug. In addition, I extend special thanks to Don Maxton, whose Arcadia title, *The Rahway Valley Railroad*, provided the initial inspiration for this work.

—Steven Lynch

INTRODUCTION

The Long Island Rail Road this year (2004) celebrates its 170th birthday as the largest and oldest commuter railroad in the nation. Each day, more than 700 trains and in excess of 250,000 riders make the trip into New York City's Pennsylvania Station.

The intention of this book is to provide a view of the railroad during the period from 1925 to 1975. Included are steam engines at their zenith and the switch to dieselization after World War II, a look at behind-the-scenes operations, and details about other facets of the railroad that are perhaps not apparent to the daily ridership or casual viewer.

Many of the images in this book have never been published before, and great care has been taken to provide high-quality images and historical background information within the captions to give the reader greater insight into the operations of the LIRR.

The authors decided that rather than organizing the material in a chronological presentation, the photographs and subjects themselves would be best served by using chapters that illustrate specific material groupings. To that end, we start with chapter 1, "The Steam Era," when steam reigned supreme with massive and fast engines from the 1920s until their demise in October 1955. Behind these behemoths are the main fixture of a commuter line: the passenger cars themselves featured in chapter 2, "Carrying the Passengers."

Chapter 3, "Carrying the Freight," relates to the Long Island's little-known freight operations and some long-forgotten sources of revenue and operations. Here the reader gets a view of potato trains; coal drags; the LIRR cabooses known as hacks; freight-, baggage-, and express-related structures; and other interesting facets of the daily freight trains known as locals.

Chapter 4, "The Dieselization of Long Island," focuses on the advent of cost-effective diesels introduced in the 1940s and 1950s as the LIRR replaced its aging steam fleet with diesel engines.

Chapter 5, "Service in Electrified Territory," provides a glimpse into electrification of specific lines largely due to the parent Pennsylvania Railroad's influence and the need to enter the long East River tunnels in order to access New York City's Penn Station.

Chapter 6, "Signal Towers," provides insight into the towers that controlled the task of moving the high volume of daily traffic within a densely populated area. Regardless of the motive power and commodities carried, all railroads require a safe and efficient means of control to speed the movement of commuters and freight.

Chapter 7, "The People Who Made It Work," examines a small, representative number of the thousands of employees who take part in the daily operations that make the railroad function. Although some of these workers may never be seen by the general public, they play a vital role in the daily movement of people and goods.

Chapter 8, "Maintenance of Way," provides a glimpse into the never-ending maintenance of the railroad's track work and roadbed along the rails.

Finally, chapter 9, "Structures and Scenes along the Right of Way," features timeless images of structures and scenes that have received very little photographic exposure: the lowly structures and buildings that are used in support of the daily operations by rail personnel. These structures include shacks, sheds ("section shanties"), water towers, signals, and others unique to railroading facilities, many of which are long gone and forgotten in the march of time and innovation.

All in all, we hope that this collection provides a view of a railroad's proud past—both the physical plant and the people involved—in a timely and entertaining fashion, and that the book will contribute to the rich historical heritage of Long Island and enrich the reader's understanding of a viable and daily force in the lives of past and present Long Islanders.

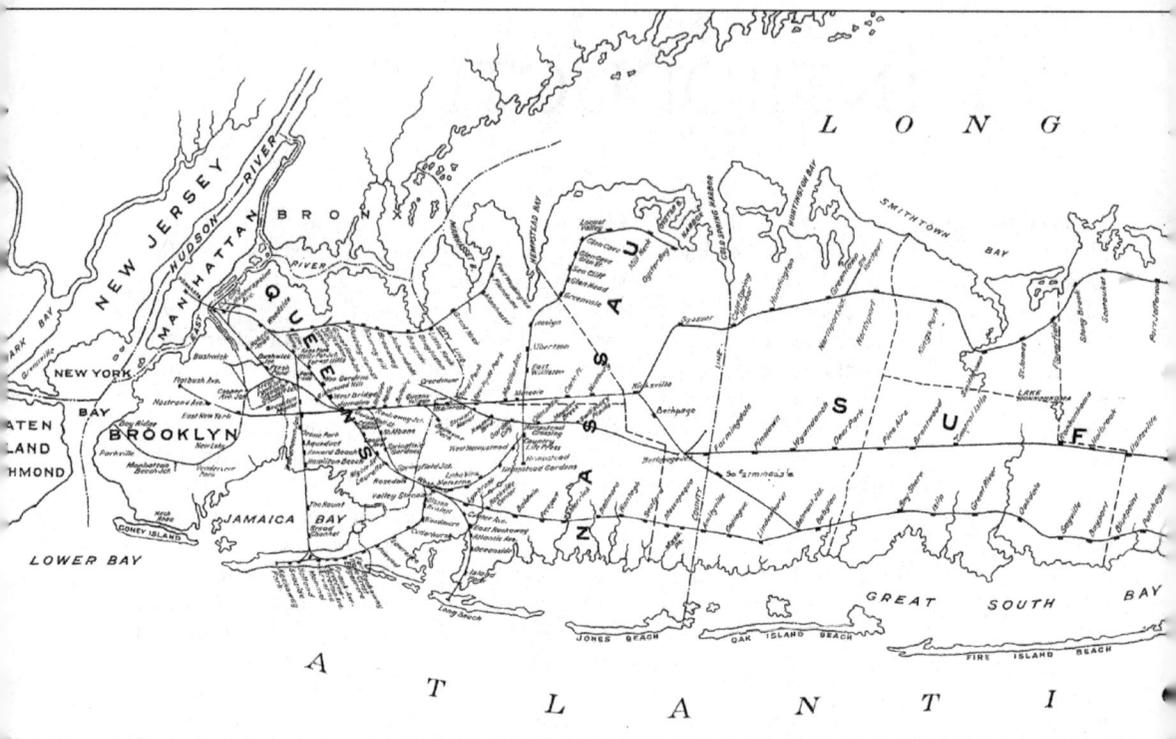

This system map of the Long Island Rail Road is dated October 1, 1939. (Courtesy of Steven Lynch.)

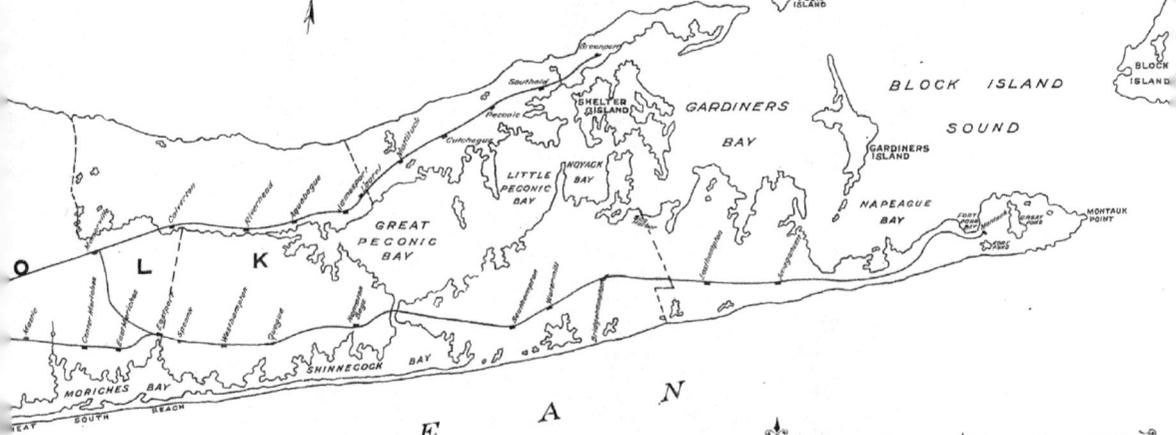

L A N D ' S O U N D

FISHERS
ISLAND

GREAT GULL

PLUM
ISLAND

BLOCK ISLAND

BLOCK
ISLAND

GARDINERS
BAY

SOUND

Greenport

Southold

Peconic

SHELTER
ISLAND

GARDINERS
ISLAND

Cutchogue

NAPEAGUE
BAY

MONTAUK
POINT

LITTLE
PECONIC
BAY

NOYACK
BAY

O L K GREAT
PECONIC
BAY

SHINNECOCK BAY

MORICHES BAY

SOUTH BEACH

O C E A N

O C E A N

LONG ISLAND RAILROAD

CORRECT TO OCT. 1, 1879

9

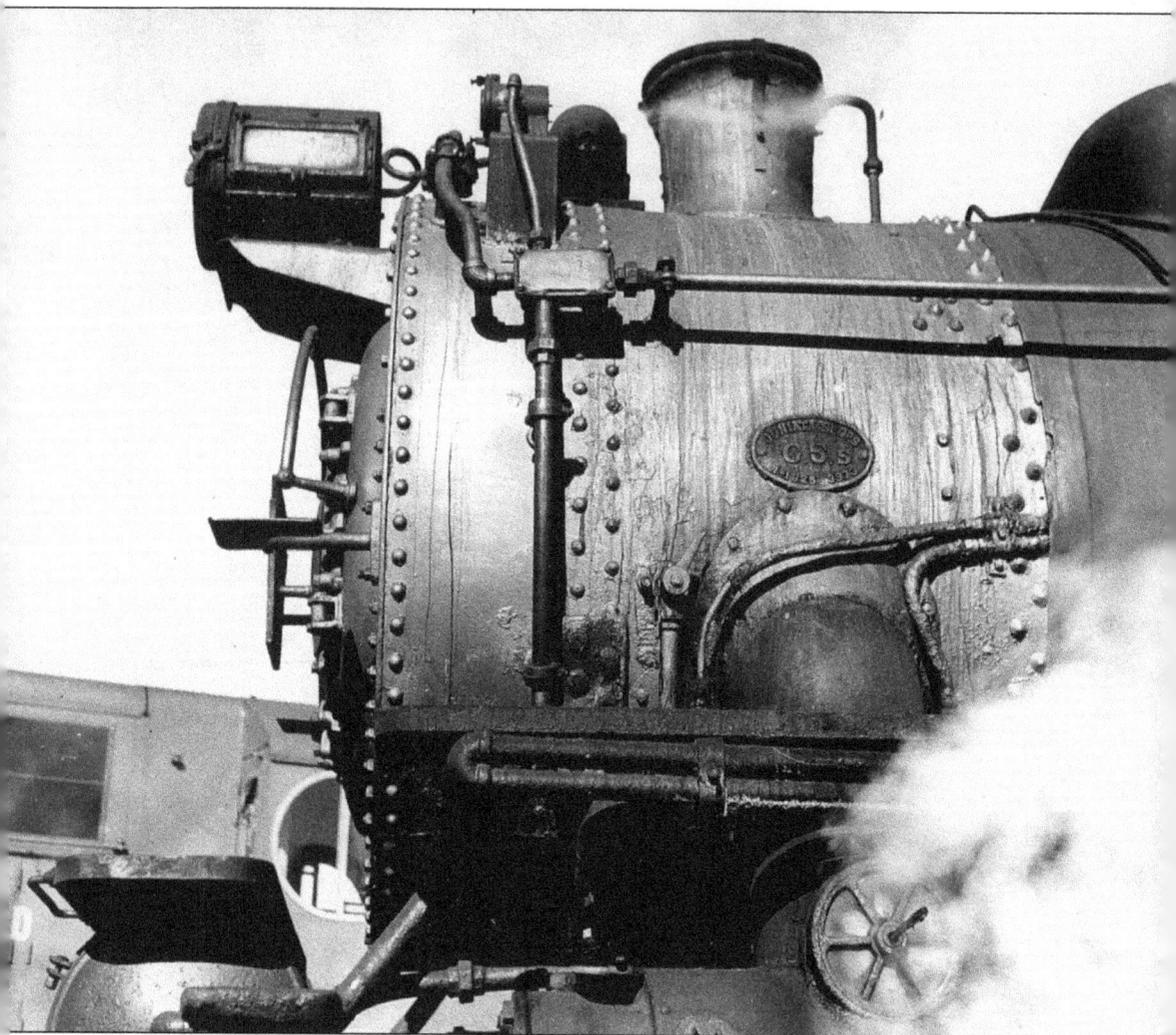

A fine example of the G5s class (4-6-0) locomotive in its last years is seen in a closeup of the smokebox of No. 24, photographed at Oyster Bay in 1951. The image clearly shows the builder's plate surrounded by rows of rivets and also clearly shows the engine's age, spotted with scale and frayed piping insulation. No. 24 is painted with the typical smokebox silver and has a spark arrestor mounted over the smokestack. In the background is the "new order"—the recently arrived Fairbanks-Morse model H16-44 diesel locomotive, which will play a part in the withdrawal from service of No. 24 and others like it in October 1955. (J. P. Sommer photograph.)

One

THE STEAM ERA

The earliest steam locomotive designs of the 19th century were slow starting and had limited tonnage capacity. With advanced boiler capacity and larger fireboxes, a new generation of locomotives evolved from the World War I U.S. Railroad Administration designs, laying the foundation for the modern commuter and freight engines of the 20th century. Providing fast acceleration and tonnage capacity, LIRR steam engines were ideally suited for Long Island's flat terrain and repeated start-stop commuter operations.

A workhorse on the railroad was the C51sa class (0-8-0) switcher. Used in freight service for many years, No. 258 is shown here at the Long Island City passenger terminal c. 1935 as it backs up to move a passenger train in preparation for its commuter run to distant points. The brakeman rides the bottom step of the tender, ready to jump off and couple the locomotive onto the train. (David Keller collection.)

The E51sa Atlantic class (4-4-2) camelback No. 4 pulls the crack LIRR name train Cannonball eastbound *c.* 1923 on the now abandoned Manorville branch approaching PT cabin and the junction of the branch with the Montauk branch at Eastport. On the left is one of the signs indicating the number of miles to the Abraham & Strauss department store in Manhattan. (James V. Osborne photograph.)

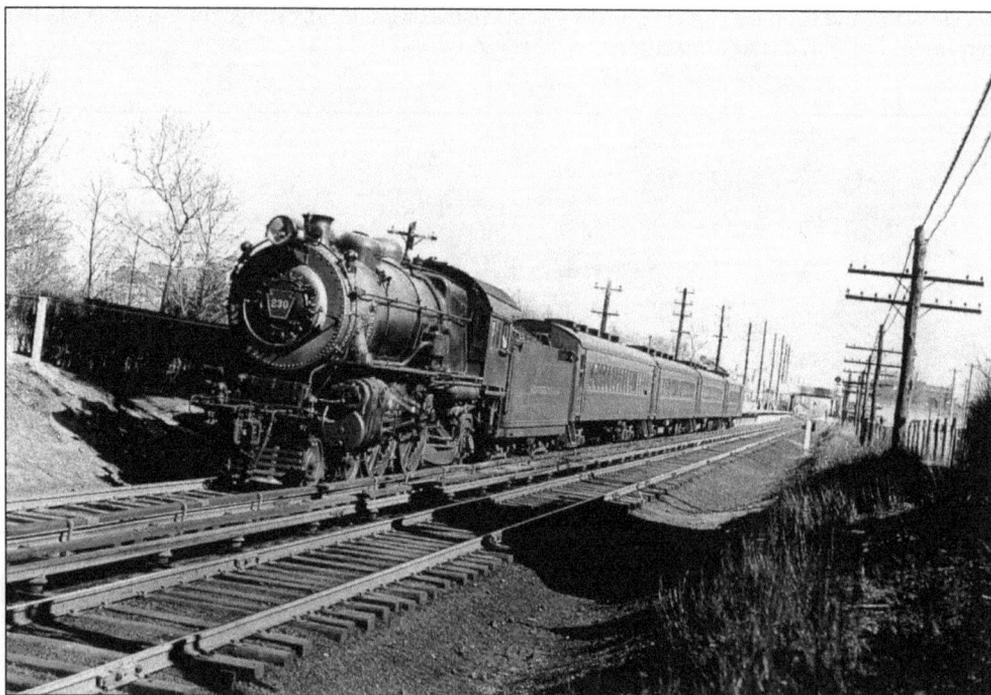

Another "speed demon" was the E6s Atlantic class. No. 230 was one of many locomotives leased from the Pennsylvania Railroad for use on the LIRR from 1900 until 1950. Here No. 230 pulls a train of "Ping-Pong" coaches from Oyster Bay westbound just after it departed from the station at Mineola on a chilly February day in 1937. The Ping-Pong coaches were so nicknamed because riders were bounced around inside the car. (George E. Votava photograph.)

12

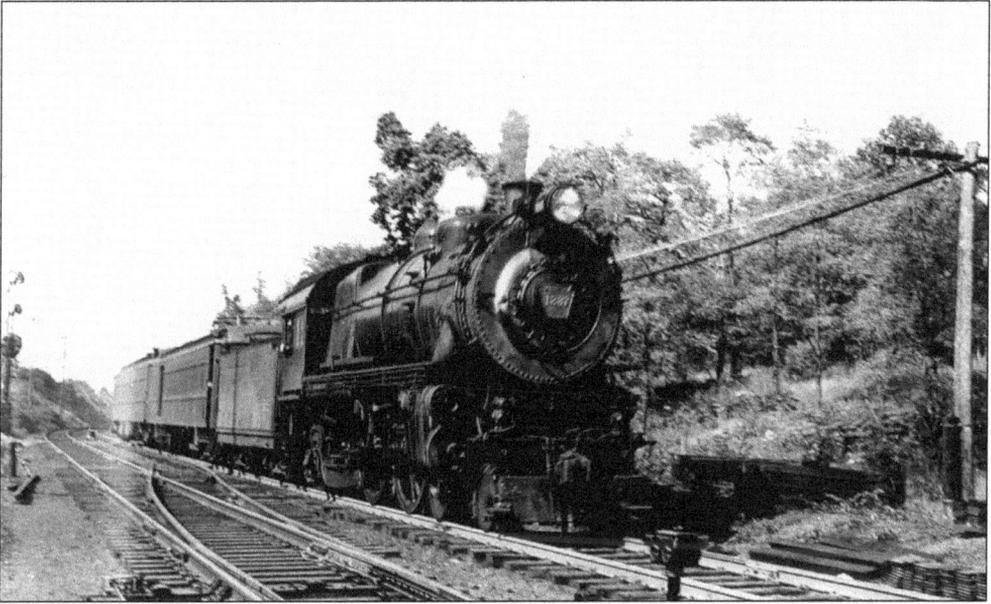

Another example of the E6s is shown here as Pennsylvania Railroad No. 1287 blows its whistle and rounds a curve at Roslyn, New York, in 1940. The unusual aspect of the scene is that the train is running against traffic. On the far left can be seen a combination of both semaphore and position-light signals, evidence of the phaseout of the older semaphore type. (T. Sommer photograph.)

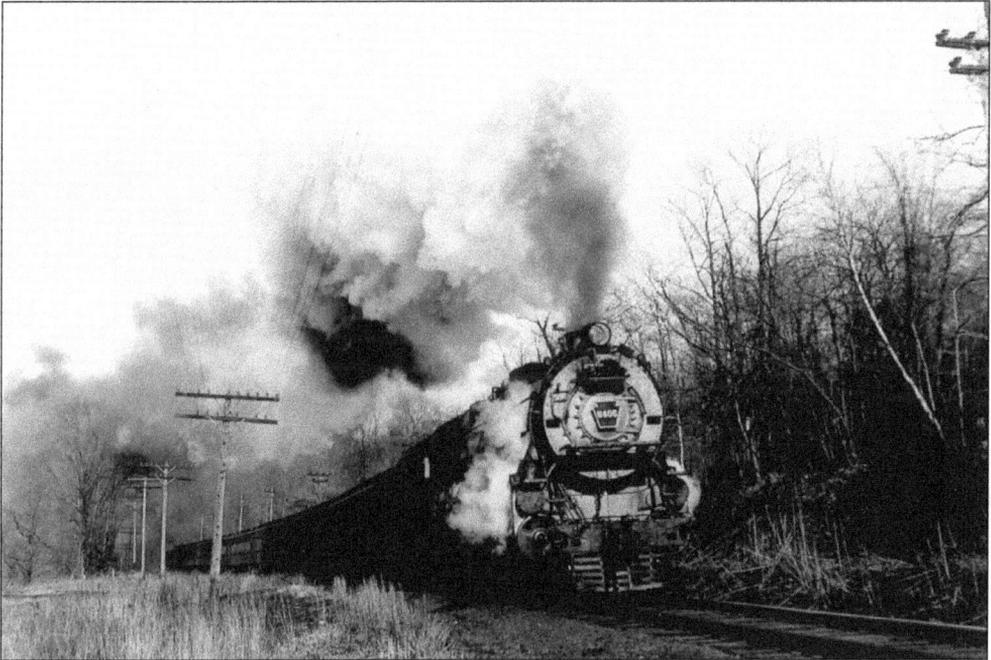

It is a wintry day in March 1947 as leased Pennsylvania Railroad class K4s Pacific (4-6-2) No. 5406 pulls train No. 4613 westbound up the hill through Cold Spring Harbor amidst smoke and steam. Built in 1927 by the Baldwin Locomotive Works, this Pennsy locomotive was used almost exclusively on the LIRR. (George E. Votava photograph.)

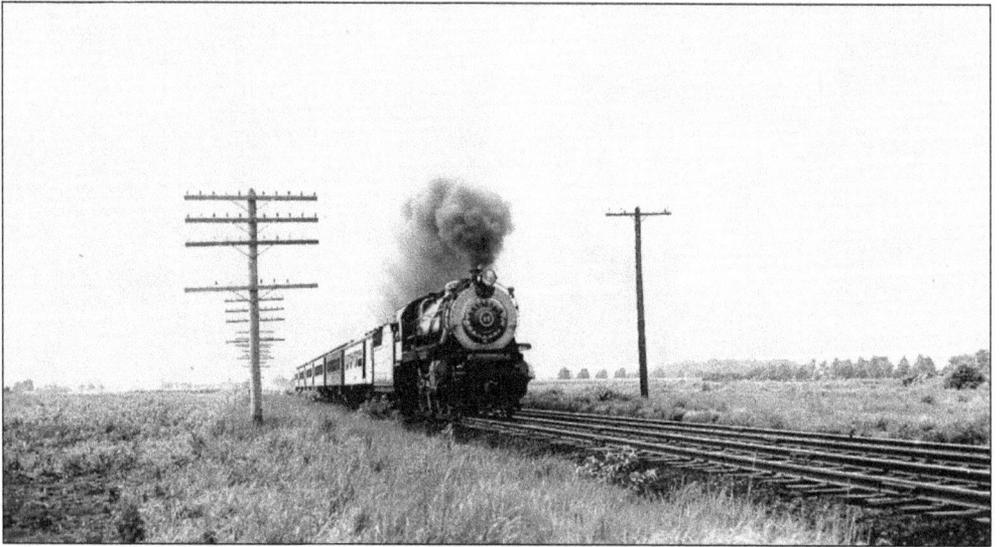

The scenery at Hicksville, New York, has changed greatly since this action shot was taken on July 31, 1937. Here G5s No. 25 pulls train No. 632, consisting of an arched-roof combine and five clerestory-roofed cars, eastbound through the rural countryside. This scene typifies the landscape of most of Long Island along the main line years ago, before the housing boom and industrial growth of the post–World War II years. (George E. Votava photograph.)

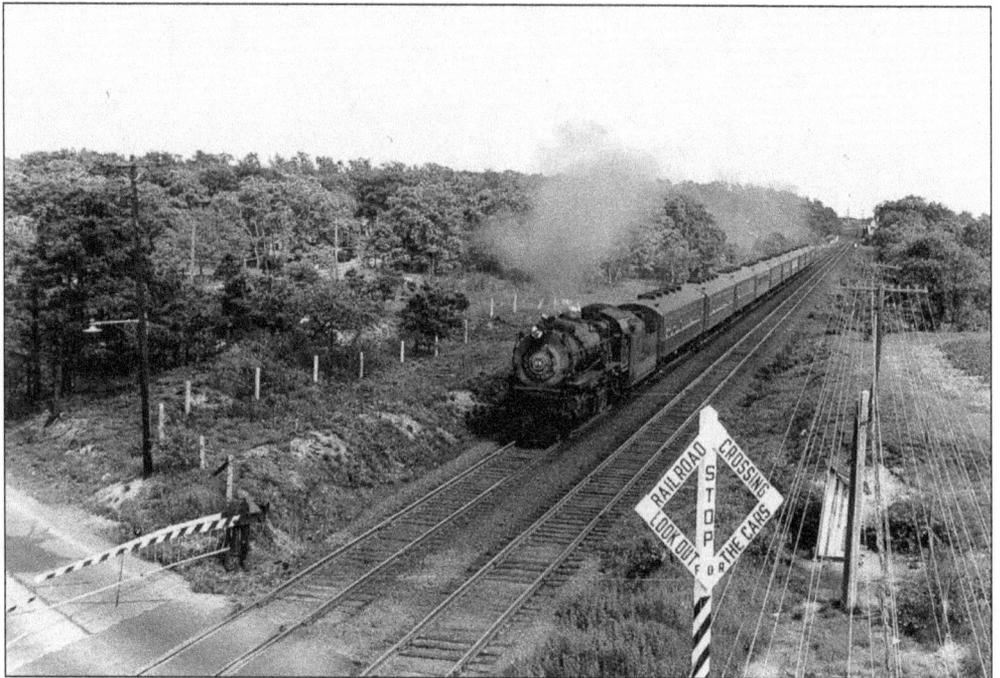

G5s No. 25 pulls westbound train No. 4227 from Central Islip State Hospital approaching the Long Island Motor Parkway overpass at Bethpage, New York, in June 1949. In the foreground is the popular wooden diamond crossing sign. Also visible is the outhouse, which served as the "facilities" for the crossing watchman. A closer look reveals the crescent moon cut into the side of the structure. (George E. Votava photograph.)

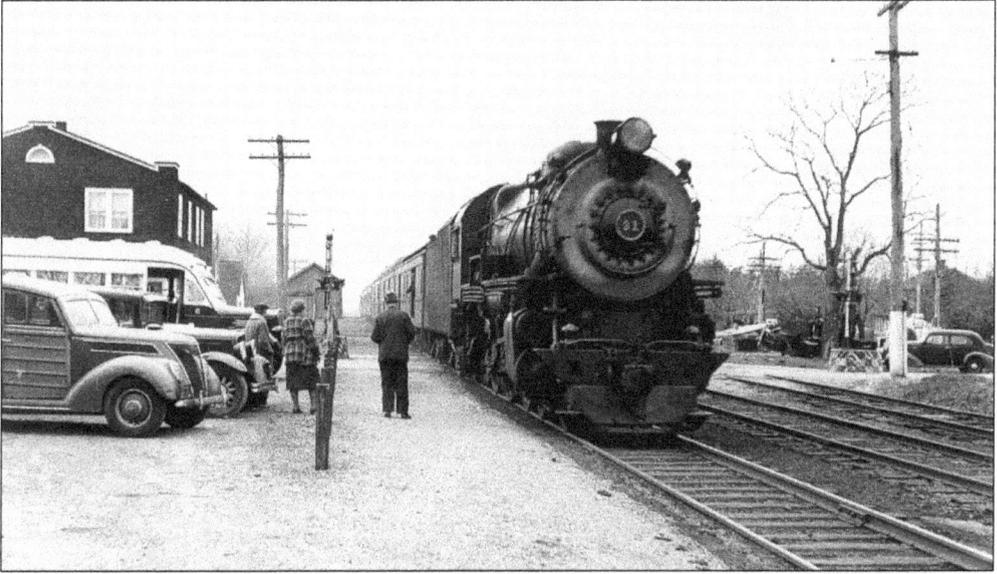

In a photograph taken before the grade elimination, G5s No. 31 pulls Greenport-bound train No. 204 eastbound over the Route 112 crossing as the train enters Medford station on April 19, 1940. On the left, trackside, is the old express house. In the center and on the right are the old "center-of-the-road" crossing flashing lights on the striped concrete abutments. The tracks and depot area depicted here were elevated by year's end. (Albert Bayles photograph.)

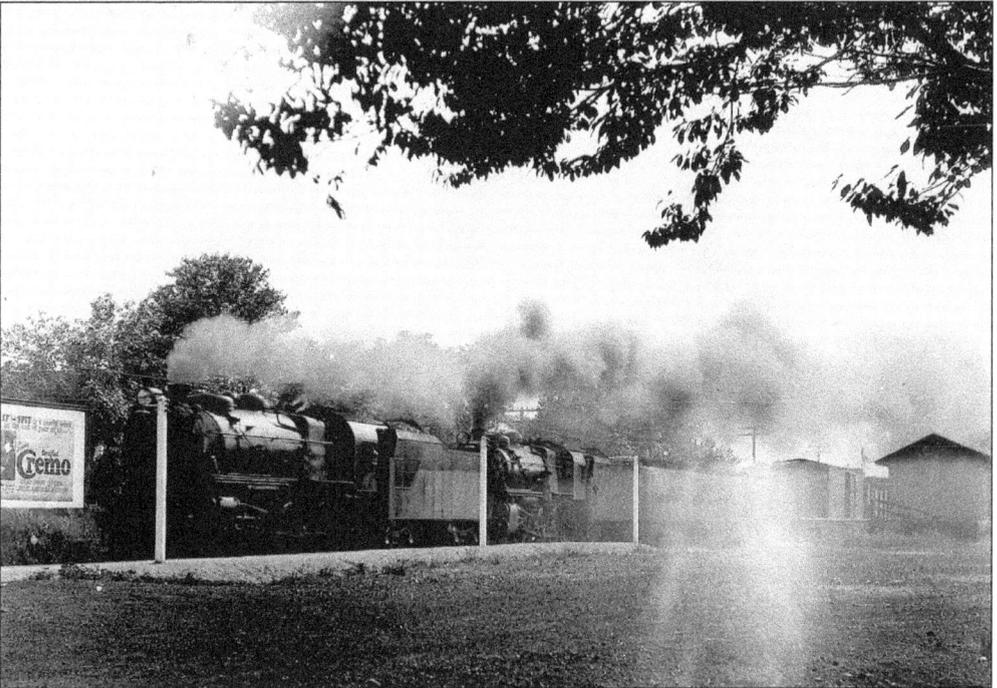

G5s locomotive No. 32 and an unidentified engine doublehead Montauk-bound train No. 12 eastbound through Central Islip at speed c. 1930. No. 12 will continue along the main line until it reaches Manorville, where it will branch off across the island to the connection with the Montauk branch at Eastport, with Montauk as the final destination. (George G. Ayling photograph.)

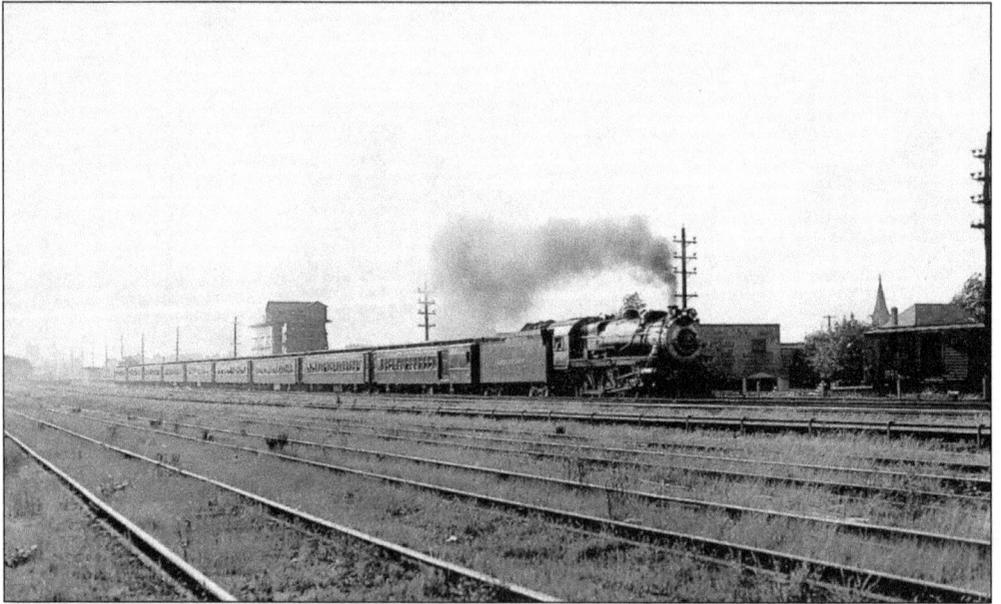

Holban Yard does not appear to have too much activity late in the day on September 2, 1937, as G5s No. 50 pulls Speonk-bound train No. 38 at speed past Hillside station (seen in the left background). In the center background is one of the many coal silos that could be found everywhere on the island, as coal was the primary fuel for heating homes. (George E. Votava photograph.)

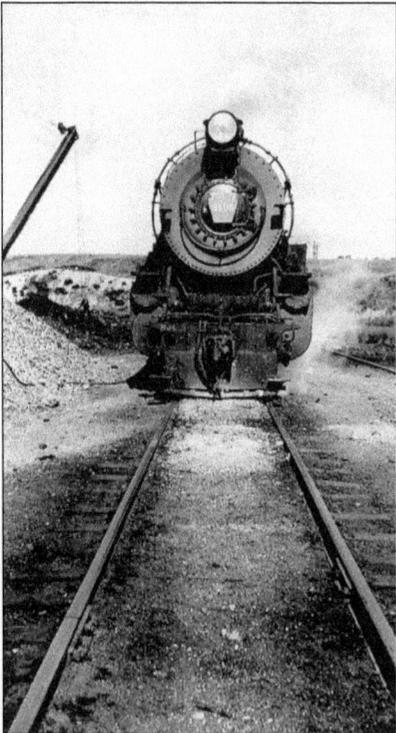

It is the literal end of the line for Pennsy K4s No. 5409 as it sits on the coaling track at Montauk, New York, in 1940. Montauk was the farthest east that the LIRR tracks extended on the south shore of the island. On the pilot of the engine are stenciled the letters "NJ-L," which meant this leased locomotive could be used in service in both New Jersey and on Long Island. (T. Sommer photograph.)

16

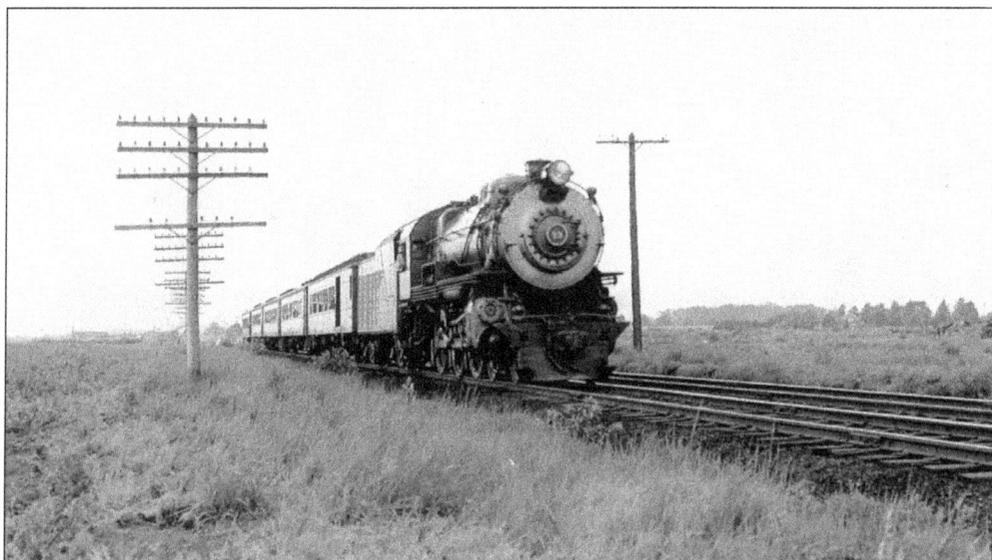

Here is another rural Hicksville scene, as G5s No. 39 pulls train No. 238 eastbound on a hot, humid day in July 1937. The condensation along the side of the tender indicates the tank is almost full of water. The breeze passing through the train from the many opened windows in the coaches is the only way for the passengers and crew to get some relief from the summer heat. (George E. Votava photograph.)

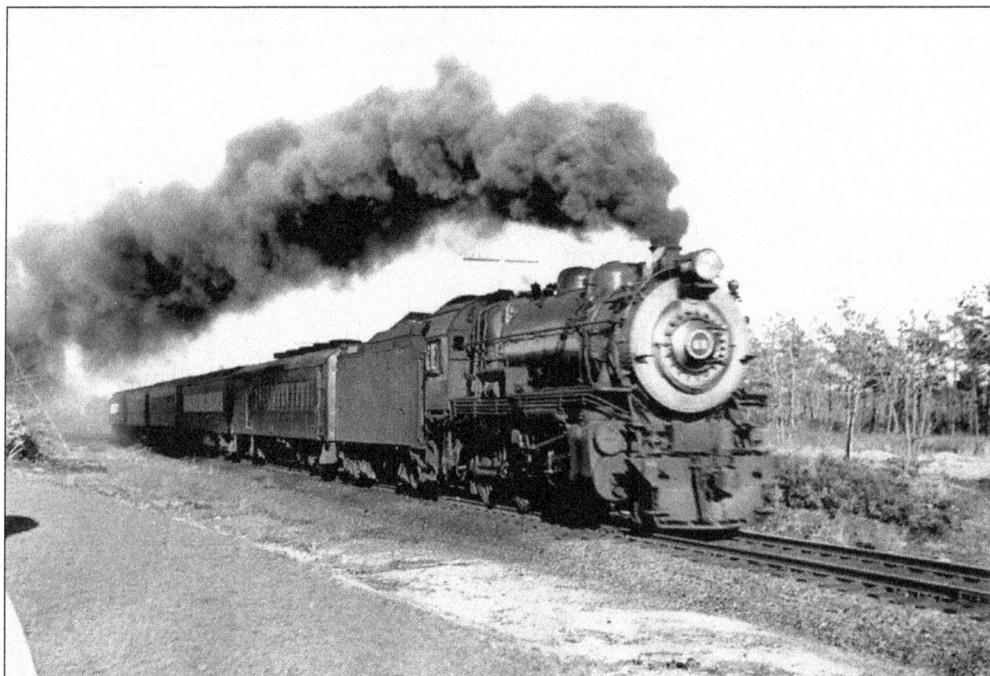

G5s No. 49 and westbound train are captured in the late-afternoon sunlight as the engine chuffs black smoke east of Medford in 1940. The locomotive's plume covers the entire train. The smoke would settle down upon everything, leaving a fine layer of coal ash that riders in the steam era knew so well; the ash would cover their clothing and blow into the train when the doors or windows were opened. (Albert Bayles photograph.)

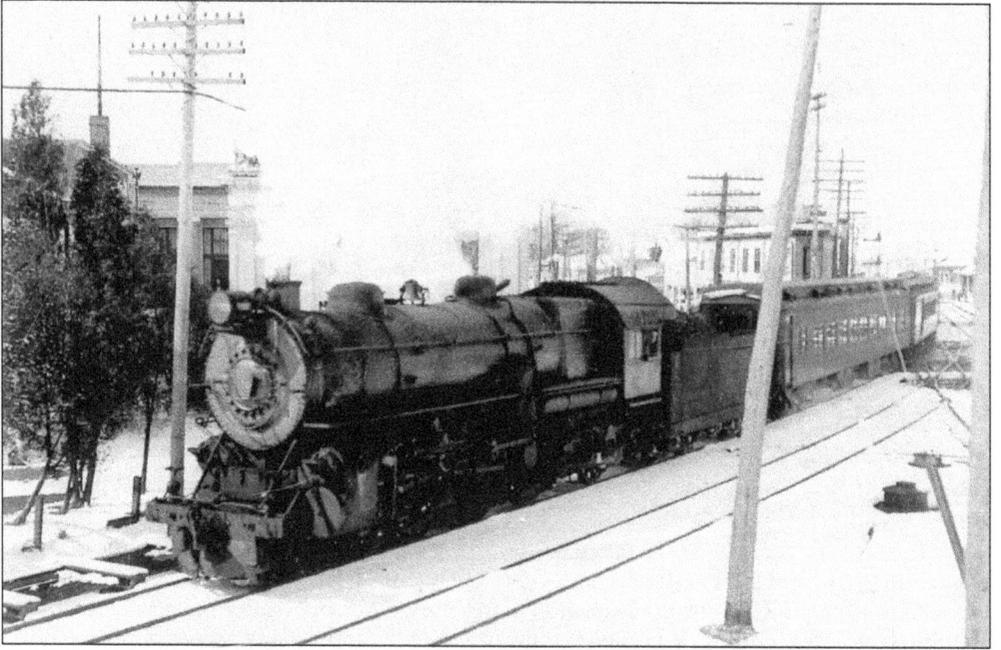

It is the winter of 1940, and a light layer of snow covers the landscape. Pennsy class K2s No. 1458 pulls a train bound for Montauk through Hicksville. The tender is filled with coal, and the fireman has a moment to sit and look out his side of the cab as the photographer snaps this action shot from the window of Divide tower. (T. Sommer photograph.)

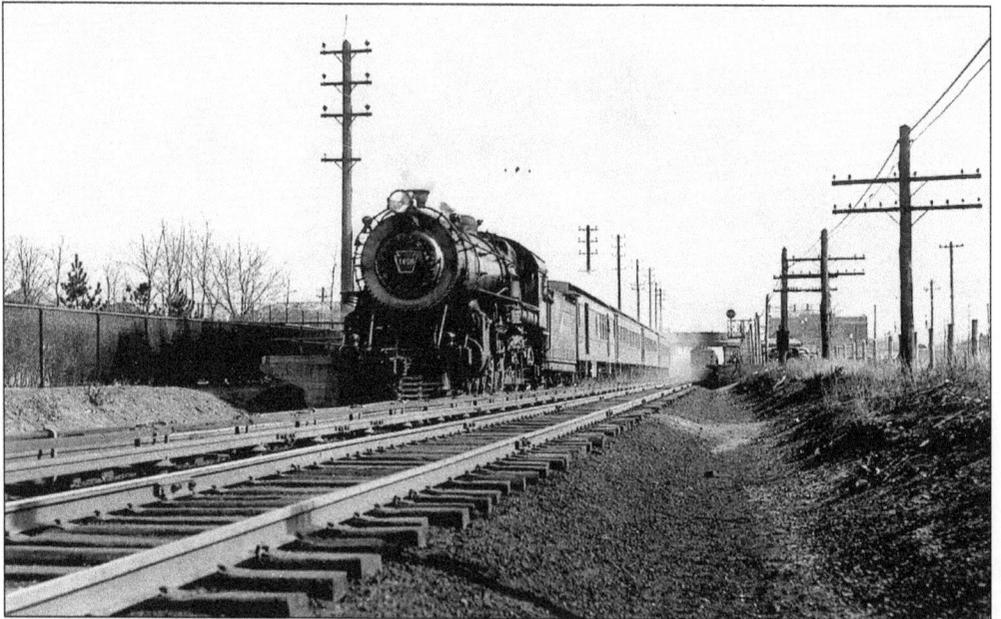

Pennsy K2s No. 1458 pulls away from the westbound station platform at Mineola on a cold, sunny February day in 1937. On the right, beyond the Mineola Boulevard overpass, is the red brick building that houses the LIRR's electric substation. The substation helps produce the electric current that allows operation of the third rail, seen in the middle of the photograph between the eastbound and westbound tracks. (William Lichtenstern photograph.)

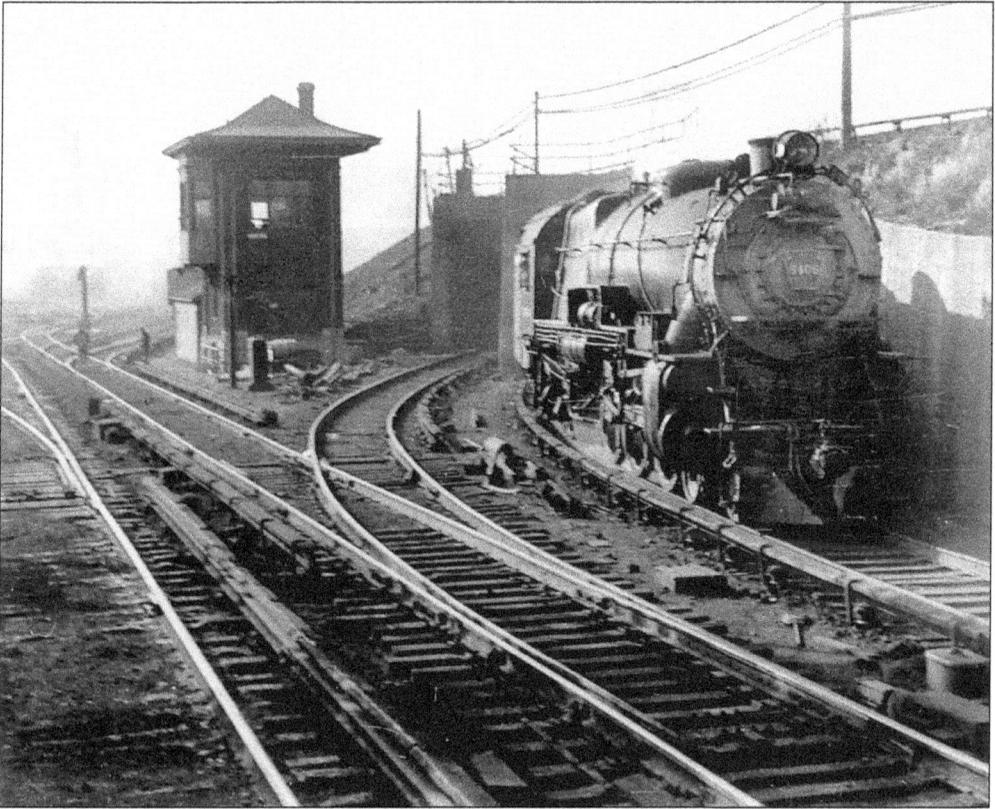

In this *c.* 1950 photograph taken from the rear of an eastbound train on the Atlantic branch, Pennsy K4s No. 5406 backs under the Montauk branch at Dunton interlocking tower in Dunton, Queens to access the Richmond Hill Storage Yard. On the far left, visible through the smoke and haze, are the Morris Park Locomotive Shops. (David Keller collection.)

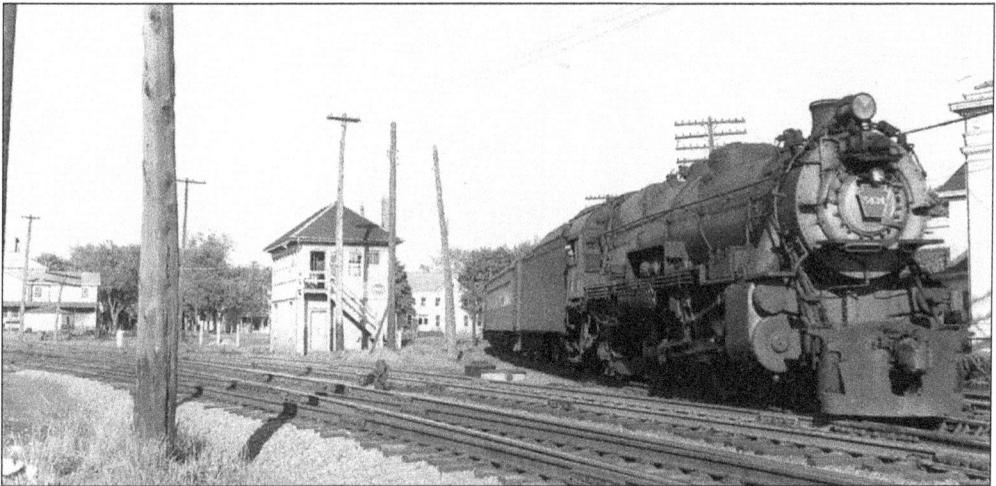

Pennsy K4s No. 5434 pulls a westbound train on the main line past the old Divide tower at Hicksville on May 8, 1949. The tracks branching off to Port Jefferson are in the foreground. The entire Hicksville depot area, wye junction, and tower were elevated in the early 1960s to eliminate the grade crossings in the town. (George E. Votava collection.)

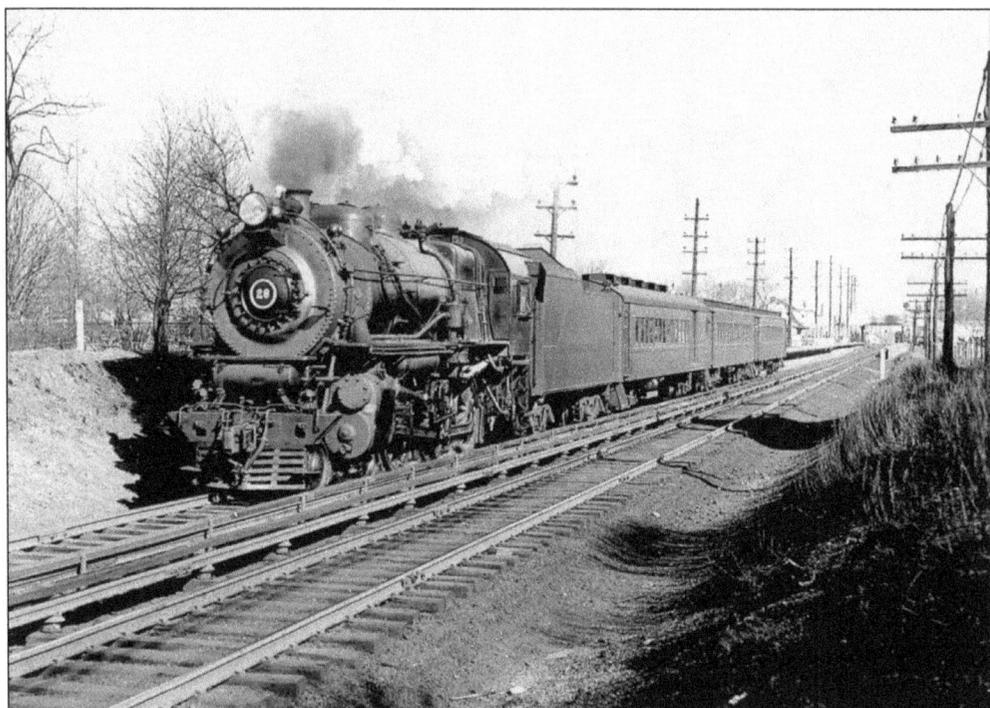

It is another bright, chilly, Long Island day as G5s No. 28 leaves the westbound platform at Mineola with a three-car train in February 1937. The engine's rods are down, and it is puffing smoke and releasing crisp steam into the cold, early-afternoon sky. In the distance is the Mineola depot and the Mineola Boulevard overpass. (George E. Votava collection.)

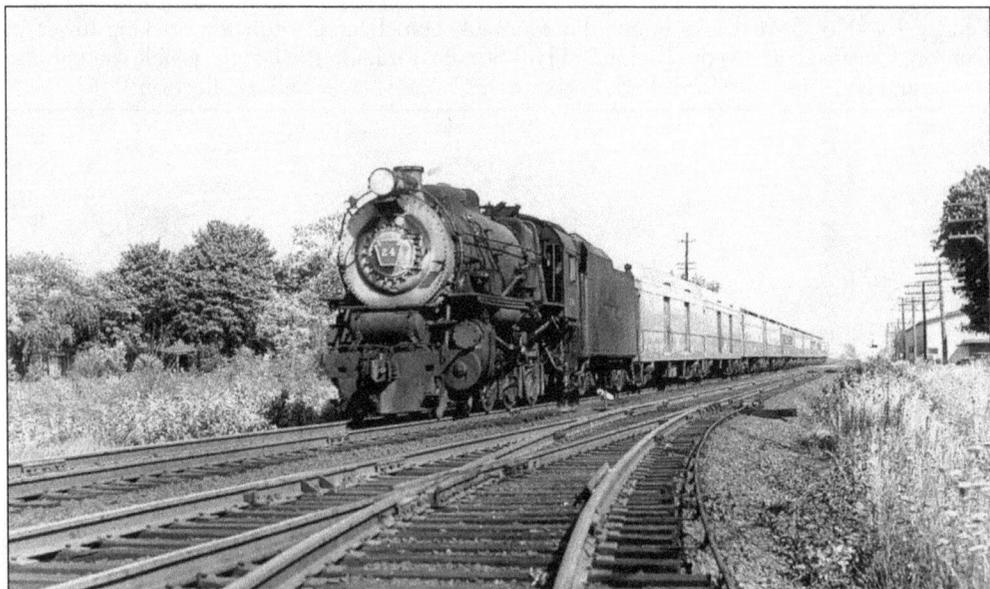

On a warm summer's day in July 1953, G5s No. 24 pulls train No. 237 westbound at Hicksville. The train consists of two baggage cars and nine passenger cars, all in the fairly new Tichy light-gray color scheme. The fireman's door is open as he tries to get a breath of air in the cab. (George E. Votava collection.)

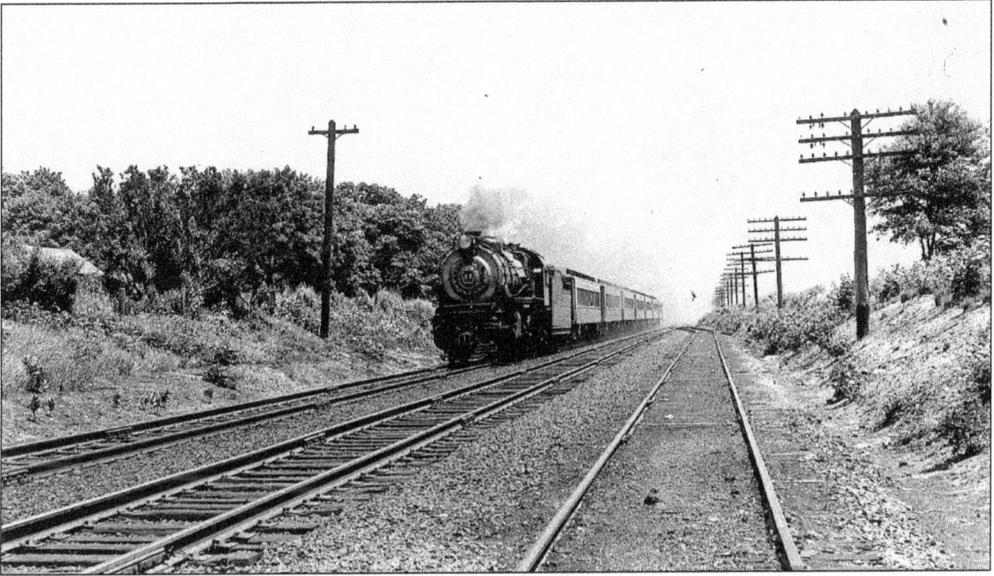

G5s No. 25 appears to be moving at breakneck speed as it pulls train No. 4607 westbound near Westbury. The locomotive's plume envelopes the entire train in coal ash and smoke. It is another warm summer's day in June 1947, and the foliage alongside the tracks is full. Also full are the old telegraph and telephone poles with the old glass insulators, and the tender of No. 25, which is loaded with coal. (George E. Votava photograph.)

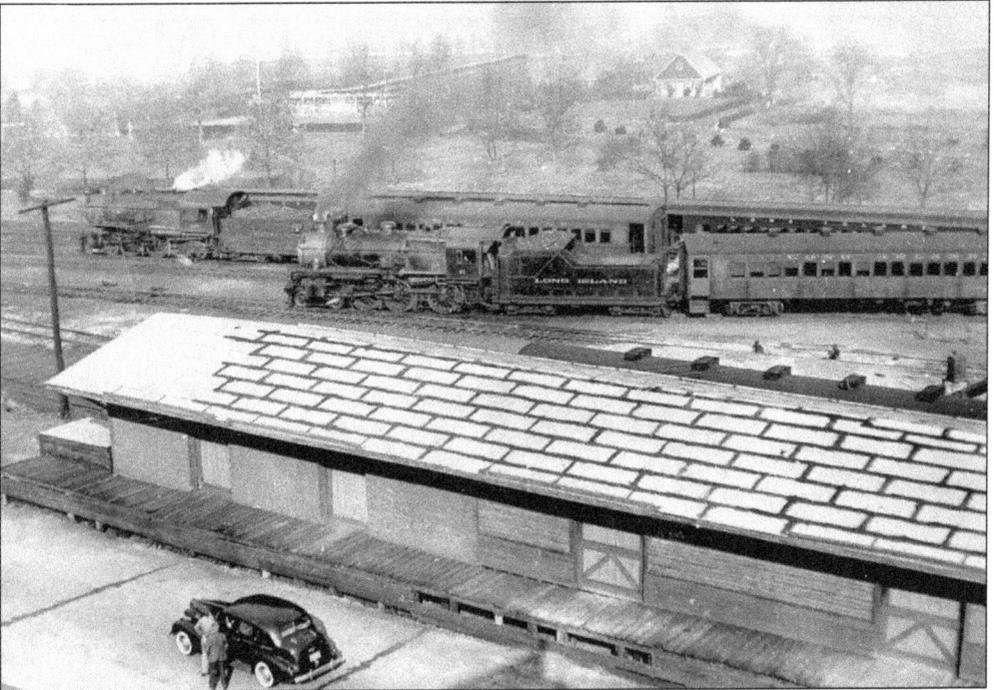

It is 1938 and the photographer has climbed to the top of the Long Island Coal Company's coal silo in Oyster Bay to snap this shot looking northwestward of G5s No. 21 and Pennsy E6s No. 1680, with their respective trains, laying up in the yard. In the foreground is the old freight house and a brand-new, shiny sedan. (T. Sommer photograph.)

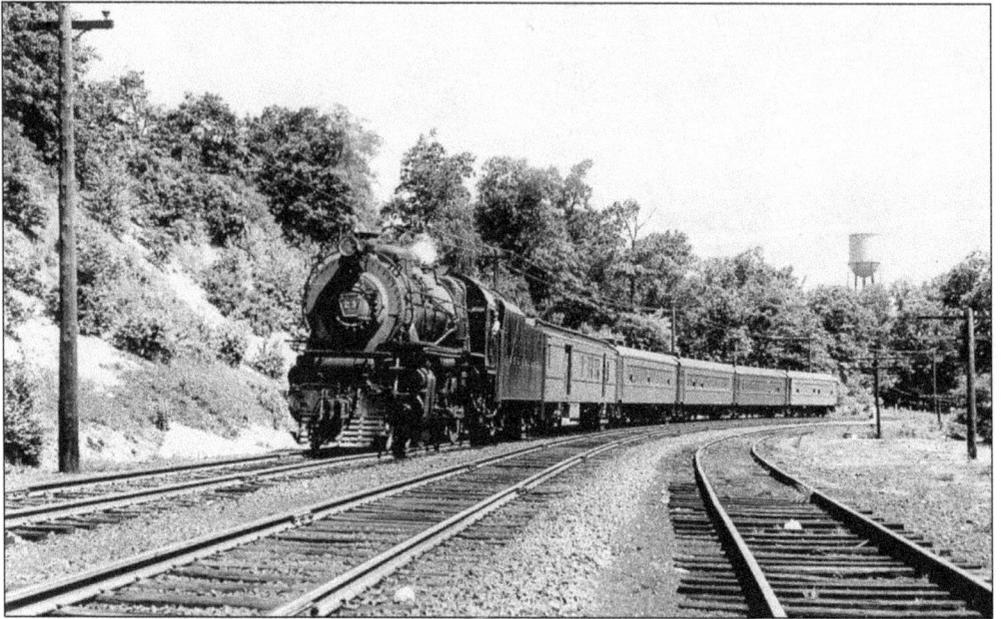

G5s No. 23 blows its whistle as it pulls train No. 529 westward around the curve at Sea Cliff in July 1947. The lead car is a Railway Post Office car, and the fireman has a rare moment to sit and look out the window of the cab before it is time to resume shoveling coal into the hungry firebox. (George E. Votava collection.)

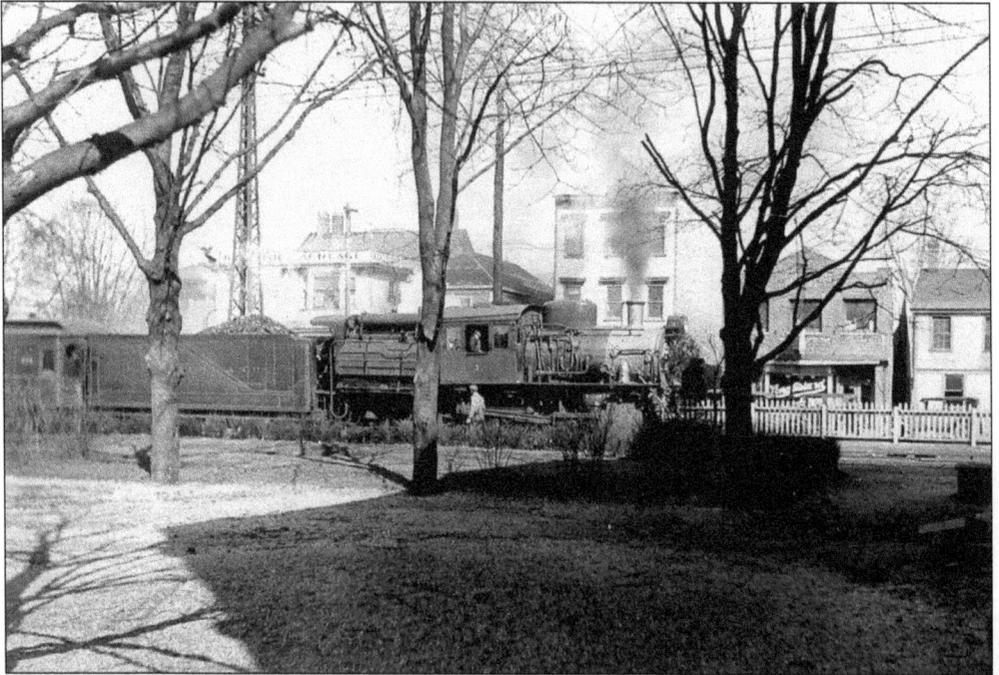

The engineer of Atlantic class E51sa camelback No. 3 wears a white shirt collar and tie with jacket under his overalls as his locomotive pauses at the former Mineola station site c. 1928. The shadow on the ground is cast by the LIRR's electric substation. Camelback No. 3 was withdrawn from service in April 1929, not long after this photograph was taken. (David Keller collection.)

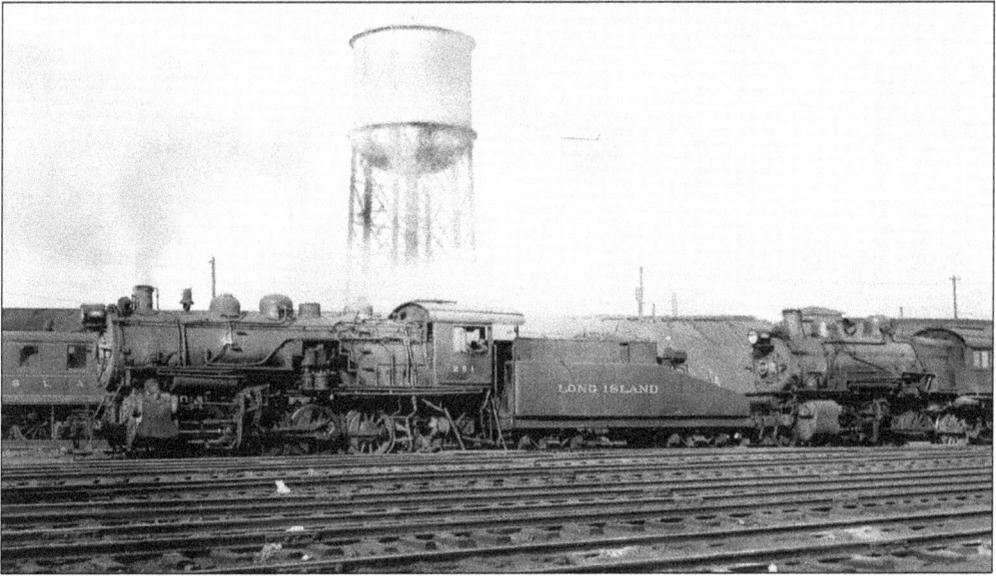

Freight locomotives 0-8-0 switcher class C51s No. 251 and 2-8-0 Consolidation class H6sb No. 308 are doubleheading westbound past Morris Park Shops c. 1939. In the background on the left is a class DD1 electric locomotive, newly pinstriped in time for the 1939–1940 New York World's Fair. Richmond Hill yard is on the other side of the embankment, and the roof of the trainmen's building cupola is just visible. (David Keller collection.)

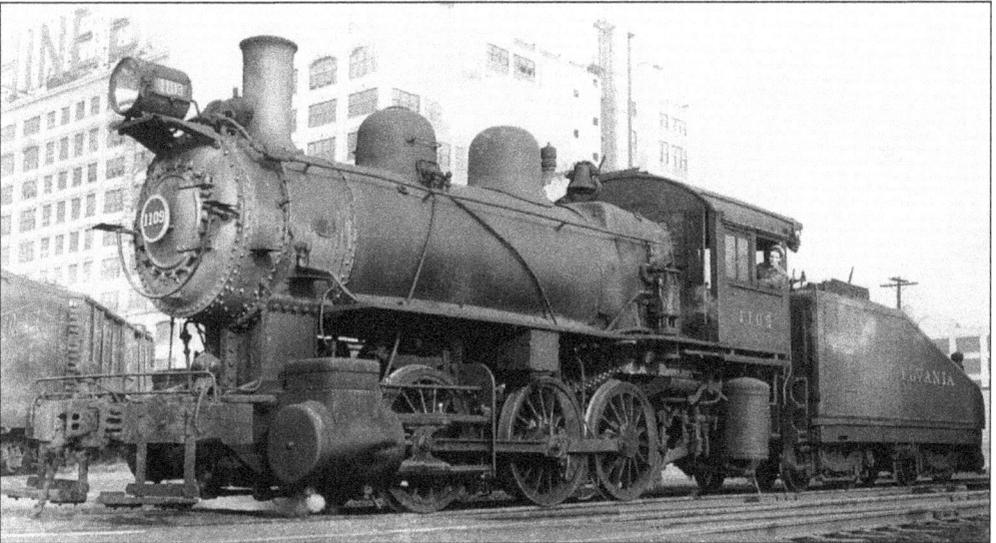

Pennsy switcher class B8 (0-6-0) No. 1109 stands with its fireman on the Degnon Terminal switch leads at Skillman Avenue, Long Island City, in November 1946. In the background is the Sunshine Biscuit Company, which, along with Silvercup Bakery, was famous for making this part of Long Island City smell very nice, indeed. (W. J. Edwards photograph.)

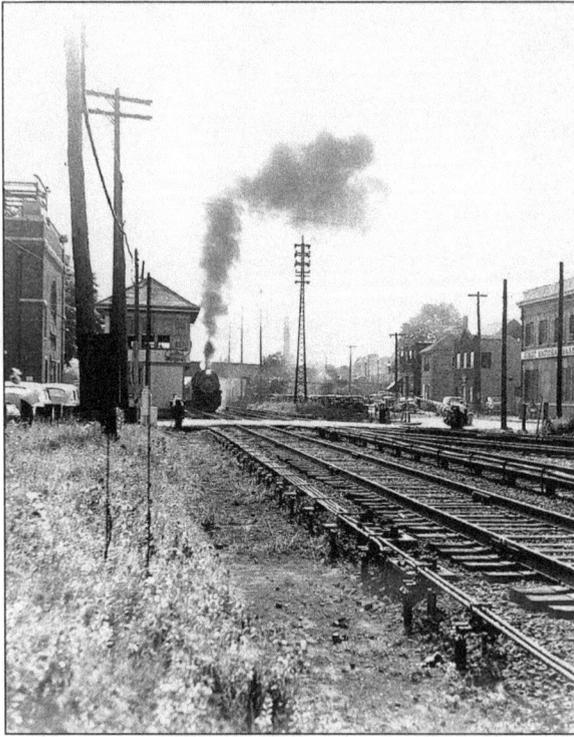

Chuffing smoke straight up, G5s No. 28 leaves eastbound from the Mineola station and is about to pass Nassau tower in this 1950 view. The manual crossing gates are lowered, having been cranked down by the block operator in the tower. In the foreground are the pipes containing the linkage to operate signals and switches from the tower when the levers are thrown. (J. P. Sommer photograph.)

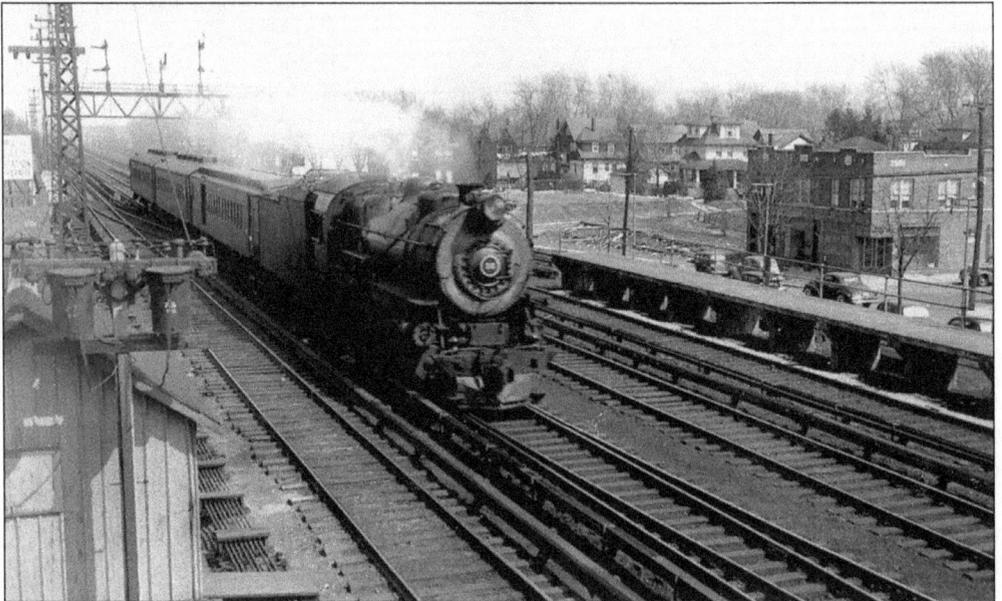

Barreling westbound along the express track is G5s No. 36, pulling a three-car train through the Hollis station. In this 1941 view from Hollis tower, one can see the crossover tracks to the left of the train and in front of the locomotive that allowed westbound trains to get from the local track to the tracks accessing Holban Yard, just west of the Hollis station location. (T. Sommer photograph.)

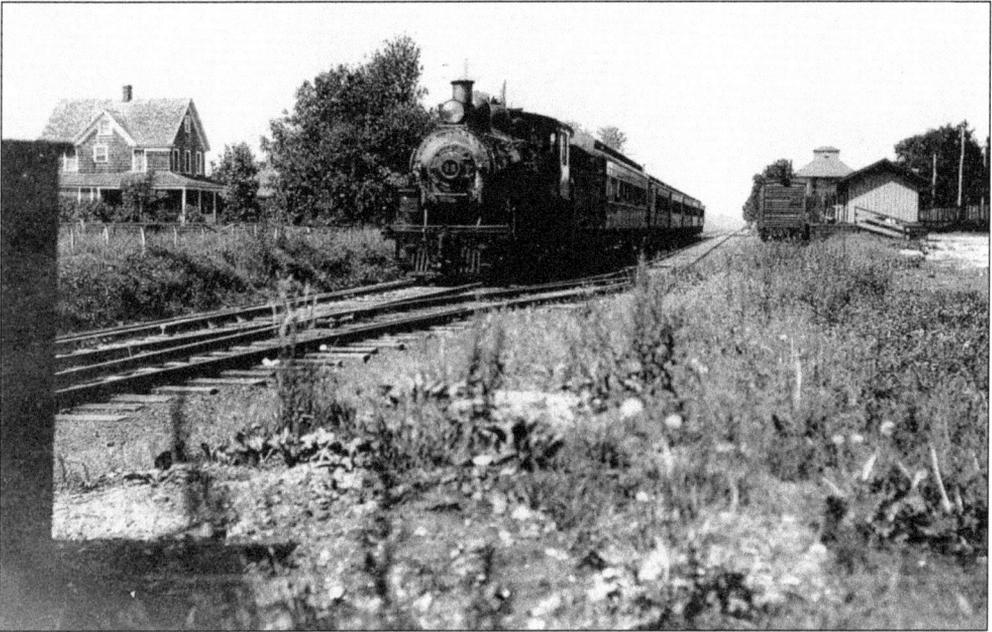

Nearing the end of its life, but still in service, this neat little American class (4-4-0) D56 No. 82 with train travels eastbound approaching Central Islip in the mid-1920s. Also visible are a boxcar at the old freight house, some work gondola cars on the siding on the right, behind the freight house, and the ubiquitous coal silo in the background. (George G. Ayling photograph.)

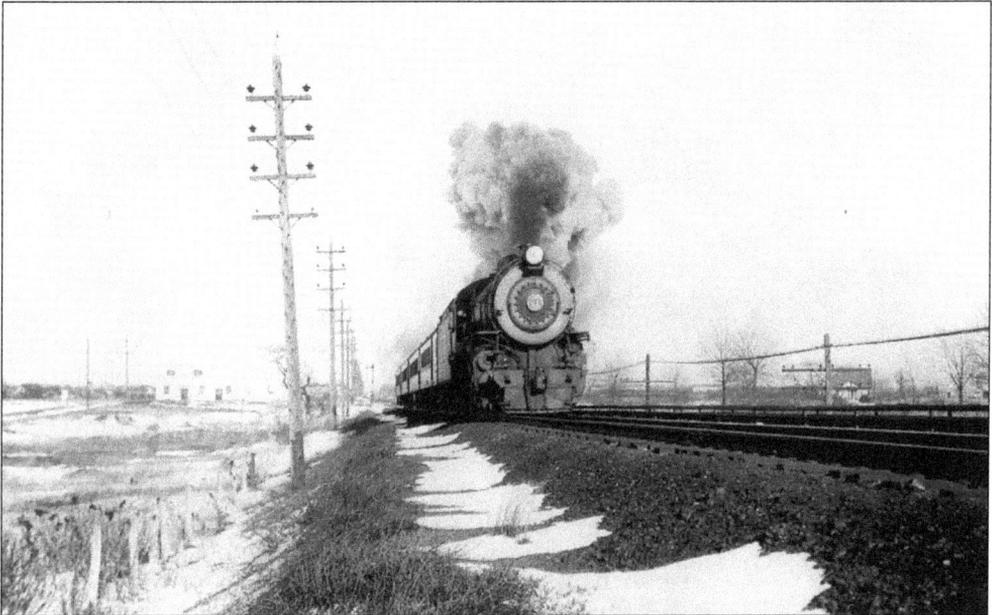

G5s No. 42 puffs hot smoke into the cold, crisp Long Island air as it pulls its train westbound at speed through rural Mineola in February 1941. (George E. Votava collection.)

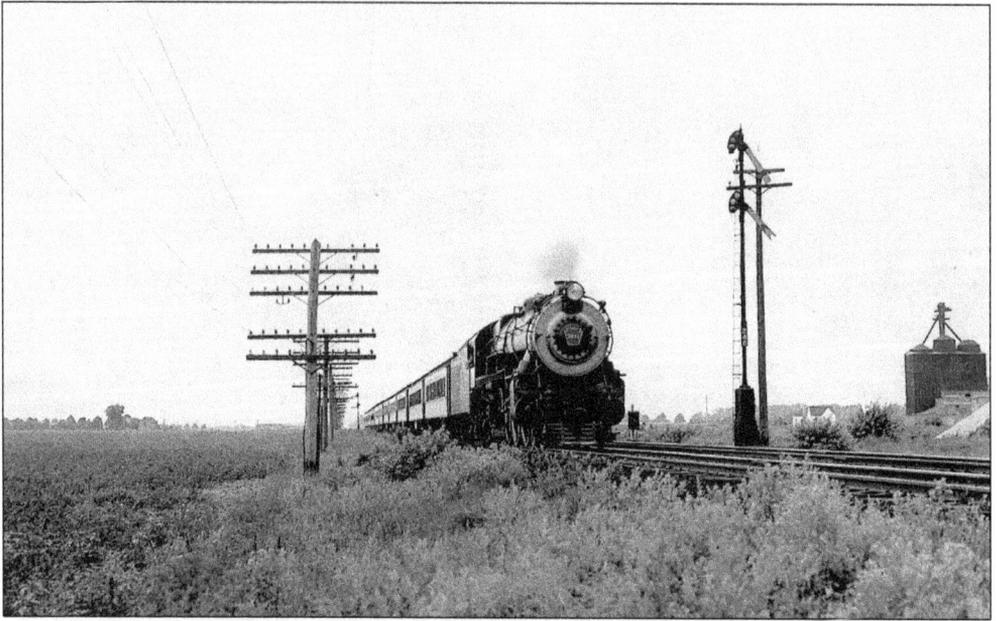

Pennsy K4s No. 3841 pulls Saturday-only train No. 12, the Shinnecock Express, eastbound through Hicksville on a hot, humid July day in 1937. To the right of the locomotive are the old semaphore arm block signals, which are set for oncoming traffic on the westbound track. Farmland appears to abound on the left in this scene. (George E. Votava photograph.)

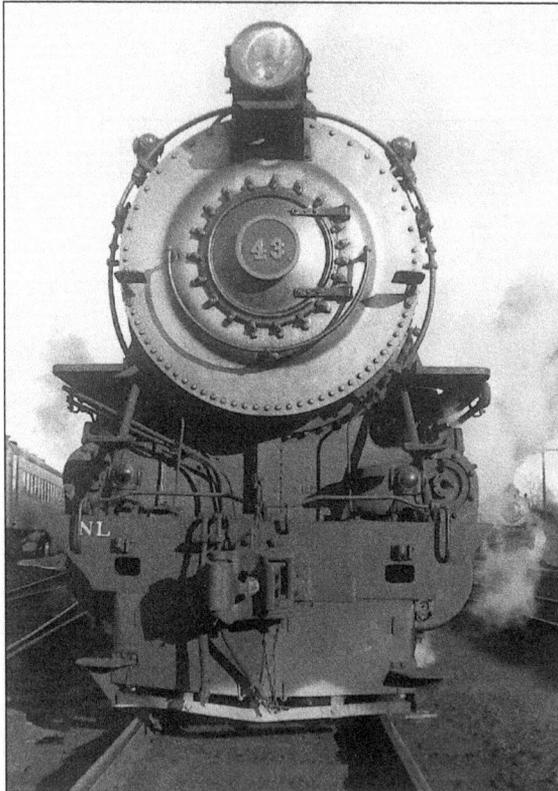

G5s No. 43 stands at rest in a late-afternoon scene at Oyster Bay in 1940. Sporting a round number plate and classification lights atop its smokebox, No. 43 would acquire a new look in the years that followed; the lights were removed by Pennsylvania Railroad edict, and the round number plate was exchanged for a keystone-shaped PRR plate. The NL stenciled on the engine's pilot represents the New York–Long Island region. (T. Sommer photograph.)

Two

CARRYING THE PASSENGERS

Passenger travel and trains, once the nation's primary means of transportation, have almost disappeared from the American landscape. Failing revenues, airlines, and the automobile spelled doom for passenger trains. However, the LIRR has remained the largest commuter operation in the world, thanks to the region's density of population, proximity to New York City, and congested highways with limited access to Manhattan Island. Also, the LIRR's suburban stations are conveniently located along the main branches, providing ease of entry into Penn Station in the heart of New York City.

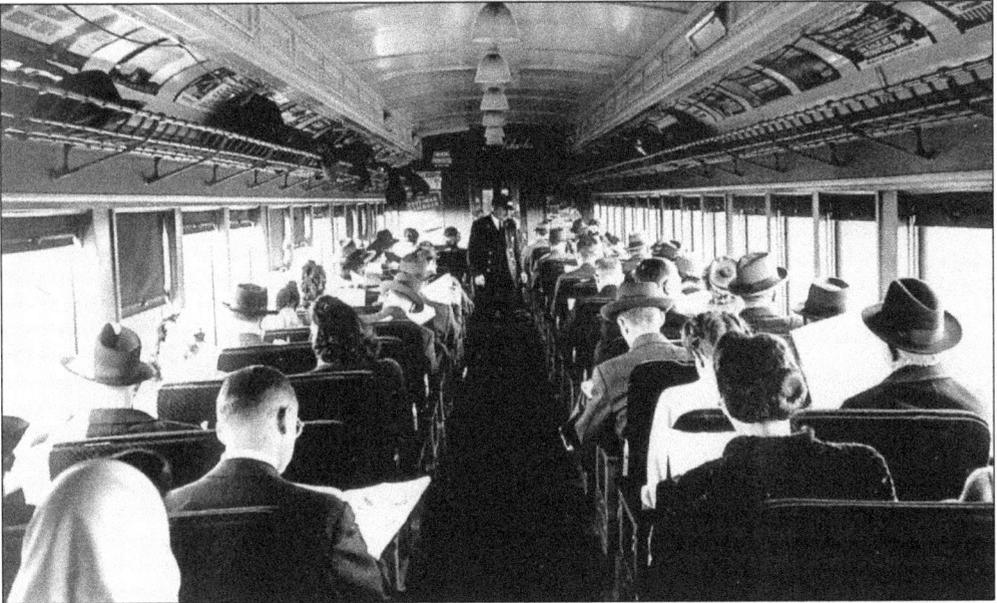

Commuting was always a fact of life on Long Island. Here a bunch of morning commuters ride in an old clerestory-roofed coach. Most of the men are wearing snap-brimmed fedoras and overcoats, in the style of 1945, and the conductor has stopped to chat with one of the riders. Perhaps he is about to call out, "All change at Jamaica!" (George Christopher photograph.)

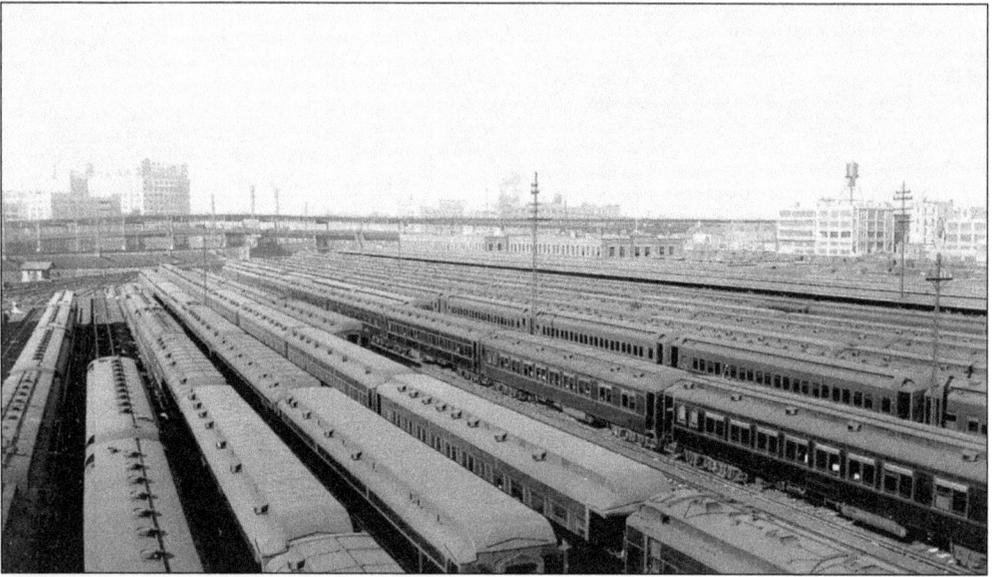

Sunnyside Yard in Long Island City, Queens, once boasted of being the largest passenger car yard in the nation. In this scene, one can see how true that claim was. The yard is filled with passenger cars, parlor cars, and Pullman cars. In the background is the vista of 1920s Long Island City. (James V. Osborne photograph.)

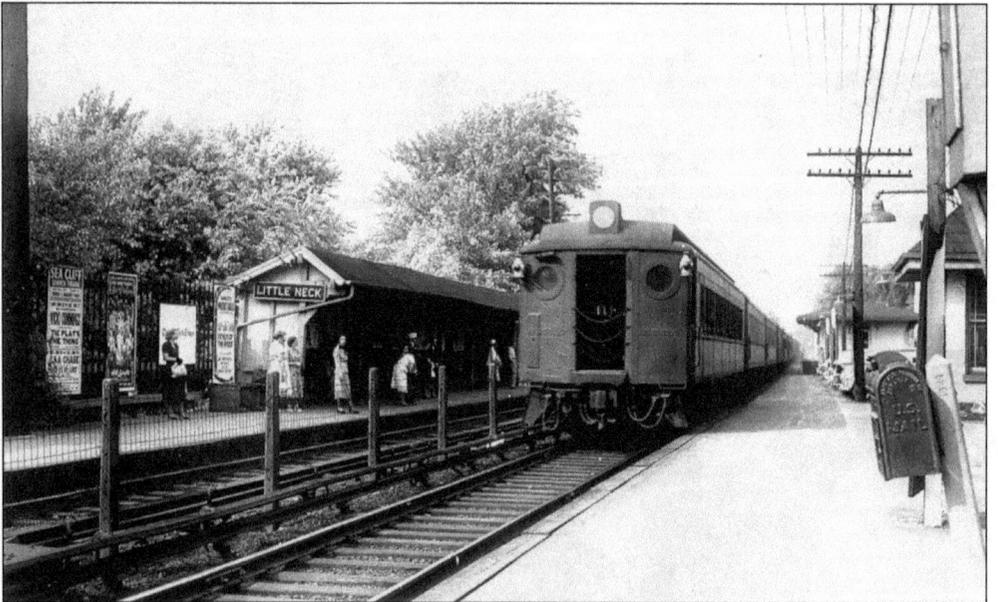

An MU train heads eastbound from Little Neck station in 1952. On the left, commuters await the arrival of a westbound train at the old, wooden shelter shed. To the right of the train is the old express house and the bay window of the depot's ticket office. In the foreground is the old-style, public U.S. mail box. (W. J. Edwards photograph.)

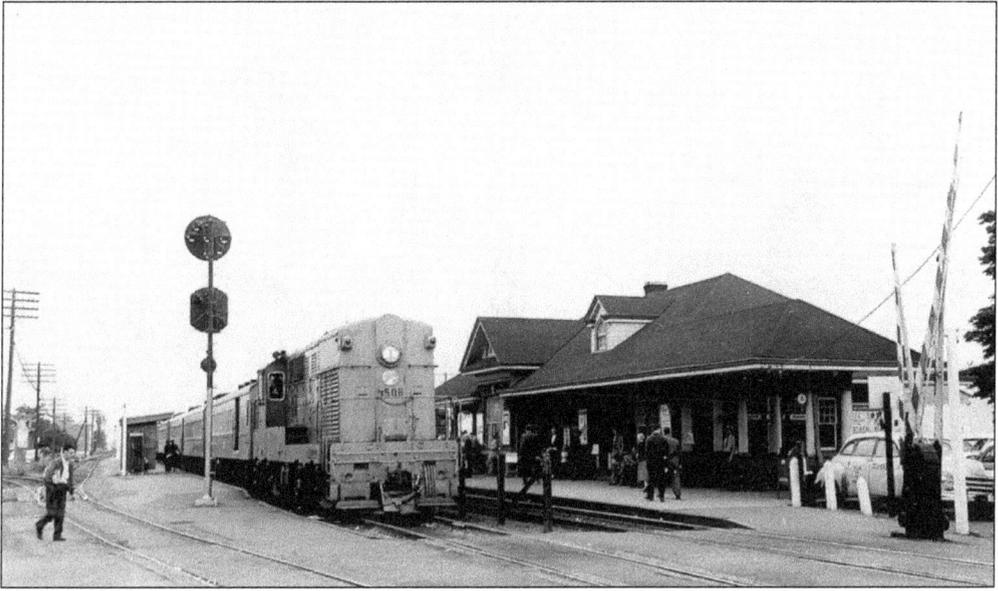

It is train time in each direction at Hicksville in 1954. On the eastbound track is Fairbanks-Morse H16-44 No. 1508 and train preparing to leave the station. On the westbound platform, a bunch of passengers at the old depot await their train into the city. On the right are the manually operated crossing gates. The longer gate protected the road; the shorter one at the back guarded the sidewalk. (W. J. Edwards photograph.)

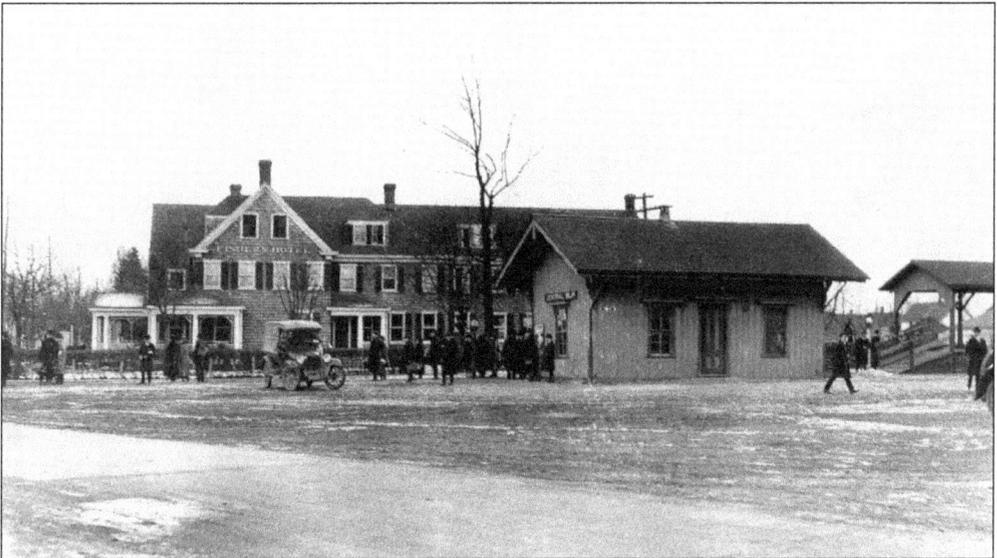

Commuters wait for their westbound train on a chilly day at Central Islip in the early 1920s. In the background is Fisher's Hotel, a Central Islip landmark at trackside for many years. The station platforms are sporting Dietz kerosene lamps, and the express house and ramp are visible on the far right. As most everyone is looking east, the train must be rapidly approaching. (George G. Ayling photograph.)

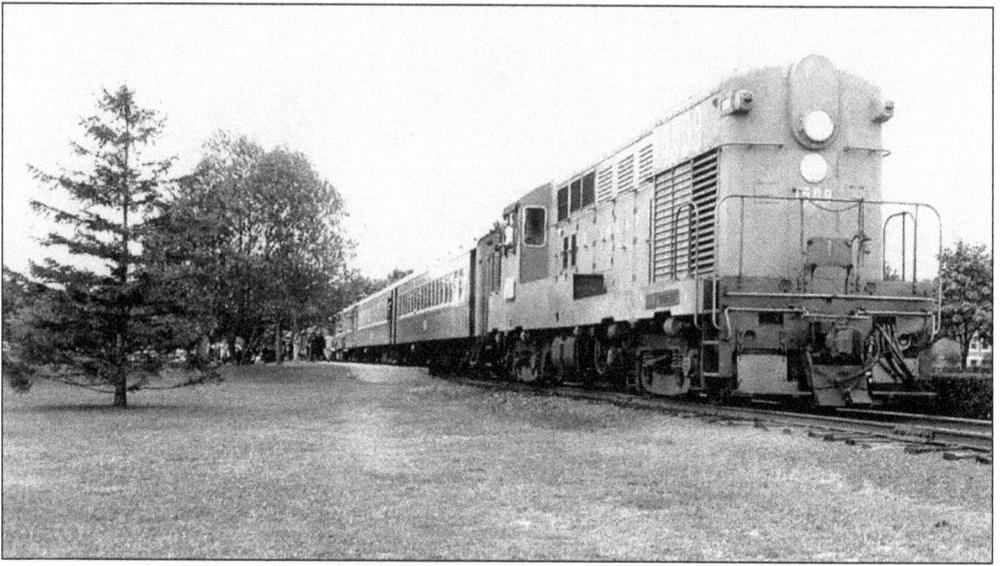

Fairbanks-Morse H16-44 No. 1509 stands at the station at Central Islip State Hospital on a summer day in 1952. The LIRR operated trains to all the state hospitals on the island. Here the conductor stands in the doorway of the second car to observe that all passengers are clear before he gives the signal for the train to pull away. (W. J. Edwards photograph.)

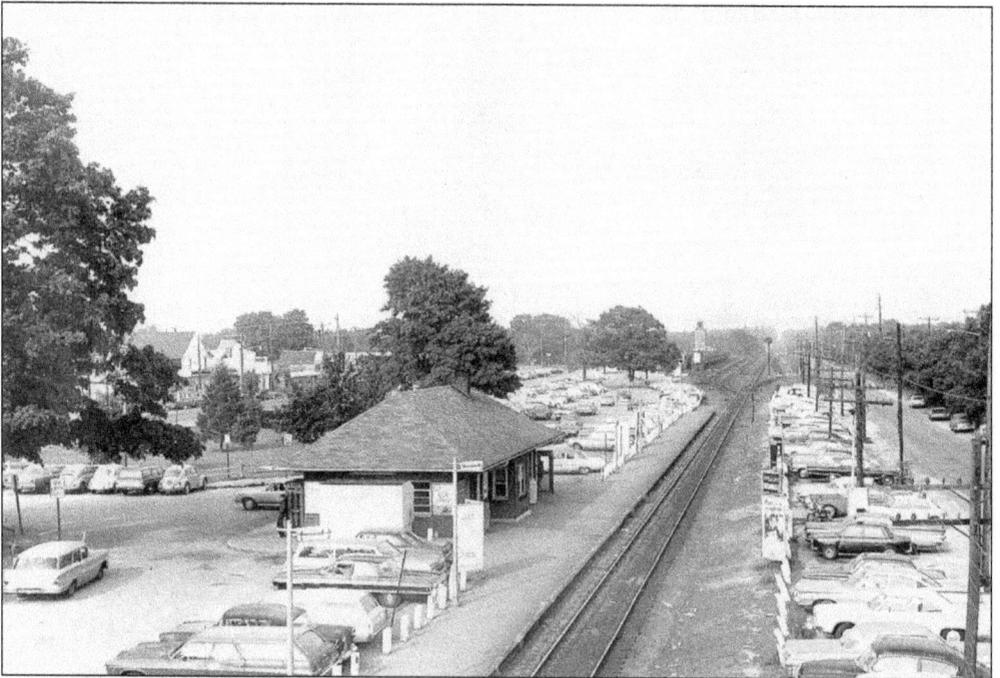

For 1970 this scene represented a crowded commuter parking lot at Ronkonkoma. Looking eastward from the Ronkonkoma Avenue 1912 bridge, the view shows the depot and yard in the distance. Some of the overflow parking is along the street at the right. The crowding eventually led to the construction of new depot facilities on the site of the old yard, with huge parking lots and a multilevel parking garage. (David Keller photograph.)

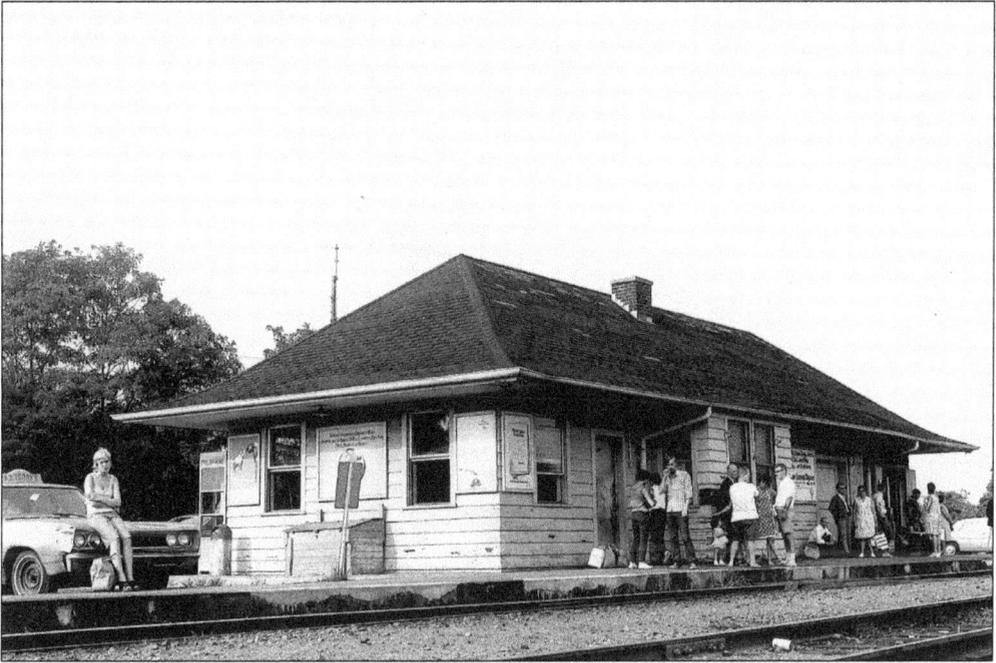

A group of riders await their train, due any moment, at the old Deer Park station in September 1970. The beat-up taxi and worn-out depot make quite a pair. Opened on December 17, 1936, with the grade elimination of Deer Park Avenue, the station remained in use as a depot until 1987, when the station stop was relocated farther east. (David Keller photograph.)

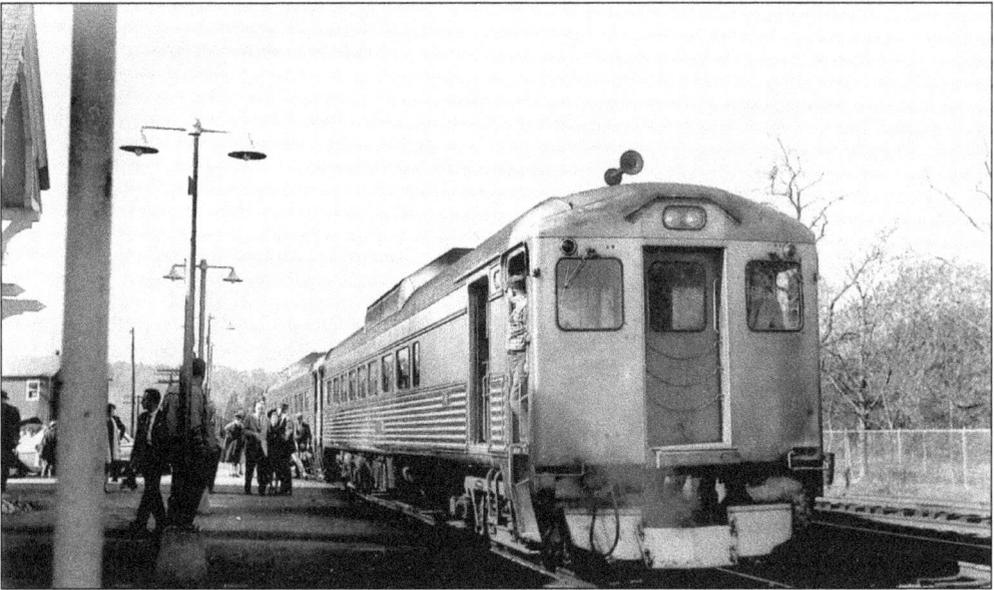

Budd RDC-2 and 1, Nos. 3121 and 3101, have just discharged their passengers after arriving at Oyster Bay. The motorman looks out his door as he awaits the signal to leave the station platform and head for the yard, where he will lay up until it is time for his return trip. On the far left, part of the depot is visible. (David Keller collection.)

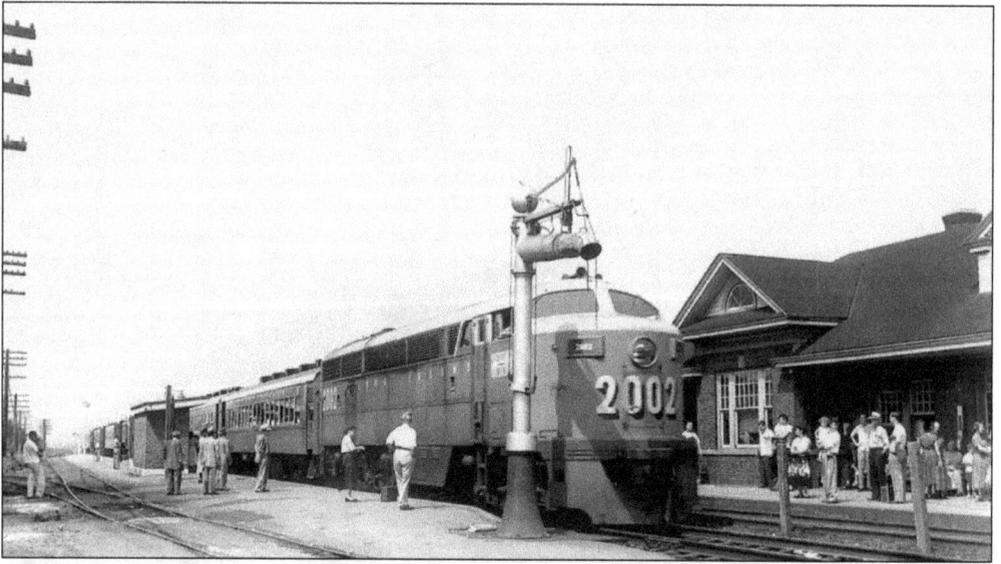

FM CPA20-5 No. 2002 pulls an eastbound train into Hicksville, while passengers on the westbound side wait for their train into the city. Steam is still evident in this July 1952 scene as a large water spout is visible in the foreground. The locomotive is painted in the Tichy scheme, with an outline of Long Island painted under the engineer's cab window, and large "battleship" numbers on its nose. (George E. Votava collection.)

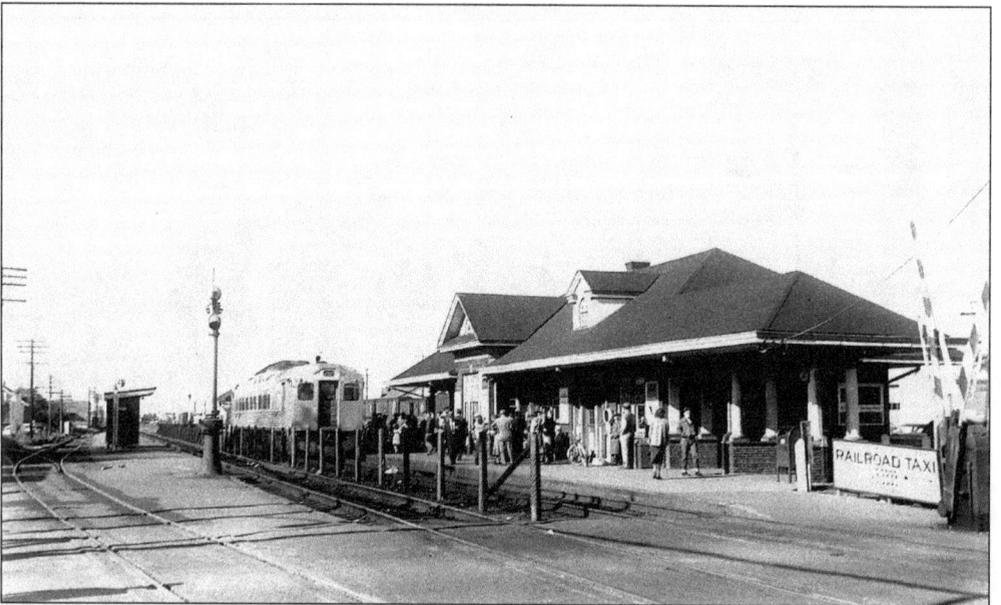

Here, again, is busy Hicksville, this time with Budd RDC-2 No. 3121 headed westbound. The platform is heavy with people in this scene from 1955. Steam will soon be gone, along with the water spout visible on the eastbound platform. On the right are the manual gates, and a string of freight cars stand between the depot and the Budd car. (W. J. Edwards photograph.)

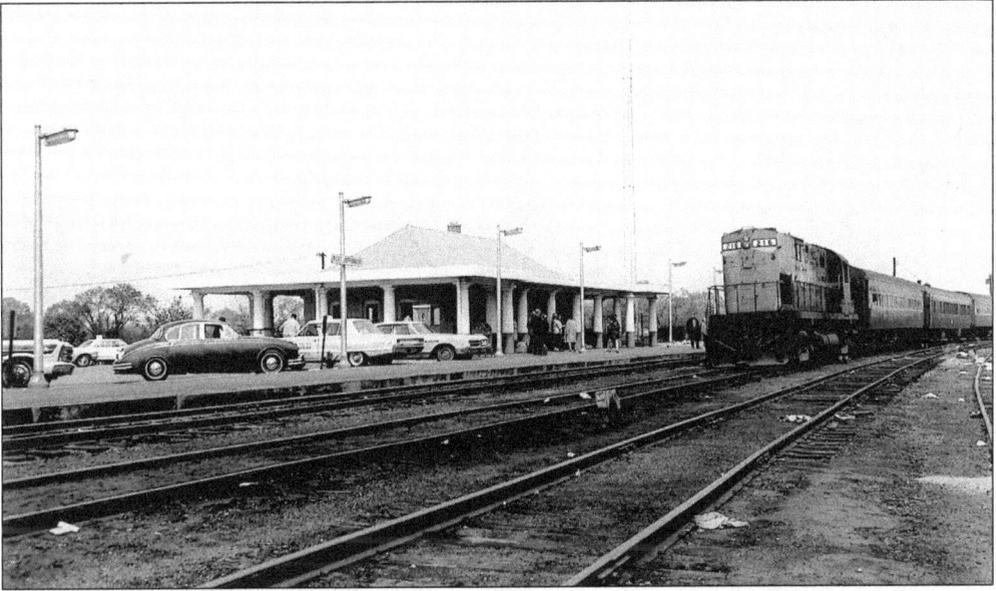

In this scene from May 1968, a few people await their westbound train on the platform at Port Jefferson. Alco C420 No. 216 with train is laying up on the siding in front of the station. This depot, built in 1903, was remodeled to this look in 1968 and was then restored to the original architecture in 2000–2001. (George E. Votava photograph.)

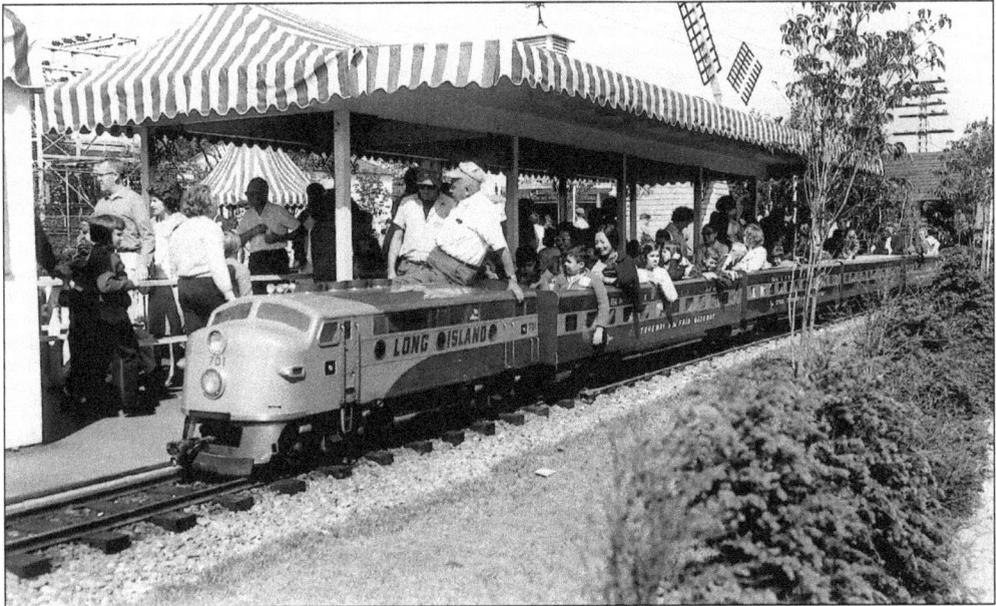

Passengers board a special train in September 1965. The miniature G-16 train, pulled by locomotive No. 701, prepares to carry visitors at the Long Island Rail Road pavilion at the New York World's Fair in Flushing Meadows. The engineer chats with a visitor while the train is being loaded. (George E. Votava photograph.)

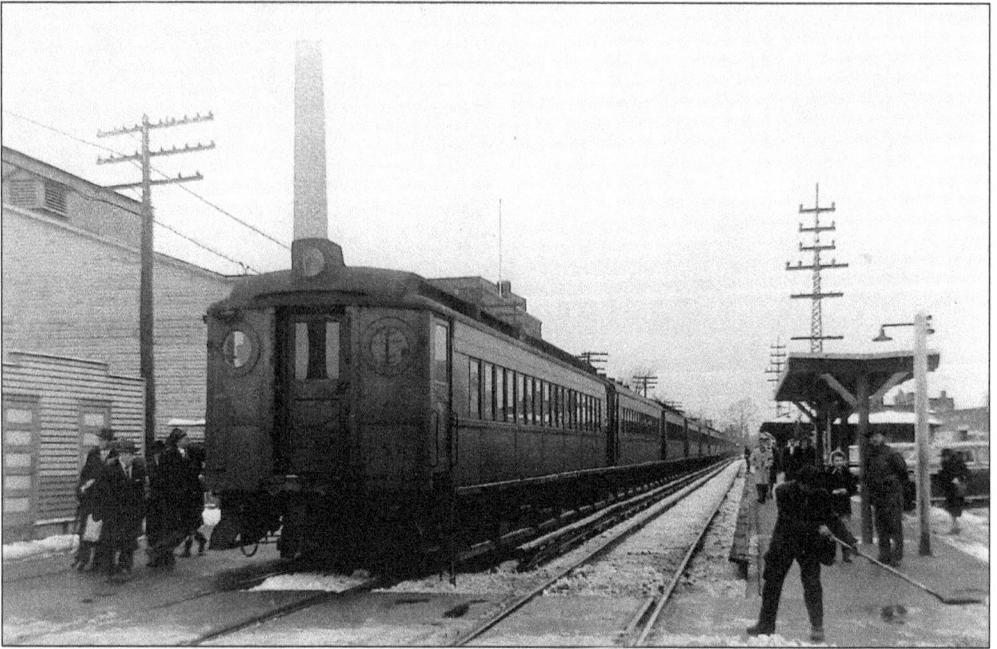

There are passengers on both platforms at Rockville Centre station at grade *c*. 1944. It is a cold, dreary winter's day with dirty, slushy snow in evidence, and an MU electric is ready to depart. A railroad employee clears the sidewalk at the crossing with his coal shovel. No pedestrian crossover is in view, so passengers must have crossed to the other platform via the street. (W. J. Edwards photograph.)

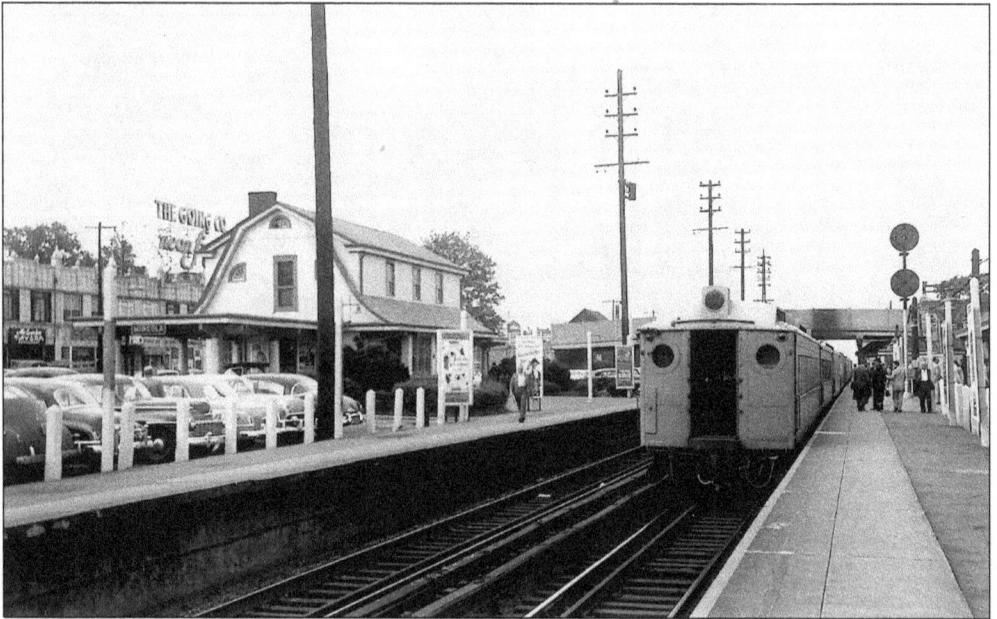

Passengers have already disembarked the eastbound MU electric train at Mineola in this 1954 scene. The Mineola Boulevard overpass bears a black stripe from the countless steam locomotives that have chuffed through since the bridge was opened for traffic in 1923. (W. J. Edwards photograph.)

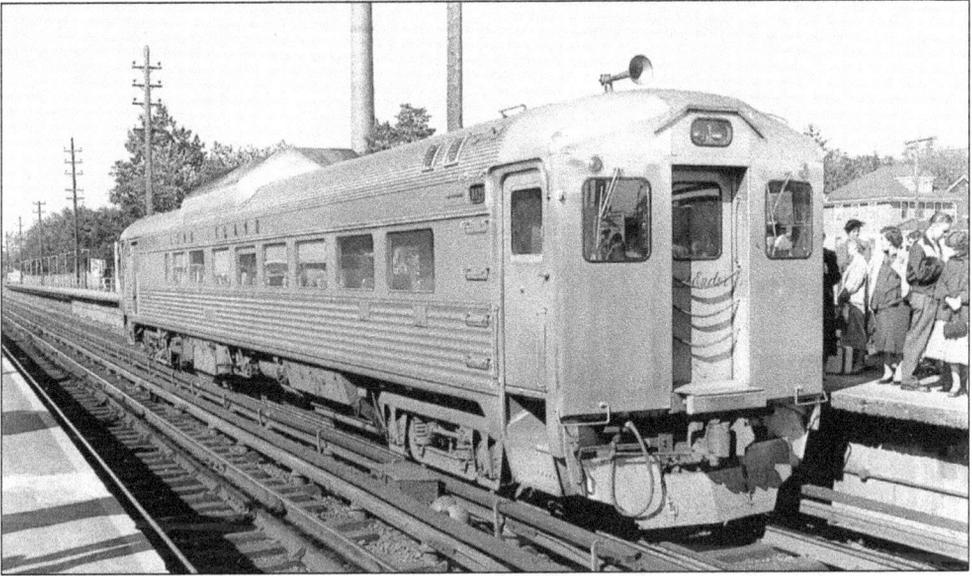

Everyone is excited about getting to ride in the brand-new Budd car. Passengers are lined up and ready to board as RDC-2 No. 3121, with the East Ender logo on its end door, sits at the westbound platform (but heading east) at Mineola in October 1955. As train No. 4286, it is bound for Riverhead. The Budd car's wide windows and operable sunshades were refreshingly new features in commuter cars. (George E. Votava photograph.)

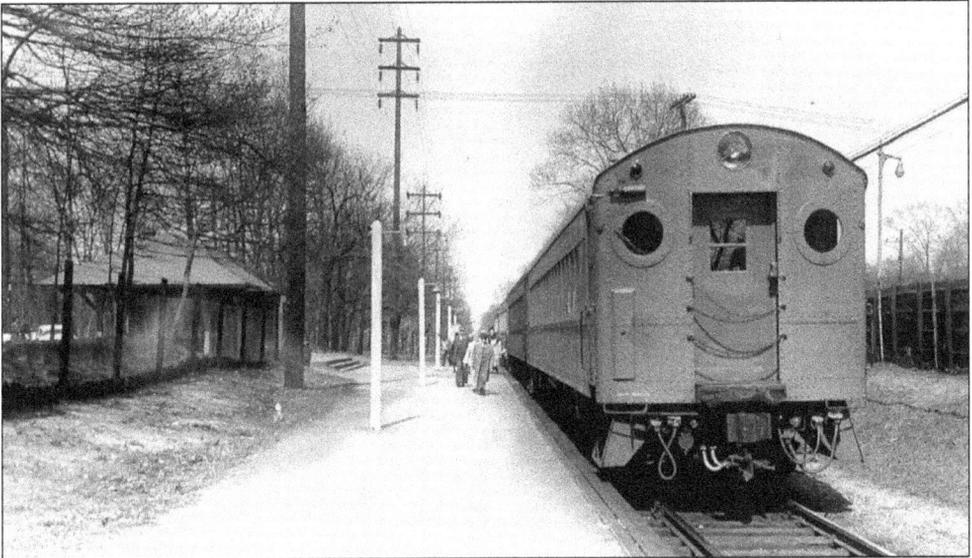

The passengers unload from this MU electric train at the station in Westwood, on the West Hempstead branch, c. 1954. The "owl's-eye" round windows at the ends of the car were a distinctive feature of these old class MP54 cars and were a bonus to railfans. The window with the windshield wiper designated the motorman's side of the car. (W. J. Edwards photograph.)

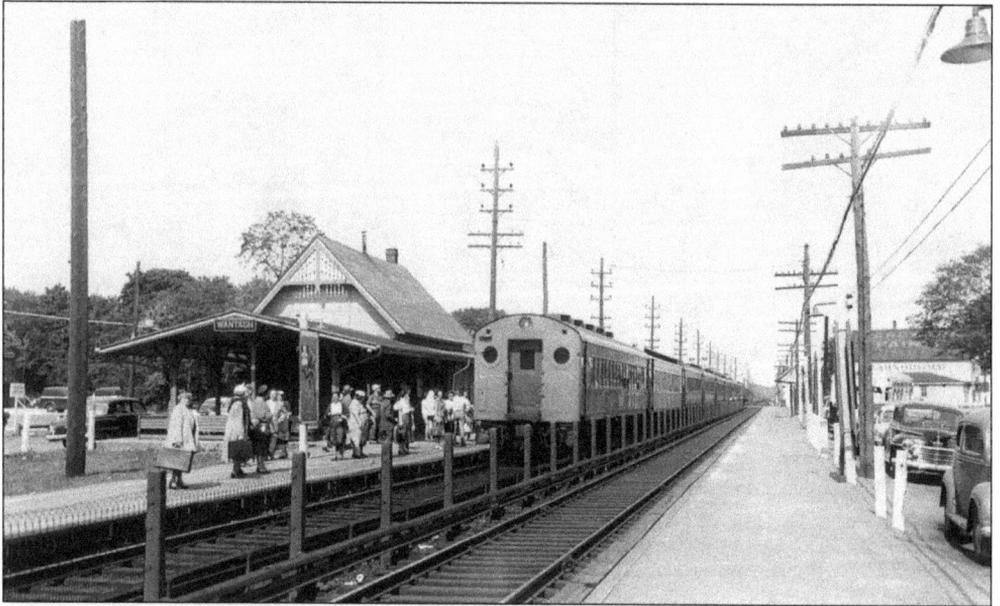

A good-sized crowd of passengers is about to board the westbound MU electric that is approaching the picturesque Wantagh station, still at grade in this 1956 scene. Some of the people appear prepared for travel as they carry suitcases. This pretty depot, adorned with old scrollwork at the peak of the roof, was spared demolition from the grade elimination of 1966 and was instead moved to become a museum. (W. J. Edwards photograph.)

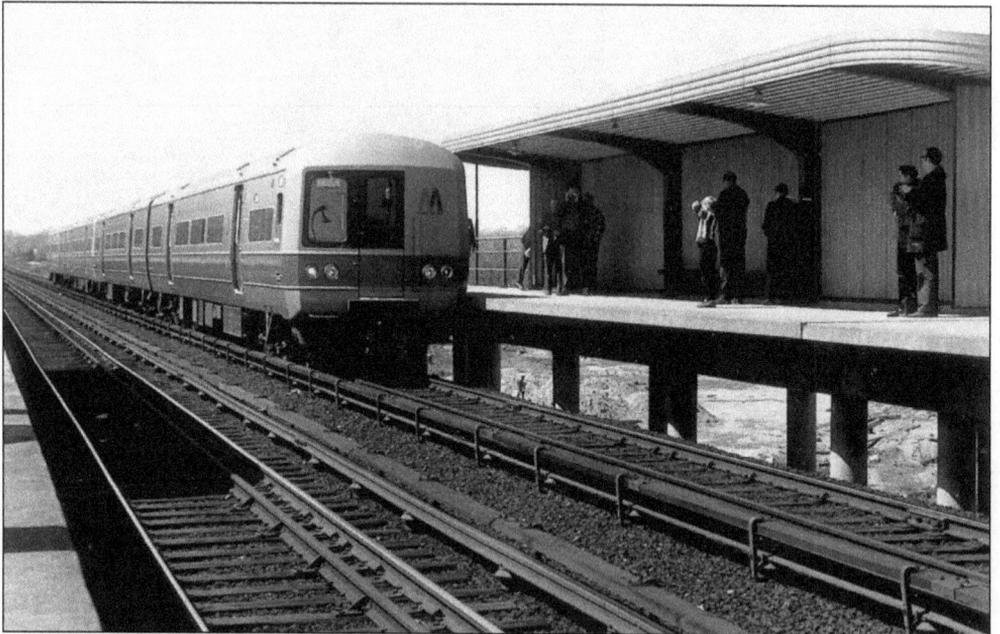

A brand-new Budd M-1 train attracts the attention of riders at the Locust Manor elevated station platform in April 1969. A few years later, these new electric cars replaced all the existing MU electric equipment used on the LIRR. With their smoother ride, air-conditioned or heated interior, and clean appearance, they were much welcomed by the majority of commuters. (David Keller collection.)

Three

CARRYING THE FREIGHT

Behind the scenes to the daily bustling hundreds of thousands were the LIRR freight operations. At its zenith, more than 1,000 siding locations were served, including many major companies in American industry such as Ronzoni, Maytag, Selchow & Righter, American Chicle, Steinway, and Westinghouse, to mention but a few. Most towns had team tracks (offloading sidings of freight for local pickup and delivery, so named from the days when teams of horses pulled wagonloads of freight from the trains) and a siding to deliver lumber and coal to the local dealers. Coal, lumber, potatoes, vegetables, seafood, and ducks were major commodities transported.

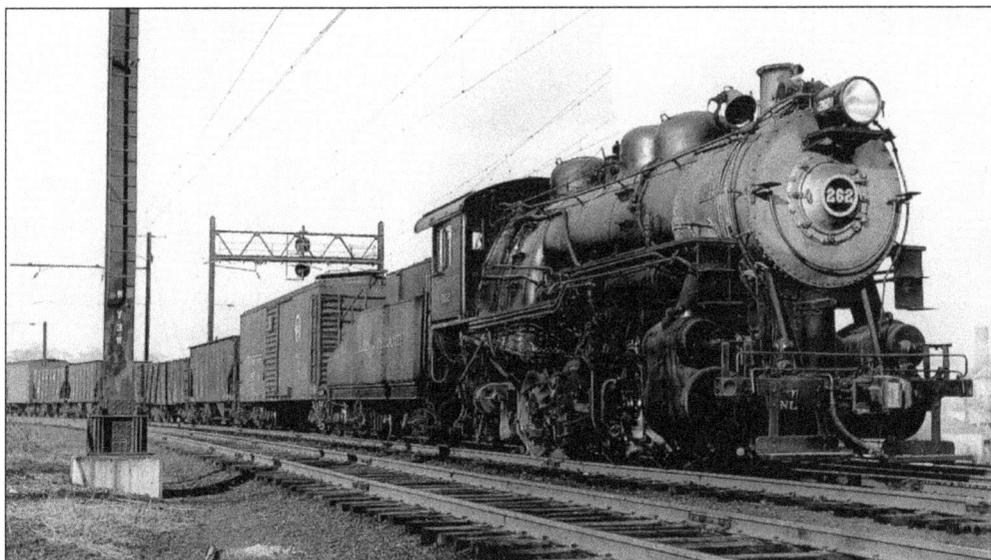

Besides being the busiest commuter road in the nation, the LIRR was at one time a very large local freight hauler. C51sa No. 262 here pulls a string of cars along the Bay Ridge branch near Glendale, New York, on March 27, 1937. With bell clanging and whistle blowing, No. 262 makes its way under the electrified catenary system as it heads toward the terminal yard and float docks at Bay Ridge, Brooklyn. (Robert P. Morris photograph.)

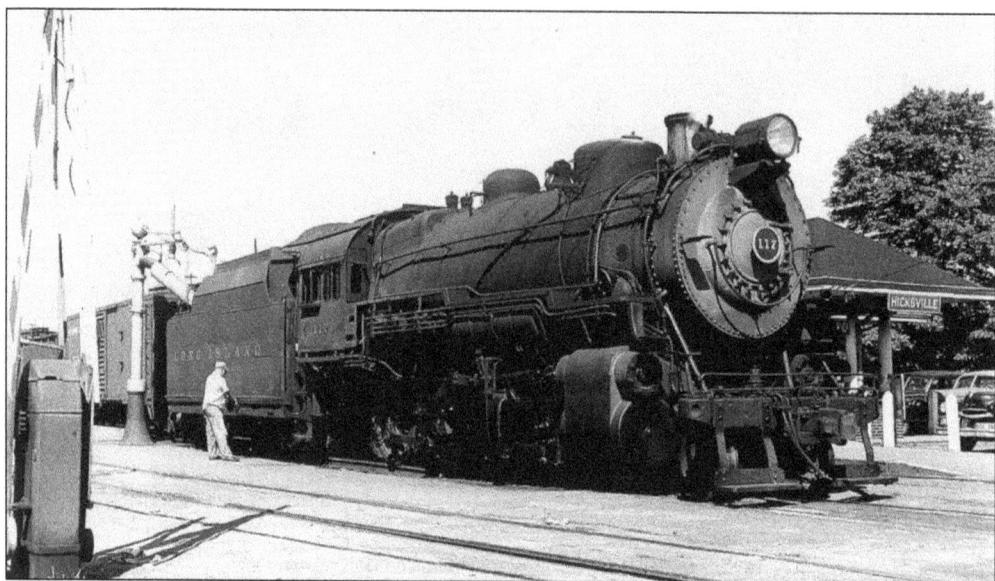

Lima-built H10s Consolidation (2-8-0) No. 117, in eastbound freight service, stops for a drink from the water spout at Hicksville, New York, on a hot July day in 1952. In the left foreground is one of the several sets of manually operated crossing gates. This busy crossing is one of many that were eliminated when the tracks and depot area were elevated in 1962–1963. (George E. Votava photograph.)

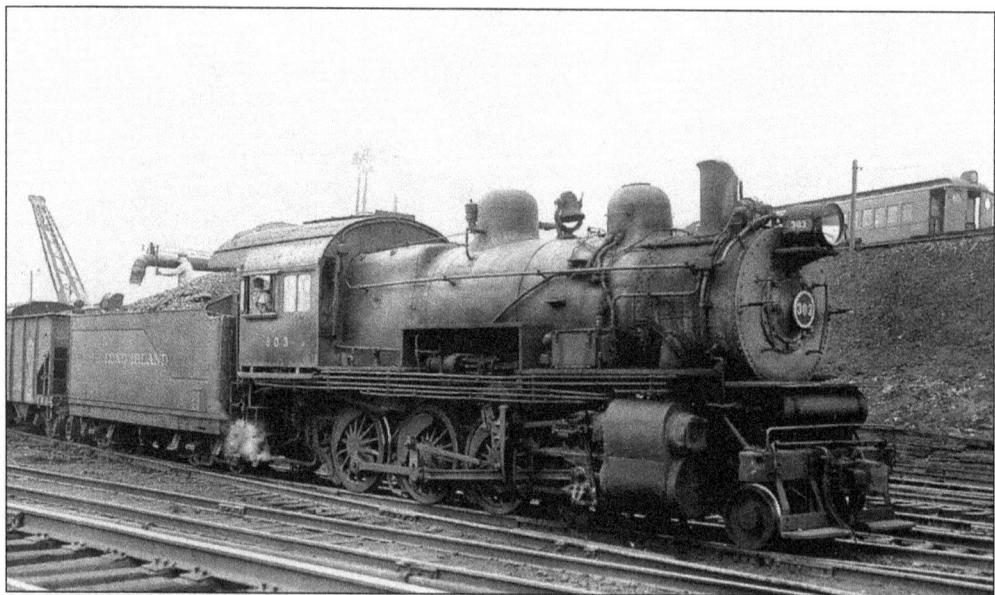

The engineer watches the fireman at work with the water spout as H6sb Consolidation No. 303 takes on water at Morris Park Shops before the train's run in June 1948. With a full load of coal, No. 303 is ready to pull out for perhaps another 10- to 12-hour freight run, typical of workdays past. In the right background is an MU electric motor. (David Keller collection.)

38

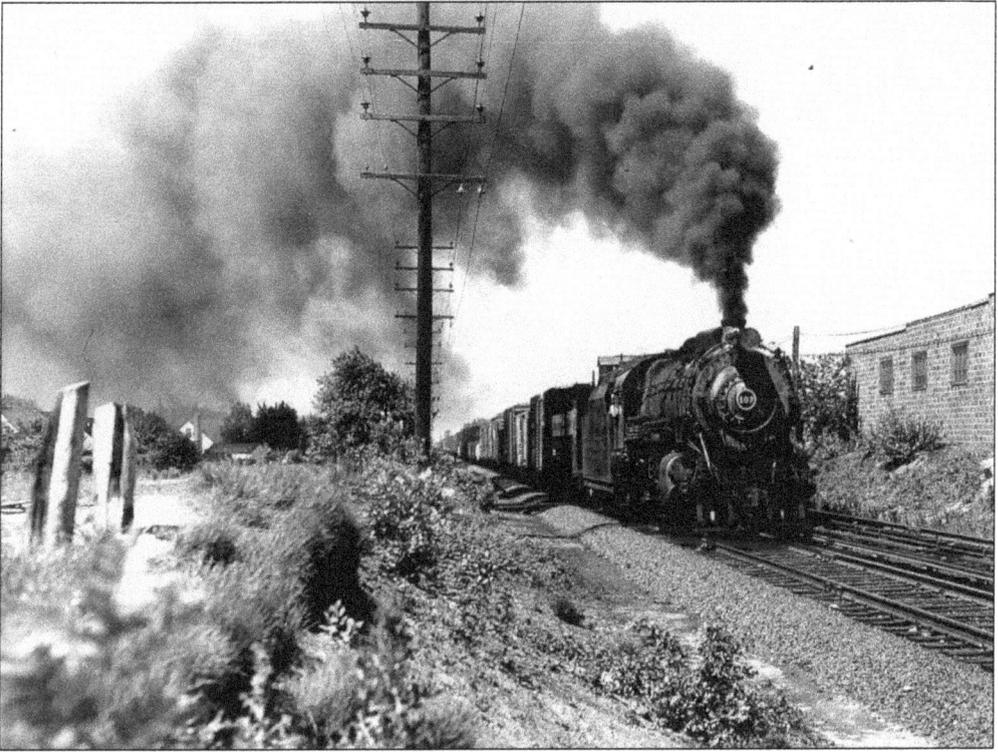

H10s No. 107 proceeds eastbound through New Hyde Park, pulling a 52-car freight on a hot day in July 1953. The passing train inundates the neighborhood with black, sooty smoke, which surely was not appreciated by housewives who had laundry hanging out to dry. (George E. Votava photograph.)

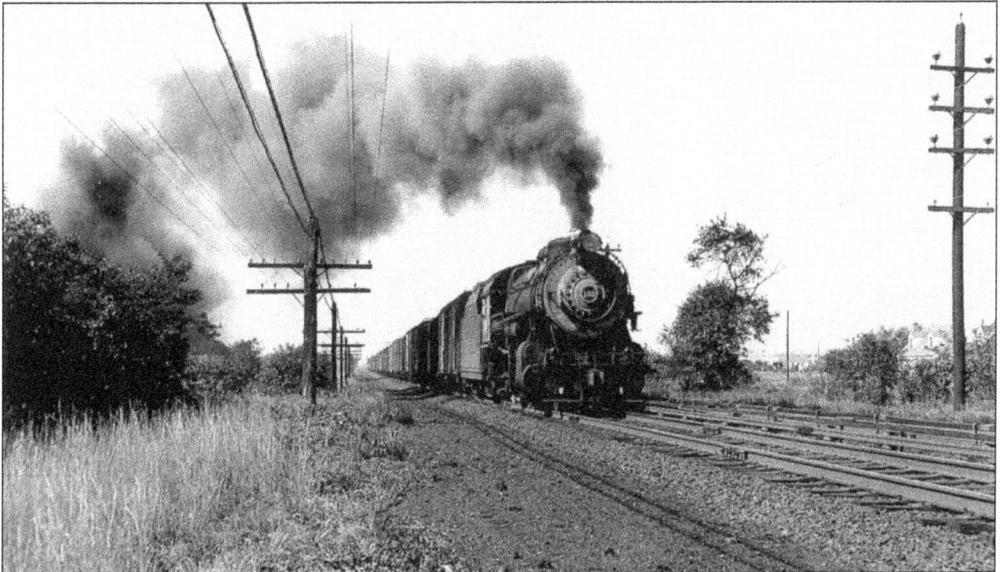

As it passes through yet-to-be-developed land, H10s No. 102 pulls a 37-car freight eastbound through Merillon Avenue, New Hyde Park, on a September day in 1948. (George E. Votava photograph.)

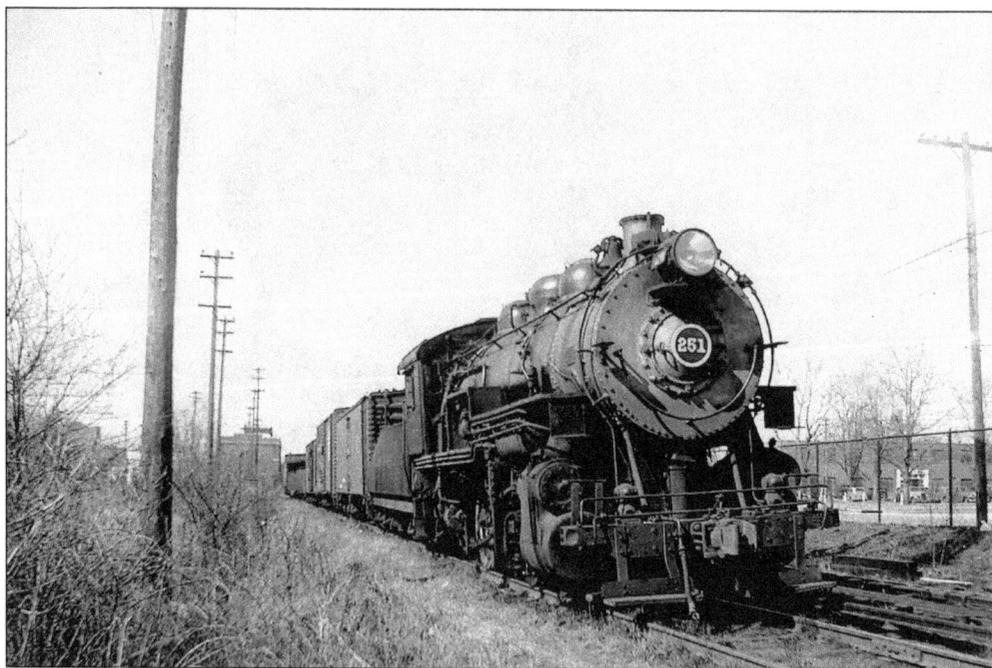

In this northward view toward the main line and the LIRR's electric substation at Mineola, C51s No. 251 pulls a freight train on the not-too-frequently photographed spur between Mineola and Garden City *c.* 1946. This spur, which at one time carried passengers between Mineola and Hempstead, and Mineola and West Hempstead, in later years was relegated to freight-only status. (Rolf H. Schneider photograph.)

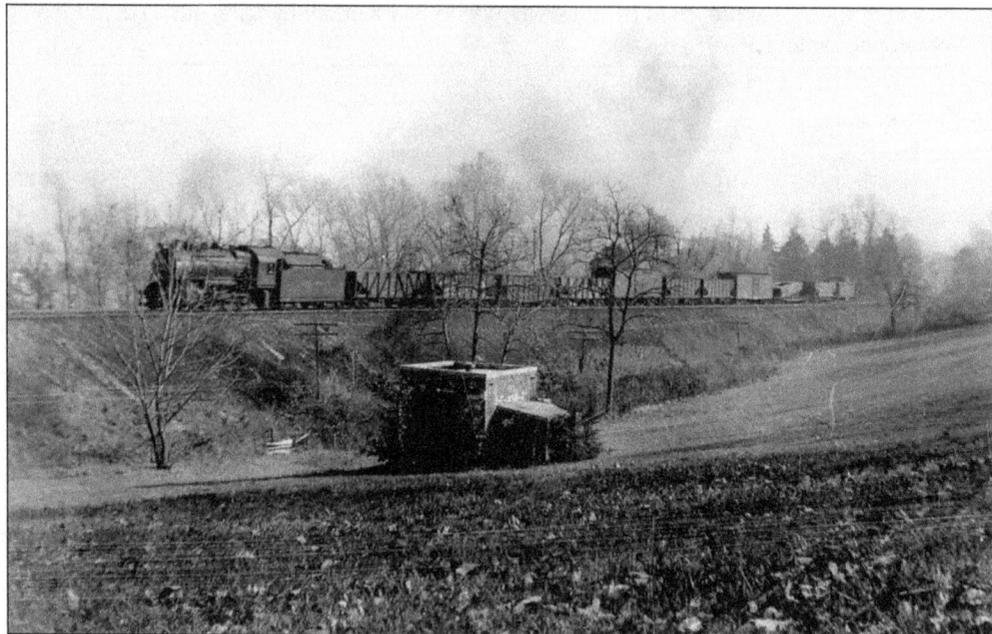

As viewed from a distant hillside, H10s No. 112 pulls a westbound freight out of Oyster Bay in 1940. Beyond the trees toward the rear of the train was Jakobsen Shipyard and the waters of Oyster Bay itself. (T. Sommer photograph.)

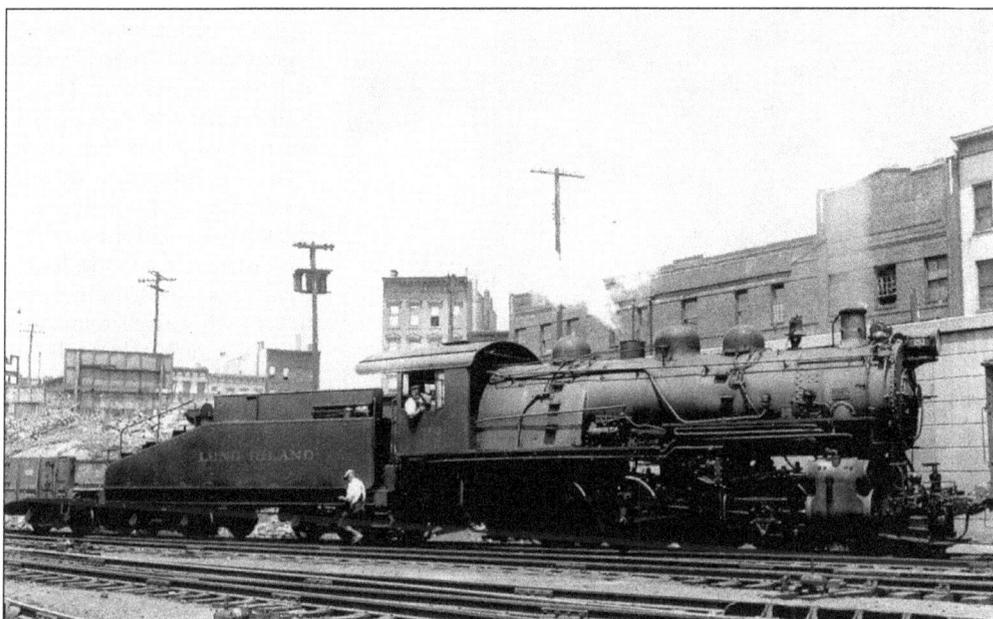

In a scene from April 1931, C51s No. 253 and crew switch freight cars at Long Island City. Note the huge rear headlight mounted on the back of the sloped tender. The sloped back allowed the train crew to have better visibility when backing up for switching moves. The engineer here enjoys posing for the photographer. (William M. Monypeny Jr. photograph.)

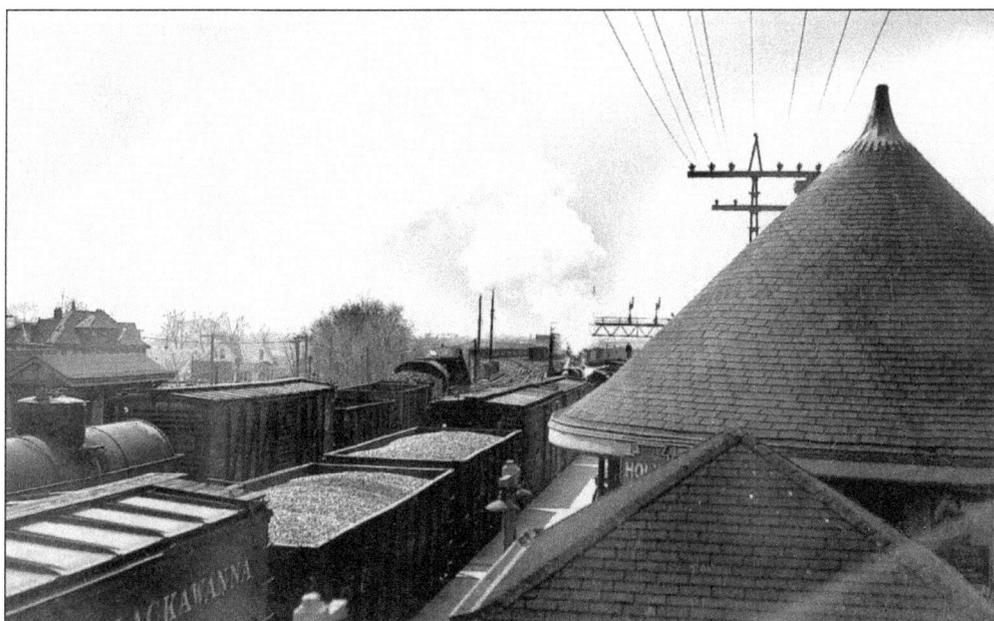

A bit of freight activity is visible in this 1940 westward view from Hollis tower. On the left is a freight train on the crossover switches accessing Holban Yard in the background. Running along the local track, alongside the platform, is another freight train with a brakeman riding atop one of the cars. On the right is one of the two rounded roof cones of the Hollis station. (T. Sommer photograph.)

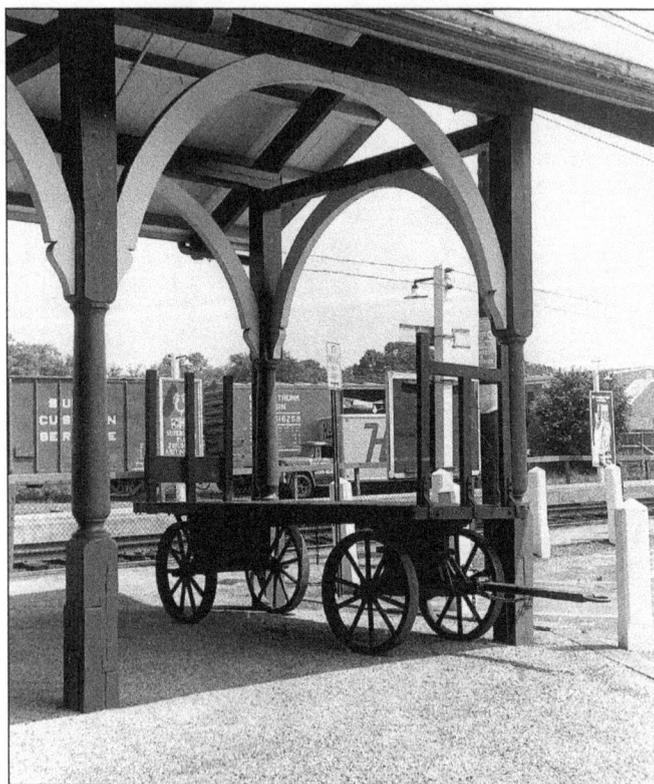

Baggage and express were big commodities handled by the railroads in days past. The Railway Express Agency was the United Parcel Service of its day. This baggage wagon, residing temporarily under the covered platform of the Farmingdale station in June 1972, was representative of many such wagons found at every station along the line and in use every day to haul baggage and express. (David Keller photograph.)

H10s No. 104 pulls its freight train from the yard at Oyster Bay in 1940. The fireman is seated for the moment on his side of the cab. The scalloped shadow above is an eave of the old covered platforms that graced the Oyster Bay depot until later that year, when they were all removed, leaving commuters with no exterior shelter. (T. Sommer photograph.)

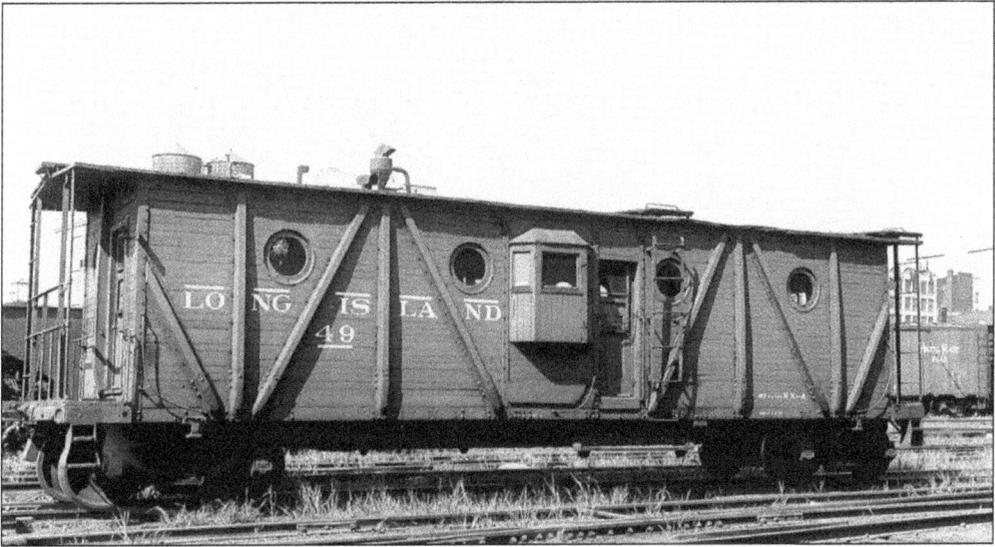

As freight cars got taller, the cupola atop the old caboose (hack) became outmoded. Instead, side bay windows were used, allowing visibility alongside the train. This odd caboose, a Pennsylvania Railroad design, was manufactured from an old boxcar in August 1913 and was classed NX-23A. This image shows Long Island Rail Road's No. 49 at the Arch Street Yard in Long Island City on September 3, 1949. (George Arnoux collection.)

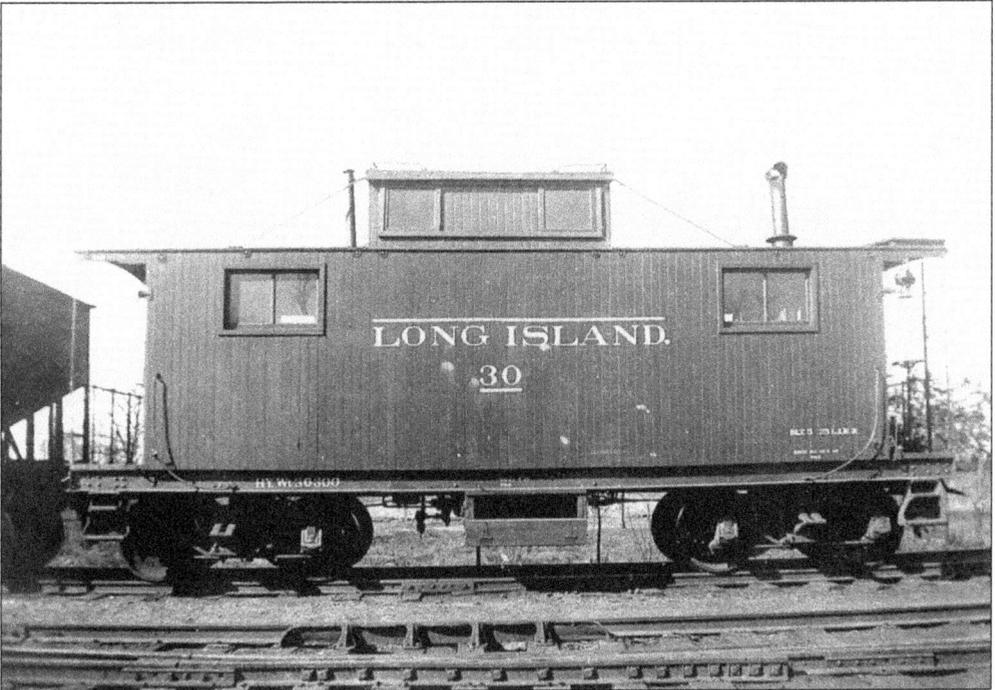

The more standard design on the LIRR was this cupola-topped, wooden-bodied, steel-framed class N52A caboose. Built in May 1925, No. 30 saw a lot of freight activity in its lifetime. The caboose was a refuge for crews in the winter and acted as the freight conductor's office. Here No. 30 stands on the end of a freight train at Oyster Bay in 1940. (T. Sommer photograph.)

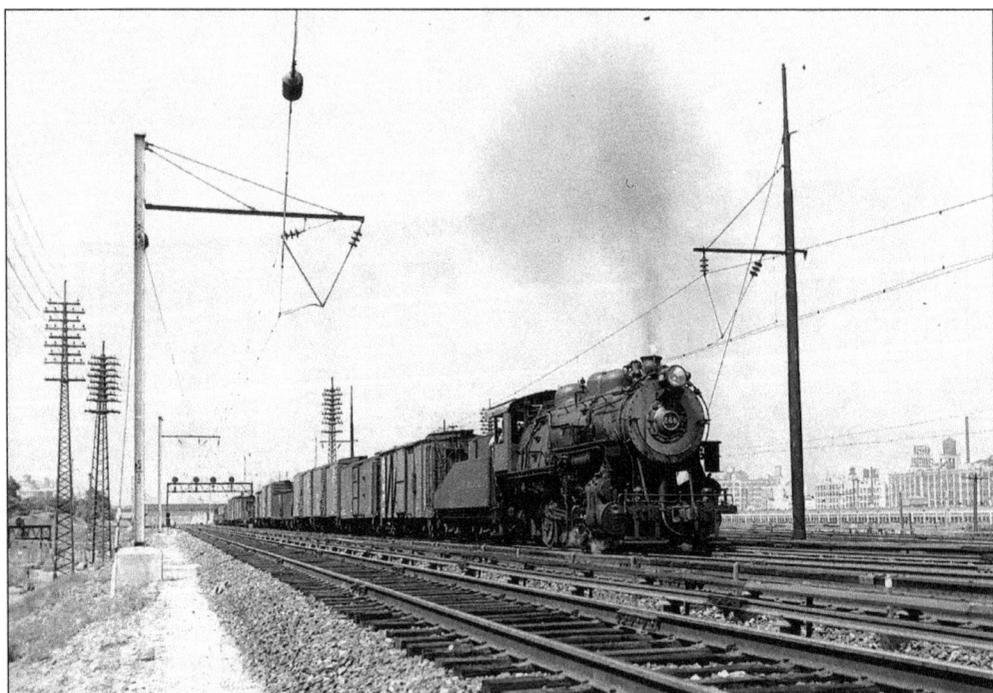

Pictured in August 1937, C51sa switcher No. 268 pulls a string of 18 freight cars through Sunnyside, Long Island City. This westward view shows both the overhead electric catenary system and the electric third rail on the outside tracks. In the right background is industrial Long Island City. (George E. Votava photograph.)

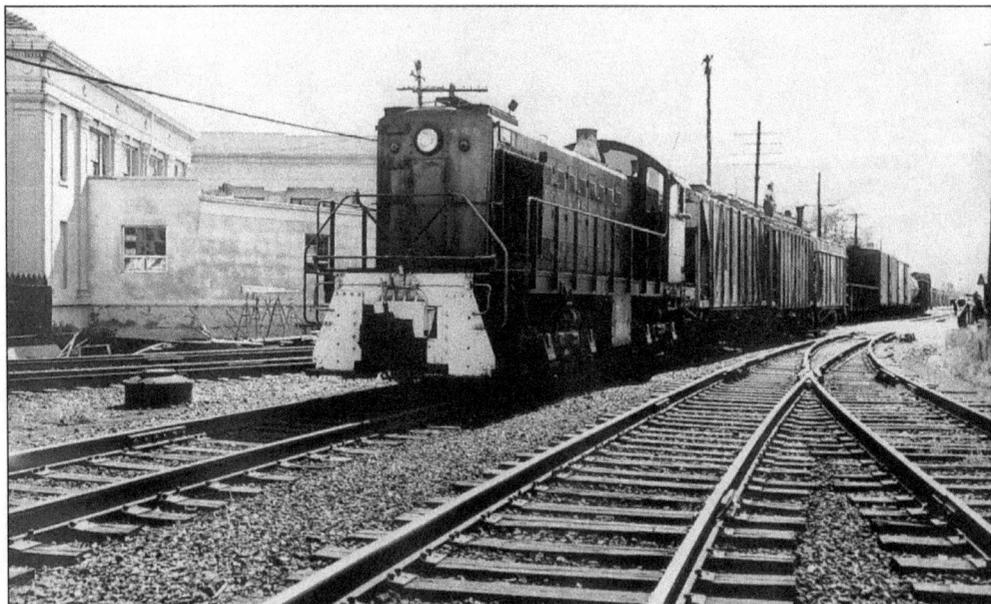

Two brakemen ride atop one of the cars on an eastbound freight pulled by Alco S2 No. 448 as it heads up the Port Jefferson branch at Hicksville in 1950. This photograph shows the diesel in the original color scheme it had when delivered, with small numbers to the right of the headlight. (J. P. Sommer photograph.)

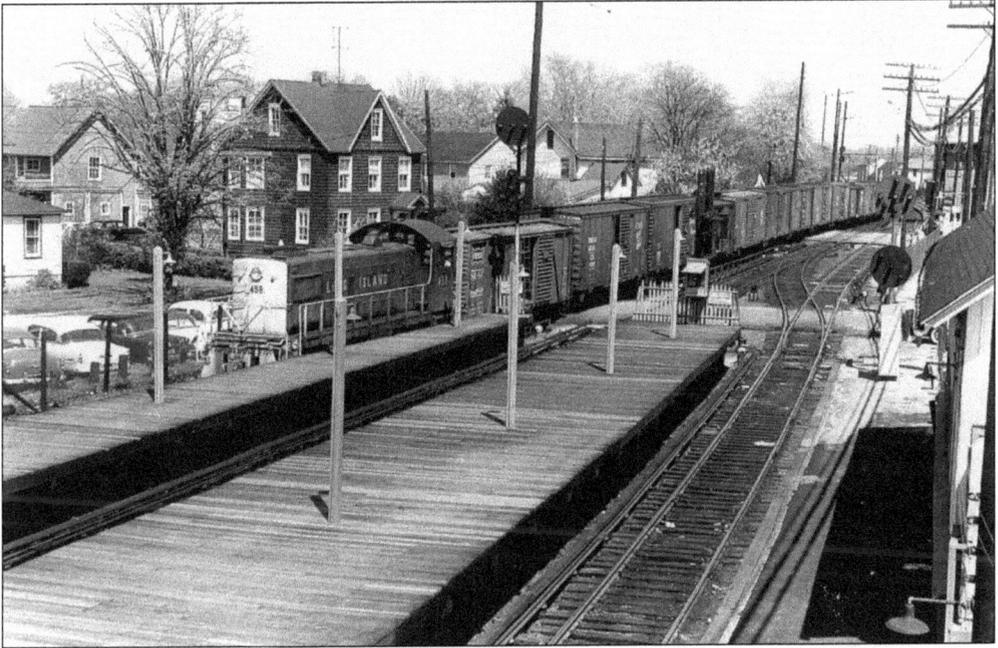

Another busy at-grade location was Babylon. Viewed from the pedestrian overpass in 1957, Alco S2 No. 458 pulls a long string of boxcars westbound over the Depot Place and Deer Park Avenue crossings and into the station. The large daily quantity of freights and passenger trains continually blocked the crossings and created traffic jams in town. In 1963–1964, this entire area was elevated to eliminate the congestion problem. (Jules P. Krzenski photograph.)

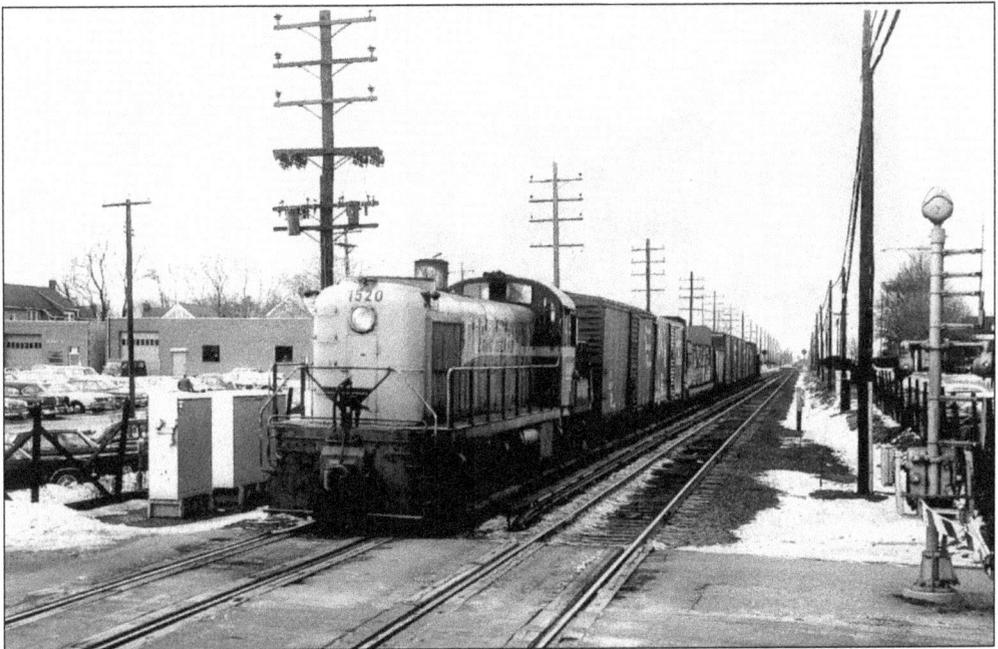

Back in the winter of 1966, when many of the LIRR stations were still at grade along the Babylon branch, Alco RS2 No. 1520 is shown pulling a short freight through the leftover snow while approaching one of those south shore stations. (Bob Yanosey photograph.)

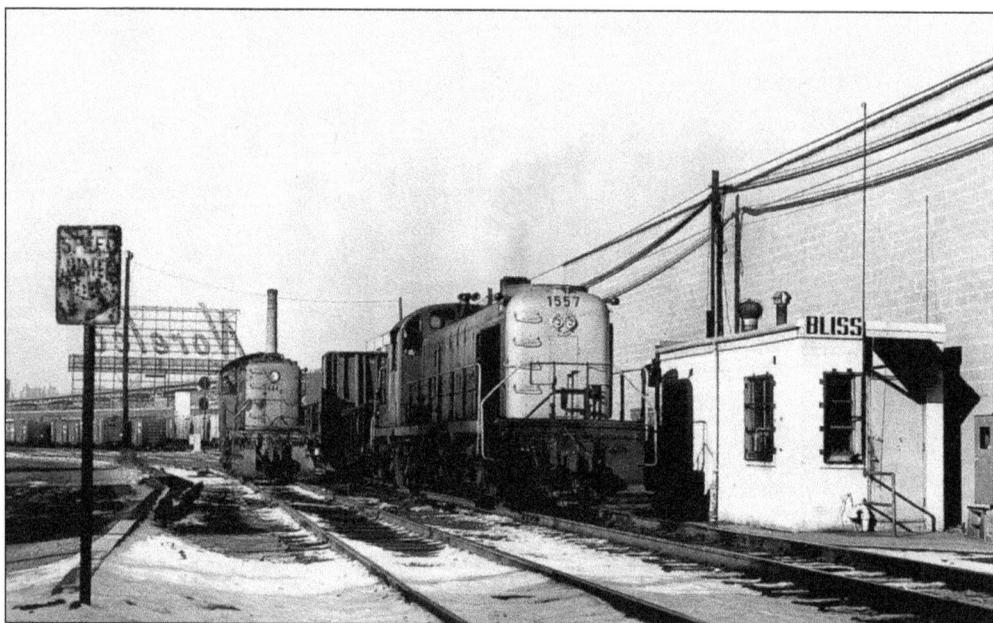

On a cold December day in the Blissville section of Long Island City in 1970, Alco RS3 No. 1557 pulls a string of freight cars eastbound past Alco S2 No. 444 (left) and Bliss cabin (right). The RS3 unit is in the MTA color scheme of blue with yellow ends, while the S2 still wears the Goodfellow-gray color scheme with orange ends. (David Keller photograph.)

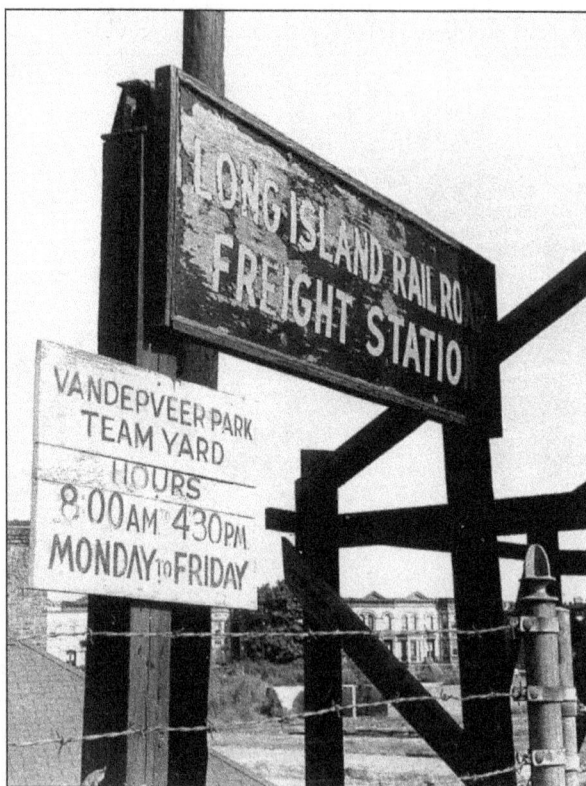

For many years, the Bay Ridge branch was a freight-only line. Shown here is the sign for the Vanderveer Park Freight Station and Team Yard, located east of Flatbush Avenue. With the end of passenger service, the Vanderveer Park depot became the freight office and remained in use as late as this scene from 1954. (Rolf H. Schneider photograph.)

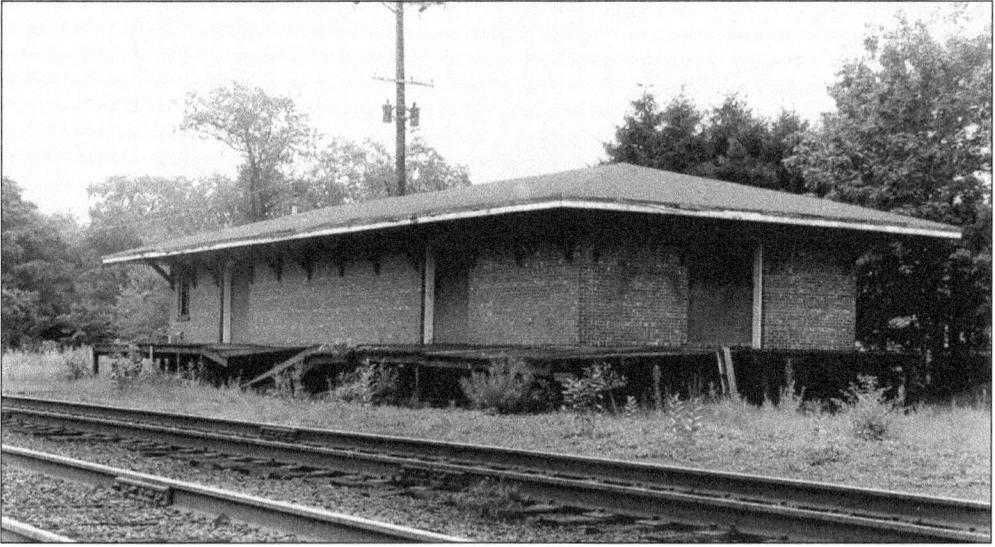

Most stations had freight houses to handle freight service. Made of brick or wood, some of the houses were of substantial size, while others were no more than wooden sheds; the size depended on volume of business. This 1967 image shows the brick freight house at Oakdale with its decaying platforms. The house's architectural style was similar to that of the 1895 structure at Amagansett. (David Keller photograph.)

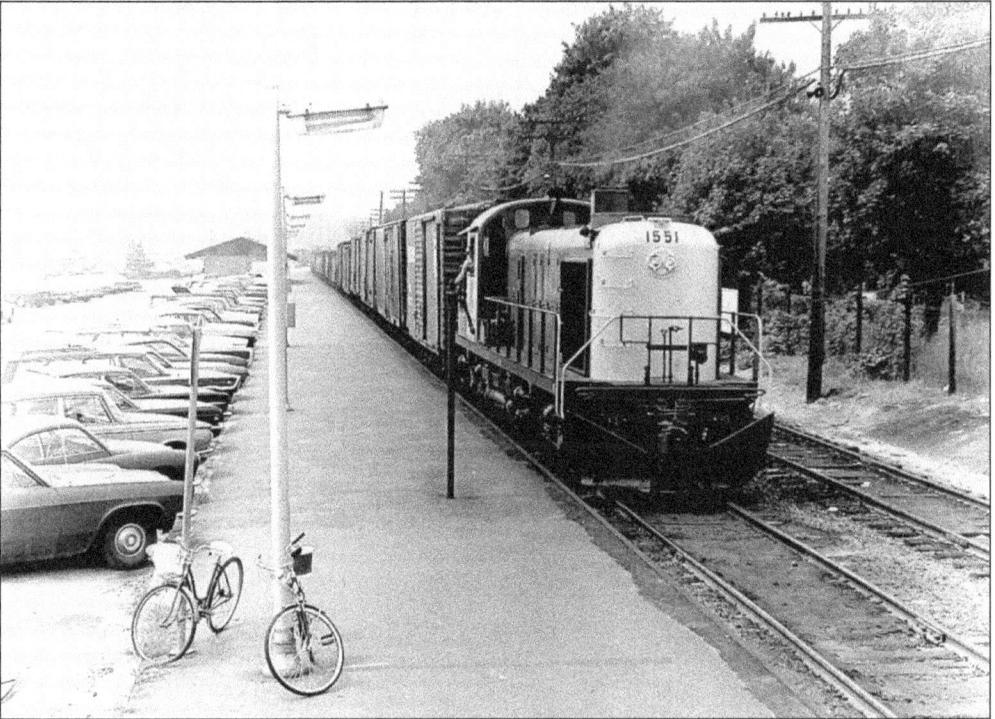

Alco RS3 No. 1551 pulls an eastbound freight through Patchogue on a hot, hazy day in August 1971. Looking westward toward the depot, through the typical Long Island haze, the view shows the engineer leaning out of his cab window with arm outstretched, preparing to pick up orders at PD tower, from which this photograph was taken. (David Keller photograph.)

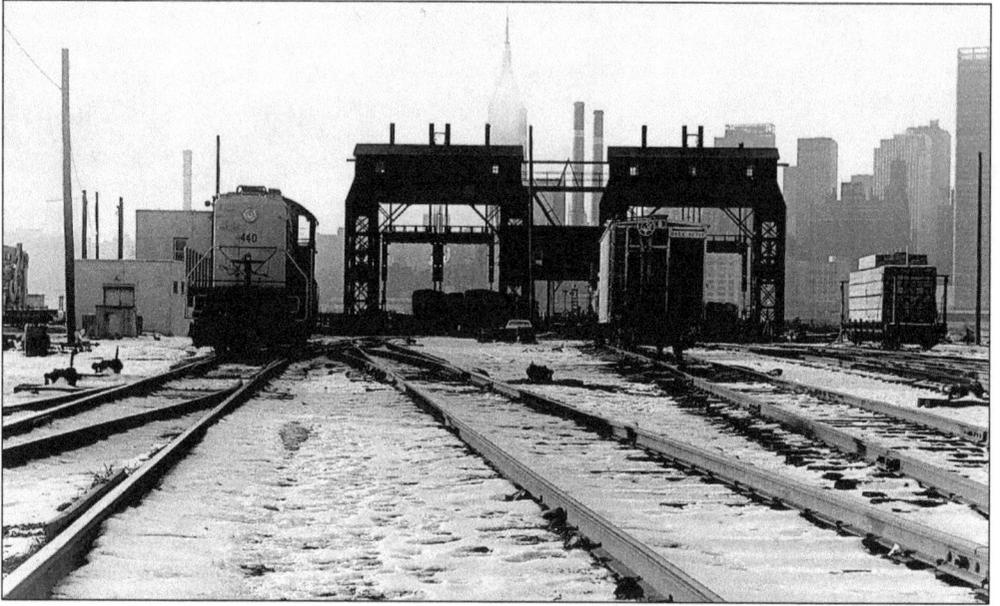

There is not much activity at the Long Island City float docks on a cold January day in 1971. In this view westward toward Manhattan and the Empire State Building, one pair of docks is visible. Freight cars were loaded on barges and shipped to all points from this location. On the left is Alco S2 No. 440 laying up. The other pair of docks is off to the left. (David Keller photograph.)

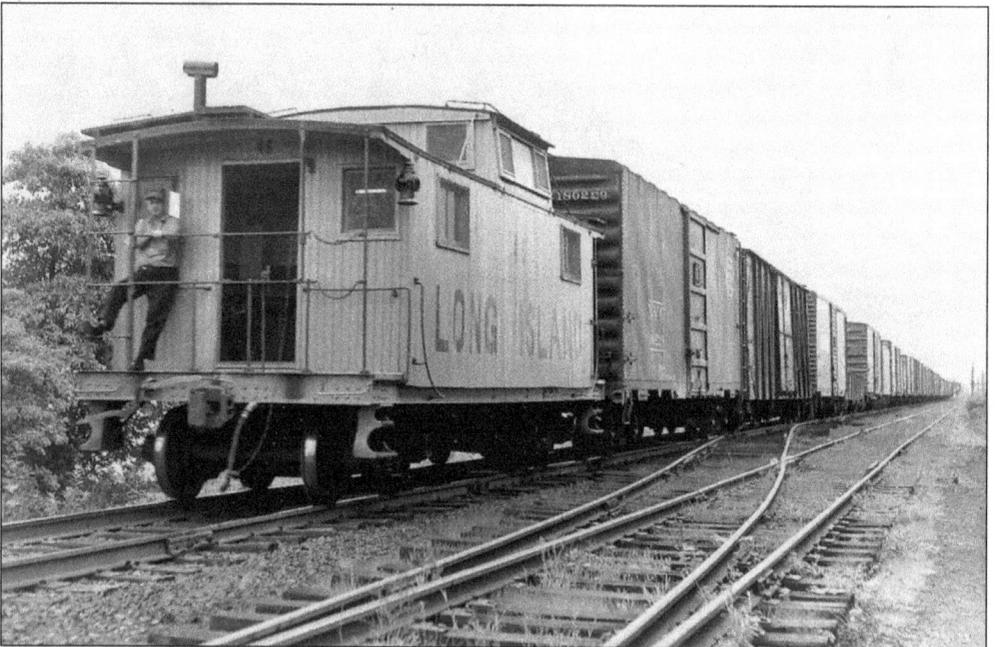

Bringing up the rear of this long freight is the class N52A, cupola-topped, wooden caboose No. 46, with a brakeman riding on the rear platform. Displaying its old kerosene marker lamps, No. 46 heads eastward over the crossover switches as it leaves Deer Park in 1957. (Jules P. Krzenski photograph.)

48

Four

THE DIESELIZATION OF LONG ISLAND

Boasting the first diesel oil electric No. 401 in 1925, followed by No. 402 (second) in 1928, the LIRR, like most railroads after World War II, began in earnest to replace its steam fleet with diesel locomotives, which were more economical to run and maintain. The first deliveries in 1945 were from the Baldwin Locomotive Works, followed in 1946 by Alco-GE (American Locomotive Company-General Electric) models, all rated at 660 horsepower. More Alco-GE units in the 1,000-horsepower range arrived over the next five years, followed by Fairbanks-Morse representatives with 2,000 horsepower and 2,400 horsepower. The diesel engines soon proved to be the demise of the steam locomotive, and by October 1955, the last sigh of steam was heard.

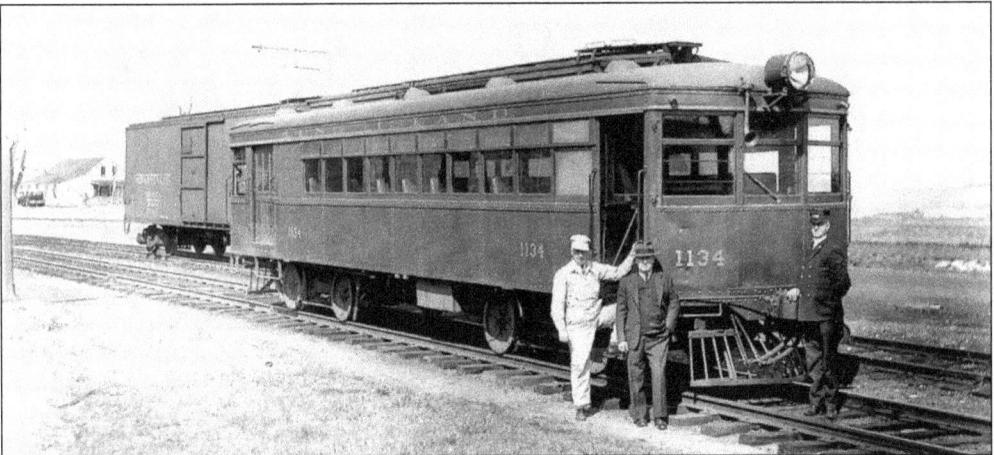

The self-propelled gas car, affectionately named Doodlebug, fit the need of the unprofitable branch line. Designed to run on gasoline, it could carry passengers and baggage and have only two crew members, the conductor and motorman. Doodlebug No. 1134 here stands at the Sag Harbor terminal with its crew and possibly a railroad official in April 1939. The line was abandoned one month later. (Fred Weber photograph.)

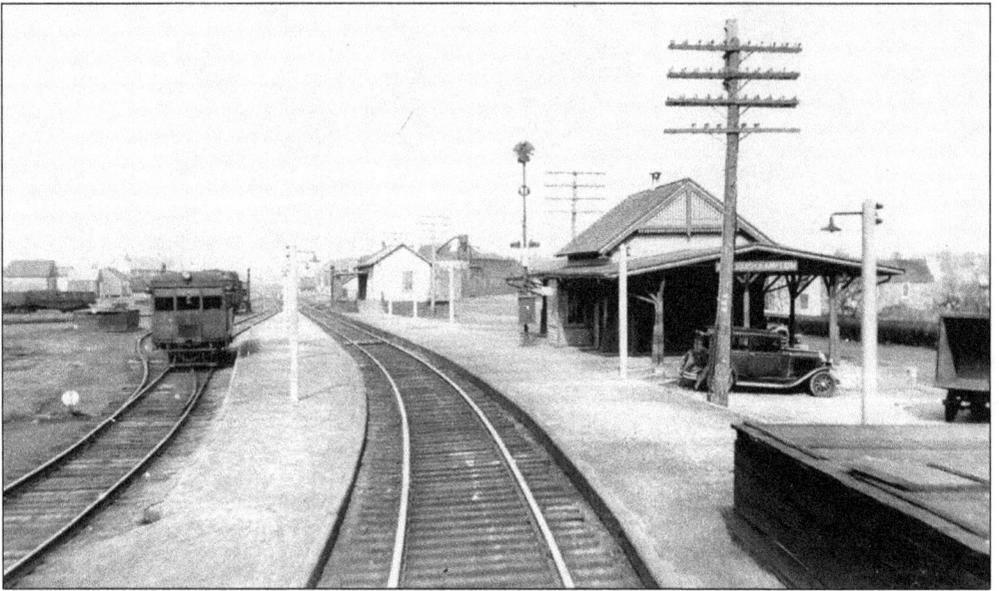

Viewed from the rear of a westbound train leaving Bridgehampton in August 1936, Pennsylvania Railroad gas car No. 4744 on the Scoot sits on the Sag Harbor connection lay-up track. The Scoot was the nickname for various shuttle trains that ran on the LIRR. On the right is the depot. While the connection and tracks to Sag Harbor were removed after branch abandonment in 1939, the depot, built in 1884, would survive until it was razed in 1964. (William M. Monypeny Jr. photograph.)

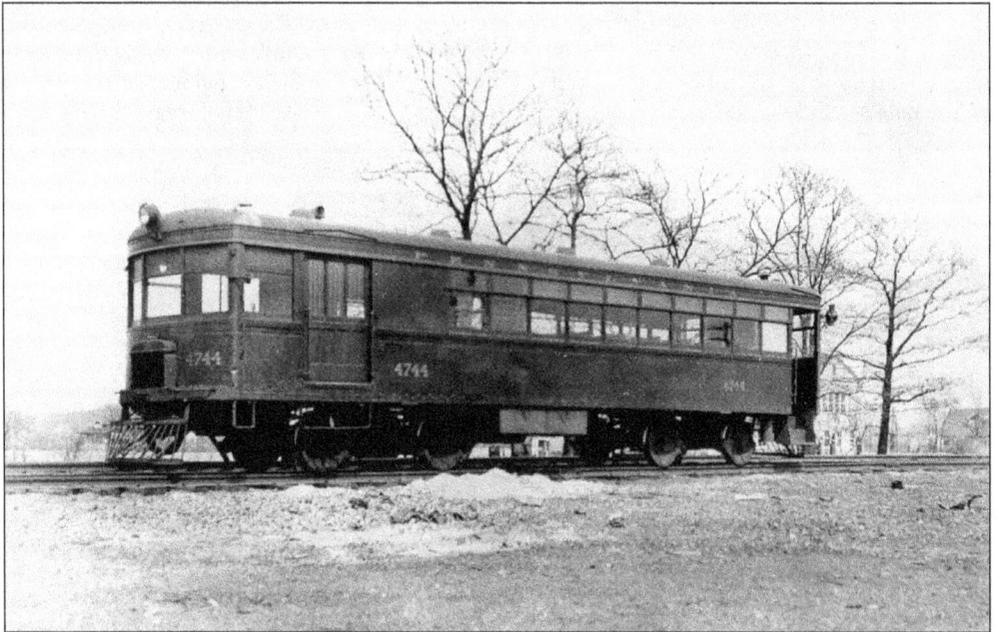

Pennsy gas car No. 4744 again is seen laying up at the end of the line at Wading River in 1937: another example that self-propelled railcars were used on branches that were losing money. Providing bare minimum service, the extension from Port Jefferson to Wading River was abandoned in October of the following year. (George G. Ayling photograph.)

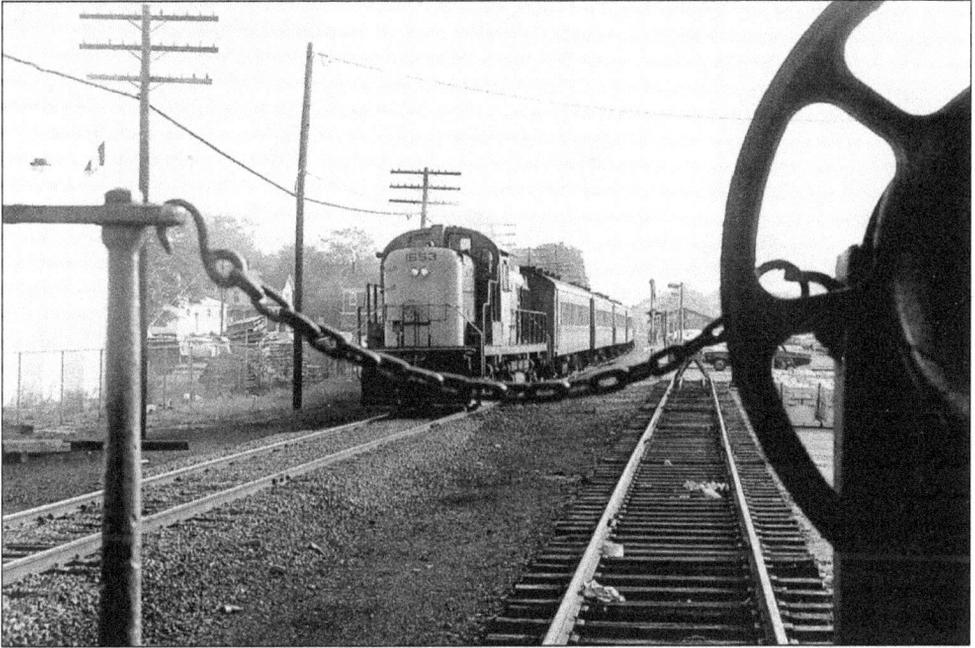

Here framed between the hand brake wheel and the rear safety chain of a caboose on the yard track, Alco RS3 No. 1553 in MTA livery pulls the Scoot westbound out of Patchogue in October 1972. The depot is visible in the center background. Off to the left was Grossman's Lumber, built on the site of the turntable that existed when Patchogue was a major locomotive terminal. (David Keller photograph.)

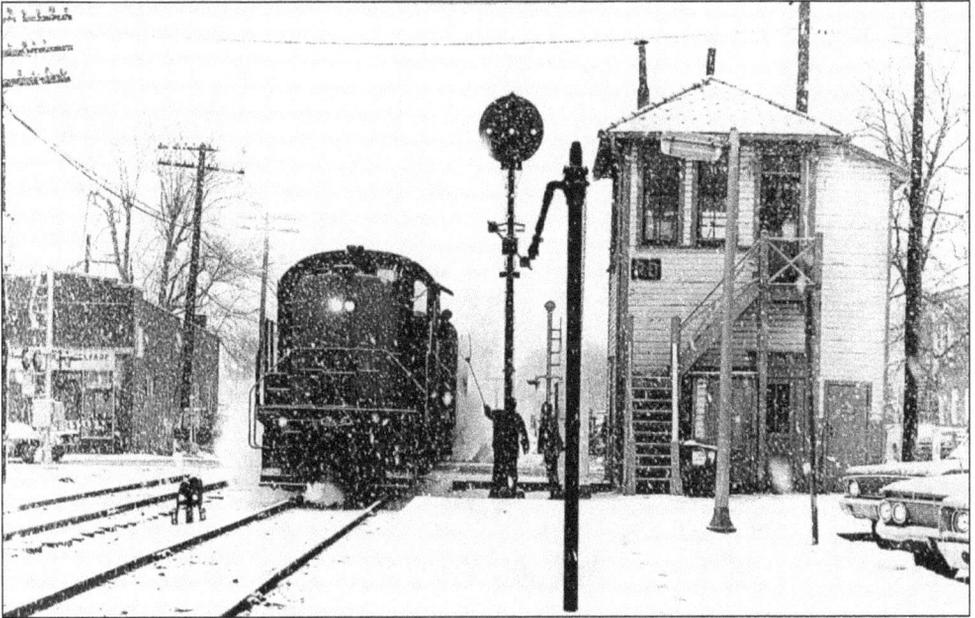

Heavy, wet snowflakes are falling this December day in 1970 as RS3 No. 1559 pulls the Scoot westbound from the north siding, over the crossover switches, and on to the main at PD tower, Patchogue. The block operator has his stick in the air, and the engineer is about to grab his orders for his shuttle run to Babylon. (David Keller photograph.)

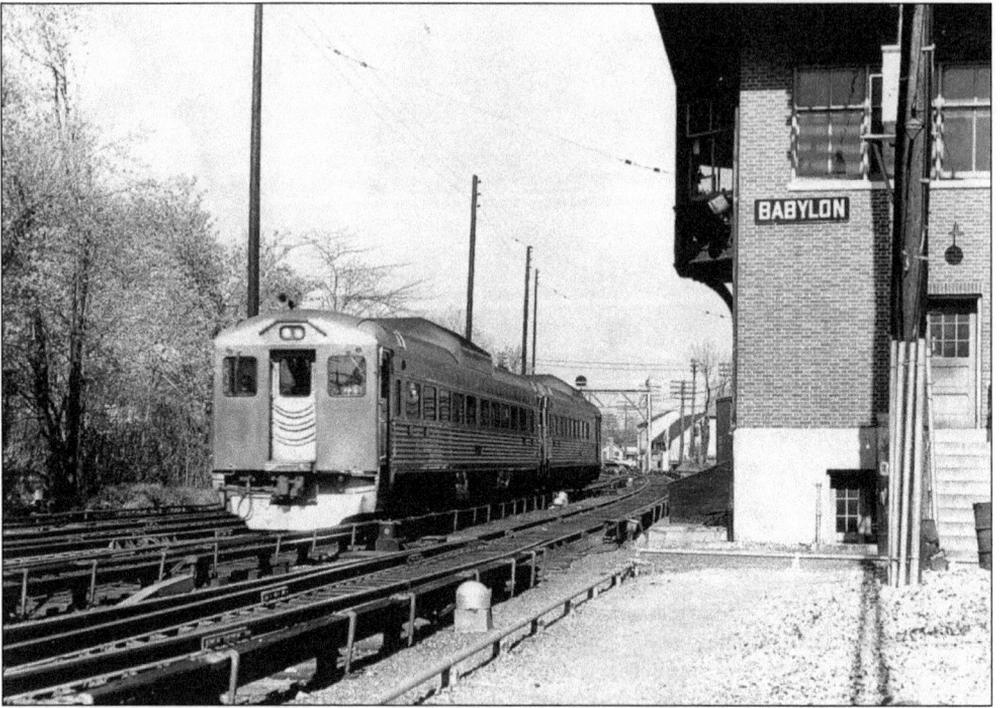

The Budd Rail Diesel Car (RDC) served the purpose of the Doodlebugs of earlier decades. The LIRR owned two Budd cars, which were used frequently in eastern Long Island service (painted with the East Ender logo on their orange end doors), and in Scoot service between Patchogue and Babylon. Here the Scoot travels westbound as it passes the old Babylon tower on a spring day in 1957. (Jules P. Krzenski photograph.)

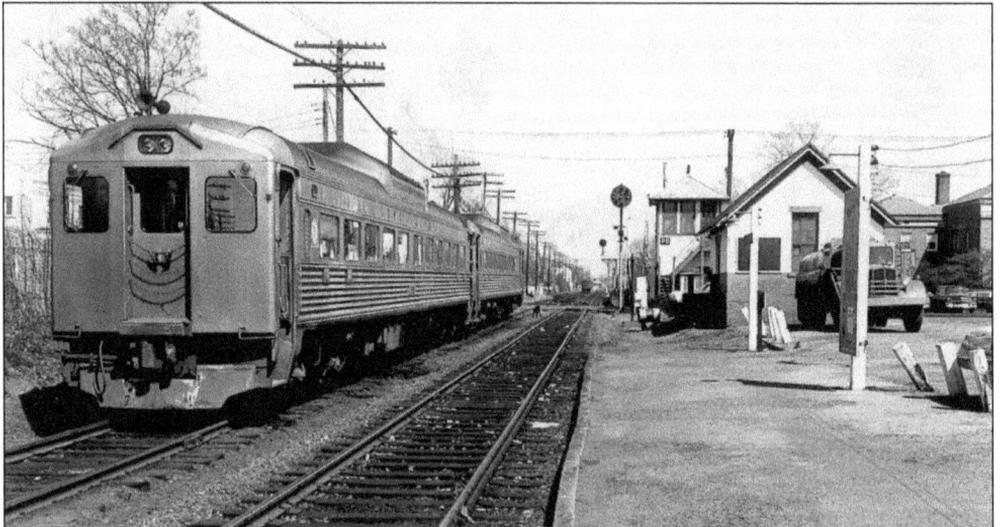

This pair of Budd cars are in Scoot service, laying up on the north siding at Patchogue in this scene from April 6, 1963, just one month before the entire depot area was torn down for newer facilities. On the right are the old white-posted electric platform lamps. Beyond them is the old baggage house, and beyond it, PD tower, which was the only structure to survive the onslaught of May 1963. (William Lichtenstern photograph.)

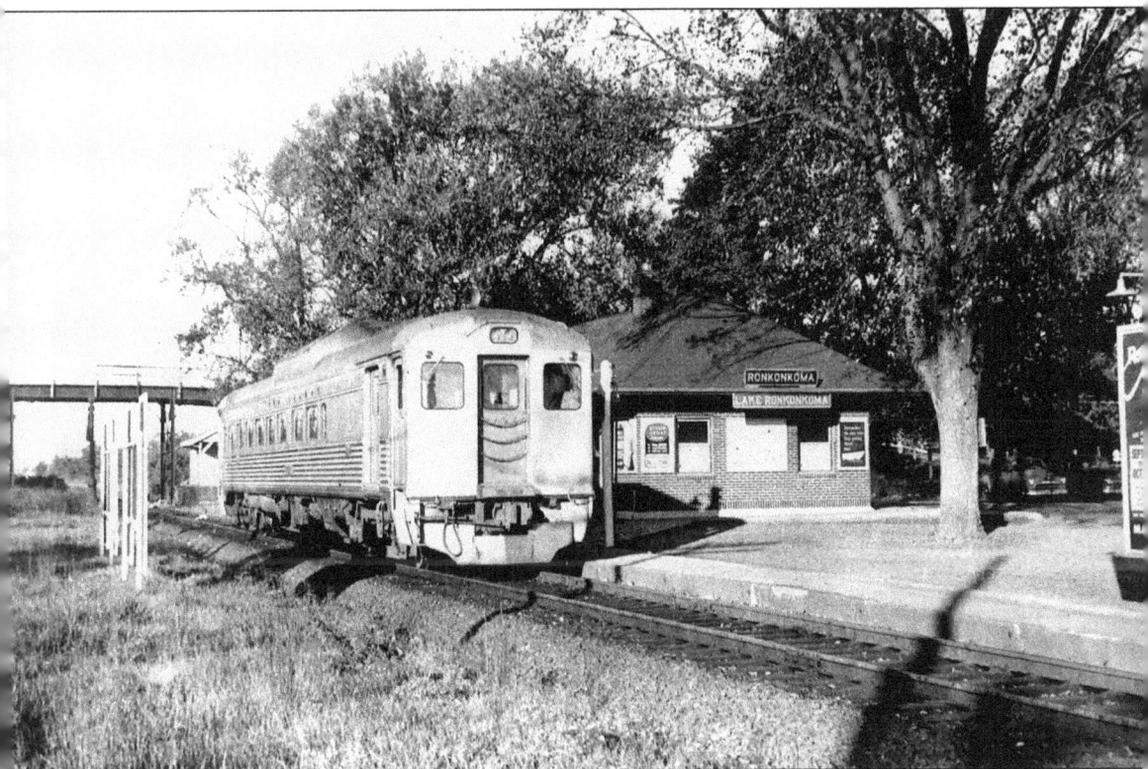

Budd RDC2 is in East Ender service eastbound at Ronkonkoma in this 1955 scene. Ronkonkoma appeared very rural and clean. Dwarfing the depot, which sported two station names, were the many Dutch elms that were planted back in the early part of the 20th century by the famous Broadway actress Maude Adams (1872–1953), whose estate was in Ronkonkoma. (This estate was willed to the Sisters of the Cenacle Community after the actress's death.) Adams paid for the planting of shrubbery and trees all around the depot grounds. Years later the Dutch elms had to be cut down after they were destroyed by the disease that bore their name. Some of the original shrubs remained on the depot grounds until the last years the old depot was in service. In the left background is the rickety steel-and-wood 1912 trestle of Ronkonkoma Avenue. This trestle lasted until a new bridge was installed c. 1989. The express house is visible just behind the RDC. (W. J. Edwards photograph.)

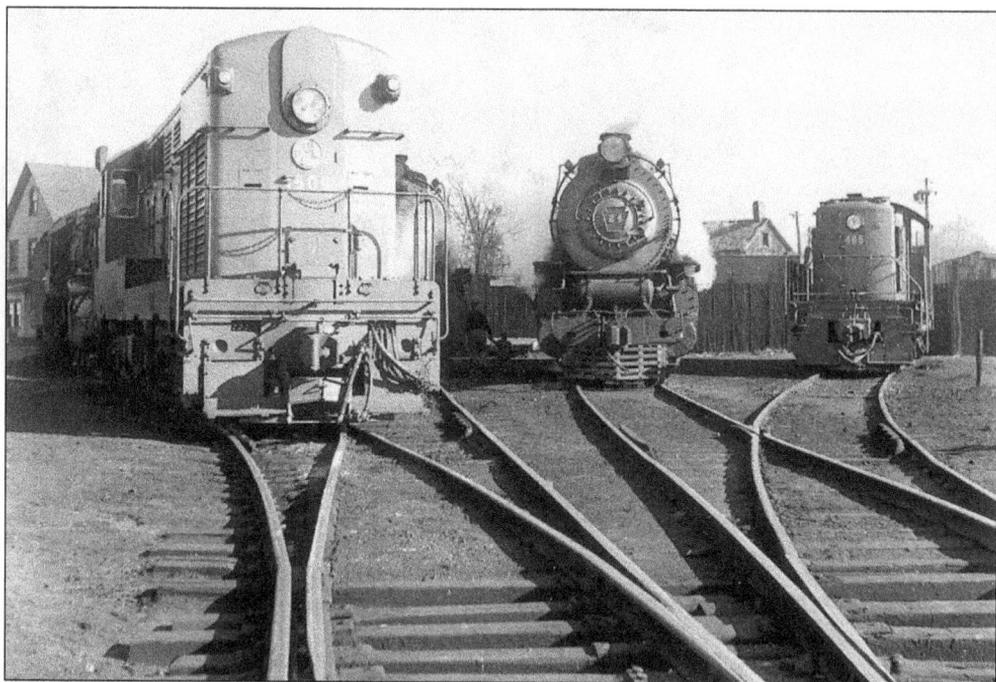

"Out with the old, in with the new" is the operative phrase in this 1952 scene at Oyster Bay. The once ever-present steam locomotives are outflanked by the new era's diesel locomotives. On the left is Fairbanks-Morse H16-44 No. 1509, and on the right, Alco RS1 No. 465. G5s No. 24 remained in operation for another few years, before it was withdrawn from service with all remaining LIRR steam in October 1955. (J. P. Sommer photograph.)

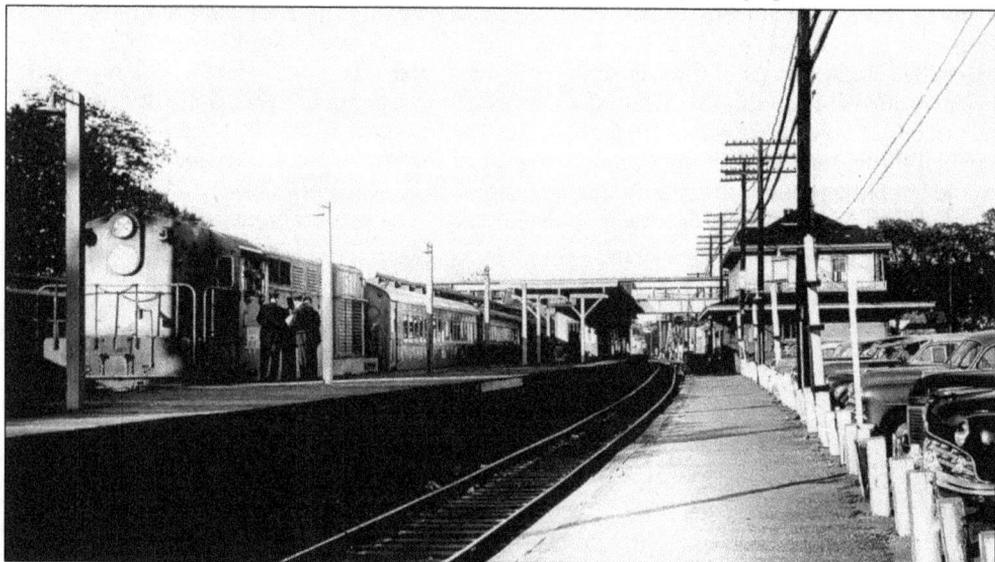

The train and engine crew are engaged in quite a discussion around the cab of Fairbanks-Morse H16-44 No. 1507. Perhaps they are discussing the orders they received at Babylon tower. Then again, perhaps they are discussing the chances of the Brooklyn Dodgers winning the pennant that year. It is summer 1954, and this view looks eastward toward the old 1881 two-story station, with its eave scalloping and upper wooden balustrade still evident. (W. J. Edwards photograph.)

Under a light dusting of snow, Alco Century model C420 No. 211 pulls an afternoon train westward from Port Jefferson and is about to dip under the Sheep Pasture Road overpass just west of the station in January 1972. In the foreground is the whistle post, in place to warn the engineer to blow his horn (or whistle in steam days) for an upcoming crossing. (David Keller photograph.)

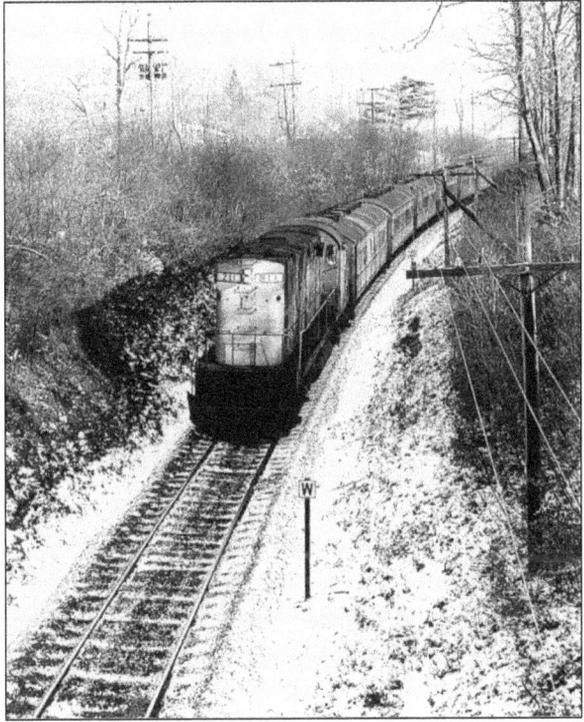

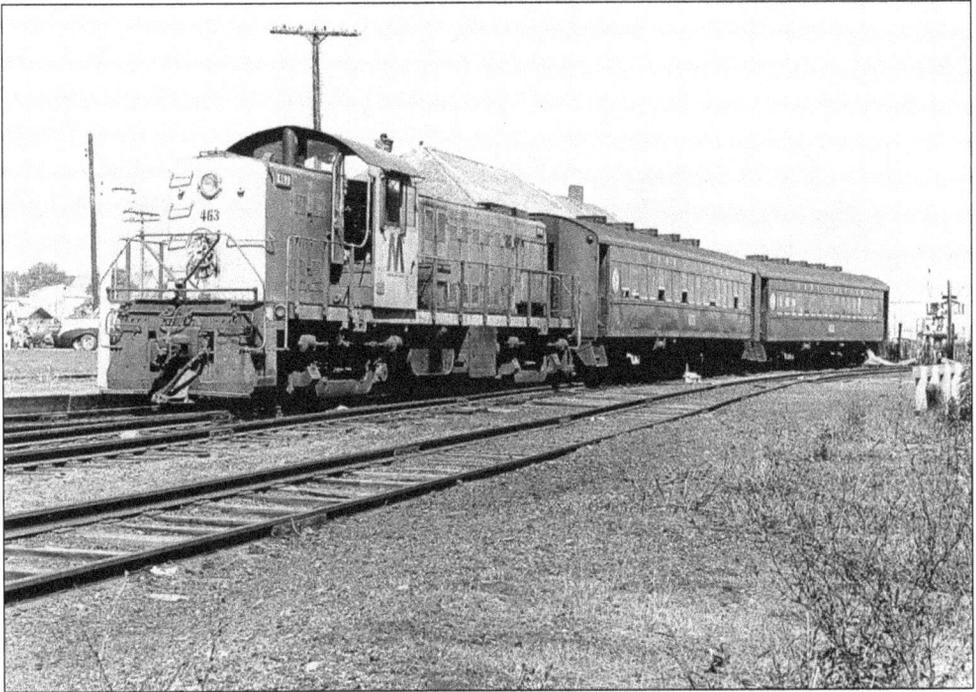

Alco RS1 No. 463 lays up at Greenport terminal with train No. 211 as it waits to depart westbound on a hot August day in 1972. The cab door is open to get some air, and the two "Ping-Pong" cars wait to seat the small handful of riders who will head back. In the right background is the Shelter Island Ferry, still busy on this late-summer day. (David Keller photograph.)

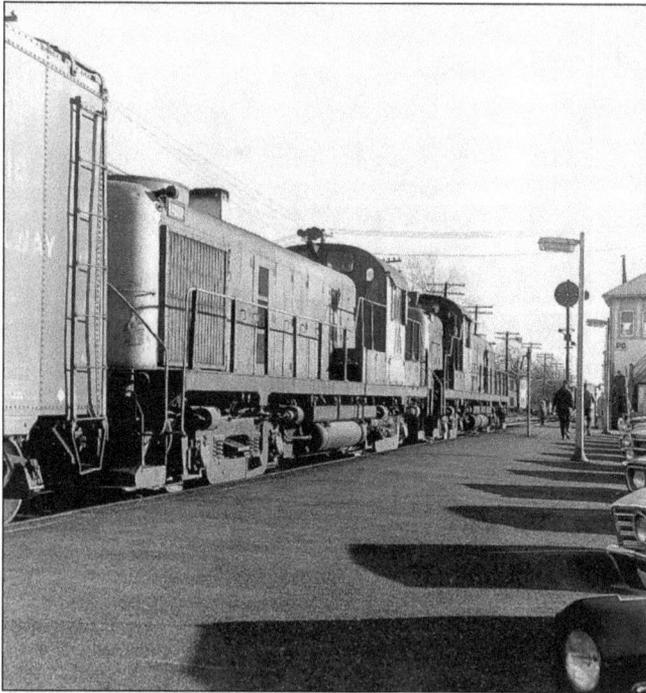

Alco RS3 Nos. 1555 and 1560 are coupled together and ready to pull an early-morning eastbound freight out of Patchogue. The train's eventual destination is Bridgehampton, and the engineer awaits the "clear" block signal at PD tower that will allow him to proceed on this November day in 1972. (David Keller photograph.)

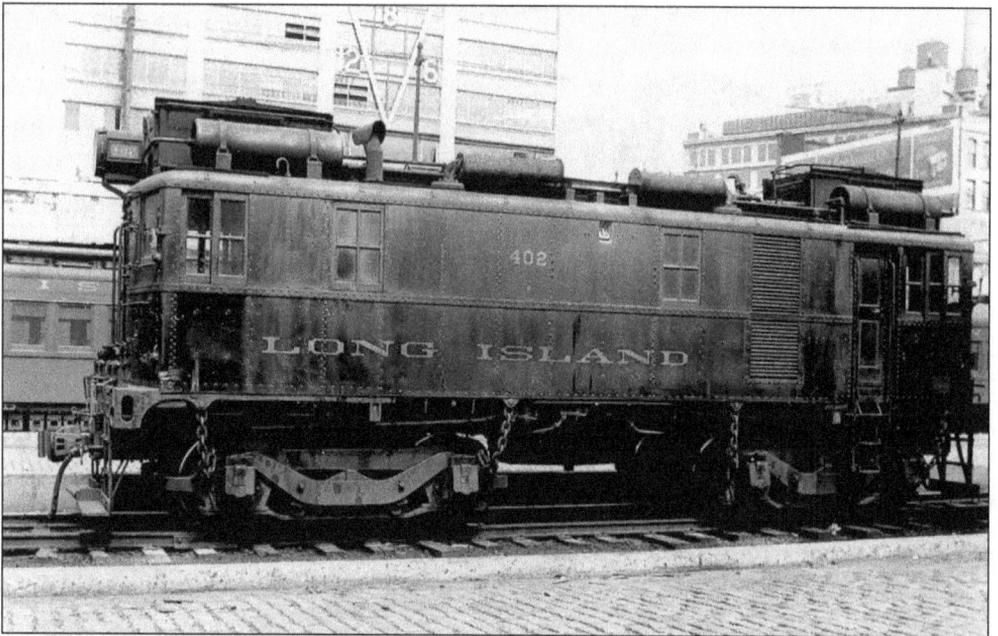

Oil Electric boxcab No. 402 (second) was five months shy of its fifth birthday when photographed here along Atlantic Avenue in Brooklyn on April 11, 1933. One of the first diesels in service on the LIRR, No. 402 was built by Alco/GE/Ingersoll-Rand and classed AA-3. It was sold in February 1953 and scrapped. (George E. Votava photograph.)

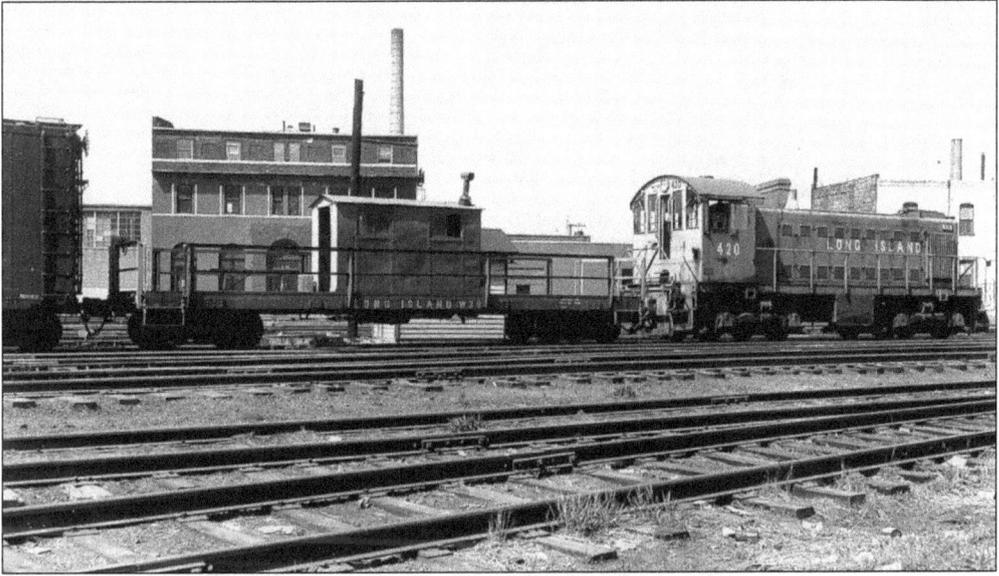

Alco S-1 No. 420 works at Long Island City in May 1963. It is coupled to idler or "reach" car No. W39, indicating that No. 420 is in the process of loading freight cars on the barges at the float docks. The idler car allowed freight cars to be spotted on and removed from the barge without the locomotive actually putting its weight on the barge itself. (George E. Votava photograph.)

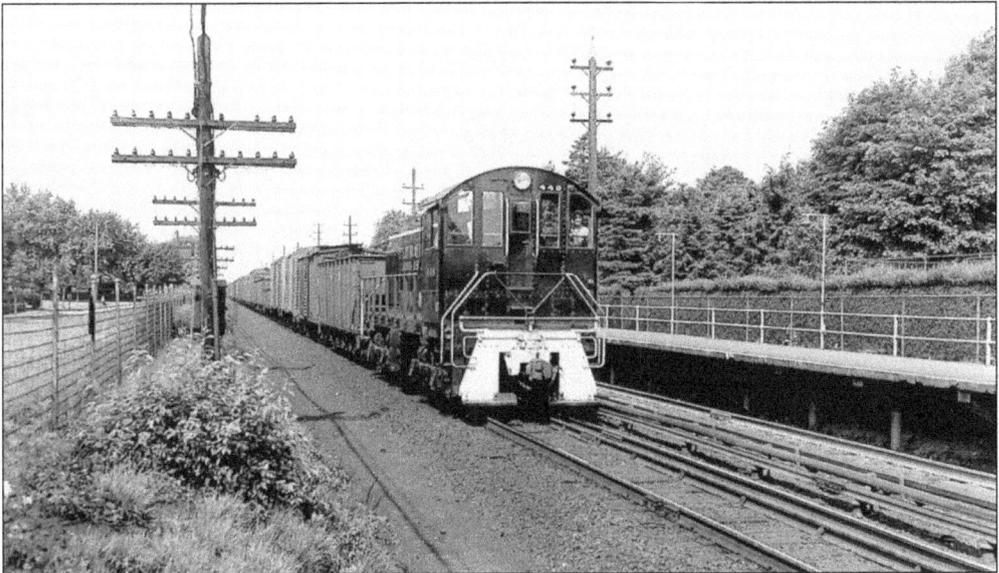

In a nontypical scene for the LIRR, Alco model S2 runs cab forward as it pulls a string of freight cars eastbound through Mineola in July 1950. In the early days, the LIRR enginemen liked to run all the units long-nose forward, even turning them on the available turntables so this could be accomplished. When all else failed, on occasion the units would be run short-nose or cab forward. (George E. Votava photograph.)

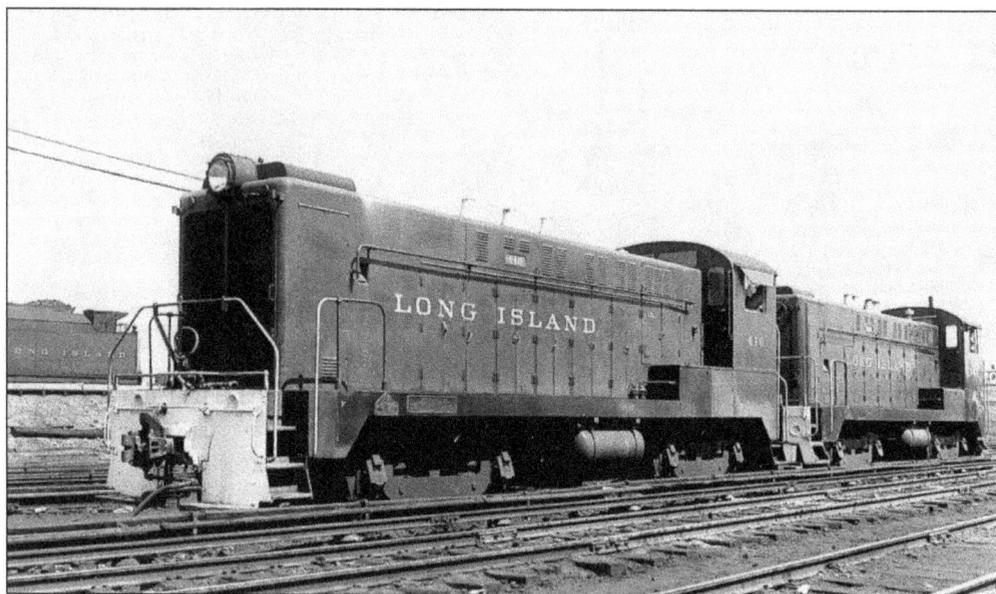

Another diesel manufacturer whose product was used early on in LIRR service was Baldwin. Shown coupled here outside Morris Park Shops in Queens are model DS4-4-660 Nos. 410 and 403 photographed in April 1950. Built in 1948, these units were sold in 1964 and 1963, respectively. On the embankment at the left is a locomotive tender with rear cabin. (George E. Votava photograph.)

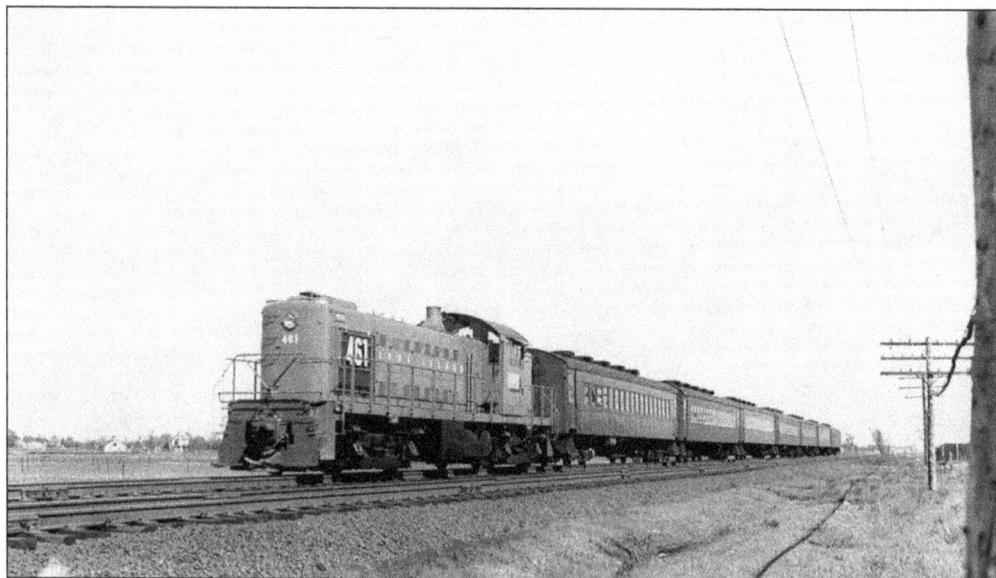

In newly painted Tichy color scheme with large road numbers on the side louvers and shadowed-map of Long Island under the cab window, Alco RS1 No. 461 pulls train No. 4227 westbound through still rural Hicksville in May 1950. (George E. Votava collection.)

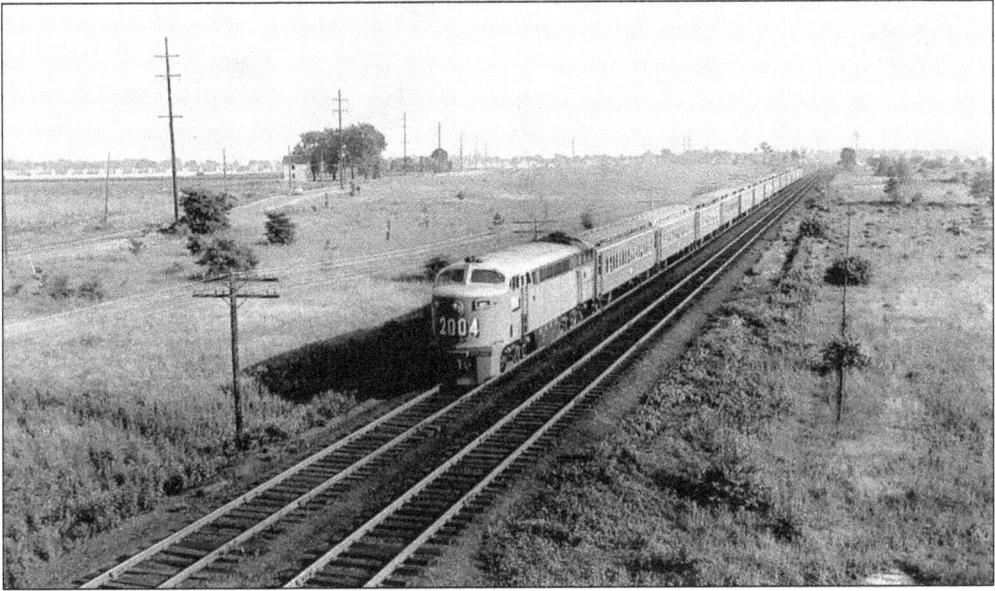

Photographed from an overpass in Hicksville in July 1953, Fairbanks-Morse model CPA20-5 No. 2004 pulls a morning train westbound through the fairly barren countryside. The postwar housing boom already under way is evident in the rear left background. In the years that followed, this entire area was developed. (George E. Votava photograph.)

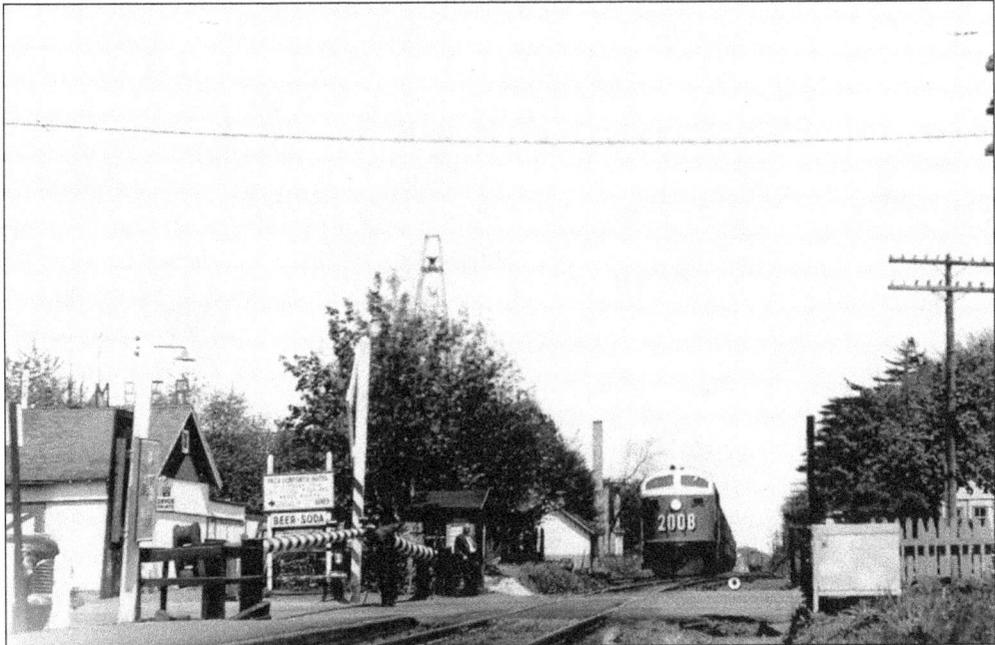

Fairbanks-Morse model CPA20-5 No. 2008 pulls a westbound train into Central Islip c. 1952. Abreast of the section shanty, No. 2008 is about to cross Carleton Avenue, protected by the watchman at his shanty, the wooden diamond crossing sign, and Central Islip's well-known pole gates. Central Islip was the only location on the LIRR where the gates were not the standard board type but instead were made from telephone poles. (George G. Ayling photograph.)

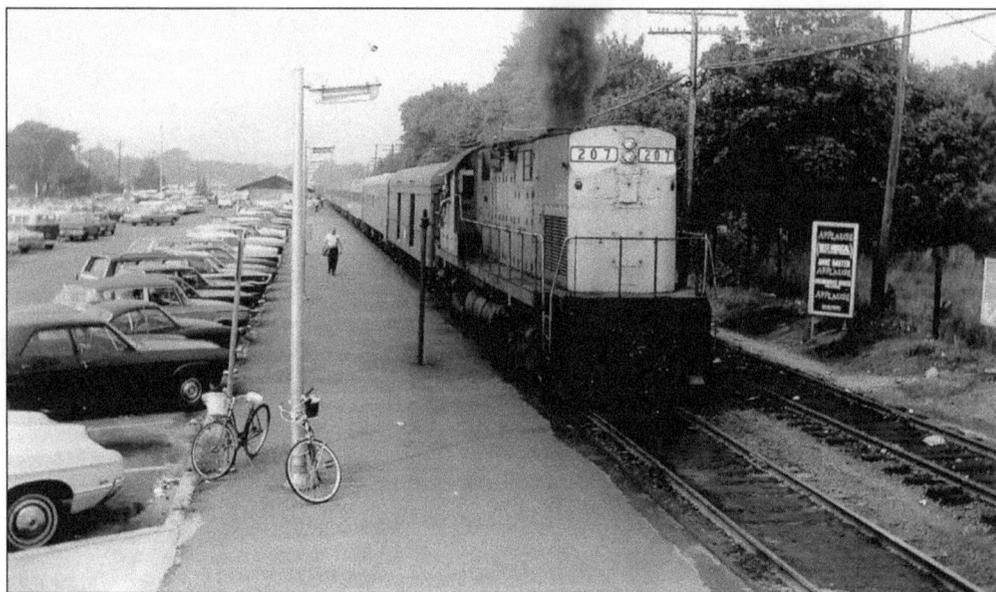

It is already hot early on this day in August 1971 as Alco C420 No. 207 leaves eastbound from Patchogue station with morning Montauk train No. 4 in tow. Photographed from PD tower, the Alco unit displays its infamous plume of diesel exhaust. (David Keller photograph.)

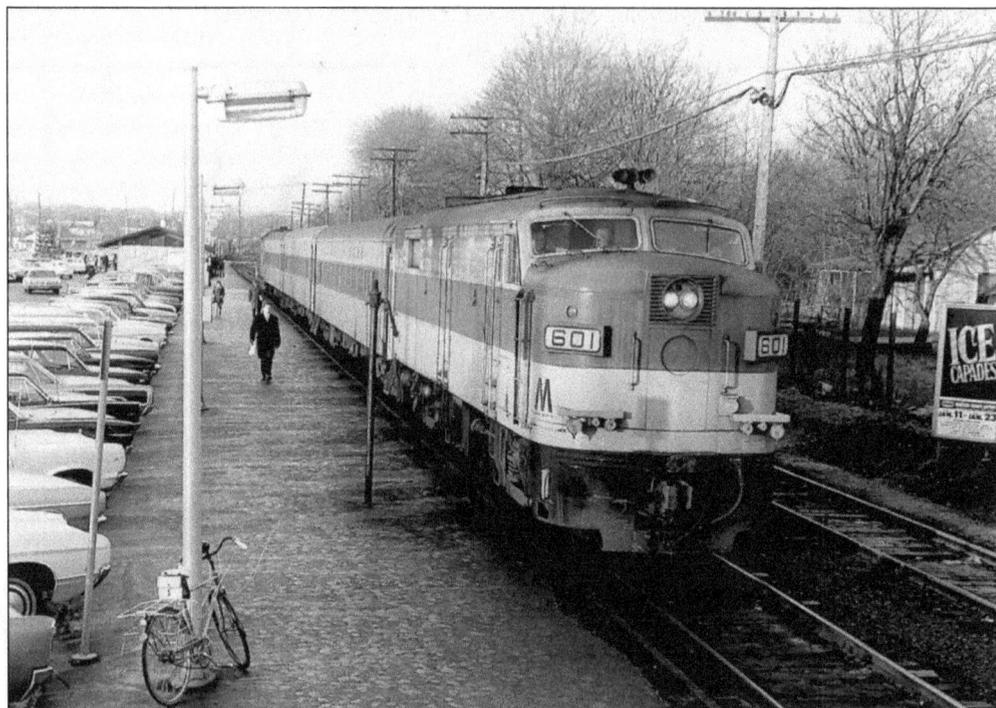

The Patchogue–Babylon Scoot had become push-pull service by the time of this photograph taken from PD tower in January 1972. With a powered Alco RS3 on the west end and a secondhand Alco FA2m control cab No. 601 on the east end, the early-morning shuttle is leaving Patchogue station to cross over and lay up on the north siding past the South Ocean Avenue crossing. (David Keller photograph.)

Five

SERVICE IN ELECTRIFIED TERRITORY

The parent Pennsylvania Railroad pushed for major electrification in the dense traffic corridor between New York and Philadelphia. As part of this project, the LIRR received third-rail electrification beginning in 1905. The electrified service permitted trains entrance into New York City via the East River tunnels, as well as constant acceleration, and provided a cleaner environment as required by law. The project was completed, and the first trains ran from Pennsylvania Station, through the tunnels under the East River, out to Long Island in September 1910. Outlying areas not yet electrified were still serviced by steam, with the famous "change at Jamaica."

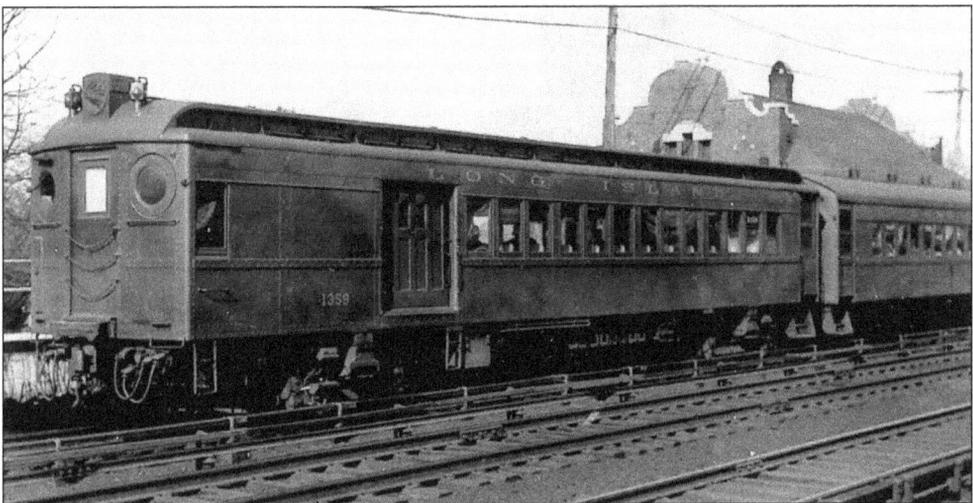

Pictured here are the electric cars that old commuters remember best. MU combine motor No. 1359 leads this westbound train at the ornate, brick Bellerose station in March 1938. The class MPB54 car was built in 1913 by American Car & Foundry. These cars, along with the regular MP54 cars, were used until the early 1970s. (George V. Arnoux photograph.)

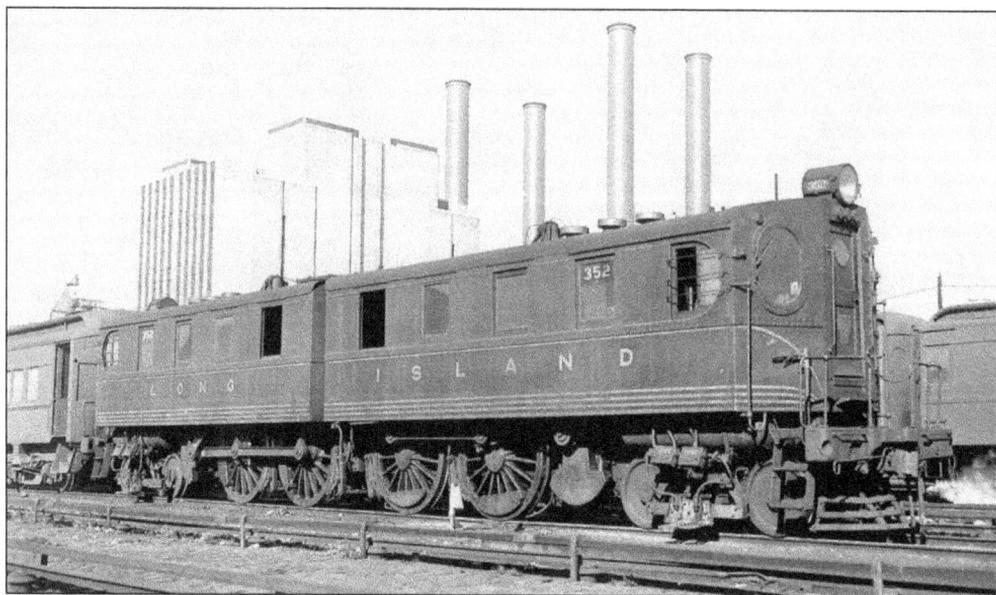

Because steam locomotives could not go in the East River tunnels to Pennsylvania Station, electric locomotives were required. The DD1 class was used on the LIRR for both passenger and freight service. Always running in pairs, DD1s and their clanking side rods were a familiar sight for many years. Here DD1 No. 352 prepares to pull a commuter train from Long Island City in 1950. (David Keller collection.)

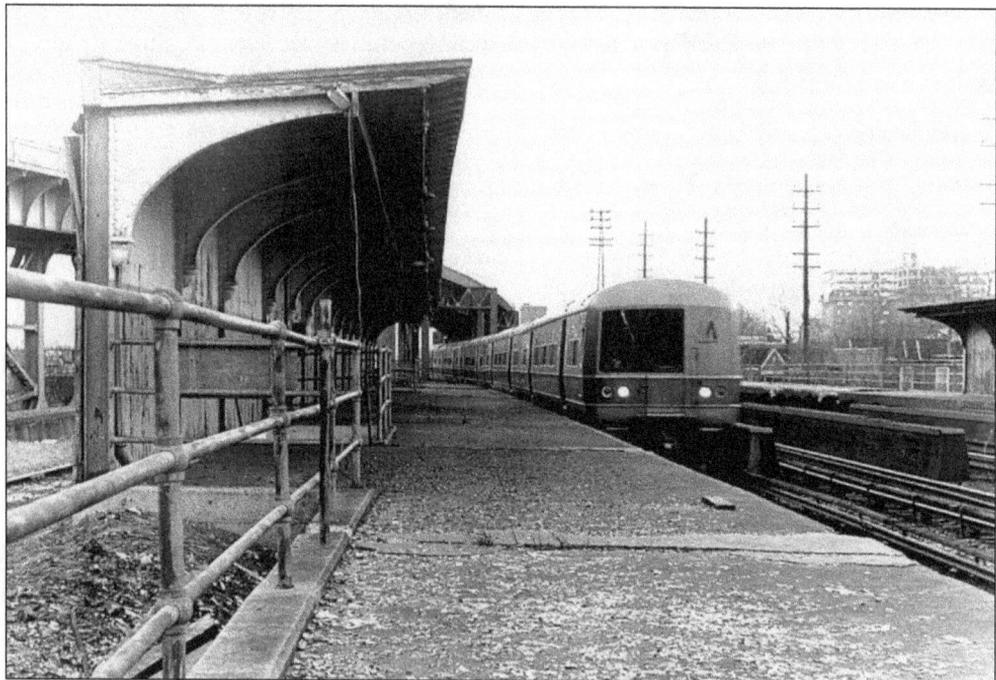

Replacing the old MU cars were the Budd class M1 Metropolitans. These new electric cars rode much smoother and were well heated in winter and well air-conditioned in summer. In this view from the abandoned platform of the former Hillside station, a string of these new cars heads eastbound on a grey, chilly Christmas Day 1971. (David Keller photograph.)

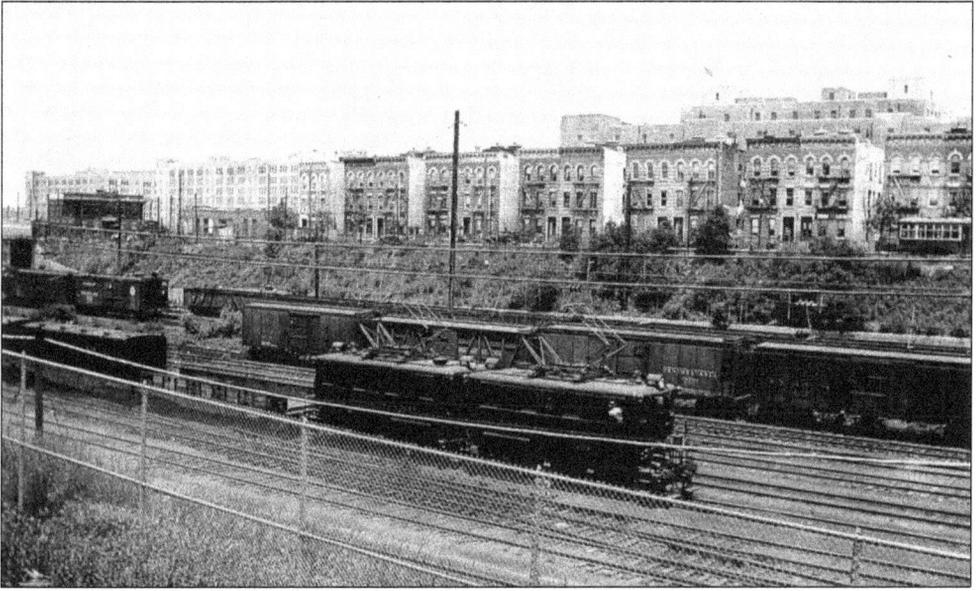

In this c. 1936 scene at Bay Ridge, Brooklyn, B3 electrics No. 337 and No. 334 are coupled together as they pull a freight from the yard. Their power was drawn from the overhead catenary system. Fire escapes on tenements and laundry hanging between buildings were common sights during this era, as was the Brooklyn & Queens Transit's "Peter Witt"–type streetcar on the right. (George E. Votava photograph.)

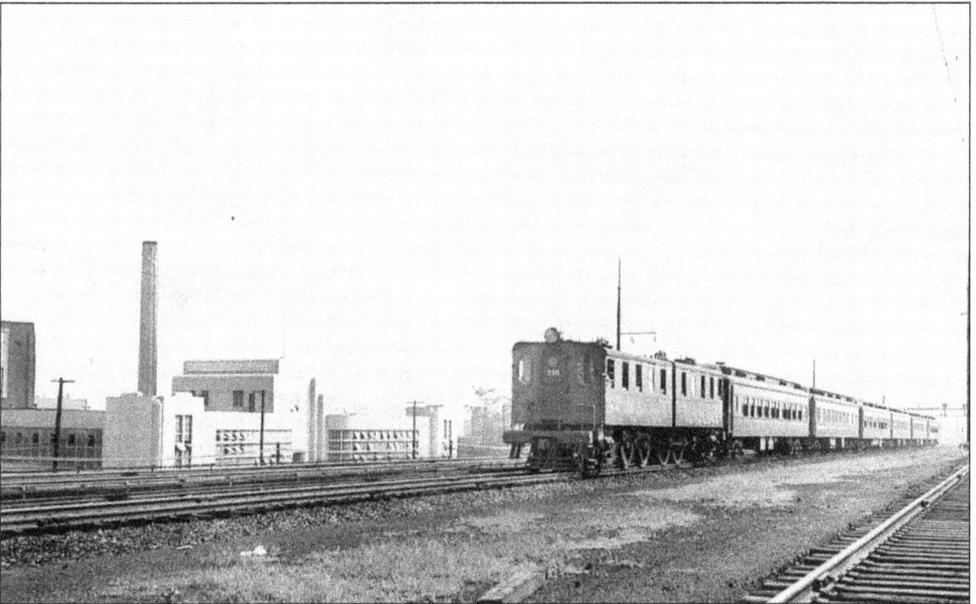

DD1 No. 339 pulls train No. 19, the Sunrise Special, westbound through Sunnyside, Long Island City, in this August 9, 1937, photograph. This was a Montauk train, typically pulled by G5s steam locomotive No. 21. However, steam locomotives could not enter the tunnels, so head-end power was changed to electric at Jamaica, and No. 339 is on the final leg of the trip. On the left is the Knickerbocker Laundry. (George E. Votava photograph.)

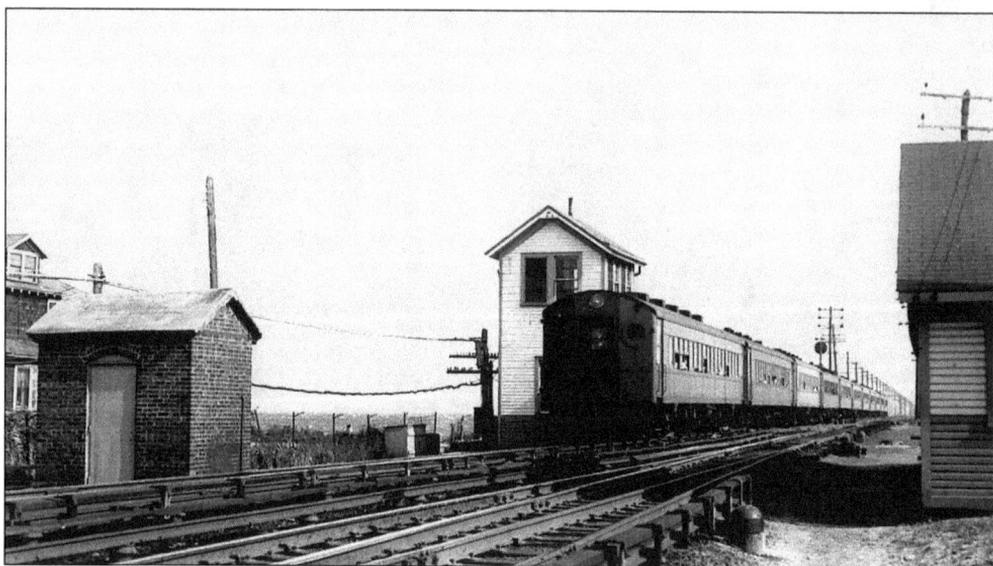

It is July 27, 1947, and MU car No. 1782 is in the lead as it pulls an electric train westbound from Far Rockaway via the Jamaica Bay trestle. Passing the old, wooden Beach interlocking tower at Hamilton Beach, the train heads back toward the city. This scene would change in 1950 after the trestle was destroyed by fire and abandoned by the LIRR. (George E. Votava photograph.)

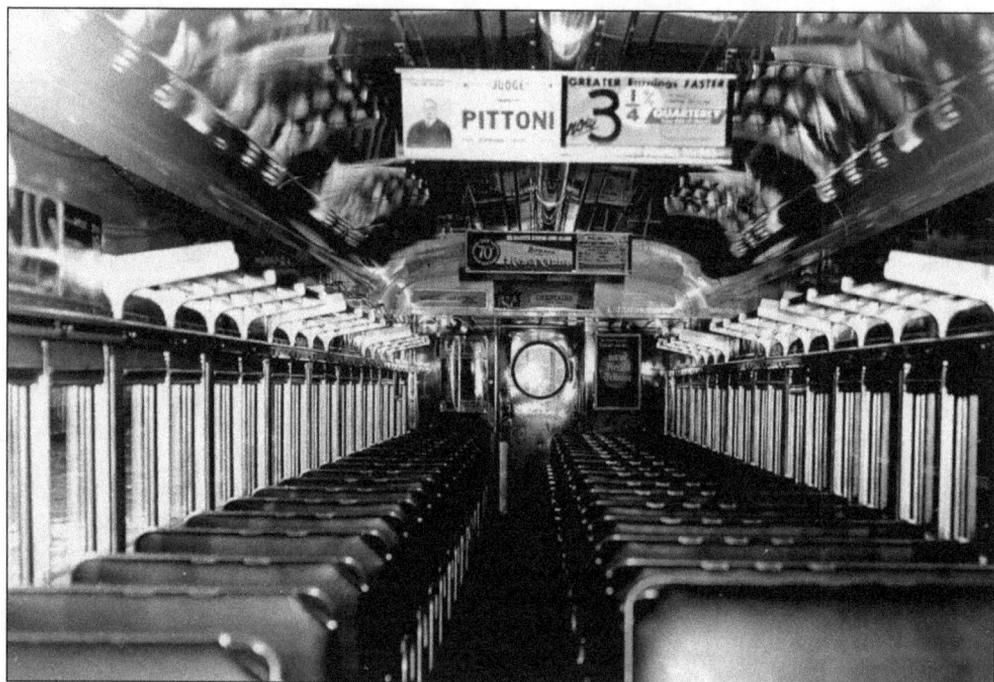

This view toward the end of a new MU electric car c. 1957 shows the "three and two" pattern of seating, which allowed five passengers to sit across. The shiny baggage racks and gloss of the painted ceiling attest to the car's new condition. At the rear of the car, over the round window, is an advertisement celebrating the 70th anniversary of the Bohack supermarket chain. (Jules P. Krzenski photograph.)

64

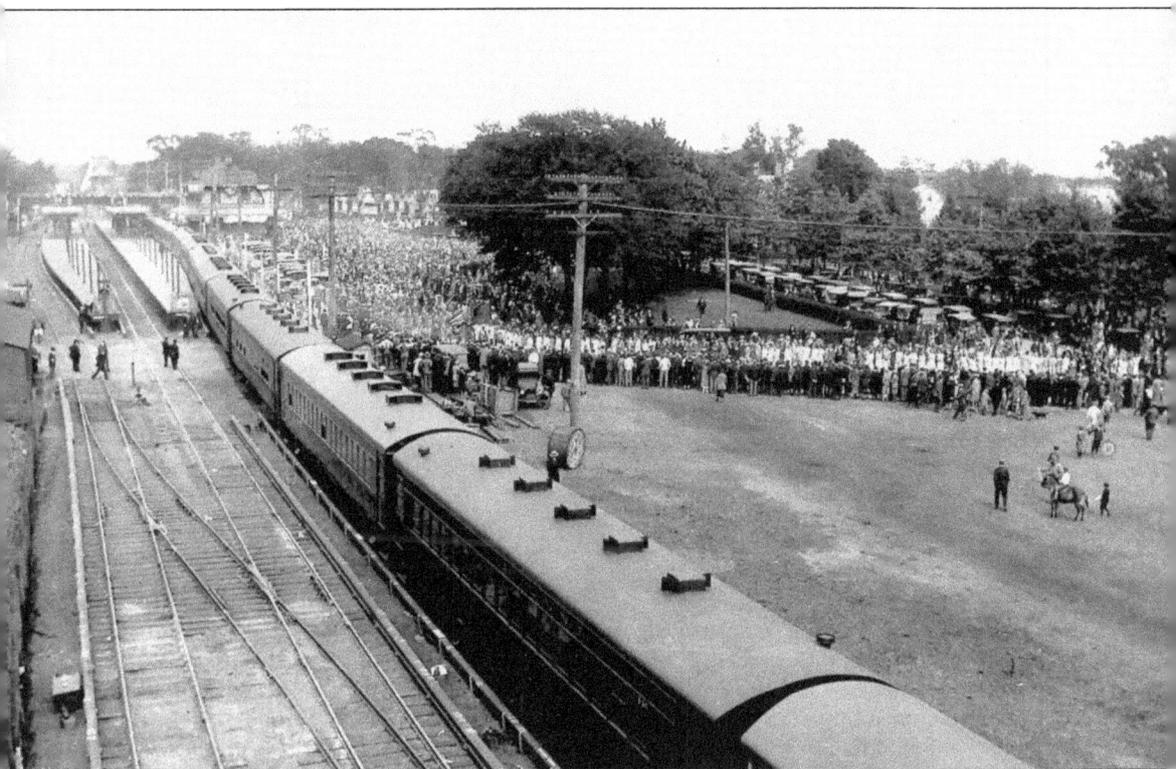

Electrification came to the LIRR in 1905 but did not reach outlying areas such as Babylon until years later. When it happened, there was a gala celebration. Shown here on May 21, 1925, the first MU electric train to Babylon has just entered the station. Thousands of people turned out for the momentous event. This photograph shows the crowd of spectators, who included curious citizens as well as clubs, organizations, fire departments, and local bands. Also visible are a variety of cars of the day. This view from the signal bridge, looking eastward toward the station area, also shows the depot bedecked in bunting, and in the distance, BJ tower, which has not yet been placed in service. (James V. Osborne photograph.)

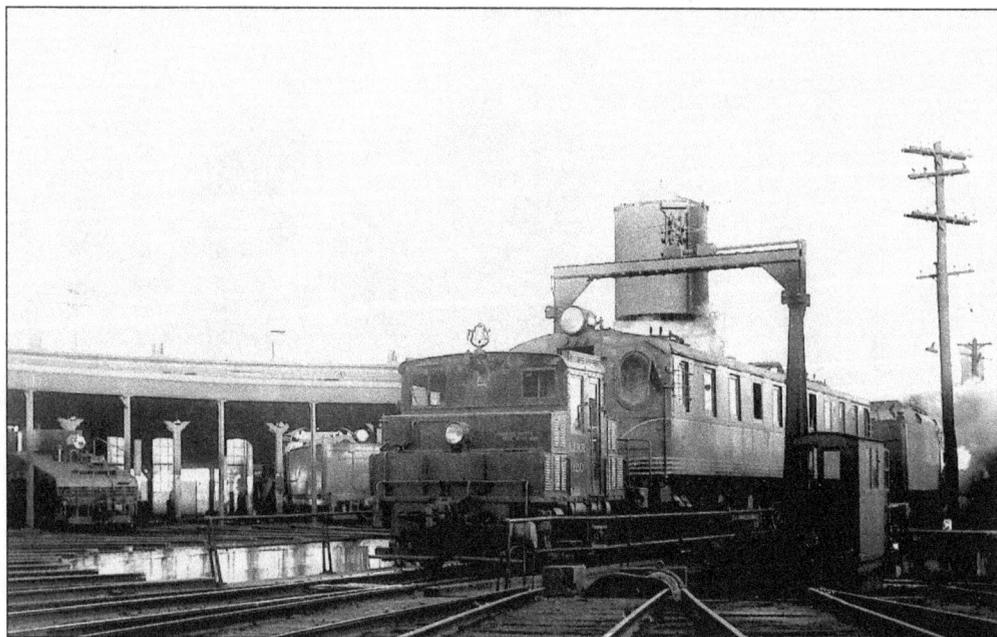

It is late in the day as class A-1 electric shop switcher No. 320 pulls DD-1 class electric locomotive No. 339 onto the turntable at Morris Park Shops. In this November 1940 scene, a locomotive steams up at the rear of the DD-1 and is ready to move. On the left is the turntable pit and old roundhouse with a couple of stalls occupied. (David Keller collection.)

The first MU electric cars used on the LIRR in 1905 were of the MP41 class. Some years later they were replaced by the larger MP54 cars. Here are two MP41 cars in shuttle service between Country Life Press in Garden City and Mitchell Field. Appearing freshly painted, Nos. 1100 and 1101 head westbound at the Clinton Road station in March 1947. (George E. Votava collection.)

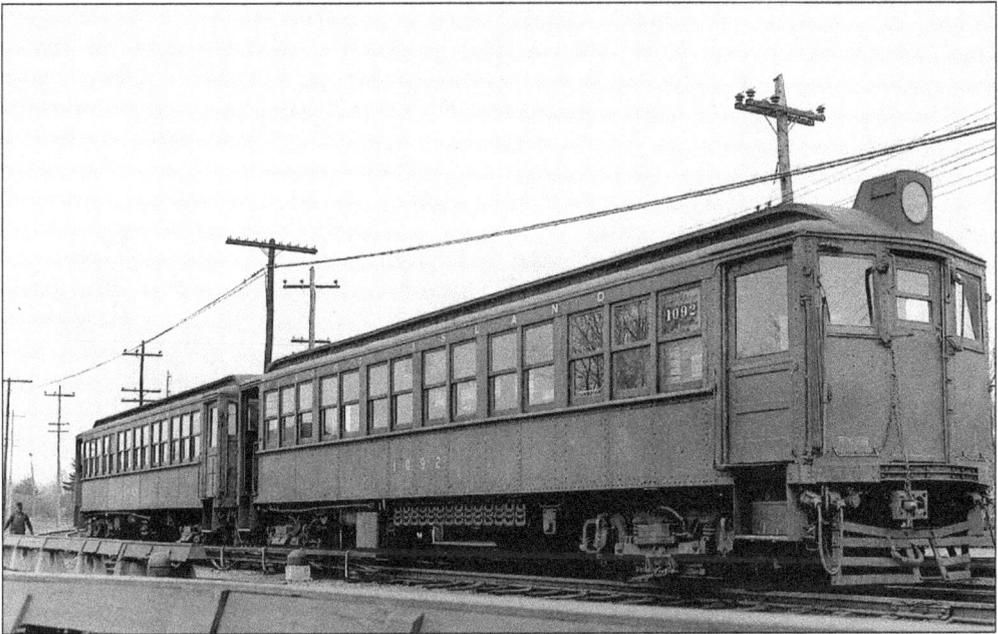

Shown are two more MP41 electric cars in Mitchell Field shuttle service. It is March 1947, and Nos. 1092 and 1089 are laying up at the platform of the Country Life Press depot in Garden City. Visible behind the rear car is the curve of the east leg of the wye, which provided an eastbound connection with the Central branch. (George E. Votava photograph.)

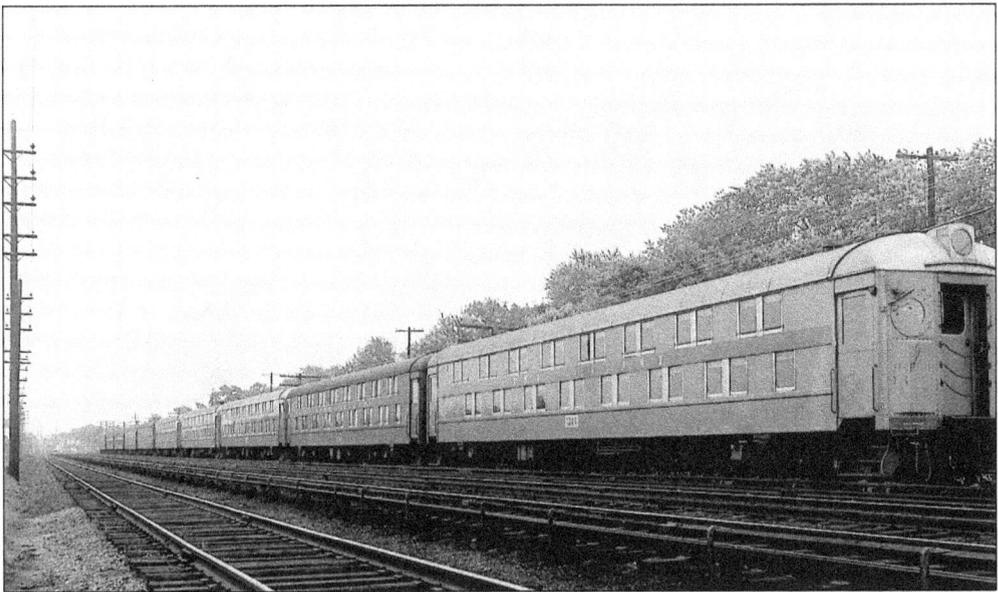

How can a train carry more passengers? Double them up. MU double-decker car No. 1288 is on the end of this 10-car double-decker train at Babylon in July 1951. Very popular with regular commuters and part-time riders alike, this style of car remained in use into the early 1970s, when the entire old MU fleet was replaced by the Budd M1s. (George E. Votava photograph.)

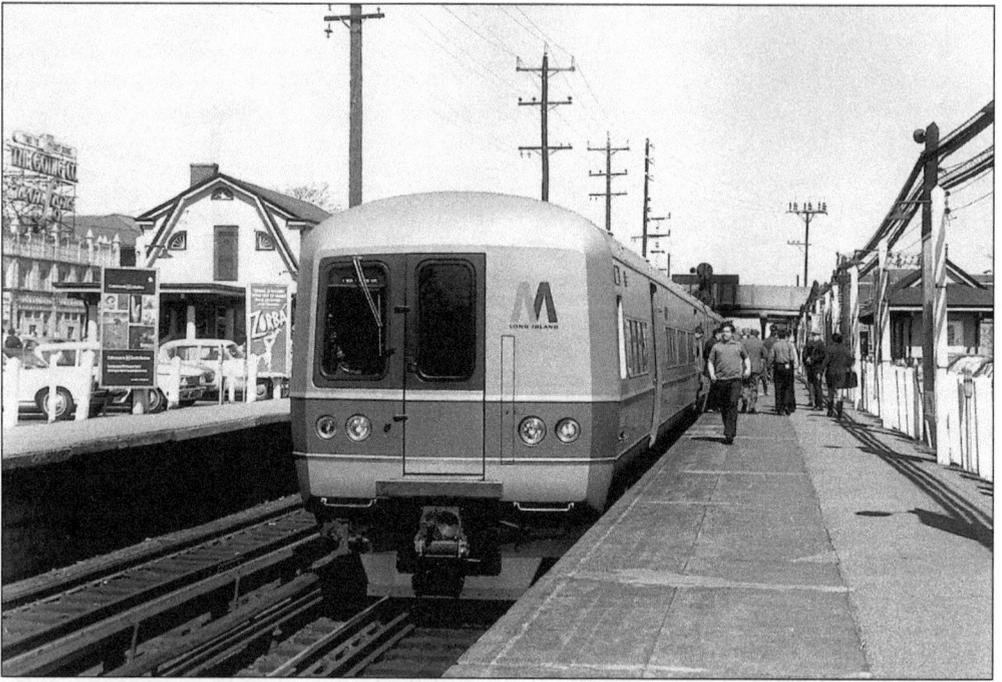

Here a Budd M1 train in the early days of its service discharges eastbound passengers at Mineola in April 1969. While quite new, and something exciting to see, ride, and photograph, the M1 electric cars would, within a few years, totally replace all the old, familiar MU electric cars. (David Keller collection.)

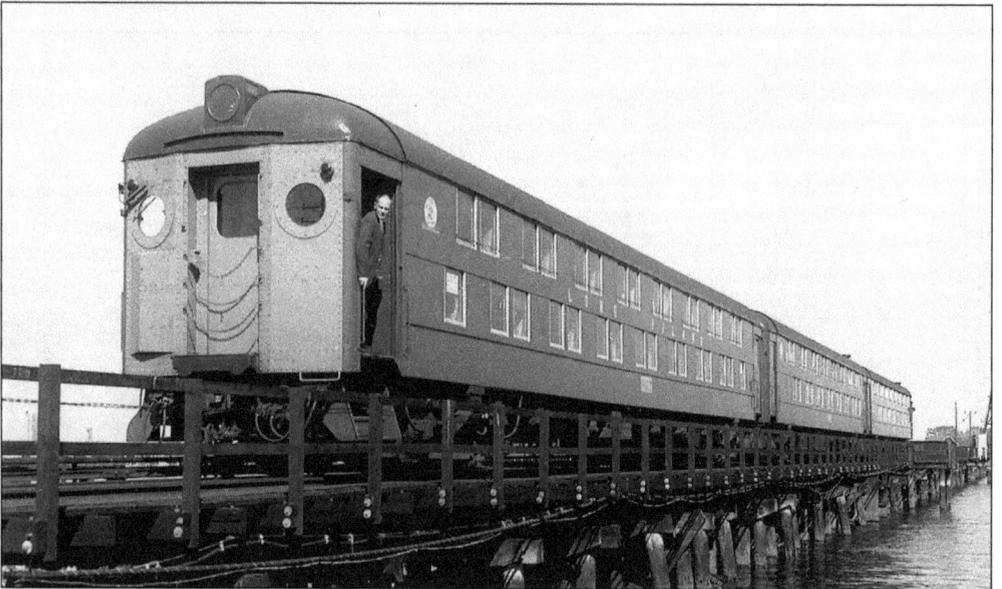

A three-car double-decker train pulled by No. 1327 is on the wooden pile trestle crossing Reynold's Channel between Island Park and Long Beach in this October 1963 shot. The trainman, minus his uniform cap, stands on the closed trap and leans out the door, perhaps curious about the photographer's intentions. Visible in the distance are the swing bridge and Lead cabin that controlled it. (W. J. Edwards photograph.)

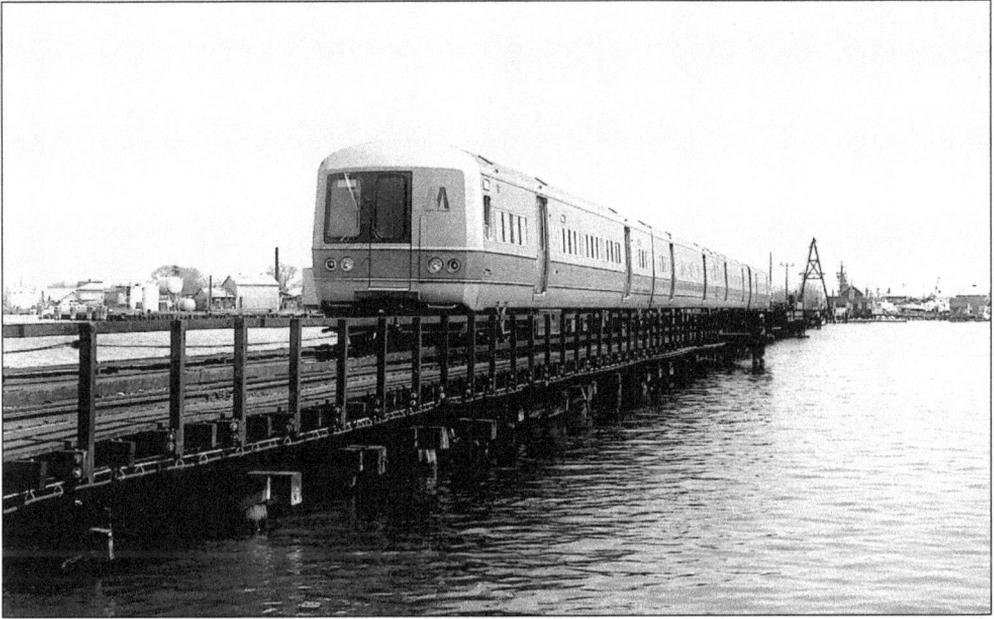

Jump ahead almost six years and another photographer has captured a scene similar to the previous photograph, taken from almost the same spot. It is April 1969, and by this time the familiar MU double-decker cars have been replaced by the brand-new Budd M1s. (David Keller collection.)

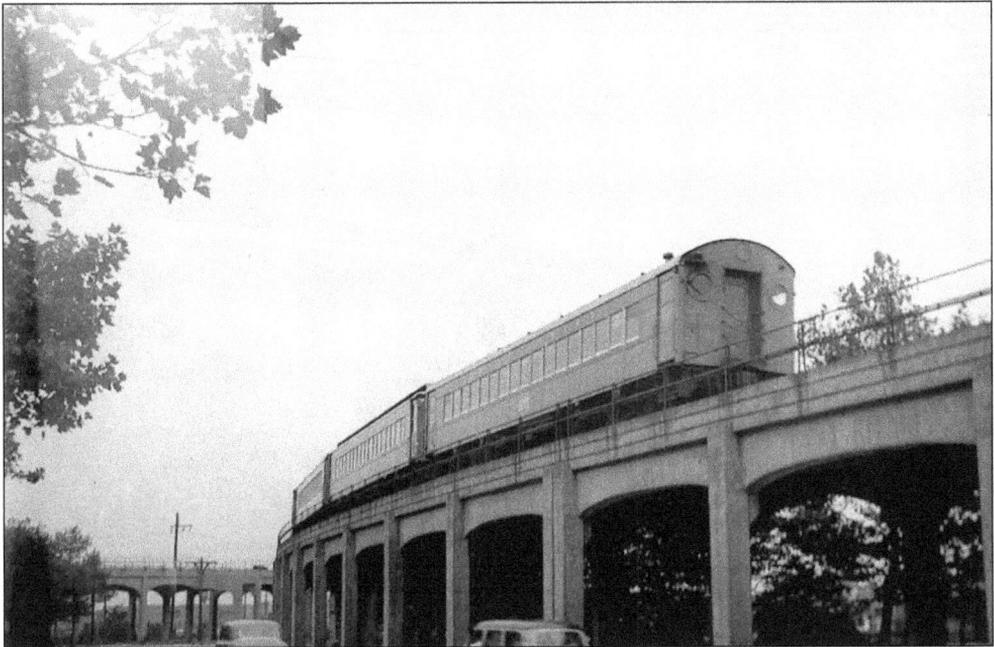

An MU electric train speeds along on the east leg of the elevated tracks and wye at Hammel's c. 1954. Pictured in the background is the elevated west leg of the wye to Rockaway Park. Shortly after this time, LIRR service to this area was discontinued and was replaced by the New York City Transit System trains to Rockaway Park and Far Rockaway. (W. J. Edwards photograph.)

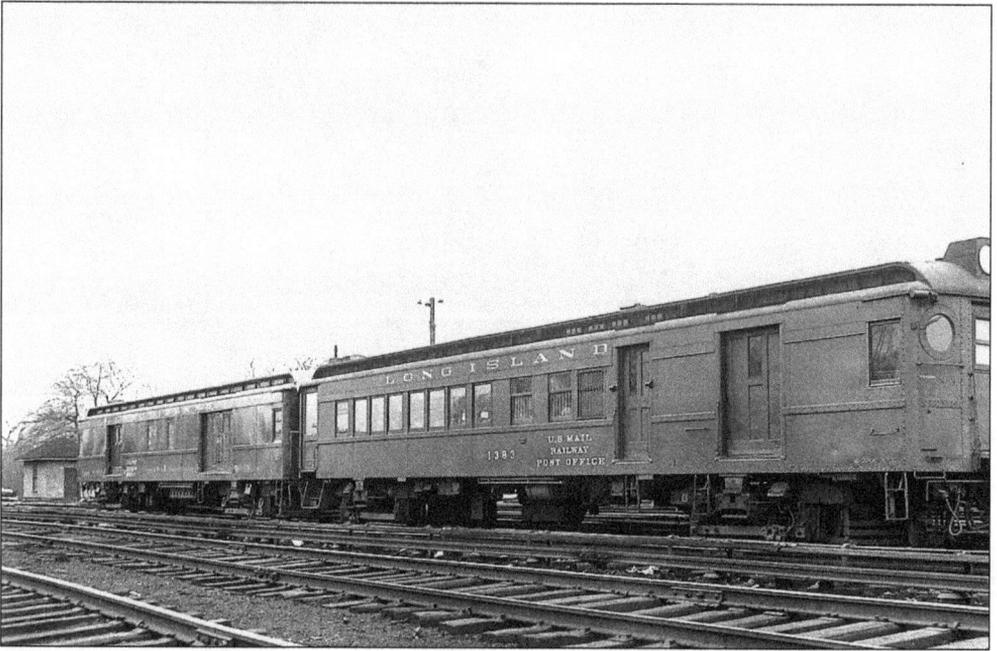

This little MU train appears to be able to do it all. The car on the right, No. 1383, is a combination passenger, Railway Post Office (RPO), and baggage car. The car on the left, No. 1215, is a Railway Express Agency (REA) car. This scene was photographed at Babylon in March 1947. No. 1383, classified as an MPBM54, was later scrapped with the cessation of LIRR mail service. (George E. Votava photograph.)

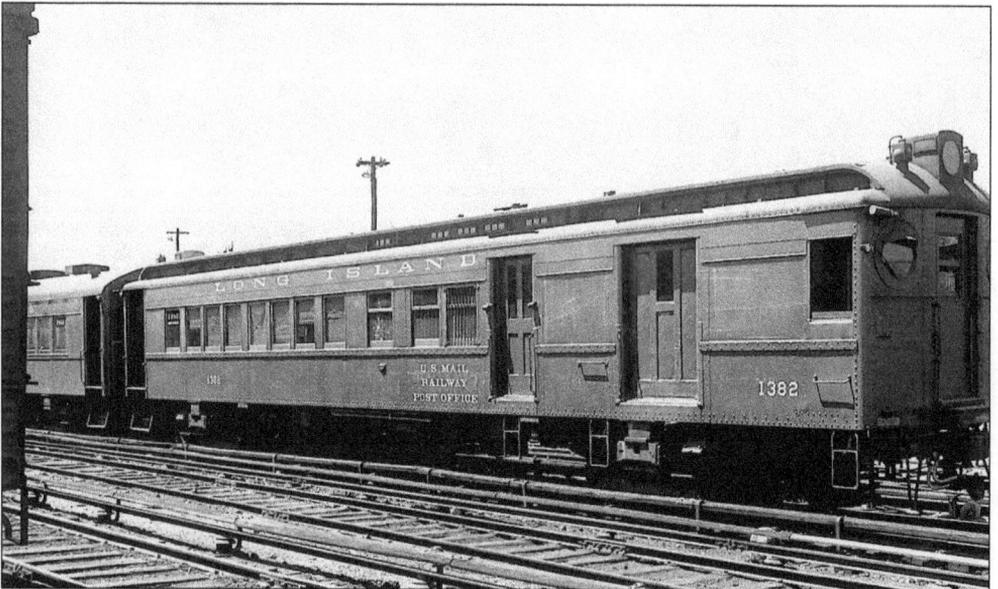

A closer view of a class MPBM54 is shown in this photograph of No. 1382 at Jamaica in May 1940. Built by American Car & Foundry in 1913, these motored cars could carry passengers, mail, and baggage in electrified territory. Their designation of MPBM stood for Motor Passenger Baggage Mail. Note the mail slot under the third window for patrons to post their letters. (George E. Votava photograph.)

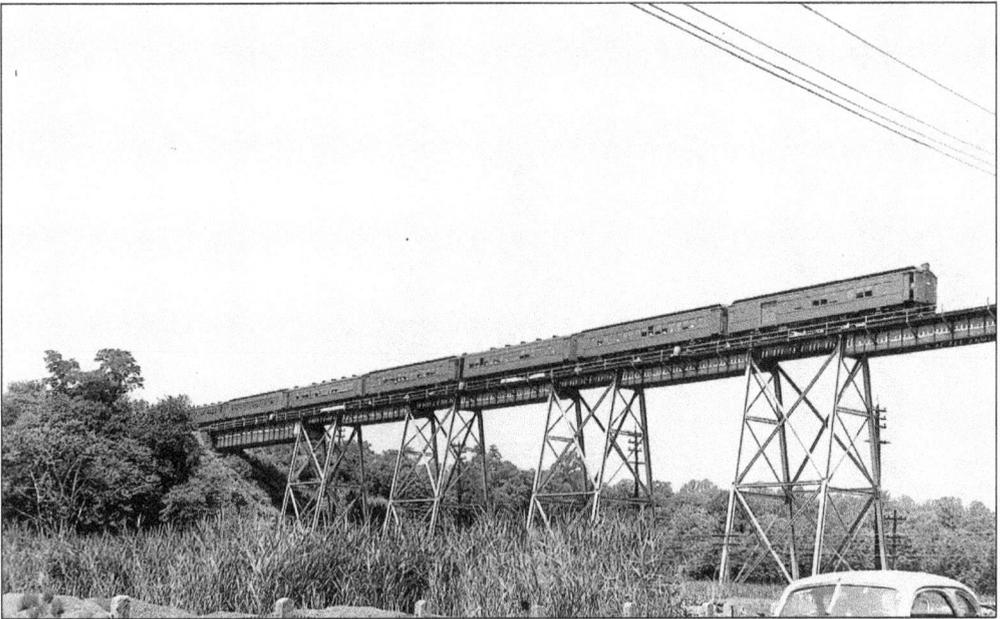

MU combine (combination baggage and passenger) car No. 1348 pulls a string of MU cars on a Port Washington train across the Manhasset viaduct in July 1947. On this hot day, many of the car windows are open, and the motorman's door is partly ajar to let in some air. (George E. Votava photograph.)

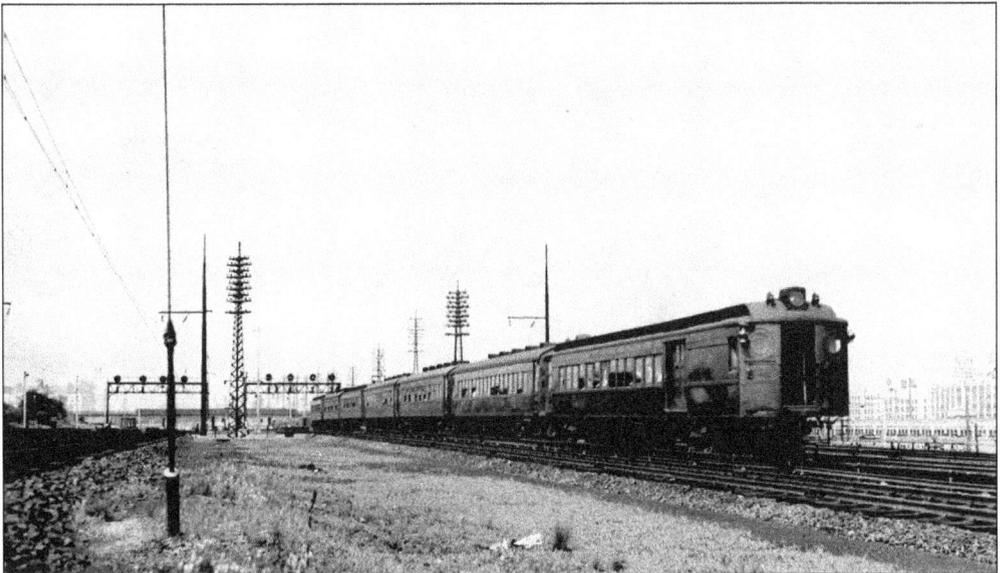

Barreling westbound through Sunnyside, Long Island City, is MU train No. 727 from Hempstead. The train's destination is Manhattan's Pennsylvania Station on this August day in 1937. Long Island City industries are visible in the right background. (George E. Votava photograph.)

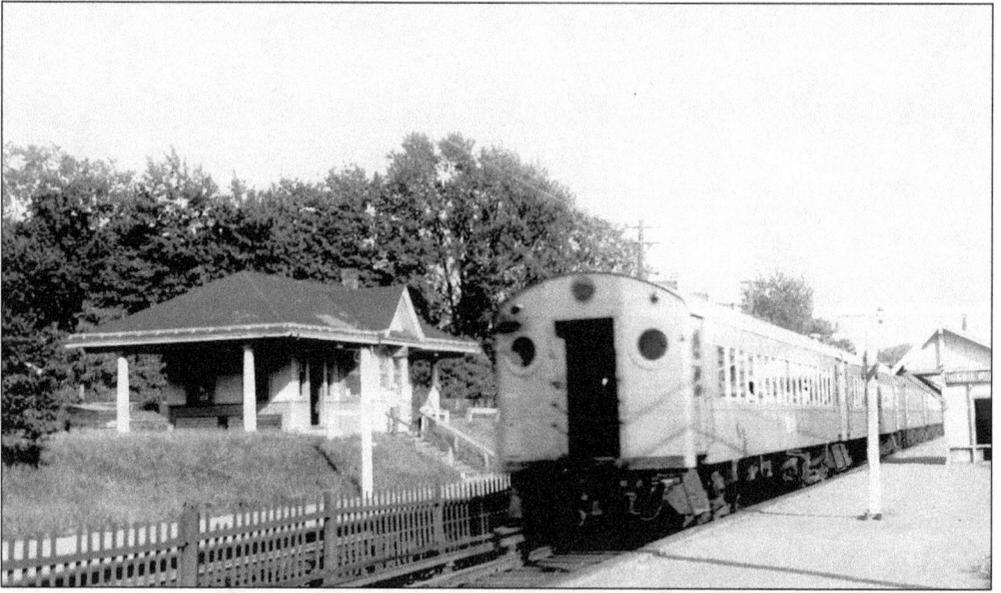

An MU electric train in Tichy colors leaves eastbound from the station at Higbie Avenue, Laurelton, on a summer day in 1954. The old wooden depot and eastbound wooden shelter shed were razed in January 1959 with the grade elimination, which elevated the tracks and also eliminated Higbie Avenue as a station stop. (W. J. Edwards photograph.)

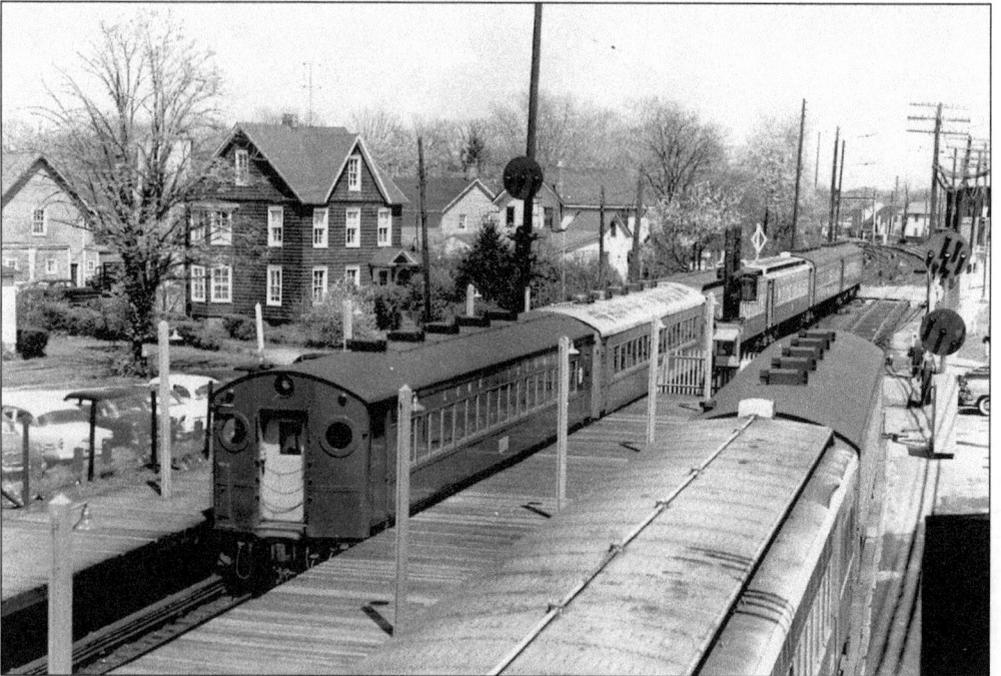

This 1957 photograph from the pedestrian crossover at Babylon shows some vintage MU activity at grade. In the eastward view, toward Babylon tower, an eastbound MU stands in the foreground at the platform, while a westbound MU heads into the station area from the storage yard. Also visible is a mixture of arched and clerestory roofs as well as Tichy and dark-gray paint schemes. (Jules P. Krzenski photograph.)

Six

SIGNAL TOWERS

The movement of trains is controlled by a variety and combination of methods: block signals, paper orders, rule books, and Centralized Track Control (CTC) are a few examples. Signal towers serve to interlock a specific stretch of track and control movement of trains within that tower's territory or block. Due to the density and volume of east–west commuter and freight traffic, the LIRR has had many towers located at strategic points to control the safe movement of trains and to manage the crossing of the LIRR's tracks by independent trolley companies.

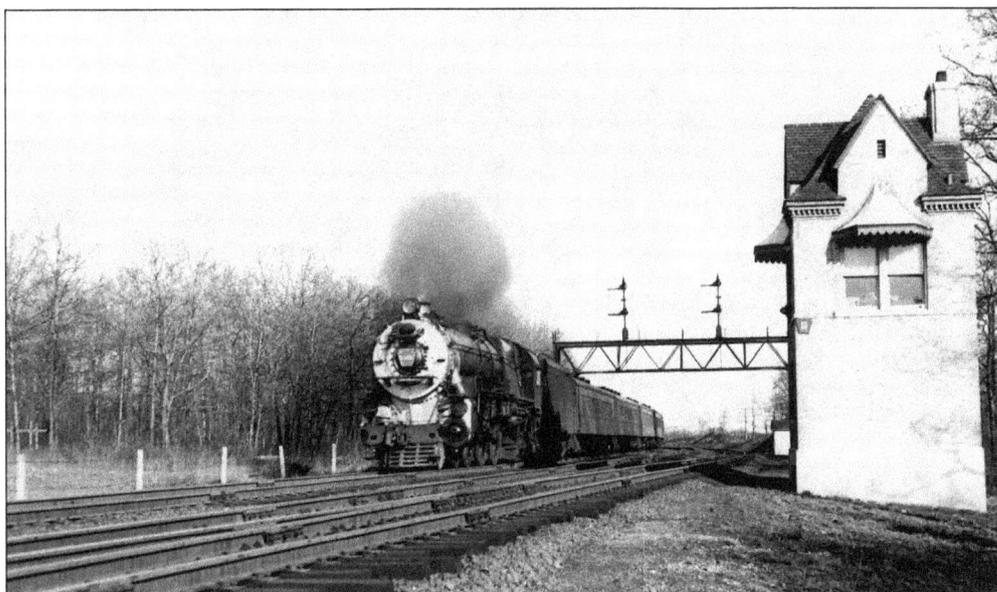

"Fancy-schmancy" is a phrase that well describes this smokebox painted white or bright silver, with black door, on Pennsy-leased K4s Pacific class No. 5406. Here the engine pulls Sunday-only train No. 4229 from Yaphank, New York, westbound past B interlocking tower at Bethpage Junction, Bethpage, in May 1947. (George E. Votava photograph.)

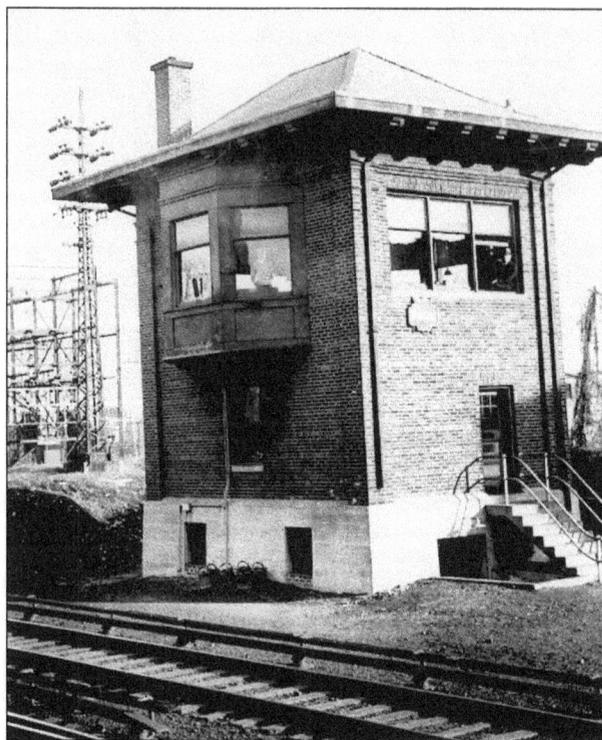

Located at the junctions of the Central and Creedmoor branches with the main line was Park tower at Floral Park. Built in 1924 as FK tower, it was renamed Park c. 1937. In this 1939 view, the block operator looks at the photographer from the upstairs bay window. This tower was razed in 1960 with the grade elimination of the main line through Floral Park. (George V. Arnoux photograph.)

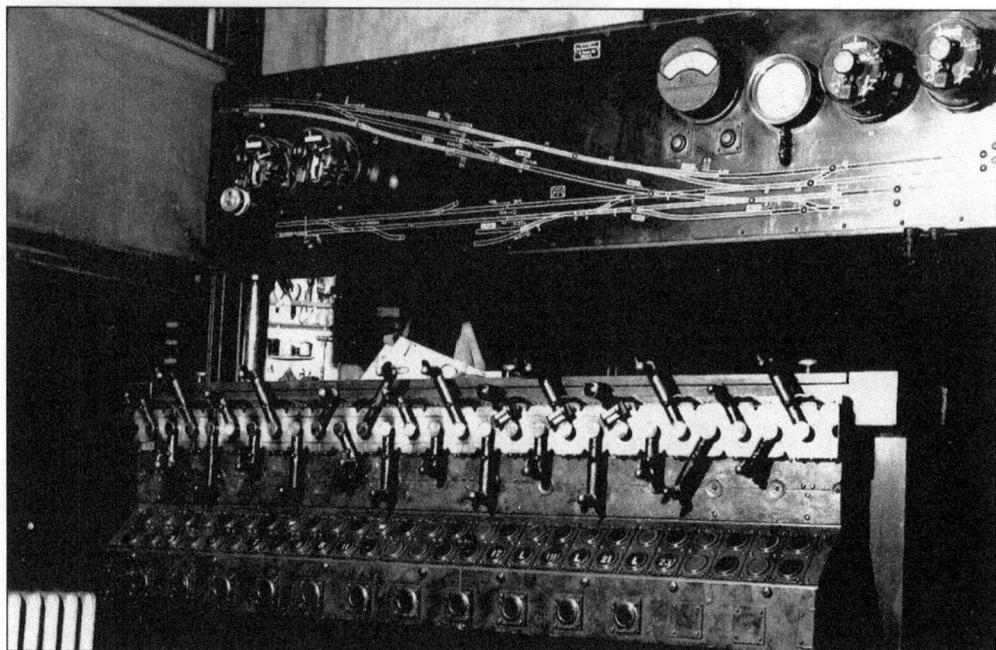

Inside Park tower is the track diagram mounted from the ceiling. Present in all towers, the diagram is known as a model board. Below each model board are the strong-arm levers or, in this case, the pneumatic handles to operate the signals and switches indicated on the track diagram. This board tracks the trains through the tower's portion of the block system. This photograph also dates from 1939. (George V. Arnoux photograph.)

74

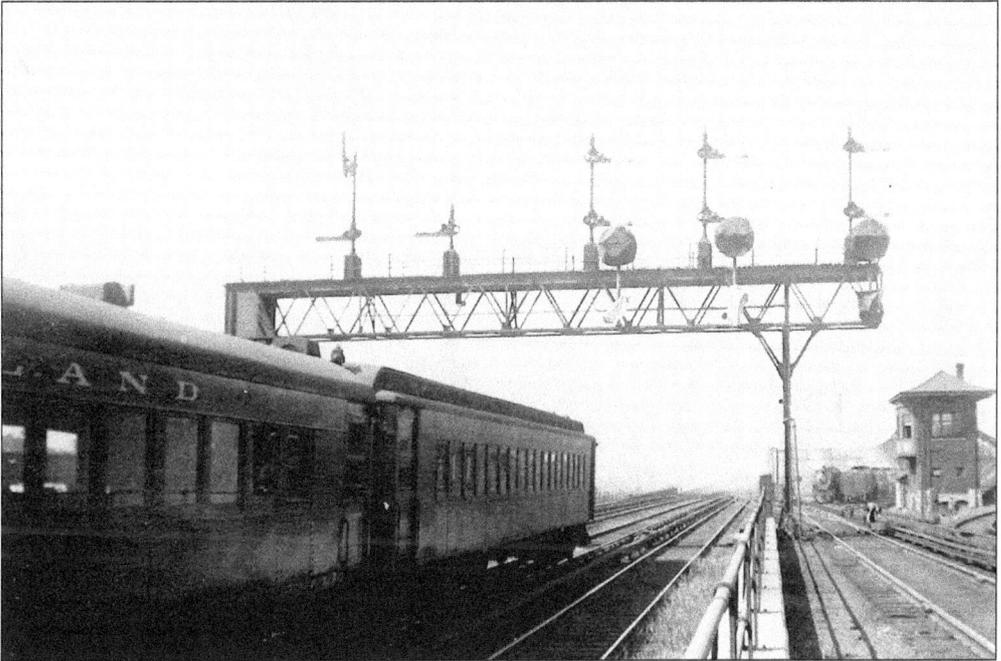

This 1940 view toward the Morris Park Locomotive Shops shows locomotives laying up, Dunton interlocking tower, and the tracks and underjump of the Montauk branch cutoff. On the signal bridge are semaphore arm signals, but under canvas wraps are the newer, position-light signals that soon went into effect. The semaphore blades, for the most part, became a thing of the past. (T. Sommer photograph.)

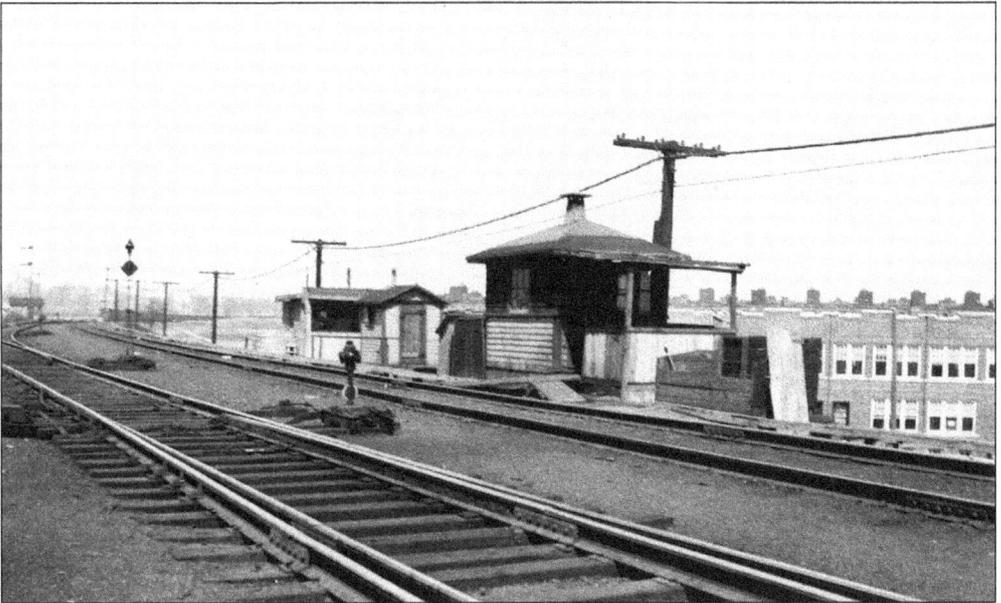

Here is a view along the Bay Ridge branch in the 1920s. The little signal cabin is designated "NO" and is located at New Lots in the East New York section of Brooklyn. Notice, between the tracks, both the low and high switch targets. This cabin lasted until 1925, when it was replaced with a second NO cabin on the opposite side of the tracks. (James V. Osborne photograph.)

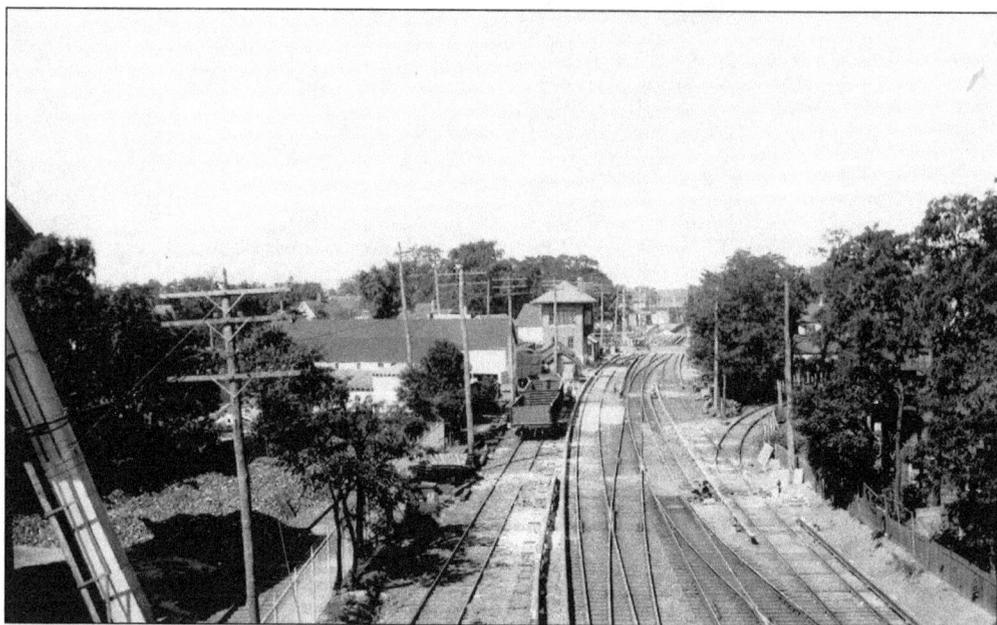

Viewed westward from the signal bridge, the almost completed BJ tower and distant station at Babylon are pictured in 1925. Also new is the electric third rail. The first electric train to Babylon arrived on May 21, 1925. Later renamed Babylon, the interlocking tower was razed with the grade elimination of 1963–1964. (James V. Osborne photograph.)

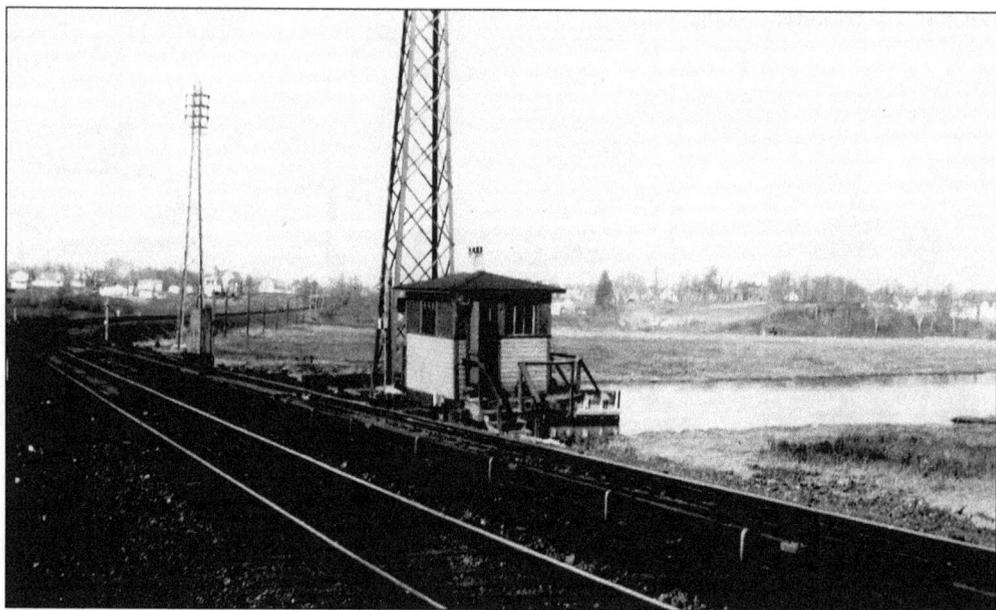

The surrounding countryside of Douglaston looks rather rural in this c. 1925 westward view of D cabin and bridge. Located on the Port Washington branch, this little cabin was the second cabin on the site but was built on the north side of the tracks and to the east of Alley Creek. In service for a very short time from 1924 to 1926, the structure afterward became the bridge tender's cabin. (James V. Osborne photograph.)

The original SG cabin, named after the original location of Thompson's Siding (SidinG), is shown here *c.* 1925. In this eastward view, on the left are the typical Long Island pines, the semaphore signals atop the signal mast, and, in the distance, a gondola car on the siding. In the far distance, just to the right of the tracks, is the express house at the Brentwood station. (James V. Osborne photograph.)

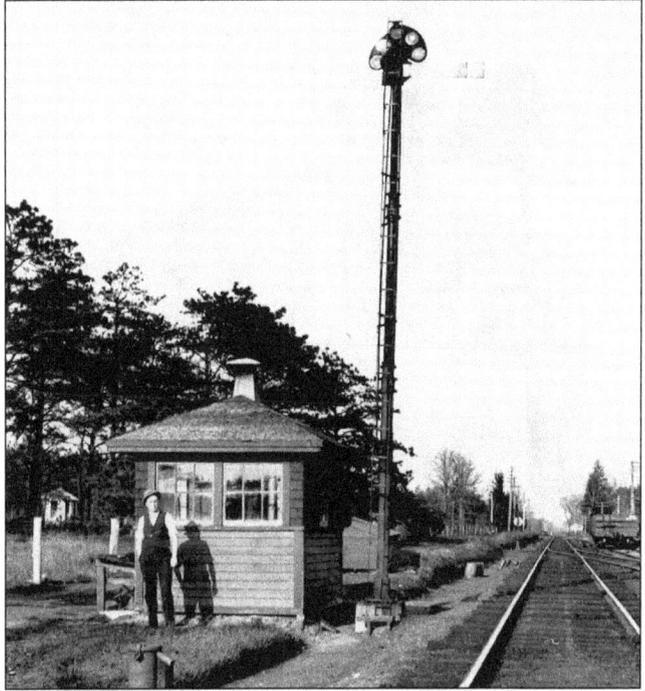

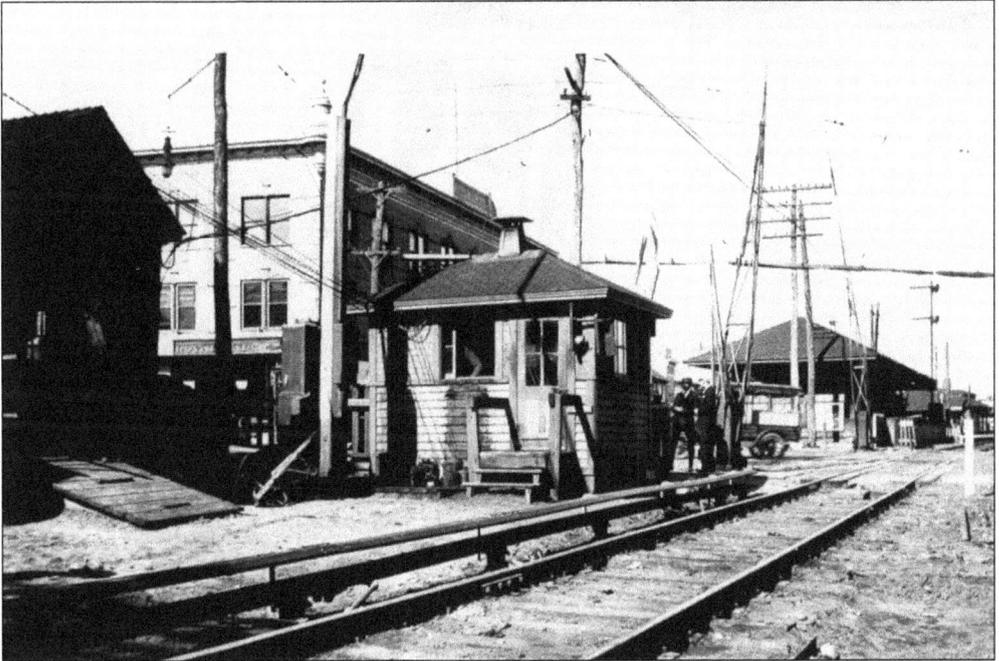

Here is busy and congested Freeport *c.* 1925. FY cabin is pictured in this westward view toward the freight house and depot. On the left is a section shanty, numerous power lines crisscrossing everywhere overhead, the diamond crossing sign, and manually operated crank-down crossing gates. In this scene, two men are engaged in conversation. One wears a straw hat, and the other sports a newsboy cap. Both were popular styles during the summer season. (James V. Osborne photograph.)

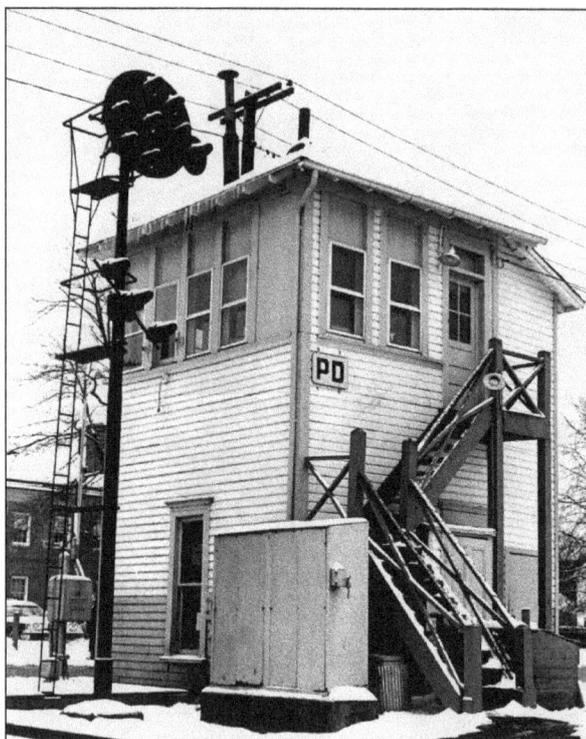

A light layer of snow has dusted PD tower at Patchogue in this scene from January 1972. On days such as this, the wooden outdoor stairs became treacherous with the slippery ice that coated them. The second window from the left has a bracket on either side. These brackets were where the train order boards were placed to indicate to train crews that they had orders. (David Keller photograph.)

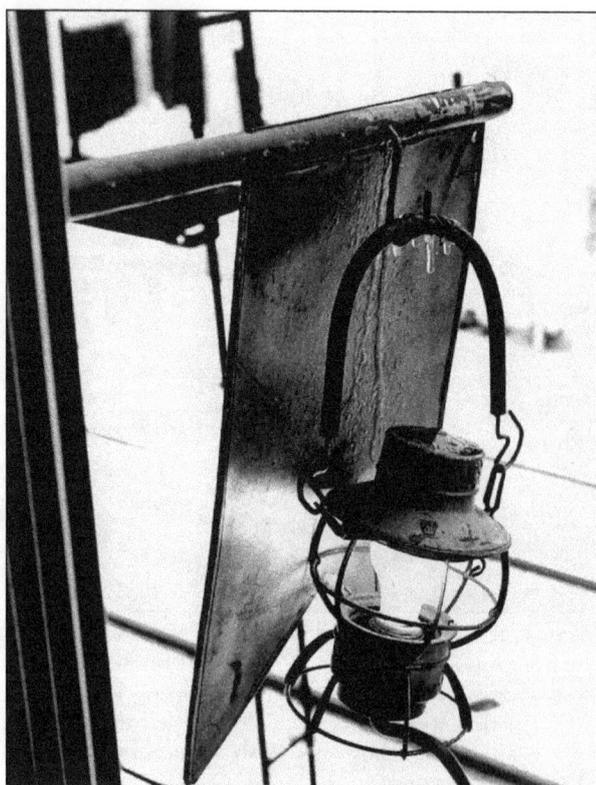

The train order board and lantern are displayed at PD tower in Patchogue on a cold and snowy day in February 1972. The order board was painted yellow on one side and, on the other side, black with a white vertical stripe. The board was posted with the yellow side facing toward the approaching train for which the orders were intended. The black side of the board indicated that the order signal did not pertain to the train coming from that direction. (David Keller photograph.)

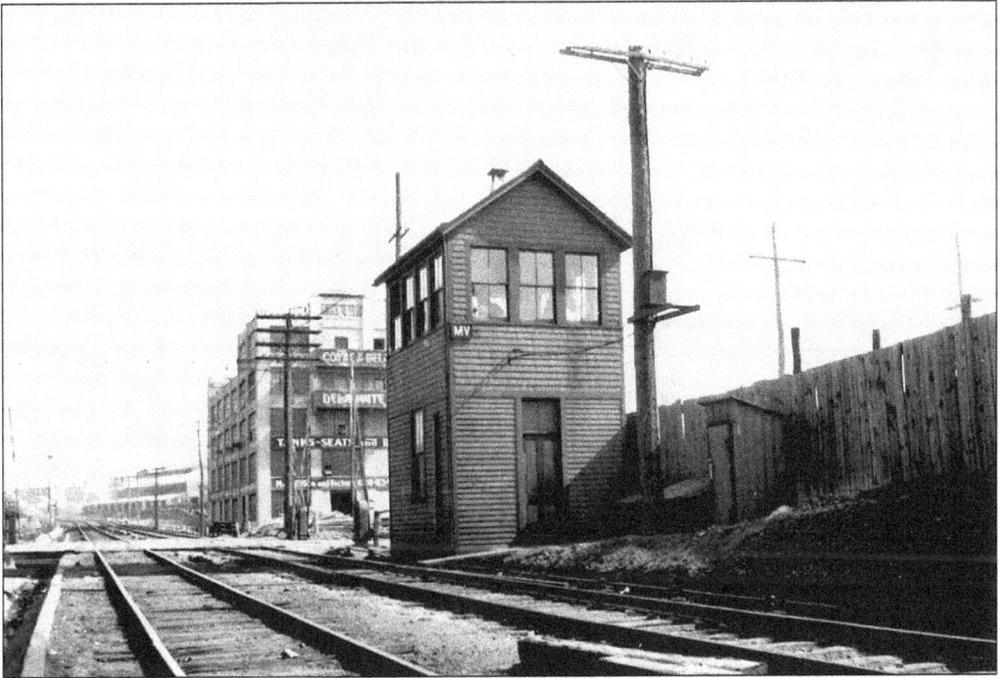

MV tower stands along the Montauk branch in Maspeth in this 1925 scene. Originally built to protect the crossing of the LIRR tracks by the Brooklyn & Queens Transit trolleys along Flushing Avenue, the tower was named MV for the surrounding area known as Mount Olivet. In 1937, the tower was renamed Olivet. This is an eastward view toward Flushing Avenue and the overhead trolley wires. (James V. Osborne photograph.)

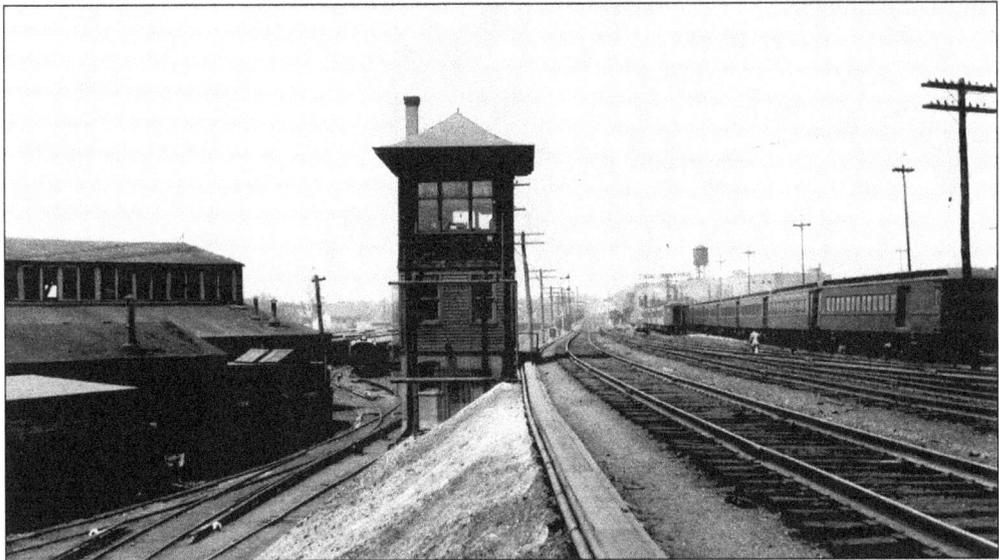

R tower, Richmond Hill, is perched on a tall, concrete foundation alongside the embankment of the Montauk branch in this 1926 westward view. On the left are some of the buildings of the Morris Park Locomotive Shops, which opened in 1889. On the right are trains laying up in the Richmond Hill storage yard. This was approximately the original site of the Shops station when the tracks were at grade. (James V. Osborne photograph.)

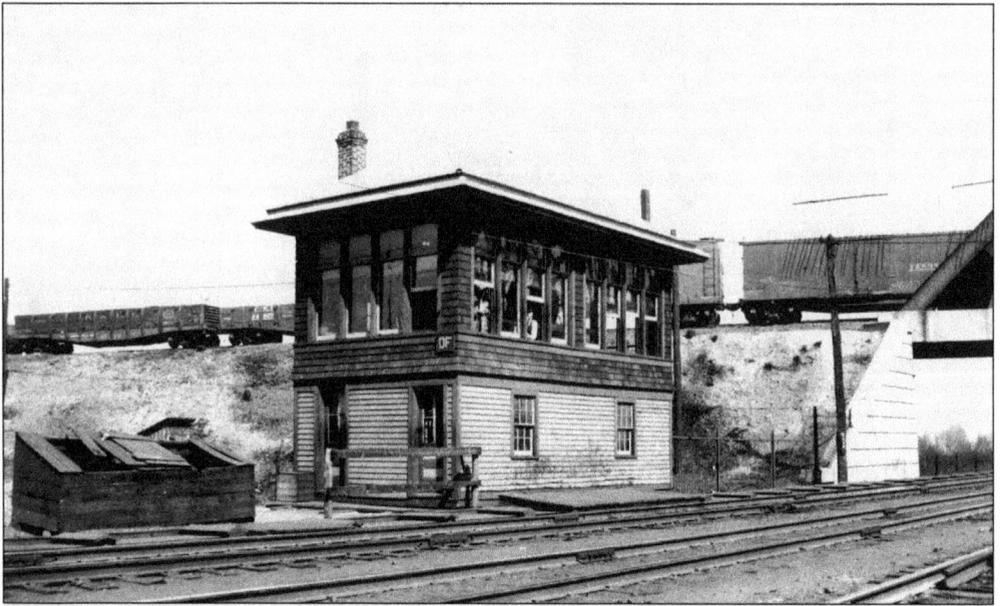

Here is Pond tower c. 1925, when its telegraphic call letters were DF. A freight passes along the embankment and trestle behind the tower. The elevated tracks are the New York Interconnecting Railroad, which had carried freight through this location beginning in 1918 and had shared the Long Island's Bay Ridge branch down to the float docks in Brooklyn. (James V. Osborne photograph.)

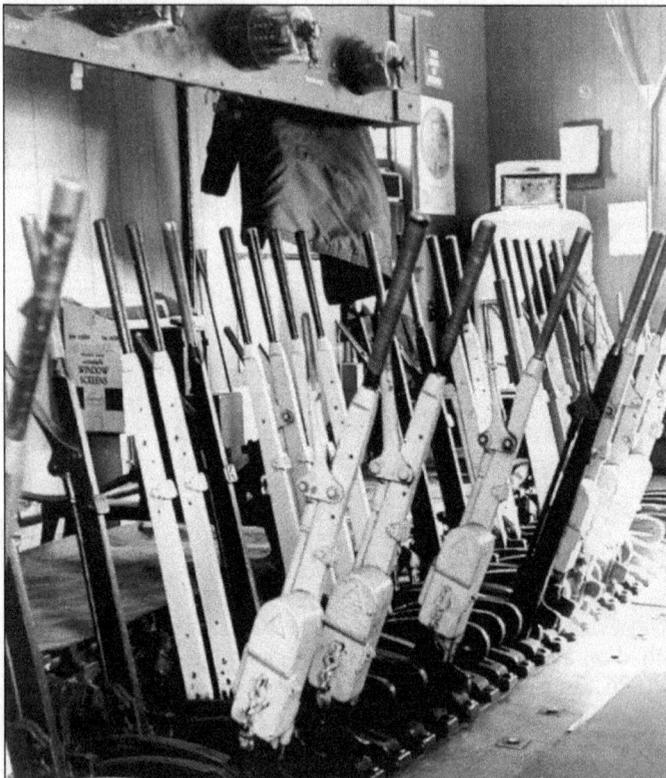

Pictured in December 1970 are the strong-arm levers to the signals and switches of the Pond interlocking plant. In addition to the locks on the levers themselves, there were additional locks in the form of buttons in the floor, upon which the operator was required to step. In the background, hanging on the wall are the Y train order sticks. (David Keller photograph.)

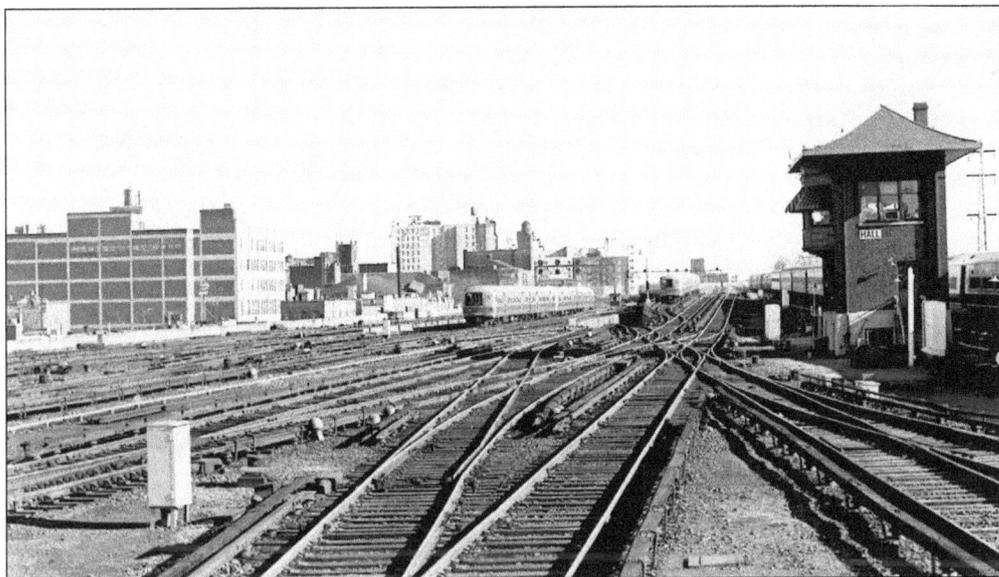

The interlocking tower that controls the tracks and signals east of Jamaica Station is Hall tower. Previously known as JE tower (Jamaica East), Hall is shown here on December 5, 1971, facing east from the end of the station platform between tracks No. 7 and No. 8. In the distance are M-1 electric trains. This massive complex, originally at grade, was elevated and put in service in 1913. (David Keller collection.)

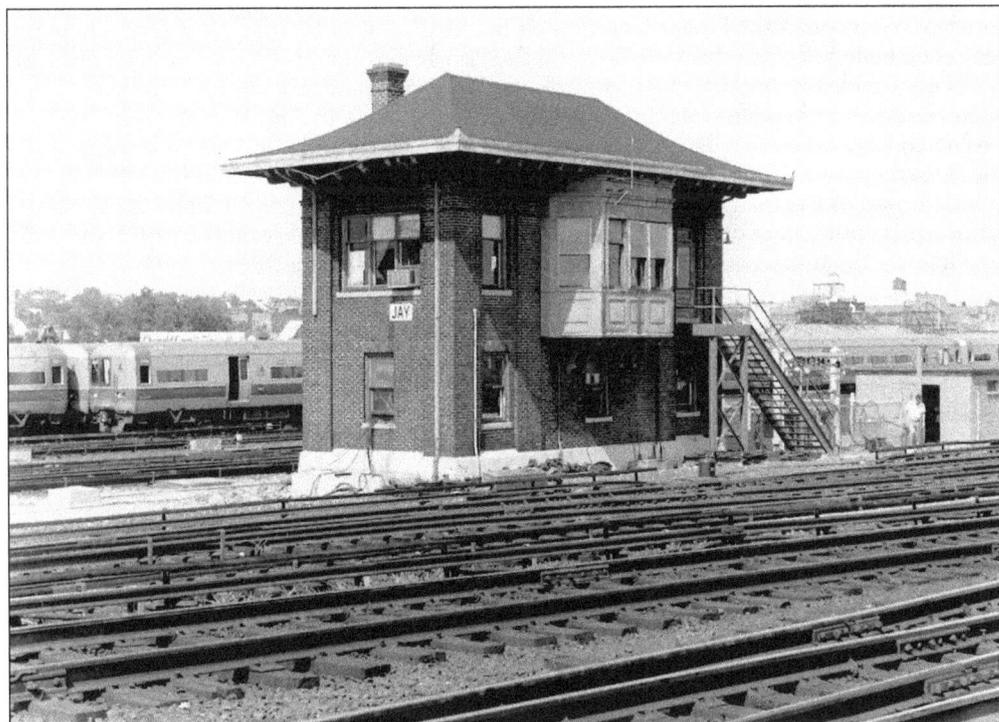

Controlling the tracks and signals west of Jamaica Station is Jay tower, originally known as J. This view to the northeast in September 1974 shows the rectangular brick tower and a cluster of M-1 electric trains laying up in the background. (David Keller photograph.)

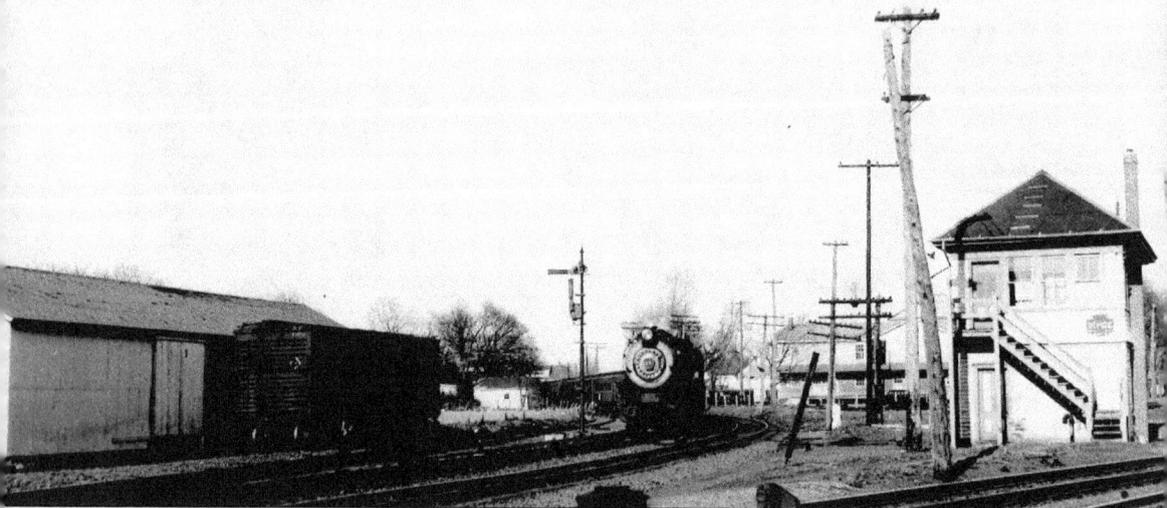

One of the most interesting places at which to observe and photograph train activity is a junction. And one of the busiest junctions on the LIRR is at Hicksville, New York, where the main line branches off to the southeast, and the Port Jefferson branch curves to the northeast. The busy Divide interlocking tower controls the Hicksville junction. Formerly named HX and then HN, the old wooden tower at grade was renamed Divide in April 1939. It is shown here on March 30, 1947, as G5s No. 33 pulls train No. 4613 westbound from Port Jefferson past the old semaphore signal. In the foreground are the tracks of the main line. On the left, a boxcar stands at one of the many cold-storage produce houses that were once fixtures all along the LIRR. This entire junction, along with the Hicksville station, was elevated in 1962 and 1963 to eliminate the many grade crossings. (George E. Votava collection.)

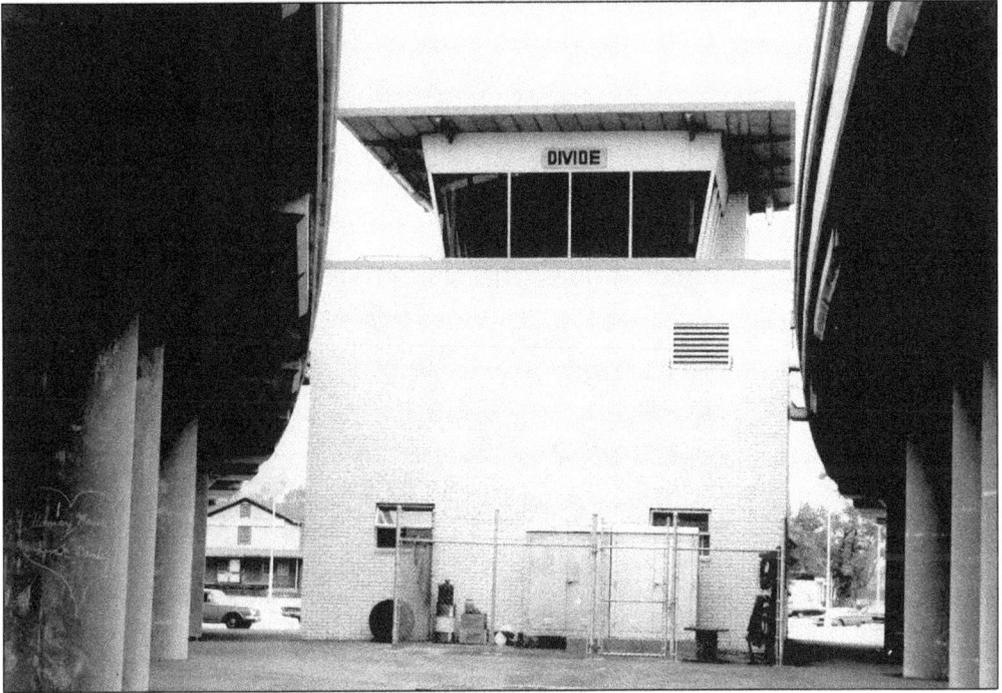

This eastward view shows Divide tower in 1967. After this track complex was elevated in 1962 and 1963, the old tower was replaced by this new structure, which resembles a control tower at a local airport. In this scene, the elevated tracks of the Port Jefferson branch curve off to the left, while the tracks of the main line curve off to the right. (David Keller photograph.)

Originally known as Wreck Lead, Reynold's Channel in Long Beach is crossed by the LIRR via a swing bridge. This bridge and train movements are controlled by Lead cabin, photographed here from the "owl's-eye" window at the rear of a moving train in 1964. Lead has since been razed, along with the bridge, and both a new tower and new bridge have replaced the old structures. (Rolf H. Schneider photograph.)

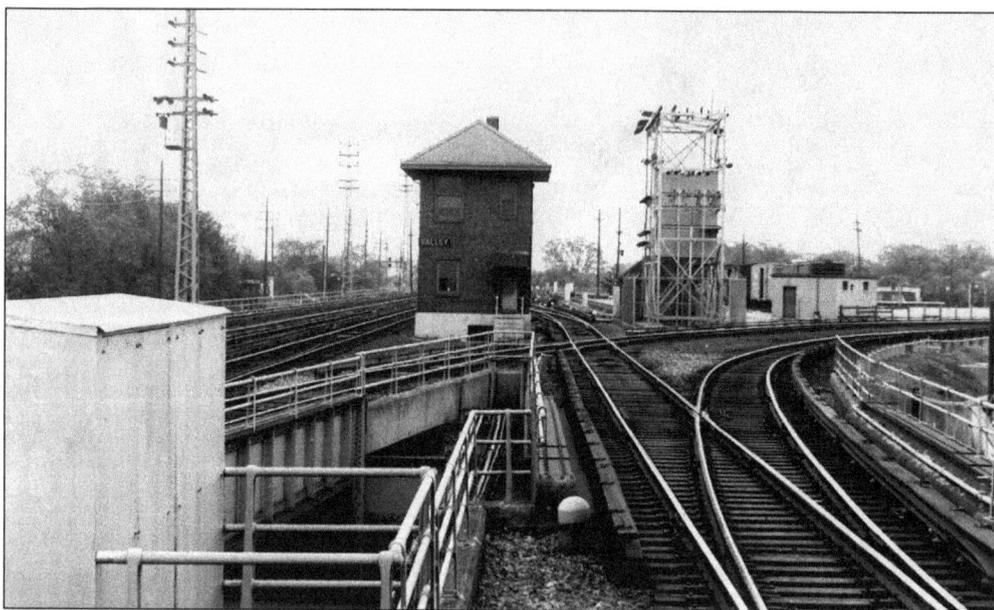

Viewed eastward from the end of the Valley Stream station platform, Valley tower is pictured in 1967. There was originally an older structure at grade that controlled the Far Rockaway branch visible on the right. This newer tower was built between the elevated eastbound and westbound tracks in the grade elimination of 1933. The tower was first known as VA but was renamed Valley four years later. (David Keller photograph.)

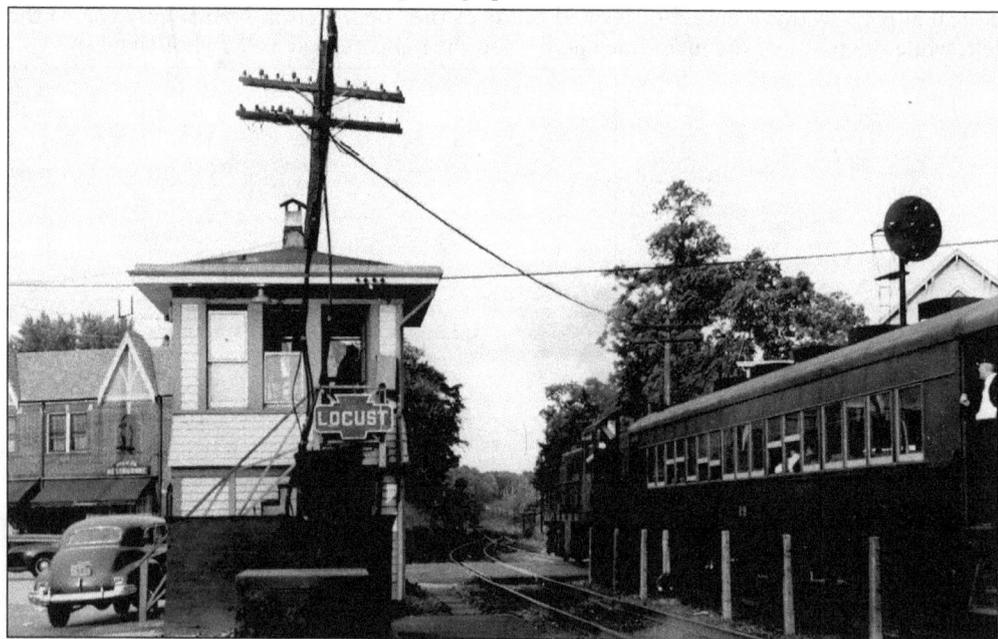

Alco RS-1 No. 463 and train leave Locust Valley and head eastbound toward Oyster Bay on a warm day in September 1949. Built in 1912 and originally named OY, Locust tower here displays the Pennsy keystone-shaped identification sign. Once the only actual tower on the Oyster Bay branch at the start-end of double track, it was taken out of service some years later and became an annex for the police department. (George E. Votava collection.)

Seven

THE PEOPLE WHO MADE IT WORK

Most train passengers are familiar with the conductor and perhaps a ticket agent. A few riders have seen the engineer. But behind the scenes is a vast army of clerks, agents, track workers, maintenance men, repairmen, car repair shop personnel, tower operators, and a host of other positions that keep the railroad rolling. The photographs in this chapter represent a sampling of some of these trades.

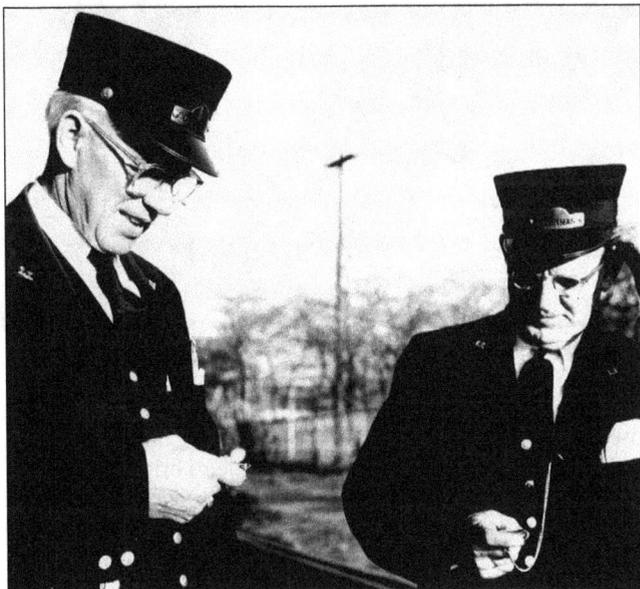

Running on time was of utmost importance in railroading of days past. Here conductor Edward A. Martin (left) and trainman George Kennedy compare their pocket watches before leaving Oyster Bay station with an early-morning commuter train on a winter's day in 1952. (J. P. Sommer photograph.)

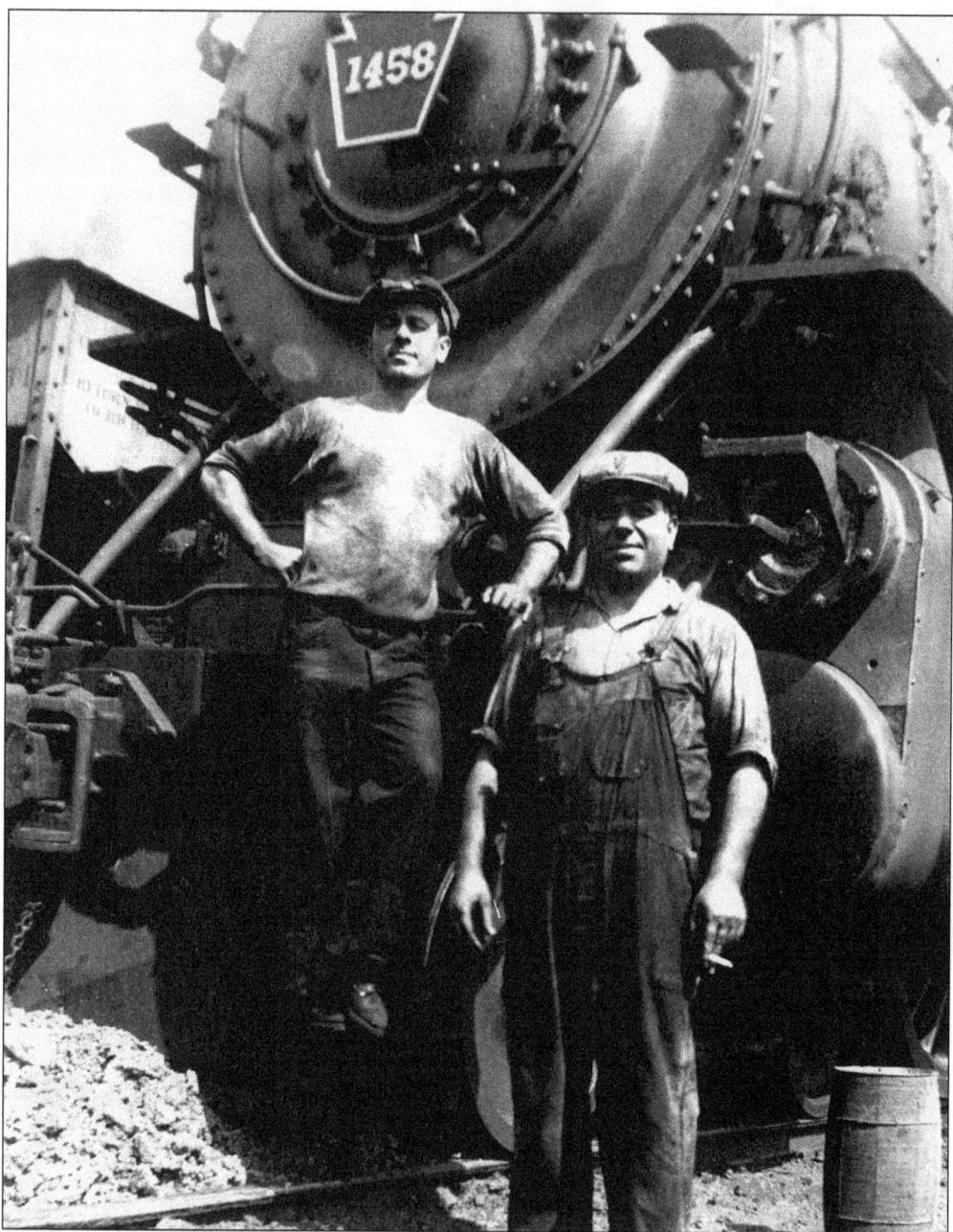

Engineers, conductors, and trainmen were the railroad men with whom the average commuter came in contact. Their jobs seemed glamorous, especially to the youngsters who admired the people in these positions. There were many other railroad people who worked behind the scenes, whose jobs were not as glamorous but were just as important. One of these positions was that of hostler. It was the hostler's job to bring out the locomotive before its run and prepare it for the engine crew. The hostler also brought the locomotive in after its run and "put it to bed." In this 1941 photograph hostlers Dominick (left) and Pasquale stand with Pennsylvania Railroad locomotive class K2s No. 1458 at the Morris Park Locomotive Shops in Queens, New York. (T. Sommer photograph.)

86

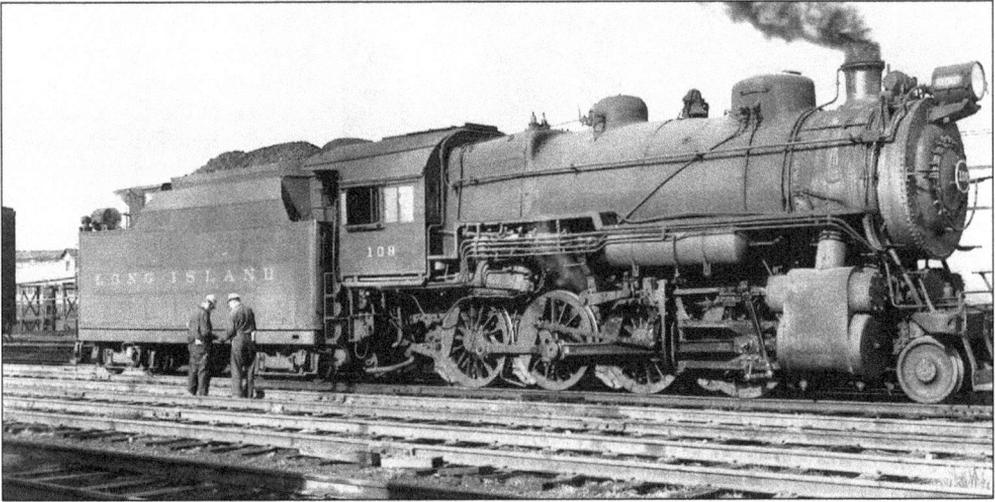

A workhorse of freight service was the H10s Consolidation class. Here No. 108 has a good head of steam and is ready to leave. Members of the train's crew check their watches before departure from Holban Yard in Hillside-Hollis, New York, in November 1954. Only 11 months later, No. 108 was put out to pasture after it had served so long and so well. (George E. Votava photograph.)

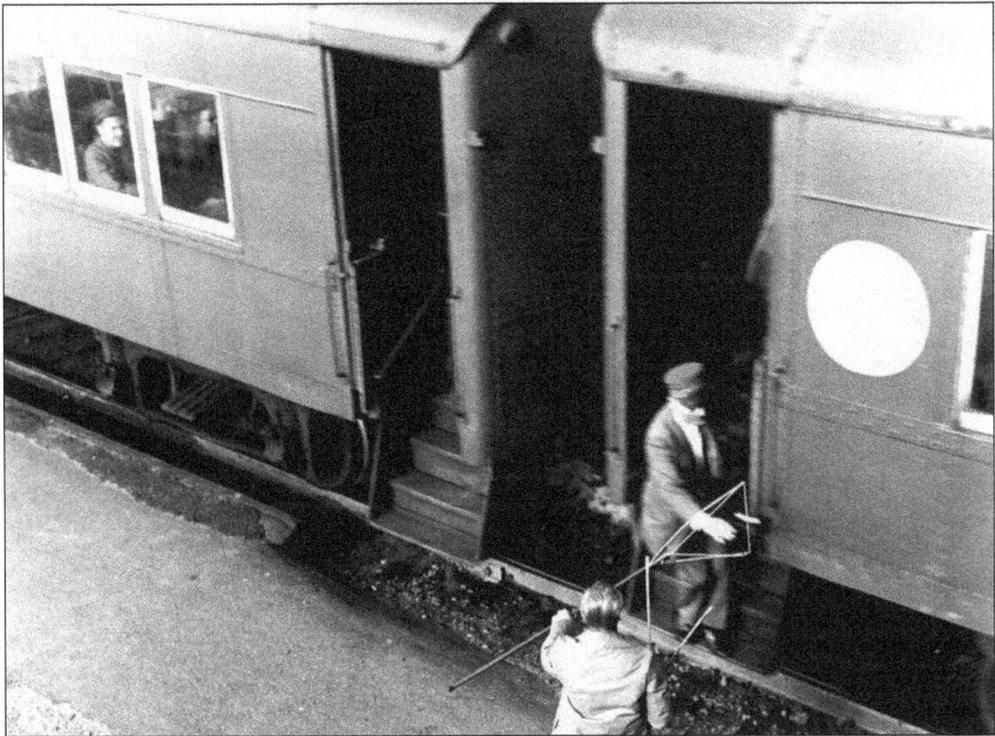

Conductor Richard Mancini (top) balances gingerly on the bottom step and firmly holds onto the grab-iron as he prepares to get his copy of the Form 19 train order from block operator Ed Sorensen. The empty Y stick indicates that the engineer has already received his copy. Montauk train No. 4 is about to head east out of Patchogue in this December 1971 view from PD tower. (David Keller photograph.)

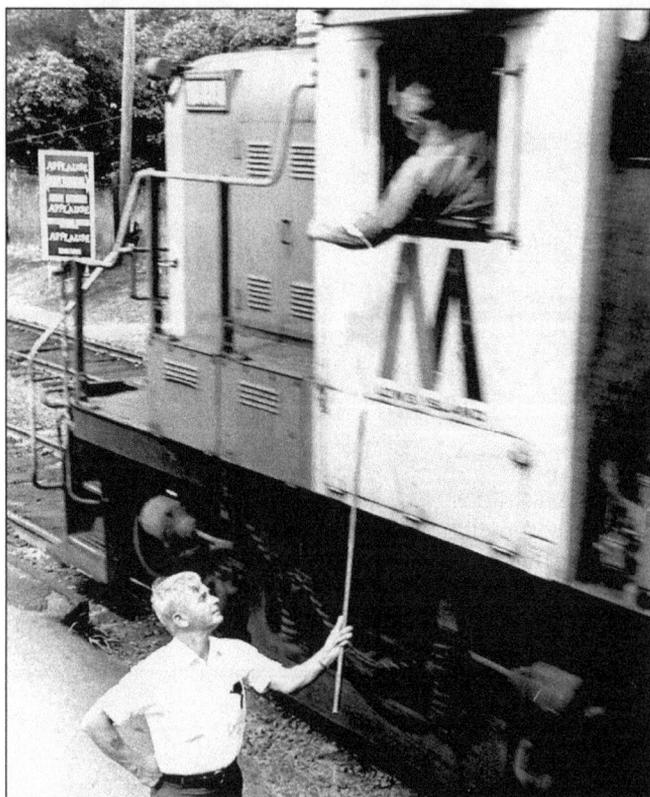

Caught on the fly is this train order, photographed at the exact moment that the engineer of the Scoot tugs it off the Y stick held up to him by PD tower block operator Ed Sorensen. It is August 1971, and Alco RS3 No. 1559 wears the MTA color scheme as it heads westward through Patchogue, bound for the shuttle destination of Babylon. (David Keller photograph.)

Block operator Ed Sorensen throws the difficult crossover switch lever at PD tower in Patchogue in this October 1971 scene. The other levers operated signals and were easier to throw. Behind Sorensen are the train order signal boards and lantern. The board-lantern combination was later replaced with a single light mounted on the mast of the block signal. (David Keller photograph.)

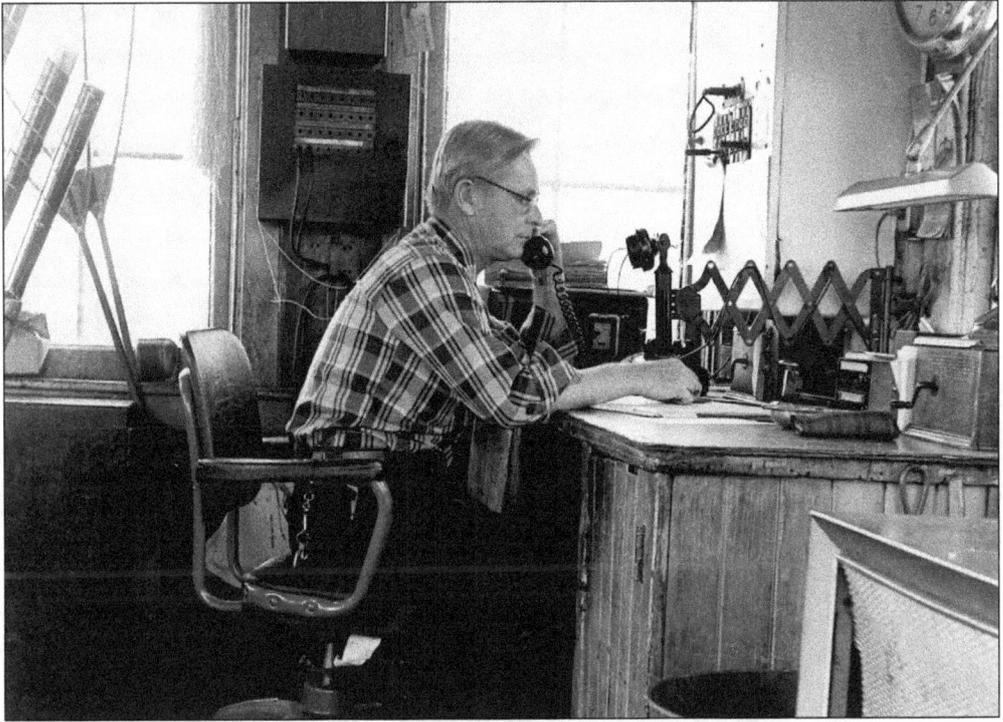

Block operator Ed Sorensen is busy at his desk at PD tower in Patchogue in this scene from December 1970. On the left are the strong-arm levers and the Y train order sticks. Strings for attaching the train orders hang from the window. In front of the operator is the old dispatcher's flexi-phone, and Form 19 office copies are visible behind his chair. (David Keller photograph.)

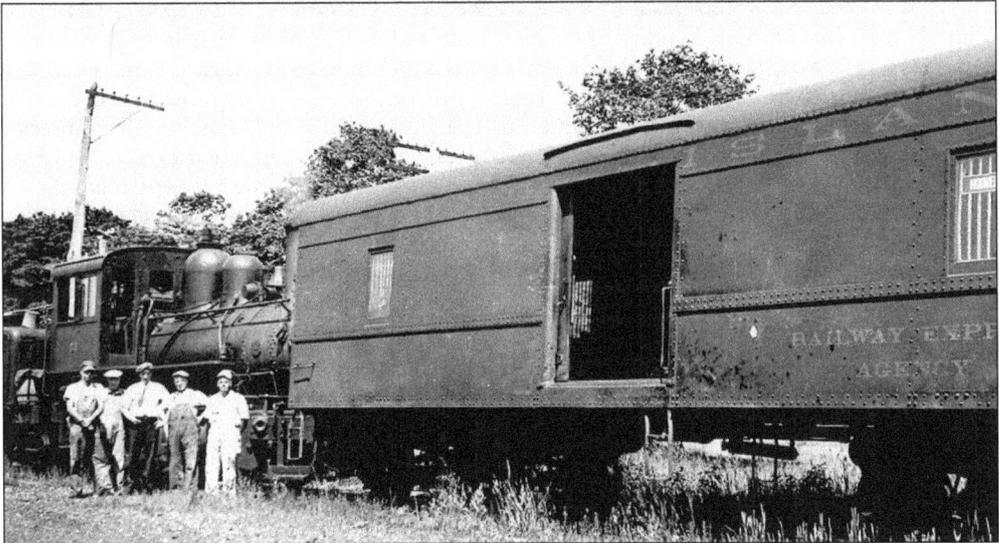

The crew of Central Islip State Hospital drill engine No. 03 are on the back siding at Central Islip station in 1933 as they switch a Railway Express Agency car. The crew members are, from left to right, engineer Gus Newman, trainman Frank "Dusty" Rhodes, Bill Blake, conductor Walter Webb, and an unidentified fireman. The little class A3 0-4-0 switcher operated between the station and the state hospital. (George G. Ayling photograph.)

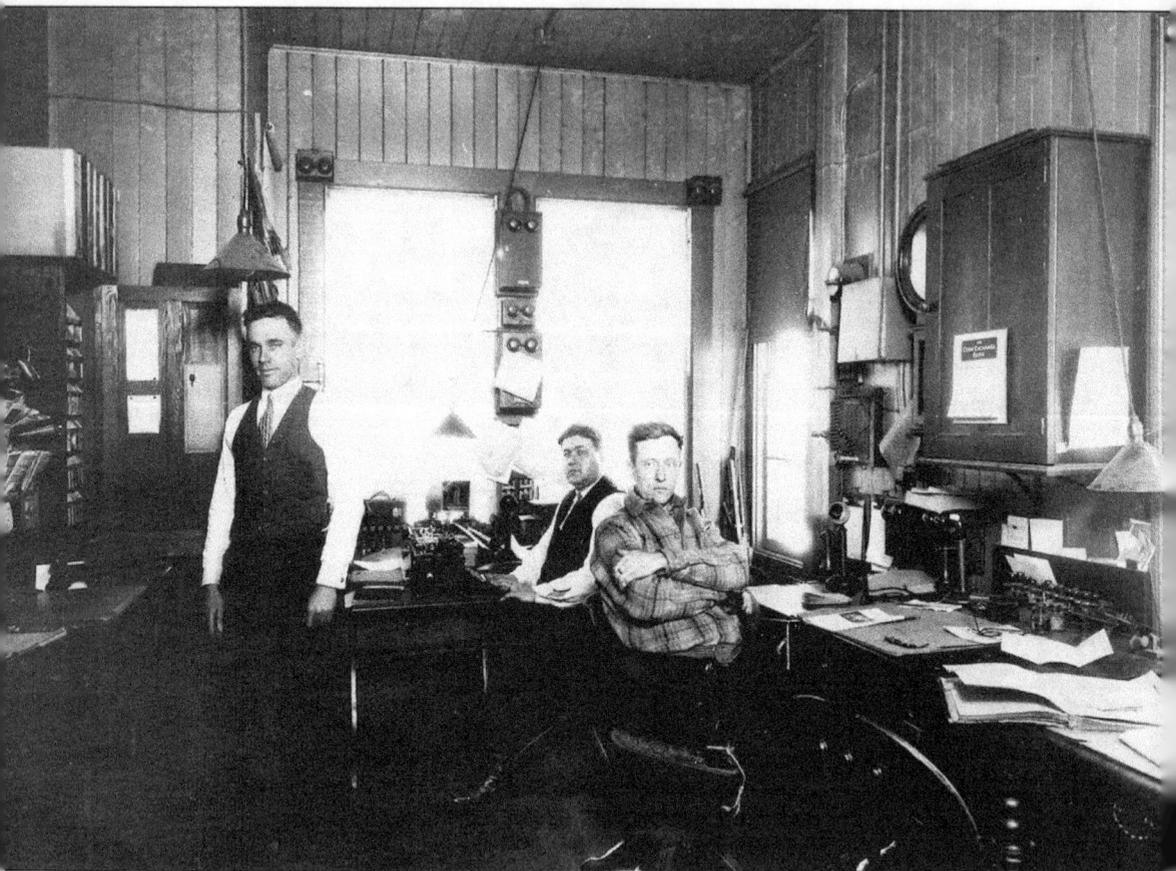

Many branch line stations handled their own train orders and block signals in addition to locations served by a signal tower or cabin. If a station had little traffic, then one man handled the orders and signals and also sold the tickets. If the location was a busy one, as was Central Islip, then several employees were assigned to the station. In this December 1928 interior view of the combination ticket office and CI block station, on the left, ticket clerk Gene Costello stands near his ticket stock and timetable rack. Seated at the typewriter amidst all his telegraphic equipment is block operator Norman Mason. Visible to the far right of the bay window are the strong-arm levers used to throw the signals, and seated on the right is station agent George G. Ayling. A close inspection of this image reveals many great vintage items typical of an office of its era such as racks of rubber stamps, old candlestick telephones, nib pens with ink bottles, and the dusty, green-enameled lampshades tied off to the walls. (George G. Ayling collection.)

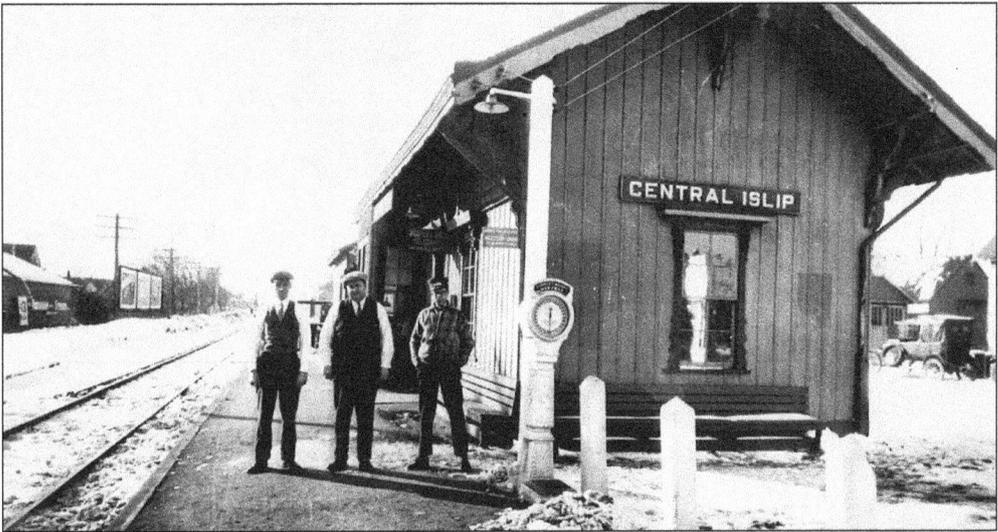

Photographed on the same day as the previous image are, from left to right, ticket clerk Gene Costello, block operator Norman Mason, and station agent George Ayling. Visible to the right of Ayling are an old Western Union Telegraph Office sign and a penny scale. On the far right are some open touring cars with their Isinglass windows rolled down against the winter weather. (George G. Ayling collection.)

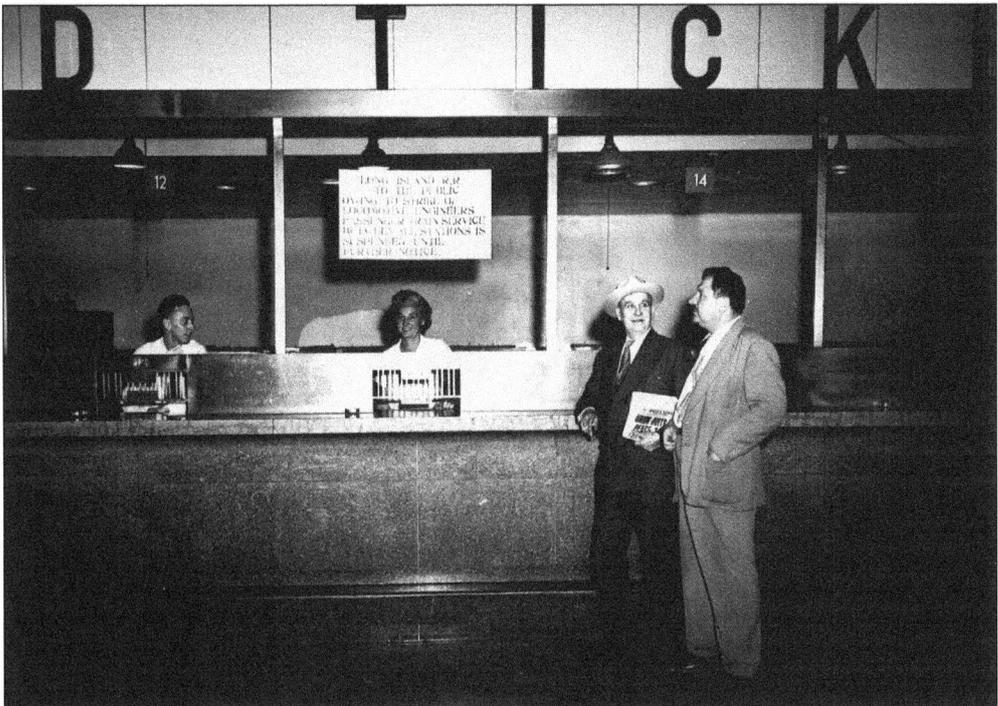

Despite the sign stating that all passenger service was suspended due to a locomotive engineers' strike, ticket clerks man the windows of the LIRR ticket office at Pennsylvania Station in Manhattan. The year is 1952, and the strike does not appear to be bothering everyone too much in this photograph. The clerks look happy, as does the man holding his copy of the *Daily News*. (J. P. Sommer photograph.)

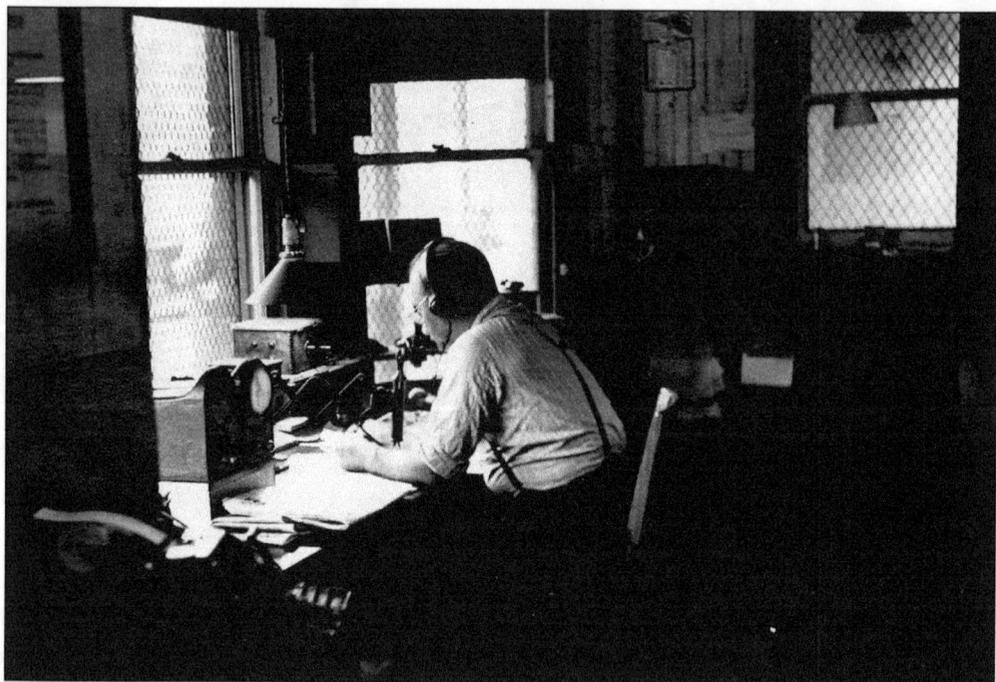

The operator at JF (Port Jefferson) talks to the dispatcher in this c. 1945 photograph. The operator's desk is built into the bay window, allowing him visibility both eastward and westward. On his left is an electric table machine that enables him to throw the signals without the need of levers. Behind his head are the telegraph sounder resonators that amplified the click-clack of all telegraph messages. (George Christopher photograph.)

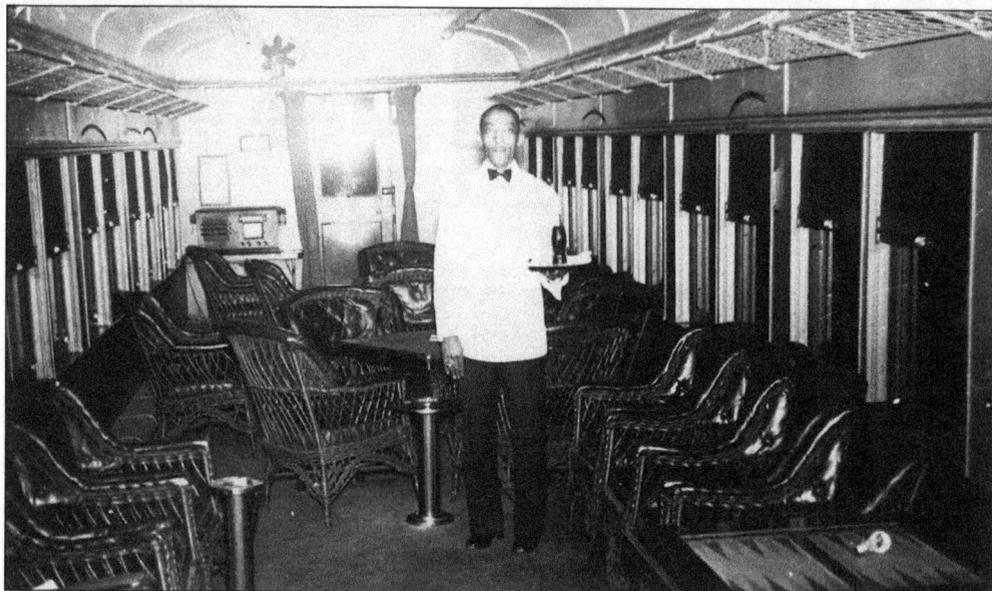

An unidentified LIRR car attendant is shown in his club car c. 1945. Wearing his uniform jacket and holding a tray upon which sits a bottle of Coca-Cola, he stands amidst the cushioned wicker chairs. In the foreground is a backgammon table. In the left background is an old radio, and above it, the air-conditioning of the era: a six-bladed fan. (George Christopher photograph.)

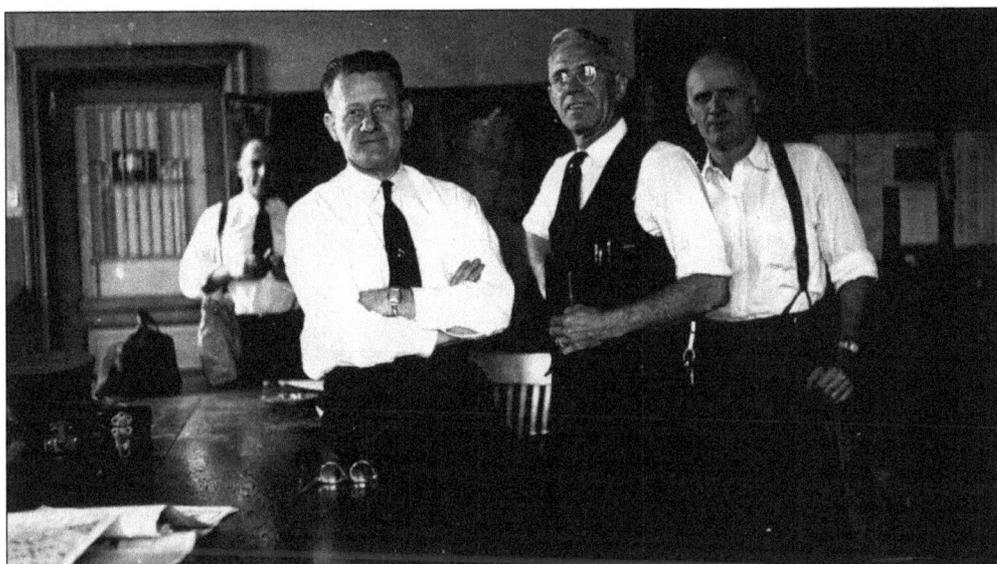

Relaxing inside the Long Island City trainmen's room and posing for the camera c. 1945 are, in the foreground from left to right, conductor Jeff Skinner, conductor George Christopher, and trainman Bill Reichart. Within this room and over many years, countless numbers of train crews rested, relaxed, napped, ate lunch, read the newspaper, or played cards while killing time between runs. (George Christopher collection.)

While SG cabin on the LIRR's main line west of Brentwood had an electric table machine to operate the SG block signals, the switch to the passing siding had to be manually thrown. Here block operator George DePiazzy throws the switch to allow a train access to the passing siding in May 1972. (David Keller photograph.)

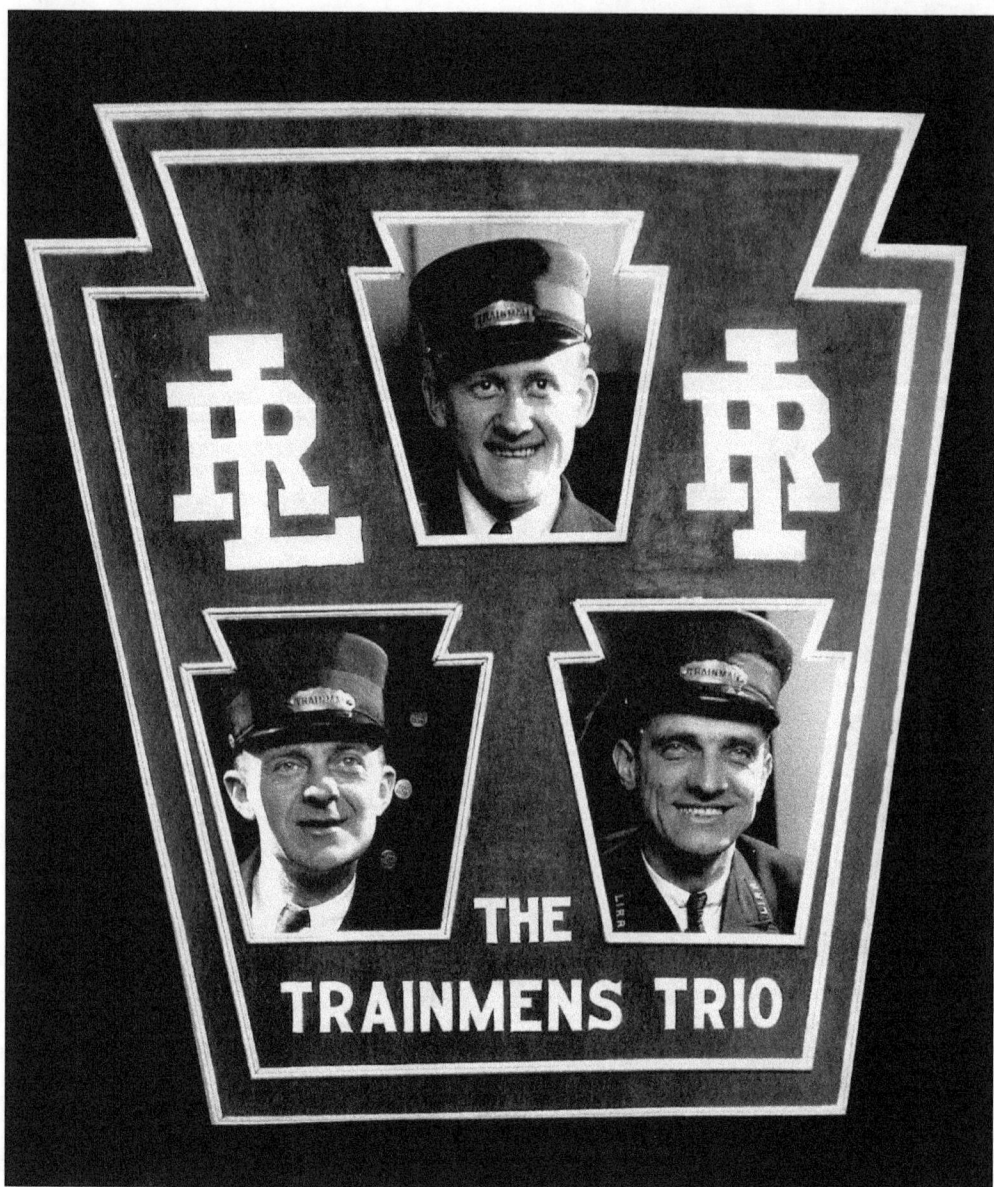

In the mid-1920s and up until the early 1930s, the LIRR sponsored a musical group called the Trainmen's Trio. The group originally consisted of Jefferson Skinner, Matty Balling, and Johnny Diehl. The trio was reorganized after Diehl left the services of the LIRR, and he was replaced by Charlie Burton. Shown here in their homemade Public Relations Advertising format are, Jefferson Skinner (at top), Matty Balling (lower left), and Charlie Burton. The group was very popular and played not only at railroad-related events but also in stage shows at local theaters. They also appeared on a float at the Atlantic City Beauty Pageant. The severity of the Great Depression and its financial stresses caused the LIRR to disband the group sometime after this photograph was taken in 1930. (Jefferson I. Skinner collection.)

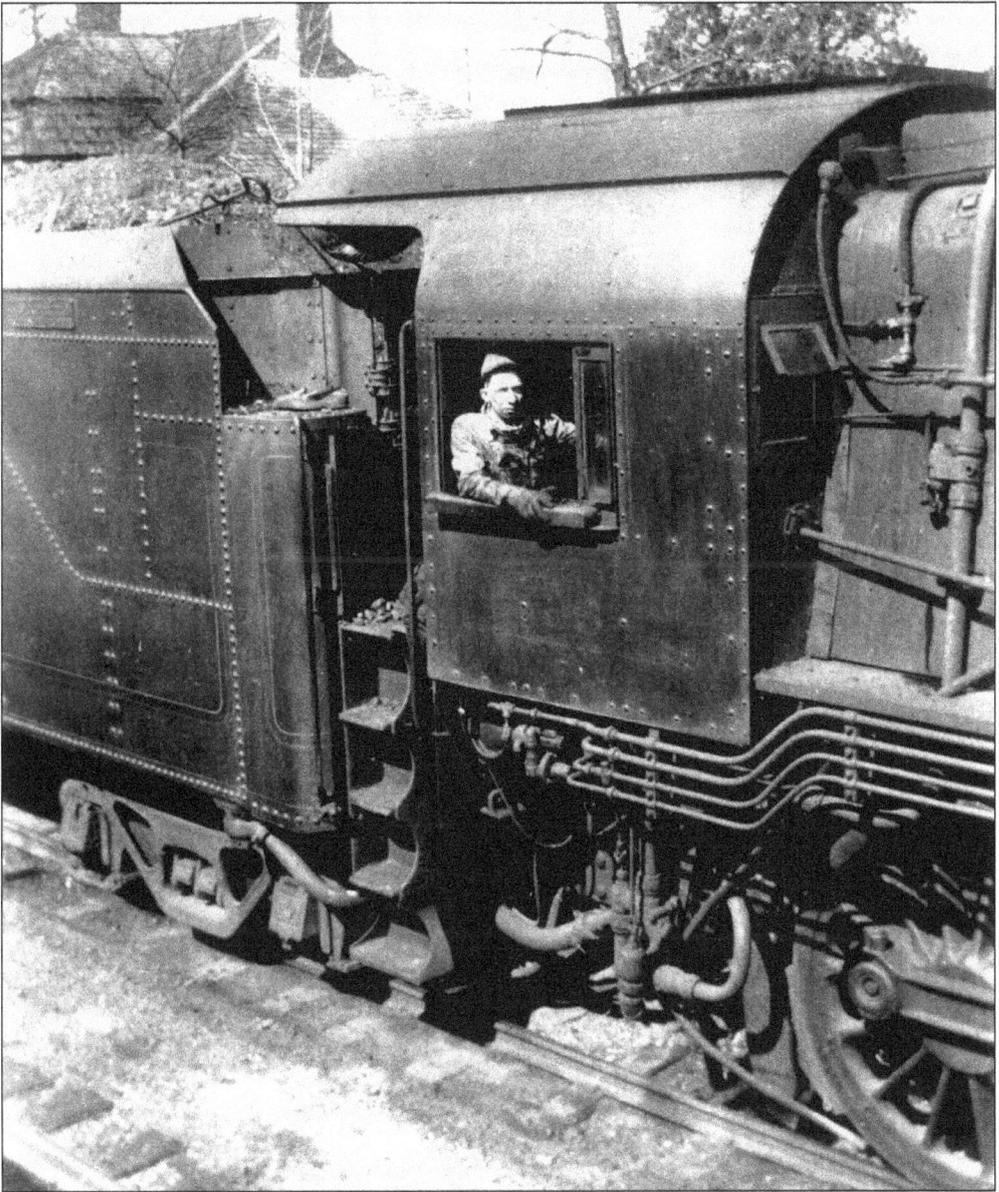

Engineer Charles "Charlie" T. Jackson poses in the cab of G5s No. 26 at Manorville c. 1930. Jackson's claim to fame came on the hot Friday evening of August 13, 1926. On that date, Jackson and his fireman, Bill Squires, were in the second engine of a doubleheader traveling eastbound at speed through Calverton when they split a switch. Both locomotives plowed into the trackside Golden's Pickle Works. The crew of the lead locomotive and some of the passengers were killed. The crew members of the second engine were flung from their locomotive and survived the crash. Jackson was thrown through the skylight in the roof of his camelback Atlantic class as it spun around 180 degrees and buried itself into the building. He suffered a broken jaw and was held by the local police and questioned throughout the night instead of being taken to a hospital for treatment. Because Jackson was the only surviving engineer, the police attempted to blame him for the disaster. He was later exonerated and remained in LIRR engine service until his retirement in the early 1950s. (Charles T. Jackson collection.)

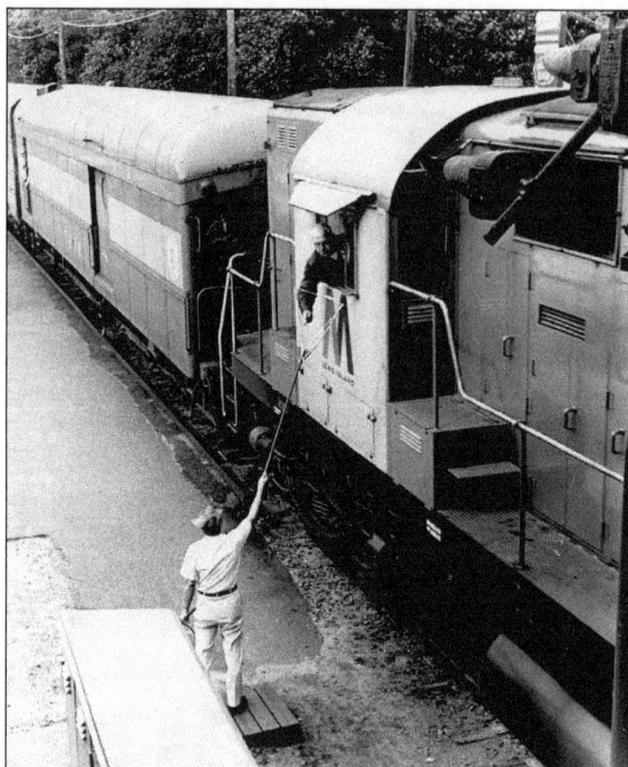

Montauk-bound at speed, train No. 4 has just left the station at Patchogue. Operating Alco C420 No. 226 is engineer Becker, who is in the process of aiming for the Y train order stick to grab his orders from block operator Ed Sorensen in this photograph from PD tower in September 1971. While the locomotive wears the MTA color scheme, the baggage car is still painted with the Dashing Dan logo. (David Keller photograph.)

The engine crew of G5s No. 24 pose in front of the locomotive at the platform of the Oyster Bay station, where the train awaits its westbound departure time in this 1940 scene. The depot still has its covered platforms, and No. 24 sports an off-center number plate. On the left, holding his oil can, is engineer Cecil Kraft. On the right is his unidentified fireman. (T. Sommer photograph.)

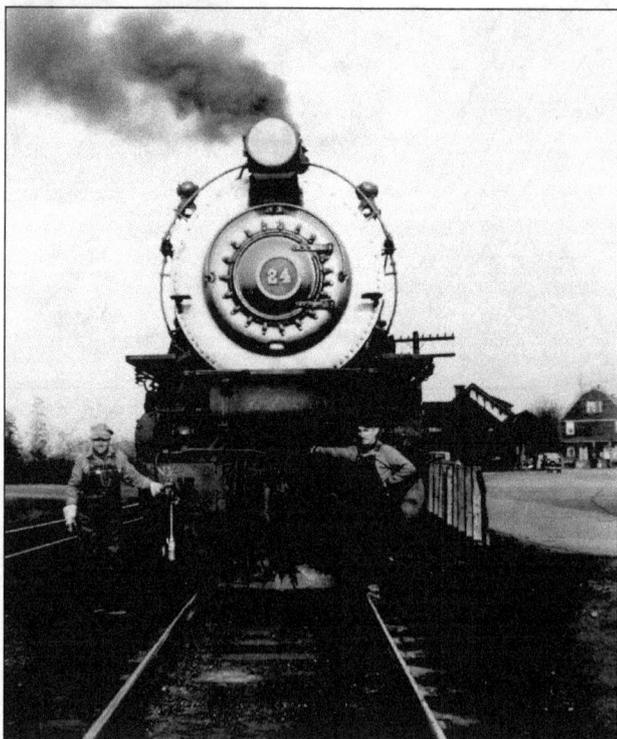

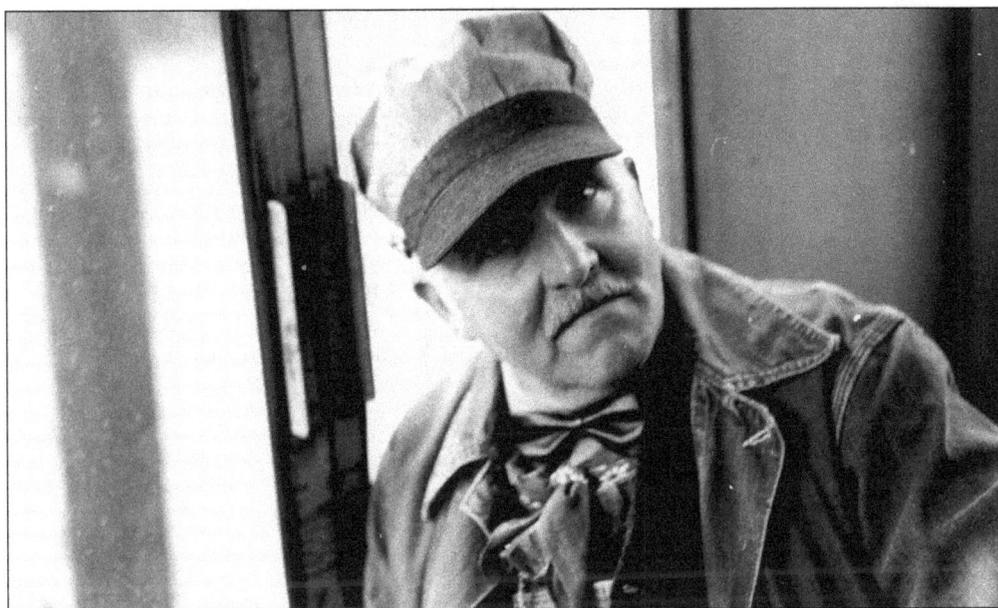

The scene changes to 1953, and engineer Cecil Kraft still wears his locomotive engineer's garb, only this time in the cab of a diesel at Oyster Bay. The steam era is almost over, and the diesel era is under way, but engineer Kraft still dresses like the stereotypical steam locomotive engineer—wearing his bow tie for passenger service—and he will continue to do so until his retirement. (J. P. Sommer photograph.)

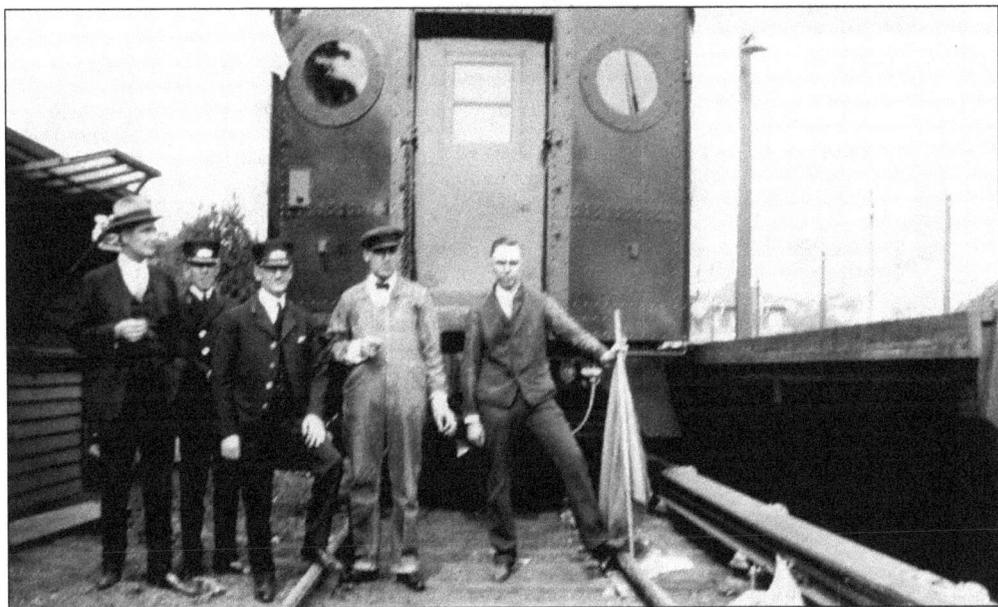

The first MU train has arrived at Babylon amidst great celebration on May 21, 1925. The train has been switched over to the westbound track, where it stands with its crew. Posing for this photograph are, from left to right, an unidentified LIRR official, an unidentified trainman, conductor George Neaves, motorman Cyril Kane, and block operator James V. Osborne. A close look reveals that the motorman is wearing a white dress shirt with cuffs and black bow tie under his overalls. (James V. Osborne collection.)

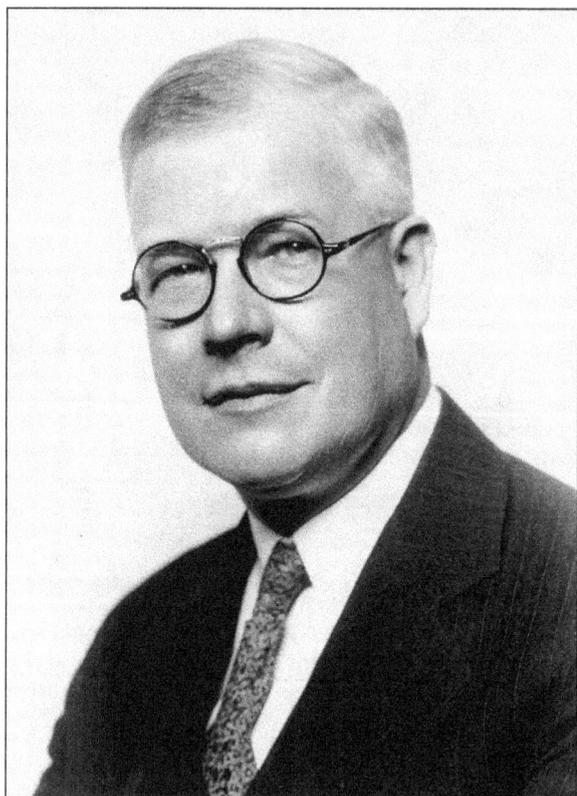

Felix R. Gerard, superintendent of transportation, poses for a formal portrait taken by trainman Jeff Skinner in 1929. As superintendent of transportation, Gerard's initials would be written by proxy across the bottom of every train order issued on the LIRR during his tenure, from 1928 until c. 1931. He later left the LIRR to become president of the Lehigh Valley Railroad. (Jefferson I. Skinner photograph.)

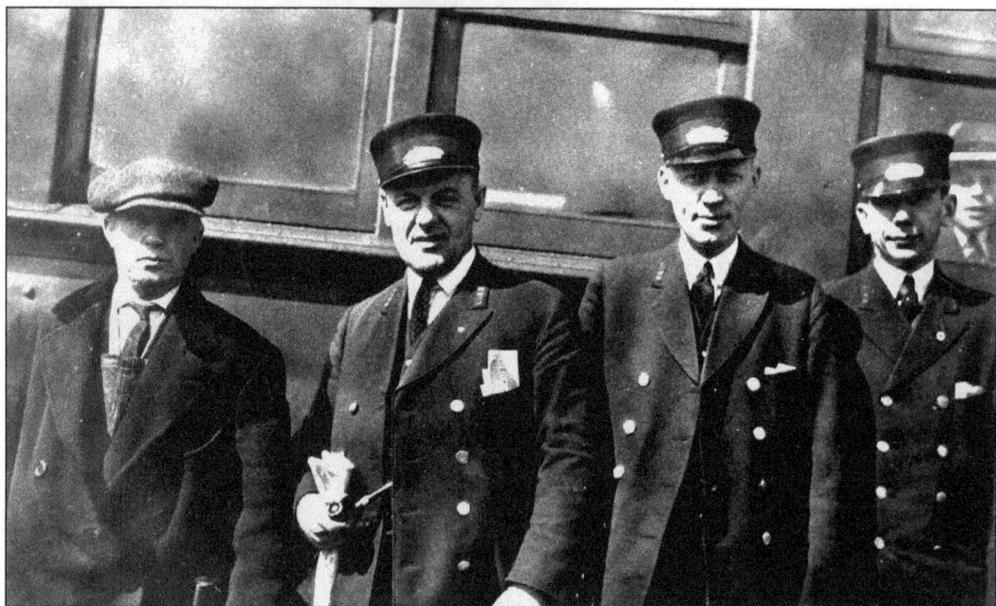

Members of an MU train crew pose next to their train at Rockaway Park in 1933. Pictured in this copy of an old, faded snapshot are, from left to right, motorman Bob Denton, conductor Harrison S. Moore, brakeman Al G. Malle, and an unidentified trainman. Noteworthy, again, is the necktie worn by the motorman under his overalls. (Jefferson I. Skinner collection.)

Once a common sight all over the LIRR, crossing shanties and watchmen soon became things of the past. This scene in December 1970 shows a crossing watchman at his post in front of the manual crank-down crossing gates that protect the Greenpoint Avenue crossing in Long Island City. The round sign on the right with the letters "SS" indicates a spring switch. (David Keller photograph.)

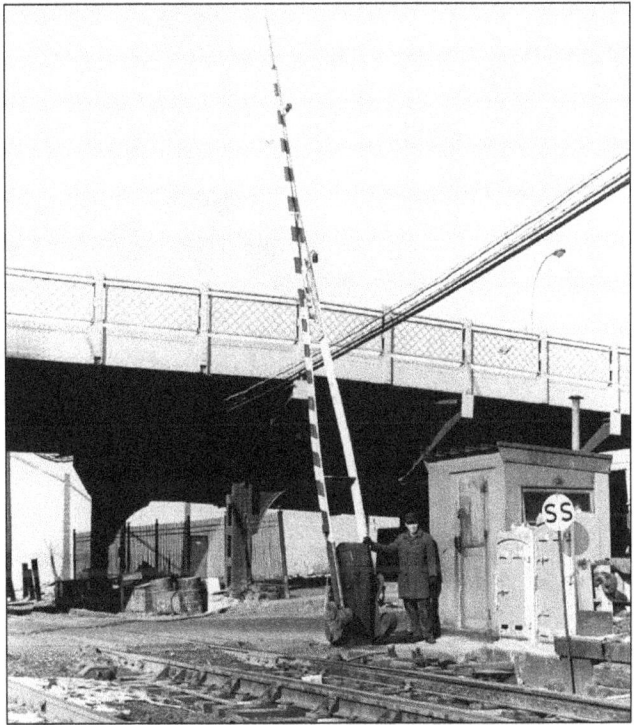

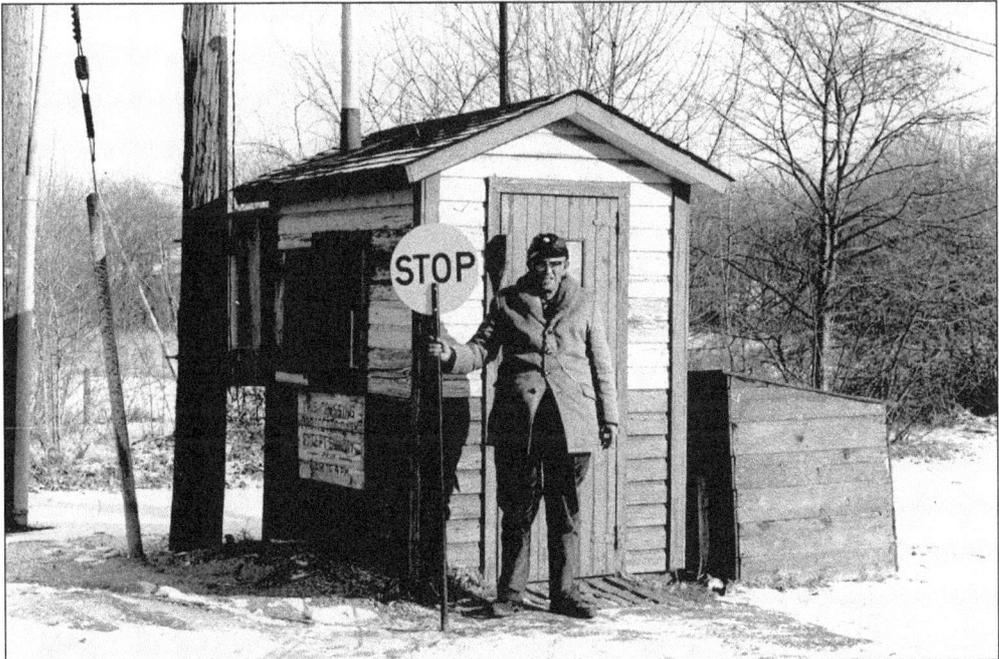

The typical wooden crossing shanty is shown here with its watchman at the Bay Avenue crossing east of Patchogue in January 1970. To the right of the shanty is the old, wooden coalbin from which the watchman would get coal to feed the pot-bellied stove inside on cold, snowy days such as this. The watchman's means of communication was a telephone housed in the "T" box on the pole behind the shanty. (David Keller photograph.)

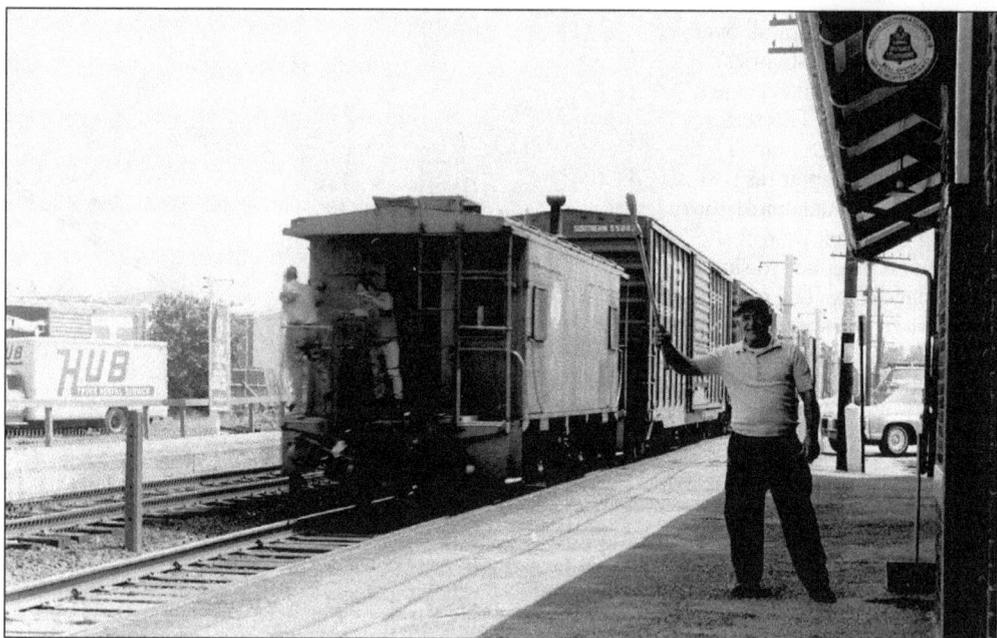

As caboose C-50 on an eastbound freight passes through Farmingdale in June 1972, station cleaner Henry Nedwick salutes the photographer with his corn broom. Nedwick's job was to keep this depot and several others clean. Still visible under the eaves of the old depot building is the old AT&T enamel sign that alerted passengers that public telephone service was available at this location. (David Keller photograph.)

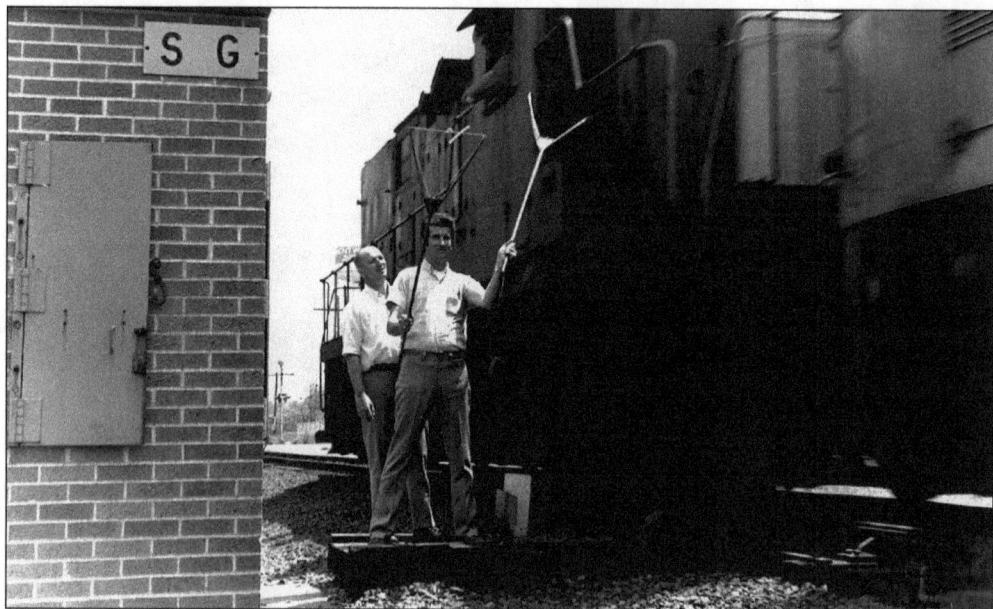

The engineer of Alco C420 No. 208 has just yanked his orders off the Y stick of block operator trainee Bob Peeling as the train speeds eastbound past SG block cabin west of Brentwood. The second stick is for the conductor riding in the head car. In this scene from June 1972, veteran block operator George DePiazzy looks on to make sure his student gets it right. (David Keller photograph.)

This ground crew on the platform at Long Island City *c.* 1945 prepares to pick up a trailer of mail to load on the Railway Post Office car in the background. The metal bar attached to the RPO car door was swung out and latched in place when the train, at speed, was prepared to pick up the mailbags suspended from the many mail cranes. (George Christopher photograph.)

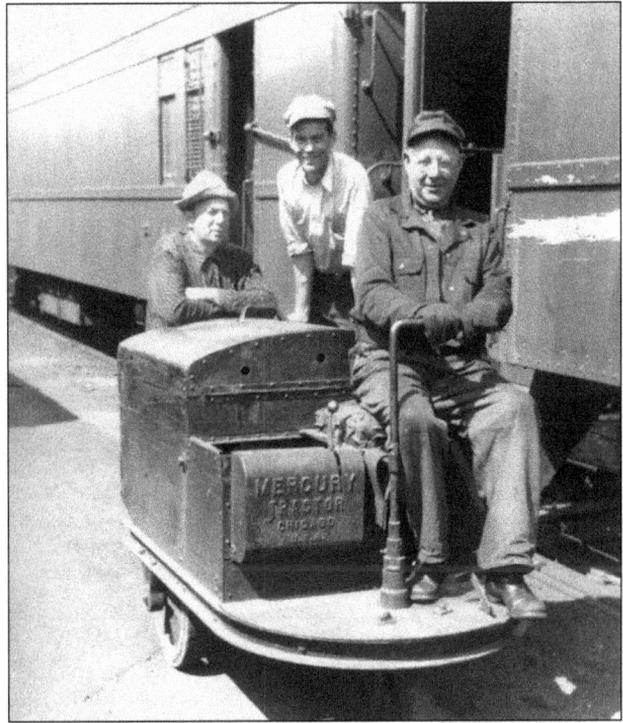

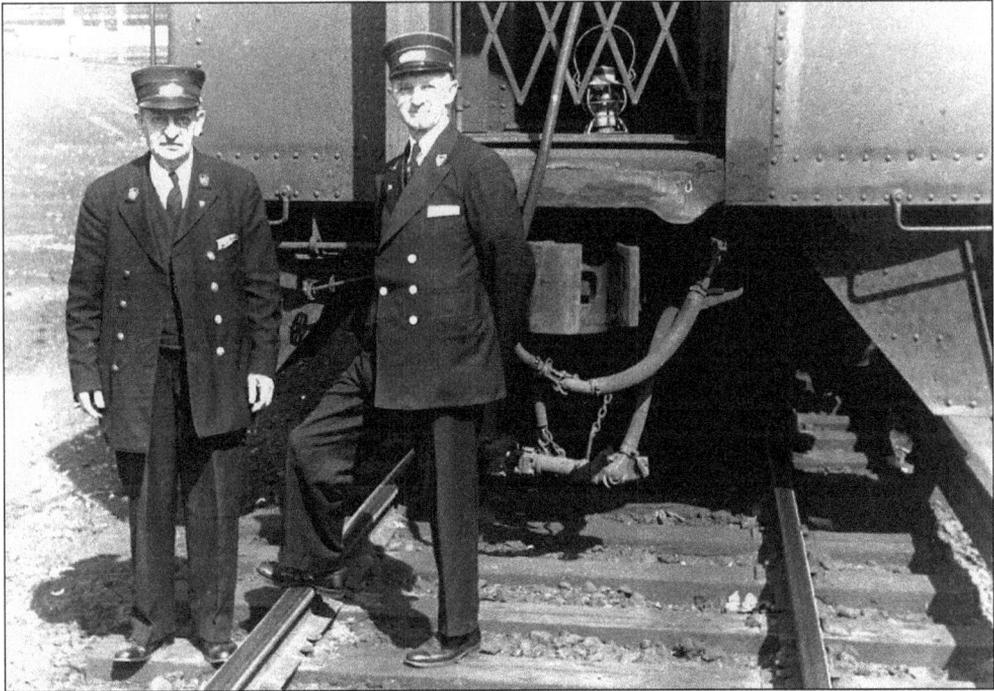

Conductor Ben Purick (left) and trainman Matty Roeblin pose at the rear of their train at Sunnyside, Long Island City, in this *c.* 1945 photograph. Both wear the double-breasted uniform coat and polished shoes. An old kerosene lantern on the rear platform is visible through the door opening. (George Christopher photograph.)

101

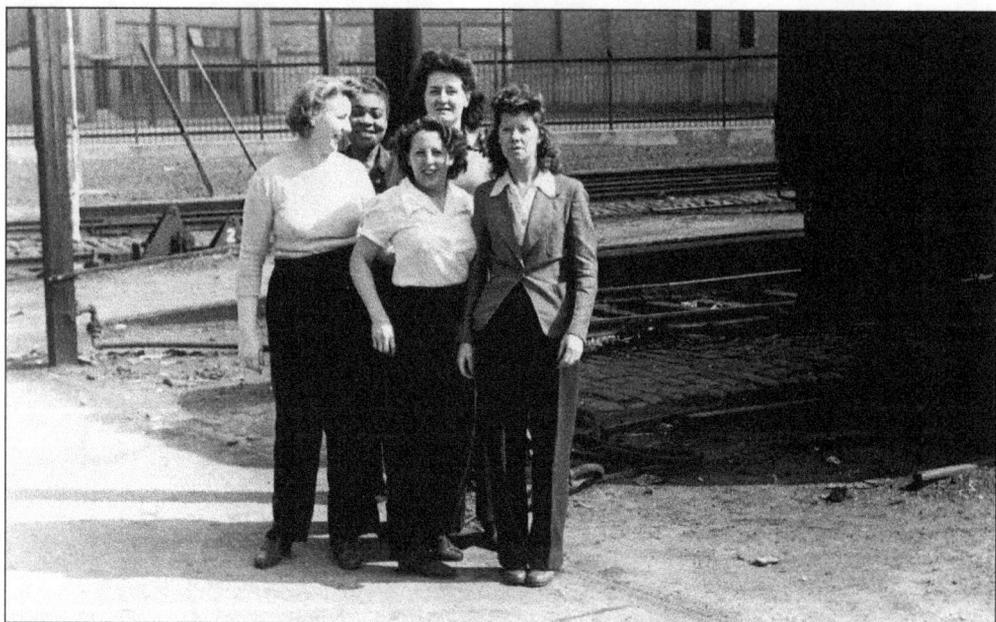

When young men left to go overseas during World War II, the LIRR held their jobs for them and filled the positions with women, with the understanding that the women would step down when the men returned. This was the era of "Rosie the Riveter." Women filled all railroad positions, from ticket collectors to shop workers. Pictured here is a group of car maintainers at Long Island City c. 1945. (George Christopher photograph.)

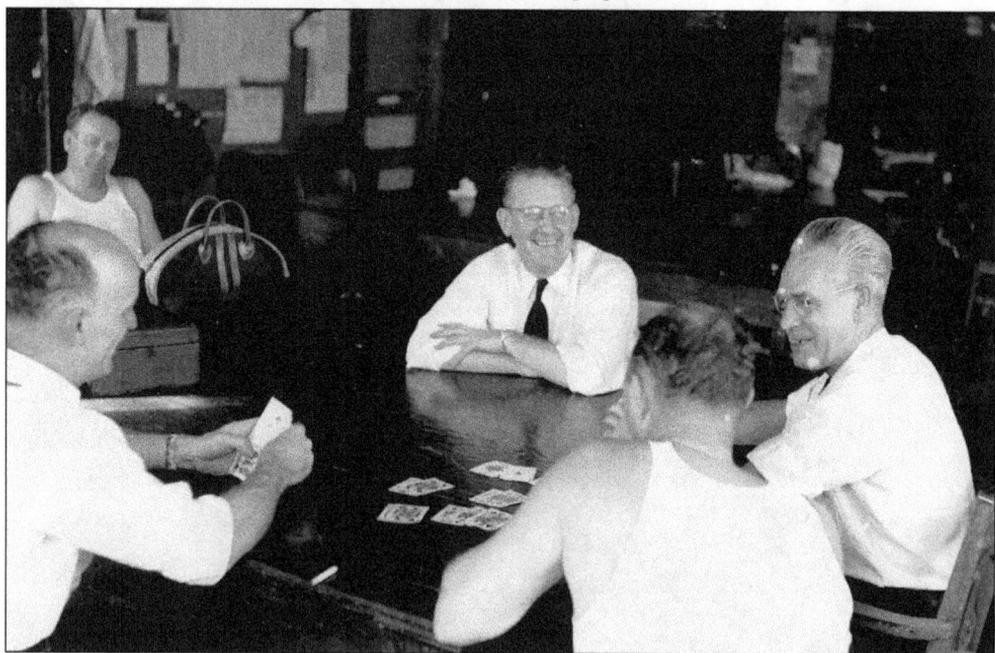

This is a typical scene of camaraderie and relaxation in the Long Island City trainmen's room c. 1945. Enjoying a card game are, counterclockwise from the left, Howard Colborn, Bill Reichart, John Harchick (with his back to camera), Bert Rumstetter, and Jeff Skinner. It appears someone has just cracked a good joke. (George Christopher photograph.)

102

Eight

MAINTENANCE OF WAY

Maintenance of Way (MOW) is the heart of railroad operations because this department provides the literal foundation upon which the entire railroad relies: the track work and its environs. From weed control, tie replacement, switch repair, and rail upkeep, to emergency facility rerouting and snow removal, the department keeps the track work and support infrastructure in place to support the LIRR's high-speed traffic density.

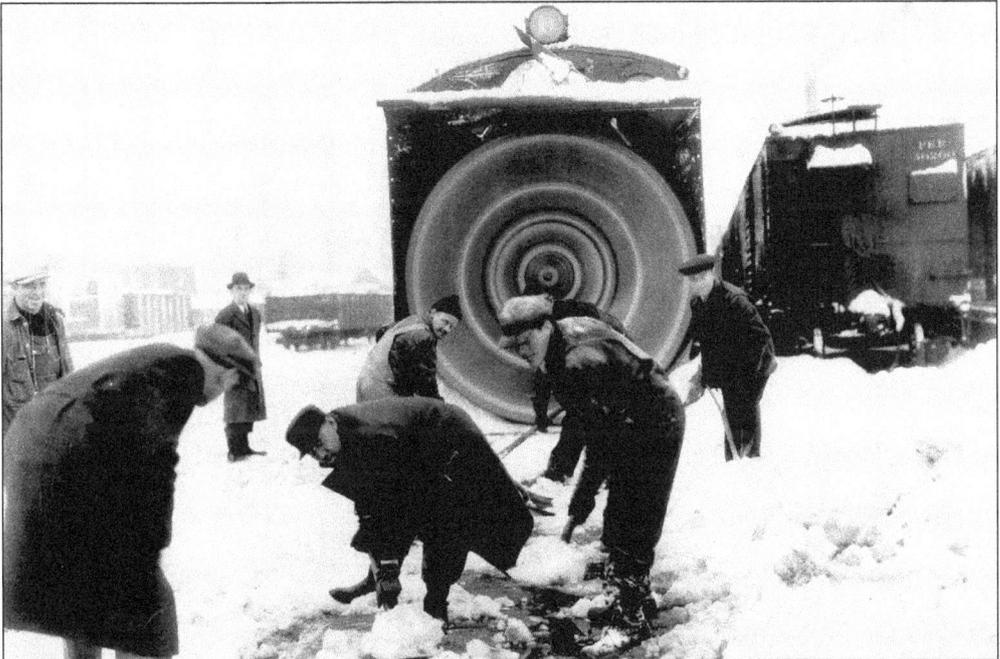

Long Island commuters will remember many winters of days past when everything stopped but the trains continued to run. Here workers clear the tracks in the yard at Patchogue, New York, with the assistance of steam-powered rotary snow blower No. 193. Although this particular photograph dates from the winter of 1921, this scene was a common one for years to come. On the far left is Bailey and Sons Lumber Company. (Jeff Skinner collection.)

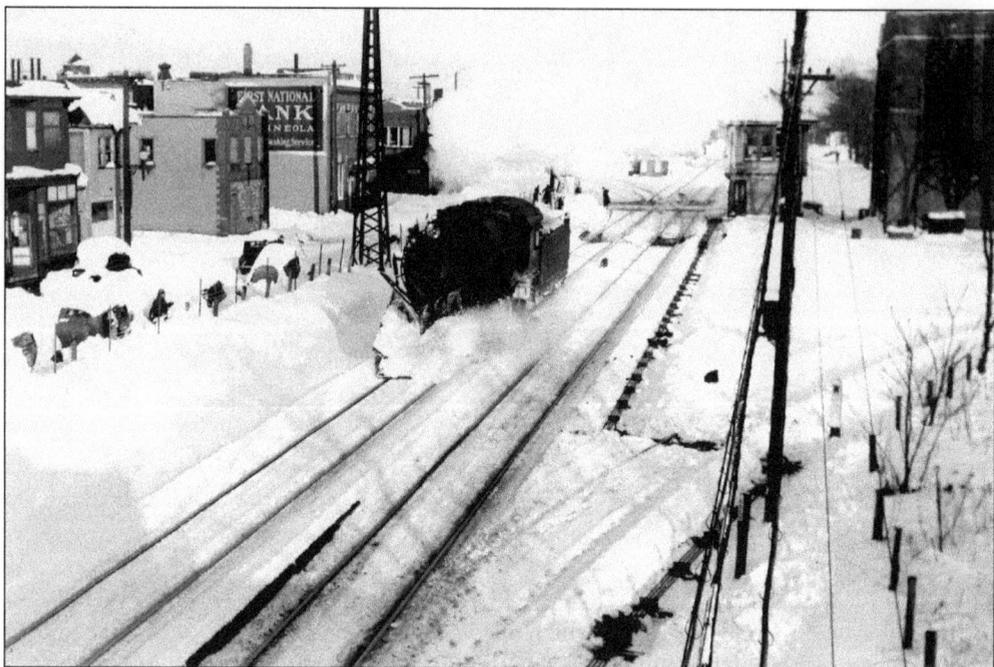

Keeping the line open was an important task during a heavy snowstorm. Leased Pennsylvania Railroad H8sb Consolidation class No. 693 does the job here, with front wedge plow in place to help clear the rails after a heavy snowstorm in December 1948. This is an eastward view from the Mineola Boulevard overpass in Mineola. (George E. Votava collection.)

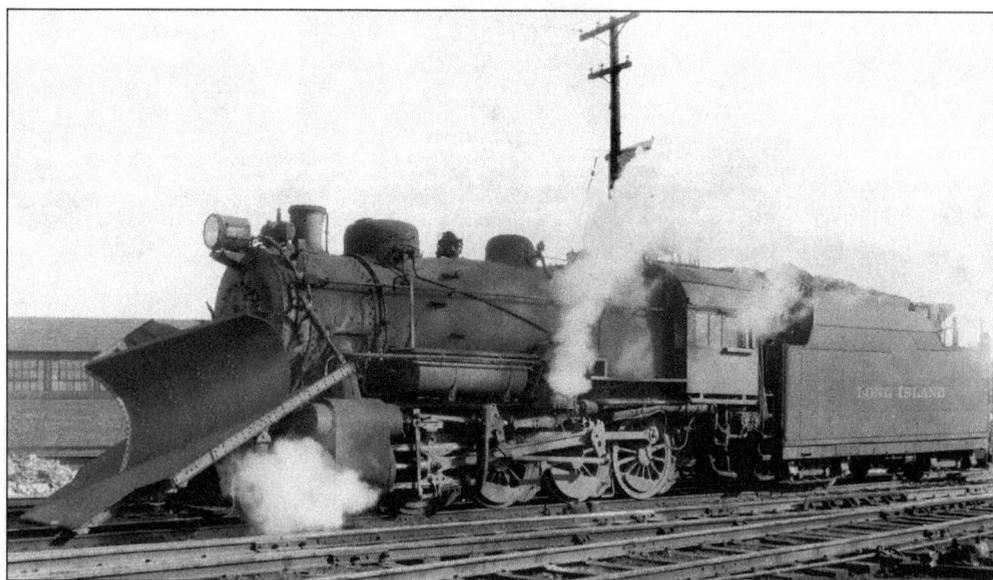

This photograph of H10s No. 111 at Long Island City *c.* 1950 provides a closeup view of the front-mounted wedge snowplow. The locomotive is steamed up, full of coal in its tender, and ready to go—but where? Perhaps heavy snowfall is in the weather forecast so the train is being readied to deadhead to an outlying terminal. (David Keller collection.)

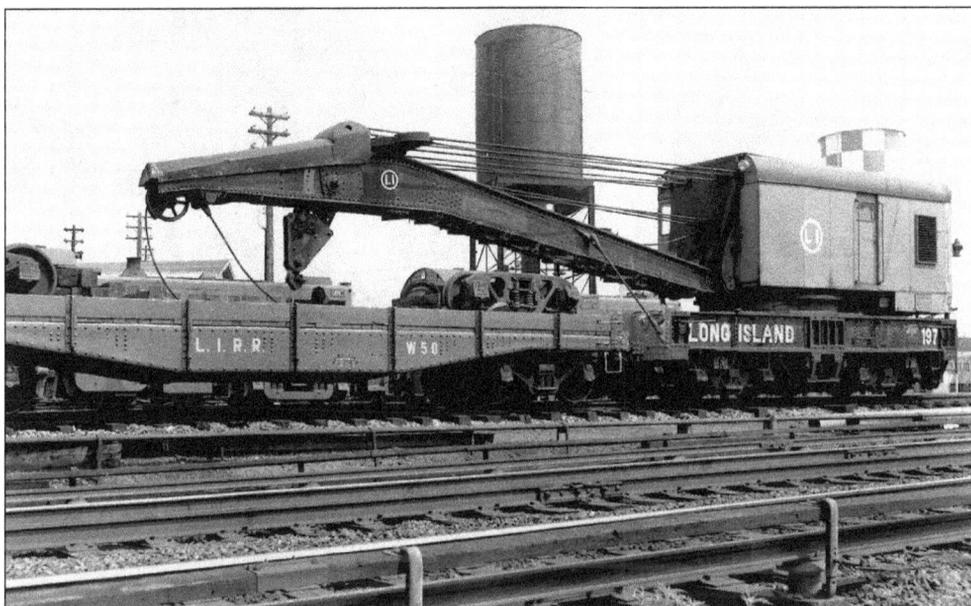

Another important piece of Maintenance of Way equipment is the wreck crane. When there is a major problem, such as a locomotive derailment, the "big guns" must be called out to lift the massive locomotive back onto the tracks. In this 1958 photograph, wreck crane No. 197 and work flatcar W50 are laying up at the Morris Park Shops in 1958. Behind them are two Alco S2 diesel units. (George E. Votava photograph.)

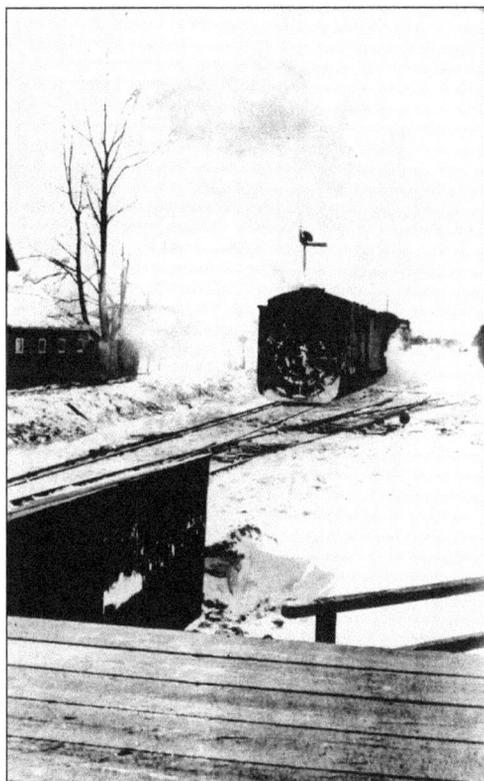

Long Island had very heavy winters in years past, and the rotary was put to lots of use. Here the rotary is pushed by a camelback locomotive eastbound through Central Islip in the 1920s. This view from the express platform shows both the rotary and camelback steaming away, as the semaphore block signal gives them the highball. (George G. Ayling photograph.)

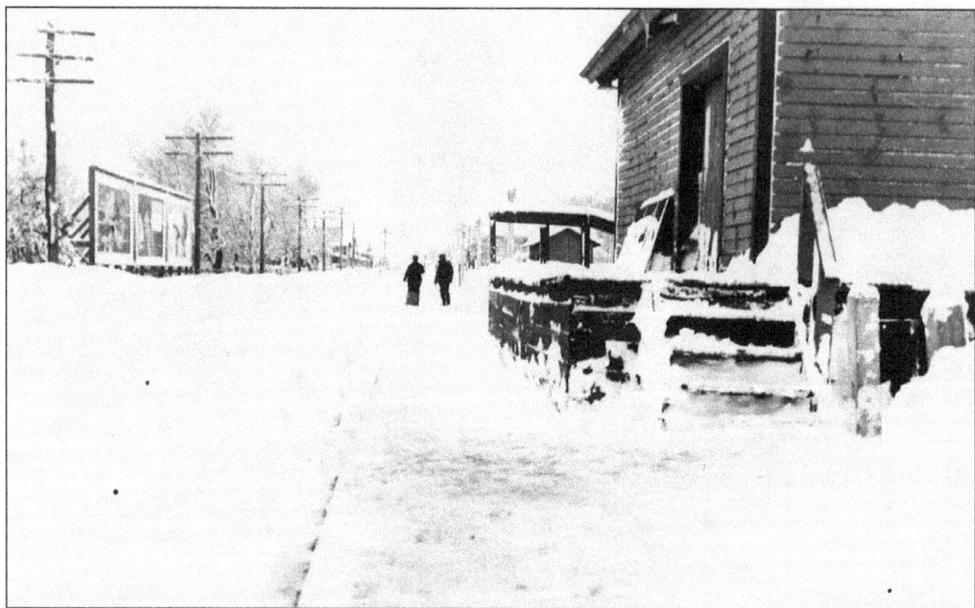

One of the "enjoyable" duties of the station employee in years past was to shovel snow from the platform. The men photographed here have done a pretty good job of shoveling the snow off both the station and express platforms at Central Islip. However, it is quite evident that the plow or rotary has not yet passed through to clear the main line, so the men probably had to shovel again later. (George G. Ayling photograph.)

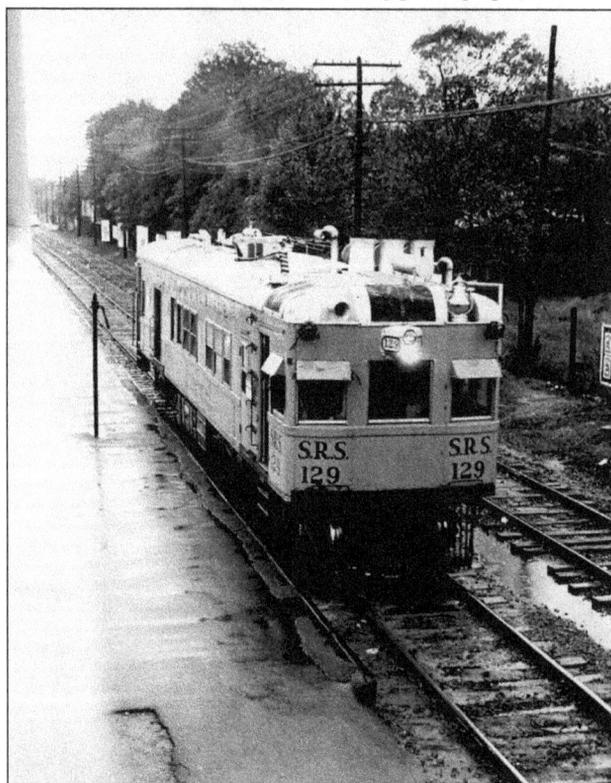

Inspecting the right of way for problems that could lead to major disaster is a job for the Sperry Rail Service. The Sperry detector cars move along the rails very slowly while using electronic equipment to discover any faults in the rails. This view from PD tower shows detector car No. 129 as it heads eastbound through Patchogue on a rainy day in October 1972. (David Keller photograph.)

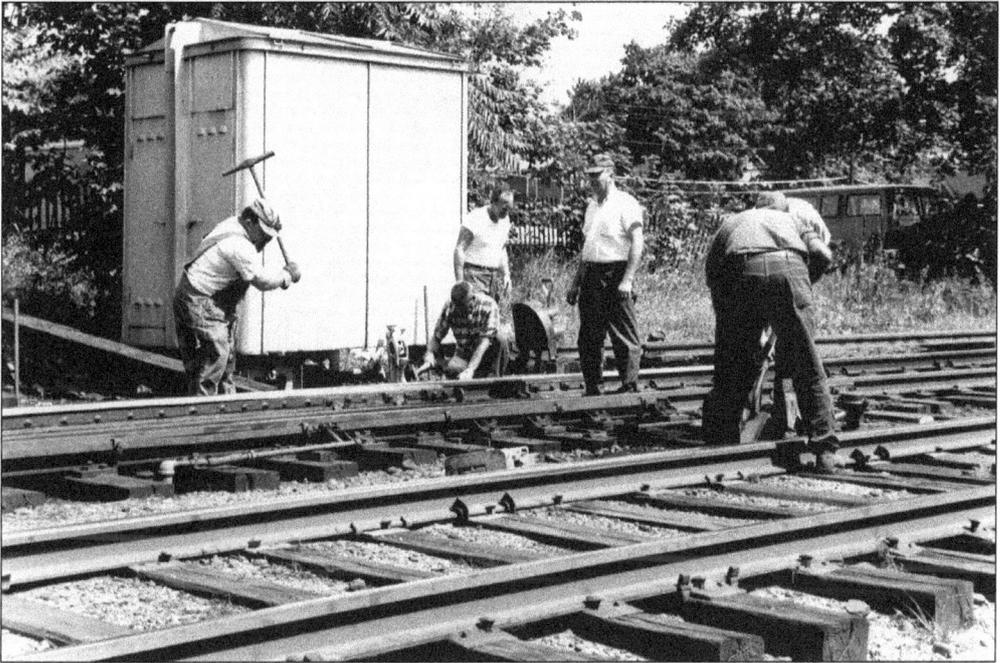

A section crew is hard at work on a summer day in 1968 as members repair the tracks on the north siding in Patchogue east of the South Ocean Avenue crossing. Crews like this one maintain designated sections of track—hence the name "section" crew. (David Keller photograph.)

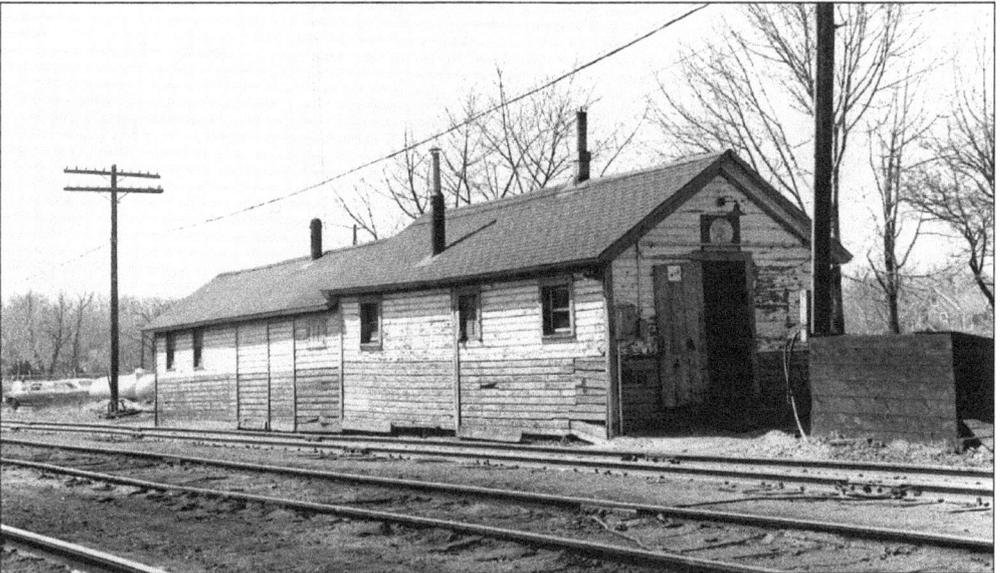

The home base of the section crew was the section house. Pictured in this northwest view is the old section house at Port Jefferson in 1968. The Dashing Dan logo is over the door. The house's wood siding is rotting, and its paint is peeling. Located just west of the Route 112 (Patchogue–Port Jefferson Road) crossing, this little structure was razed not long after this photograph was taken. (David Keller photograph.)

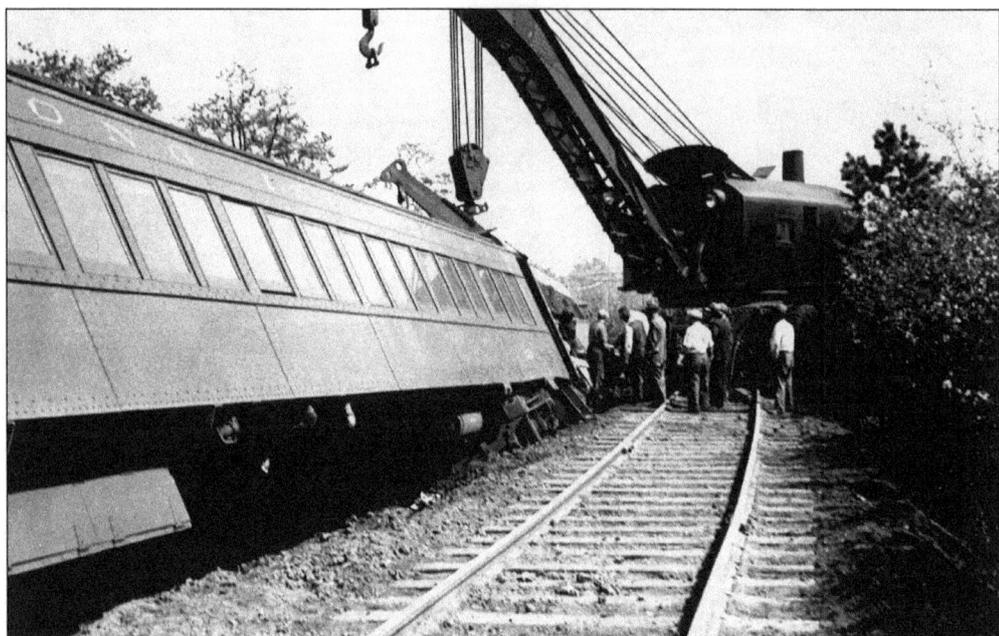

The Hurricane of 1938 wreaked havoc throughout the Northeast. On Long Island many large houses were blown out to sea, and numerous trees were uprooted during the storm. The hurricane was so forceful that it created Shinnecock Inlet. In this photograph a big wreck crane attempts to rerail train No. 26, the South Shore Express, at Quogue. The train derailed as a result of the heavy rains and storm on September 21, 1938. (George Christopher photograph.)

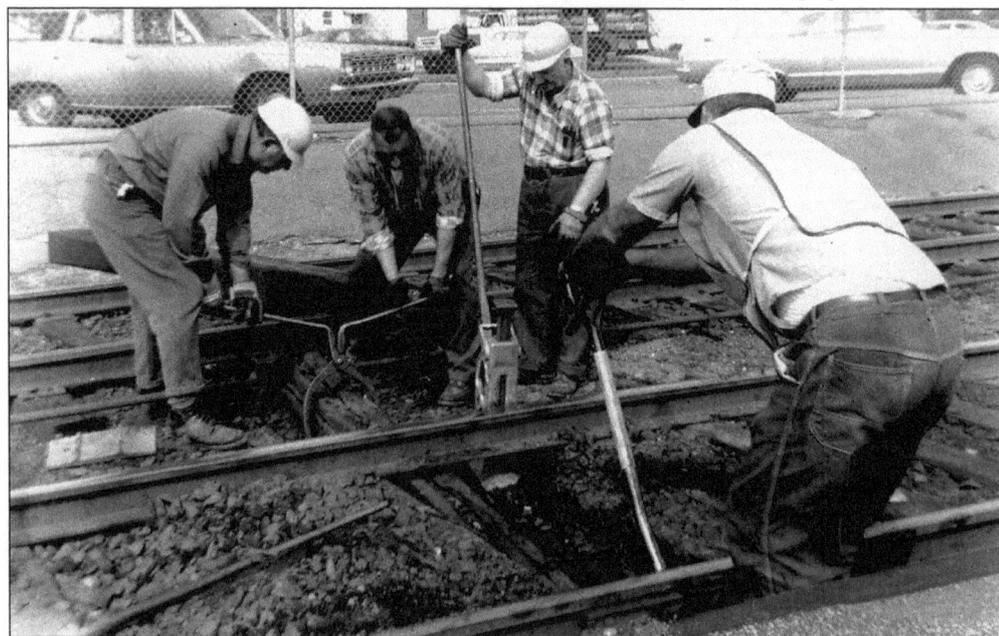

A section crew is hard at work replacing a rotten railroad tie in front of the Patchogue station platform in October 1971. One man is jacking up the rail, and another is helping to move it with his shovel. The other two crew members are jointly handling the tongs to pull and lift the bad tie. The replacement tie sits across the track behind the crew. (Henry Keller photograph.)

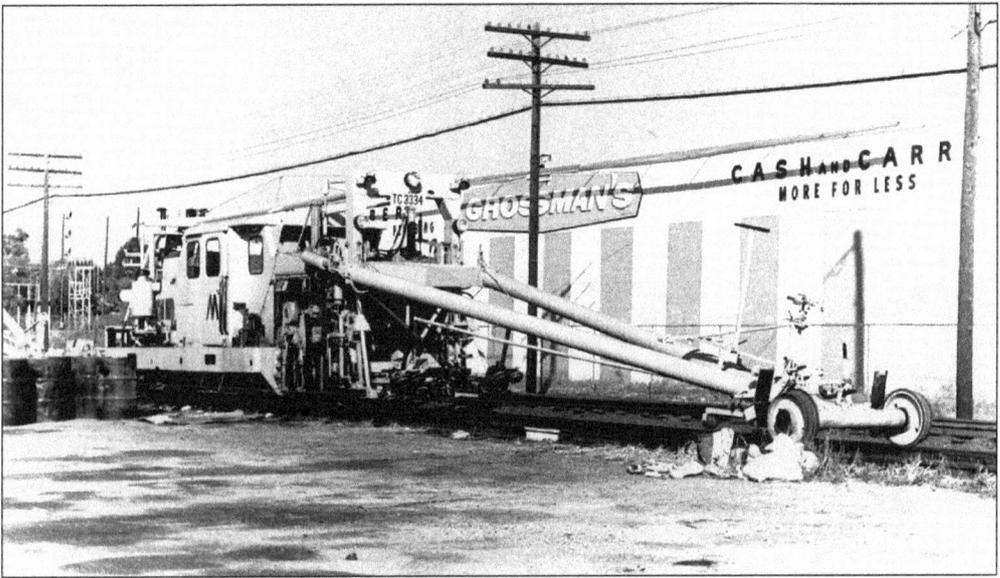

When major track work is needed, the section crews bring out the heavy machinery. Here is just one such piece. In this scene from October 1970, track car No. TC3334 sits on the siding at Patchogue, across from Grossman's lumber, as it waits to be sent out east. Grossman's, by the way, was built on the site of the old turntable. (David Keller photograph.)

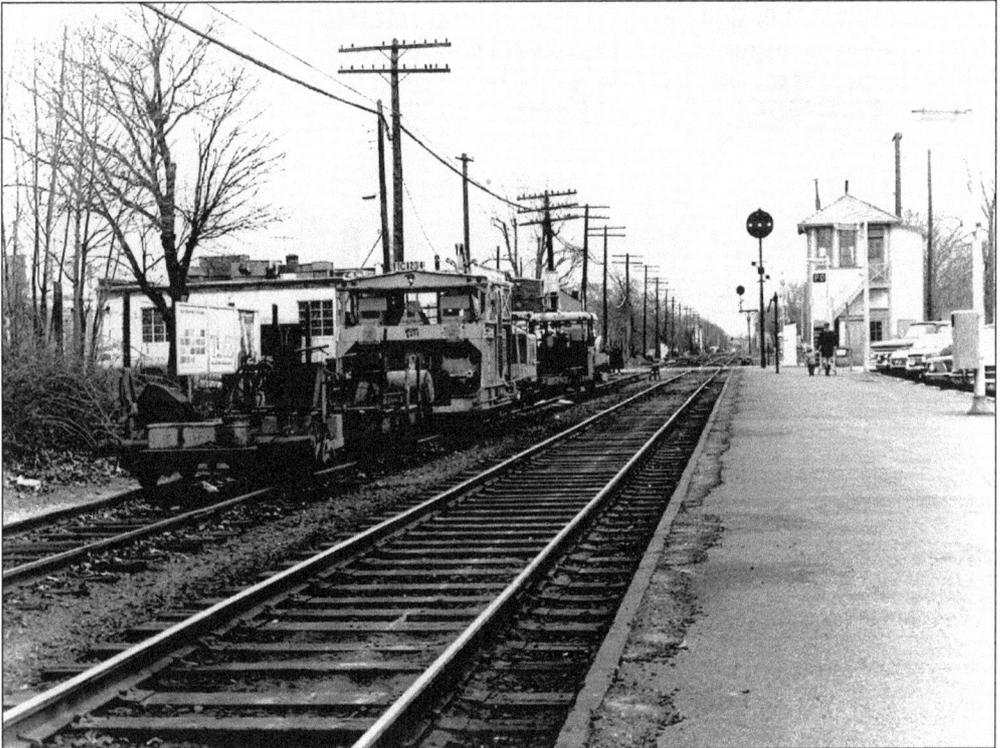

Here a string of track cars heads westward on the north siding at Patchogue in December 1970. Nos. TC1234, TC4340, and TC4350 await their orders from the operator at PD tower to proceed again westward. (David Keller photograph.)

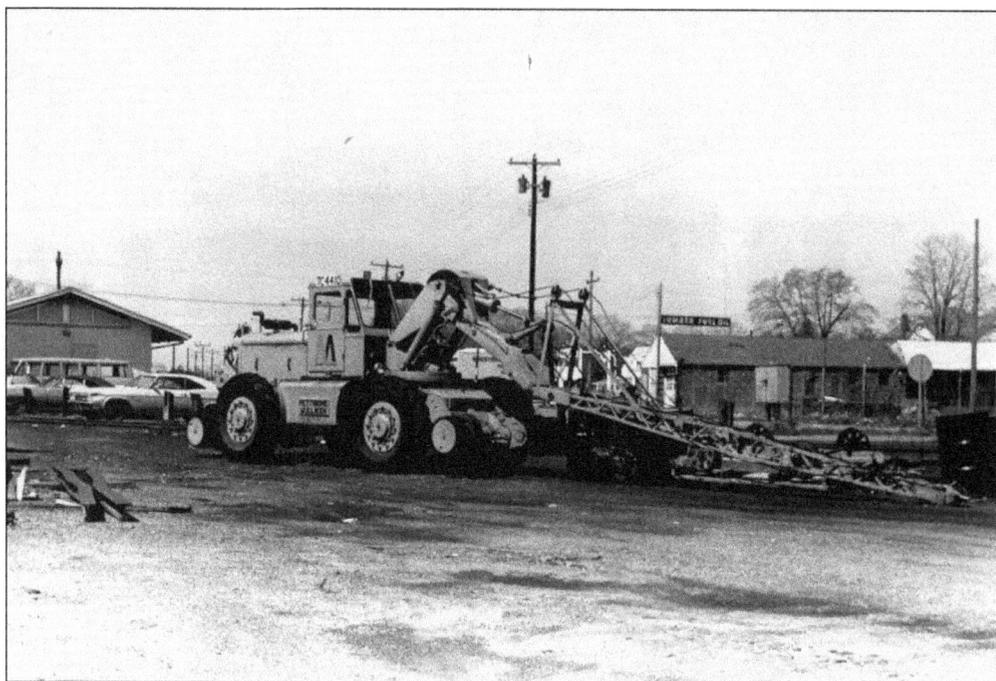

Photographed at Ronkonkoma in April 1970, rail crane No. TC4410 is equipped with both pneumatic tires and flanged wheels to allow this Pettibone Mulliken crane to operate on the street as well as on the tracks. This is a westward view toward the train crew's shanty. The track behind the crane is the west leg of the wye. (David Keller photograph.)

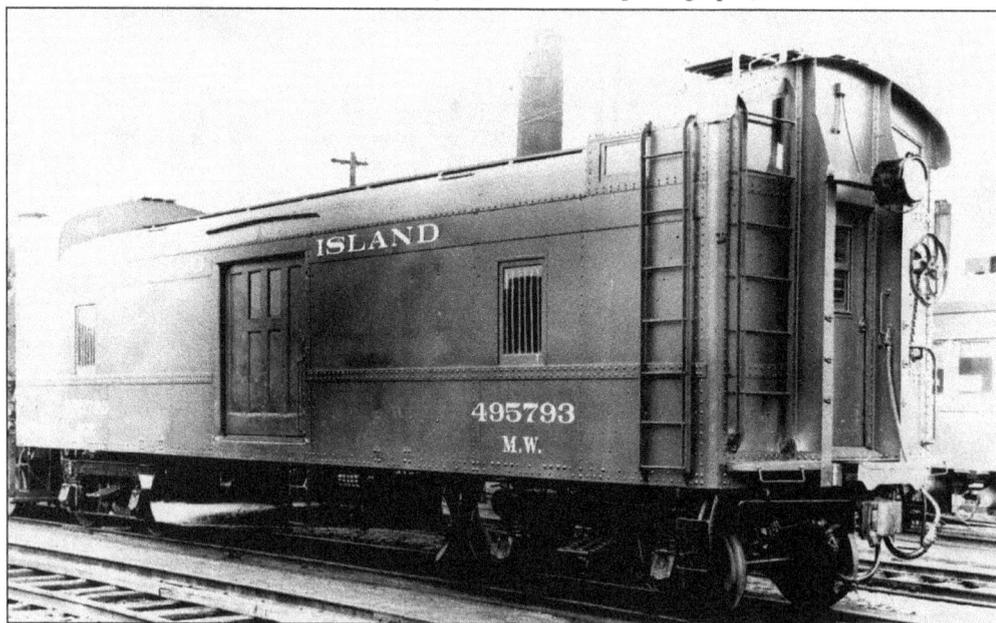

Formerly Railway Express Agency car No. 664, Maintenance of Way car No. 495793 has been converted into a snow scraper car. The car is pictured here at Morris Park Shops c. 1935. The old lettering is still visible to the left of the car number, and the barred windows are still in place from the car's days of REA service. (George V. Arnoux collection.)

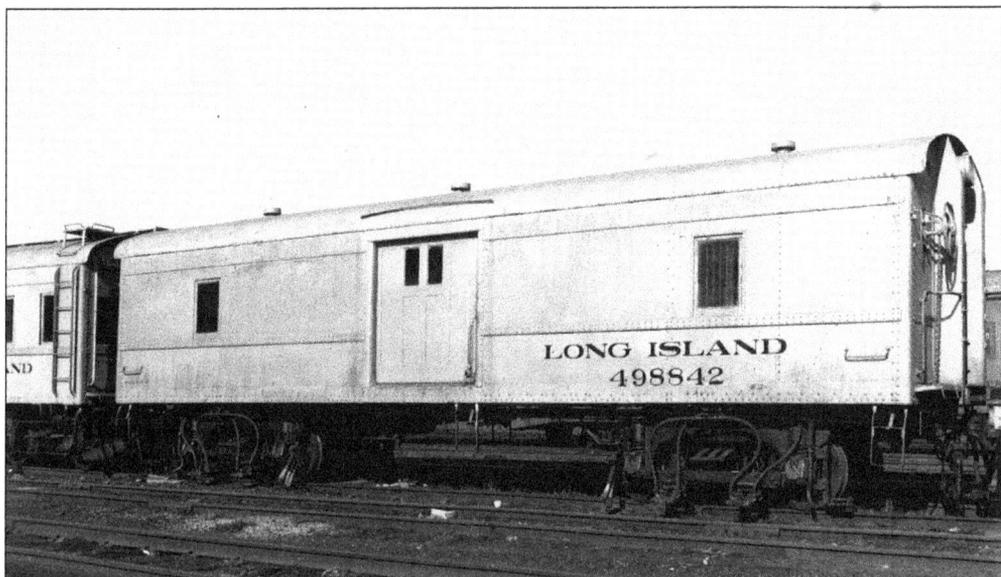

Maintenance of Way brush car No. 498842 is photographed at Holban Yard in Hollis-Hillside in February 1949. Another former REA car, former No. 655 was converted between 1934 and 1935 to brush off the third rails in electrified territory. The car was withdrawn from service by 1955. (George E. Votava photograph.)

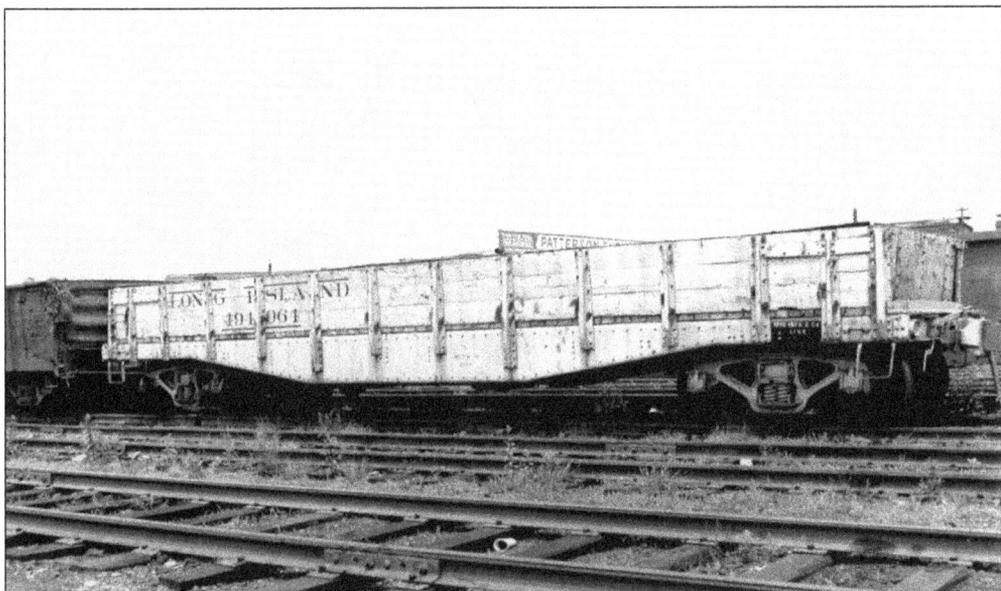

Work gondola No. 494964 is shown here at Holban Yard in July 1954. With steel frame and wood sides, the gondola car looks like it has seen a lot of years of heavy work in MOW service. (George E. Votava photograph.)

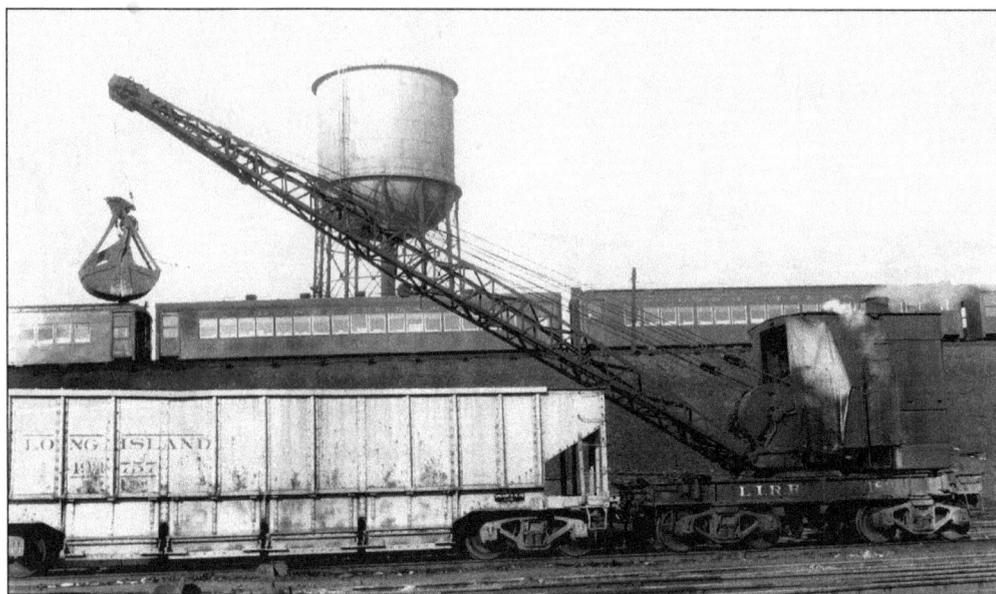

Rail crane No. 183 is steaming up and ready to go with work hopper car No. 494757 at Morris Park Shops in this December 1949 scene. Equipped with a clamshell bucket hanging from its boom, the crane will probably be dumping ballast somewhere along the right of way. On the embankment is a string of MU electric cars painted in the Tuscan red color scheme with gold lettering. (Bob Lorenz collection.)

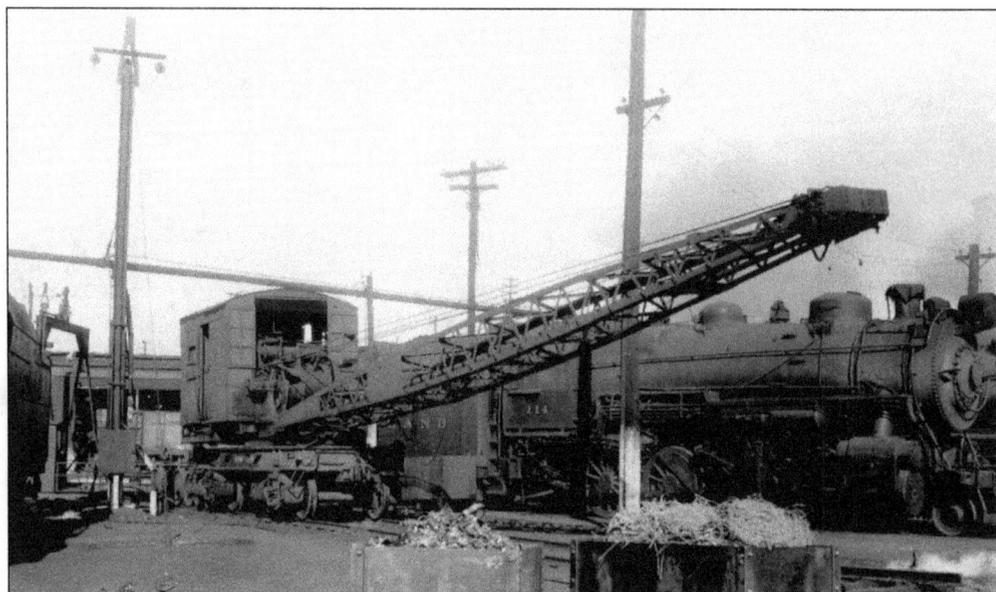

Work crane No. 490898 is on a storage track off the turntable at Morris Park Shops in this December 1949 scene. On the right is H10s No. 114 in storage. In the foreground are containers of scrap metal, and the ever prevalent smoky haze is in the air. (Bob Lorenz collection.)

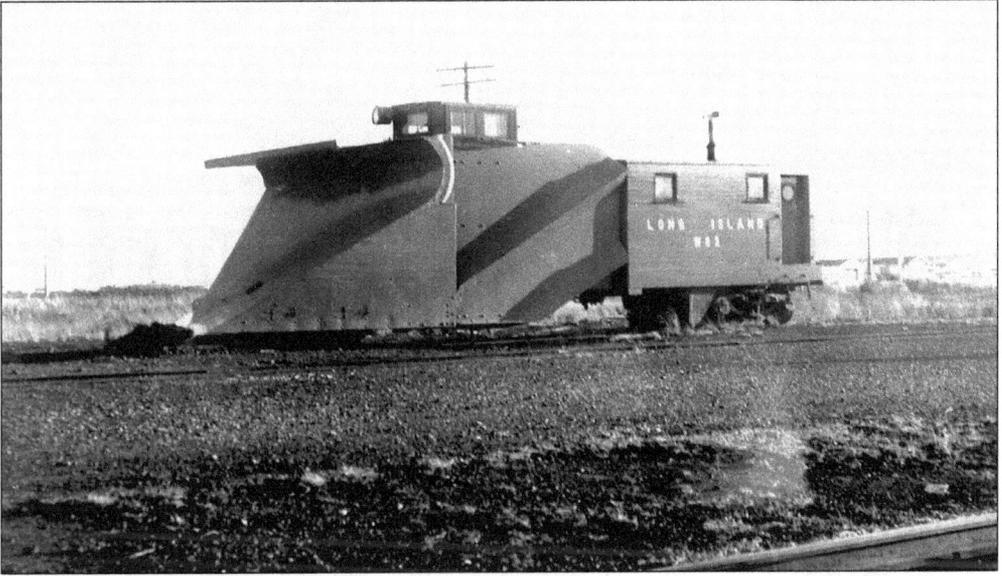

It is very late in the day as wedge plow W82 sits all alone in the yard at Montauk c. 1950. W82 has been assigned here to assist in snow removal in the event of a sudden storm. Plows were assigned to terminals such as Greenport, Ronkonkoma, Hicksville, Montauk, and Speonk, to name but a few, and they were familiar, lonesome figures in the yard. (David Keller collection.)

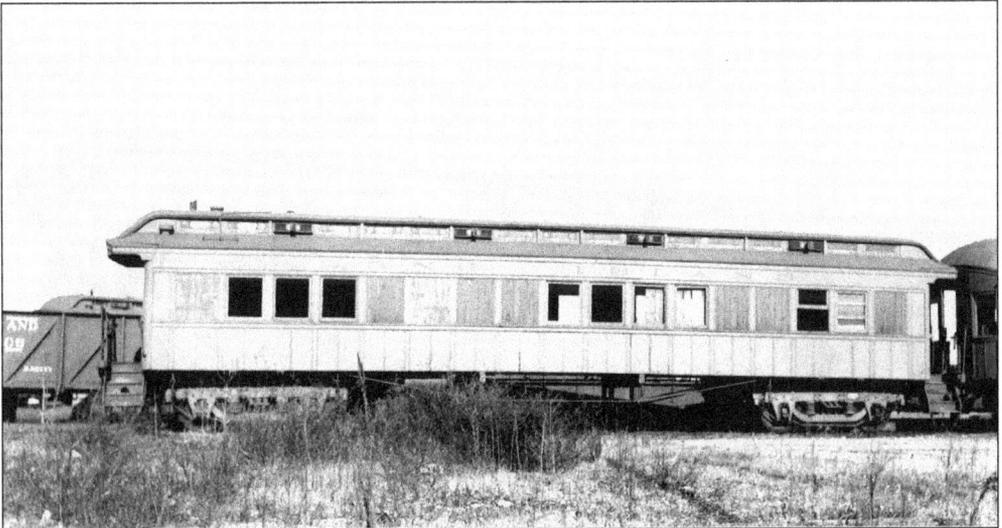

When the LIRR converted from wooden passenger cars to all-steel models in the early 1900s, some of the old wooden cars were kept for Maintenance of Way service. The old cars were used to carry crews and equipment to work sites. Here wooden M.W. car No. 119 is shown in what appears to be its last days at Holban Yard in Hollis-Hillside, in November 1932. (William Lichtenstern photograph.)

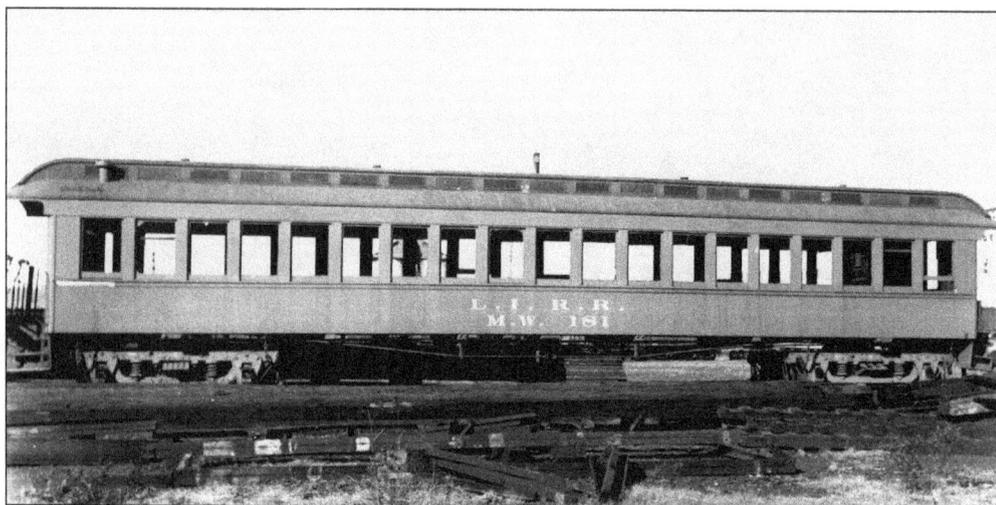

Another wooden former passenger car (minus all its windows) is seen in Maintenance of Way service at Holban Yard in November 1932. Built by Pullman in 1894 and numbered 191, the car was converted to M.W. No. 181 in December 1927. (William Lichtenstern photograph.)

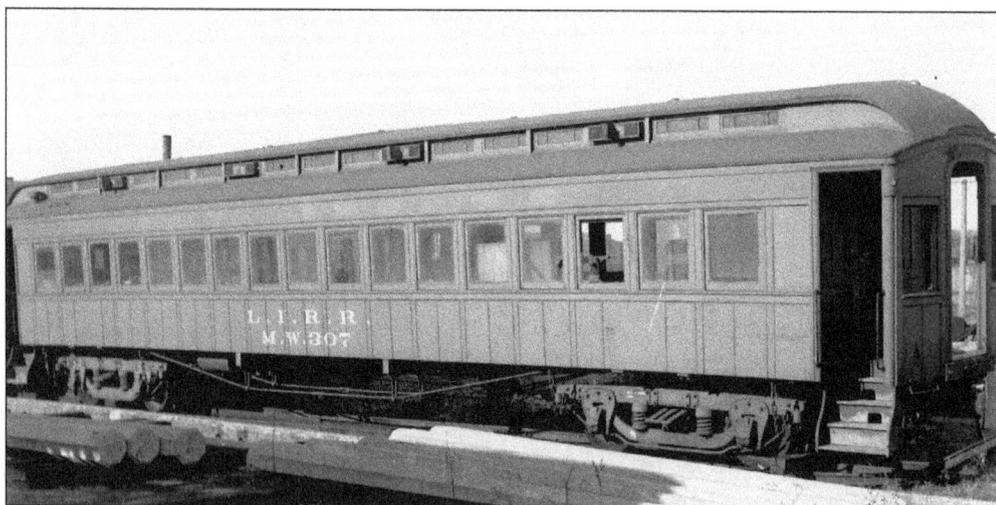

Apparently still in Maintenance of Way service as it carries equipment, this wooden former passenger car was renumbered to M.W. No. 307. This scene was also photographed at Holban Yard in November 1932. However, the car in this picture, unlike those in the previous two photographs, has closed vestibules. (William Lichtenstern photograph.)

Nine

STRUCTURES AND SCENES ALONG THE RIGHT OF WAY

Unique in many ways to serve the specialized needs of both railroad engines and their consists, as well as to accommodate other employees, passengers, freight, baggage, and express, railroad structures are a classic example of "form follows function." Various types of railroad structures are portrayed in this chapter, including sheds that shield passengers from the elements, towers that guard railroad grade crossings and control rail traffic, water towers that serve the needs of steam engines, and a host of other unique buildings designed to serve the specific needs of railroad operations.

This eastward view toward the junction of the Manorville-Eastport branch at Eastport in the mid-1920s depicts the branch coming from Manorville on the main line on the left. The Montauk branch is on the right. The semaphore-arm block signals here act as the traffic signals to the engineer. In the distance is a section shanty on the left and PT cabin on the right. (James V. Osborne photograph.)

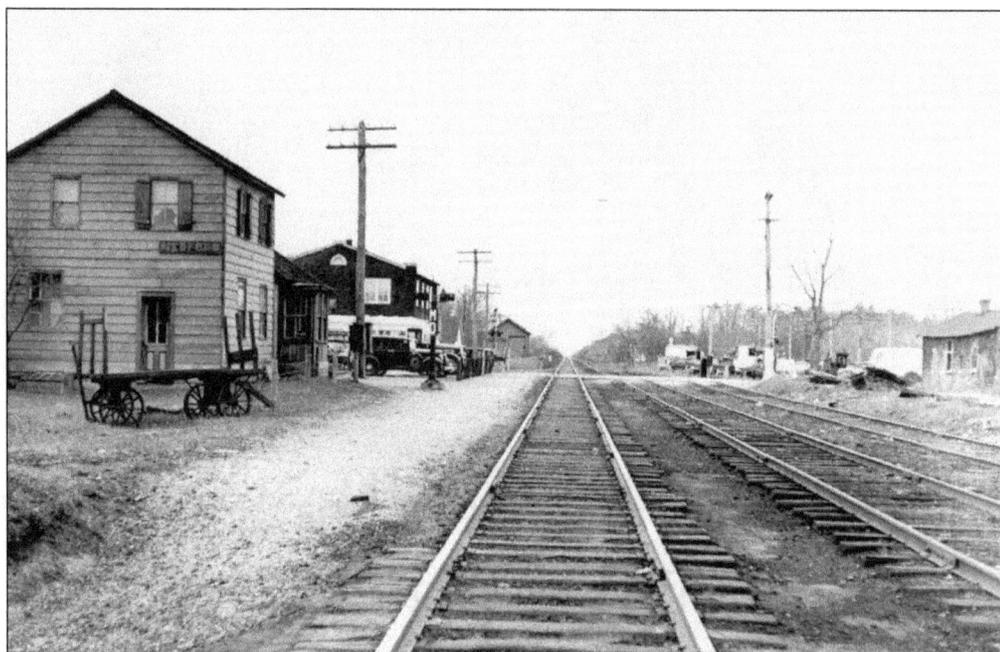

Typical of many of the small towns along the main line is this rural, pre–grade elimination scene at Medford, in this westward view on April 19, 1940. The depot is on the left. The Route 112 grade crossing is protected by crossbucks with flashing lights center-mounted on concrete abutments. Beyond the crossing is the express house. The passing siding and team tracks are on the right. (Albert E. Bayles photograph.)

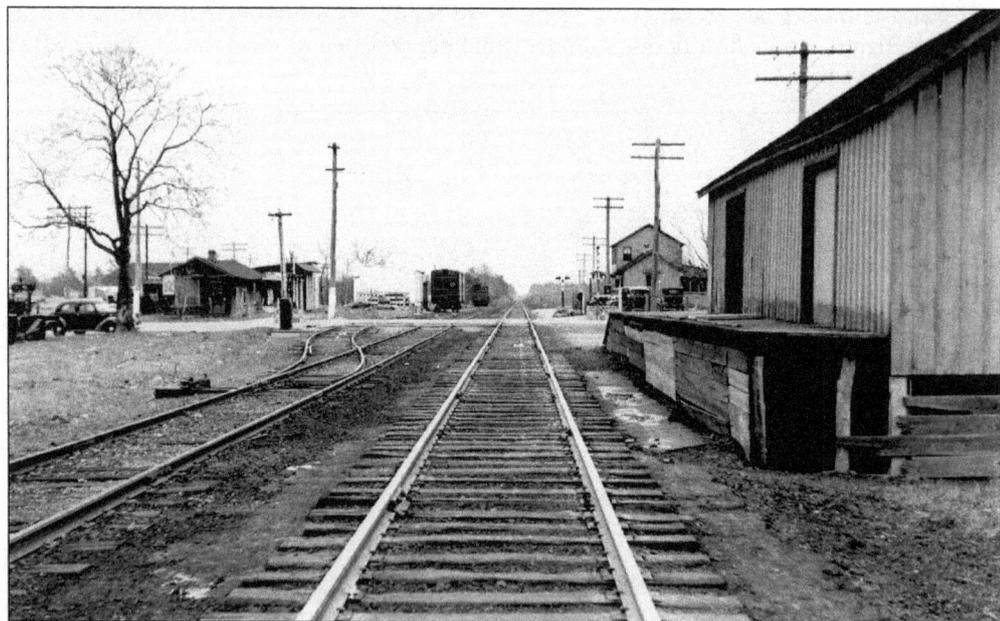

This photograph of Medford, also taken on April 19, 1940, presents a view in the opposite direction, from in front of the express house toward the depot. Boxcars are spotted on the team track, and on the far left, behind the old sedan, there appears to be an early bulldozer, perhaps located there in preparation for the upcoming elimination project. (Albert E. Bayles photograph.)

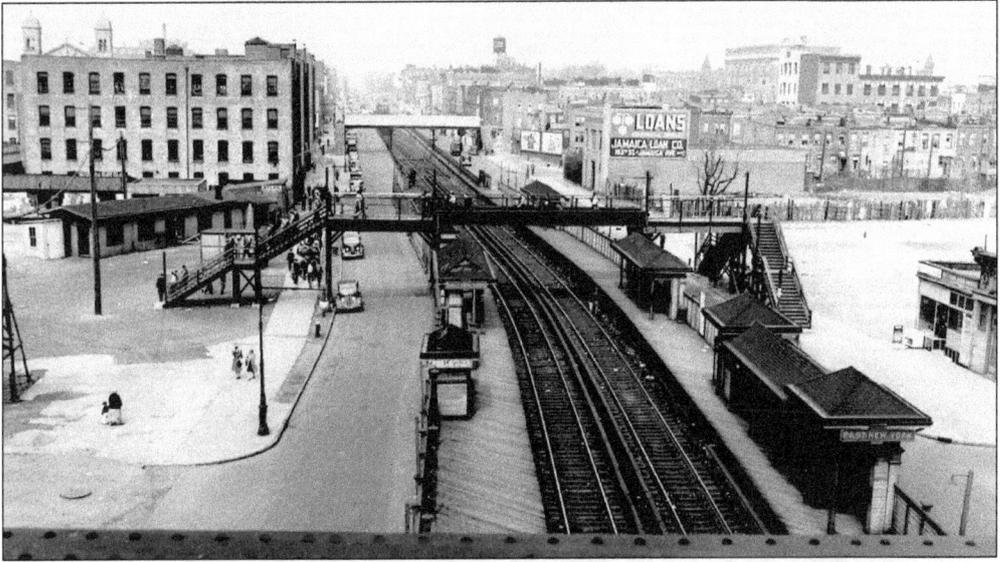

This view westward from the BMT Canarsie EL on May 6, 1940, shows the old East New York station at grade with old wooden platforms and shelter sheds. On the far left, on a diagonal, is the ticket office. A few short years later, this station was rebuilt entirely, incorporating a concrete-and-steel superstructure to carry Atlantic Avenue over the tracks and station area. (George E. Votava photograph.)

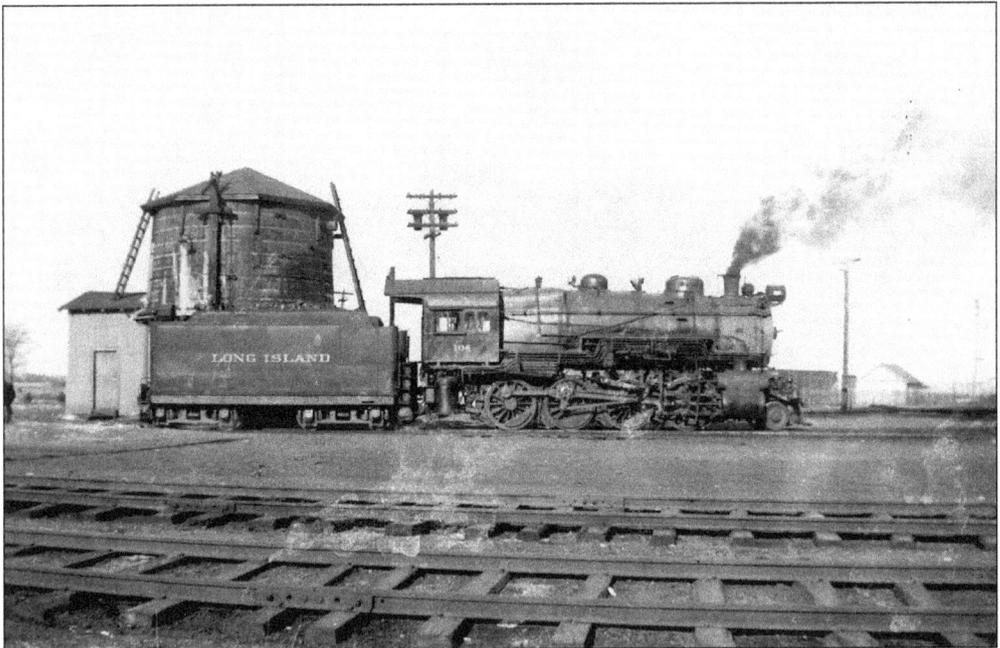

Water towers were located at all the major terminals and along the various branches as well. Water was pumped into tanks constructed of wooden slats held together by steel hoops and turnbuckles. The water in the storage tanks would then be transferred by gravity feed into a locomotive's tender when needed. Here H10s consolidation No. 104 stops for a drink at Oyster Bay terminal in 1940. The hoops on the right indicate the location of the turntable. (T. Sommer photograph.)

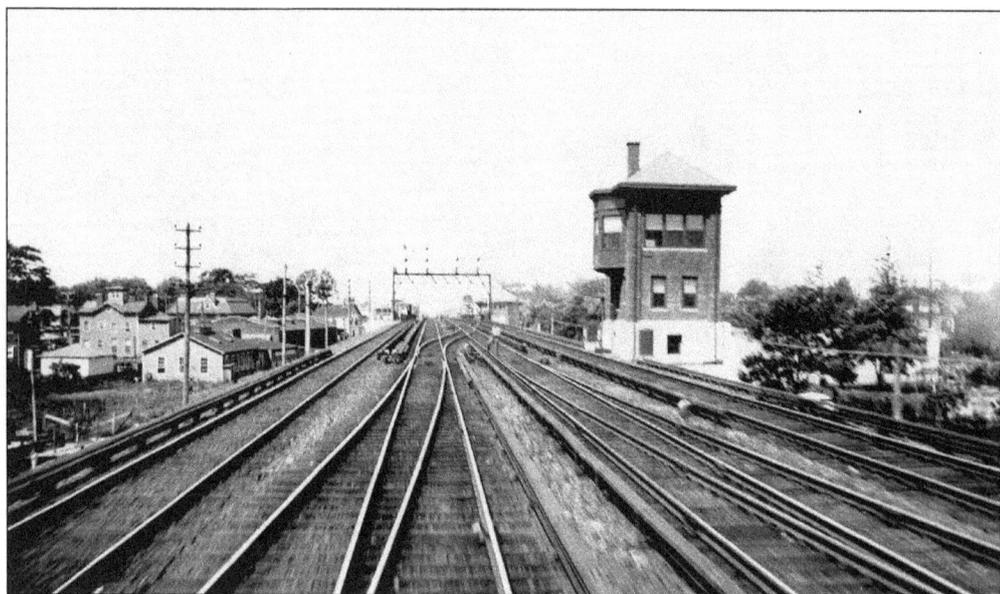

This photograph was taken from the rear of a train as it whipped eastbound through Queens Village on the express track. The mid-1920s scene shows both QU tower (later Queens) and the Queens Village station. Perhaps the man standing in the middle of the scene is the operator at QU, who has just handed up a train order to the engineer traveling through at speed. (James V. Osborne photograph.)

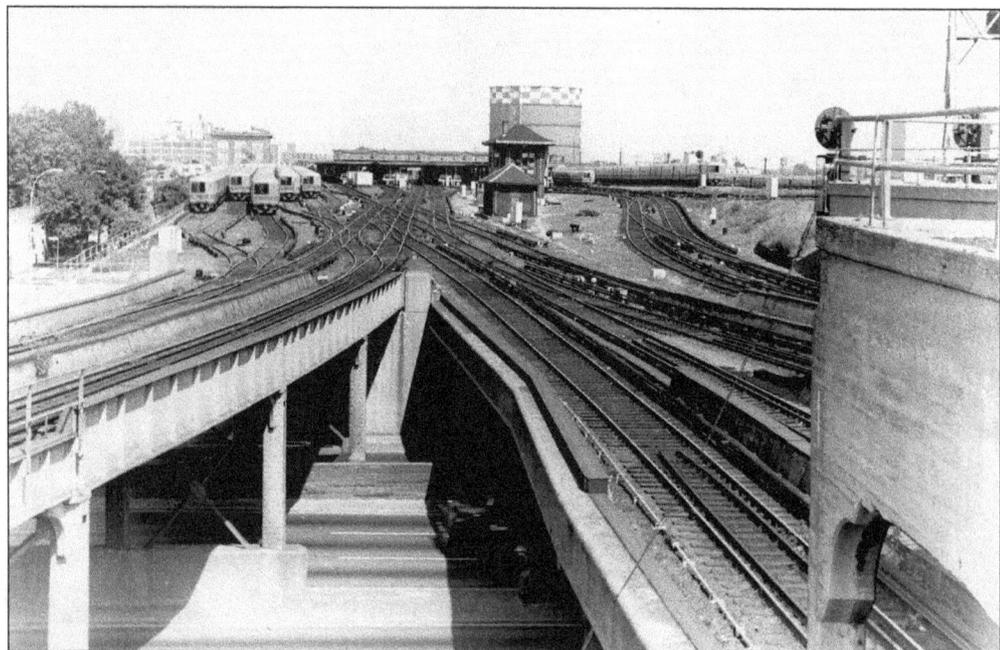

Viewed eastward from the Van Wyck Expressway overpass is the terminal at Jamaica as it looked in 1974. To the right and to the left are stored the M1 cars that had so recently replaced the old MU cars. In the center is Jay interlocking tower, and beyond are the station platforms. In the left background is the terminal building, which houses the general offices of the railroad. (David Keller photograph.)

Typical of Long Island weather is this scene at Central Islip. Although the picture was taken in 1916, very little had changed here by the mid-1920s. The view to the west shows the aftermath of an extremely intense rainstorm, which had followed a recent snowstorm. Dead center is the semaphore block signal, which is indicating the stop aspect in both directions. On the right are the team tracks and old freight house. (George G. Ayling photograph.)

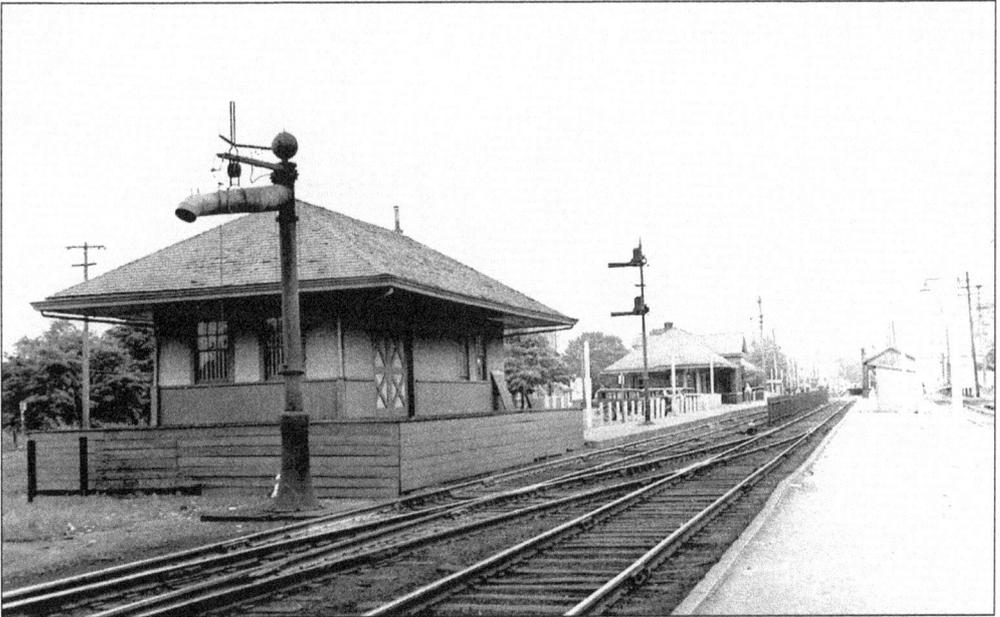

This eastward view toward the Hicksville depot shows one of the two water plugs in July 1937. Directly beyond the water plug is the express house, and between the express house and depot are the block signals. Beyond the depot is the crossing watchman's shanty with hand-operated, crank-down crossing gates. A neat, little cabriolet is going over the crossing. (George E. Votava photograph.)

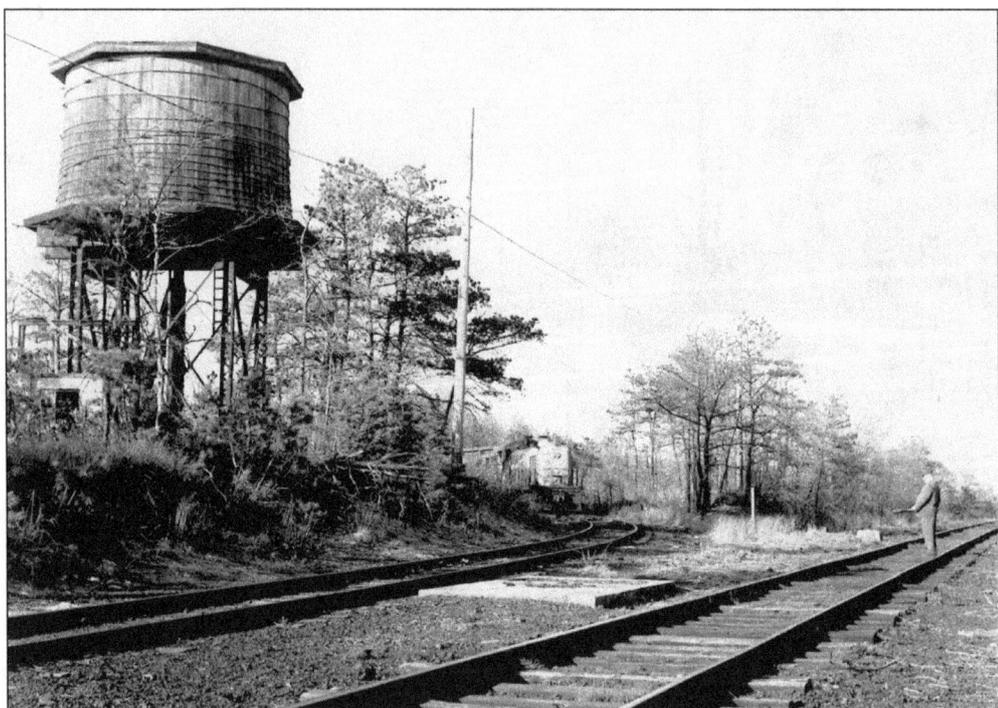

This was the once bustling Upton Junction, installed during World War I when the U.S. Army built its Camp Upton training facilities north of the main line. In this April 21, 1968, photograph, Alco RS3 No. 1556 pulls a railfan extra off the westbound leg of the wye, past the abandoned water tower. The trainman on the right is acting as flagman on the main. (David Keller collection.)

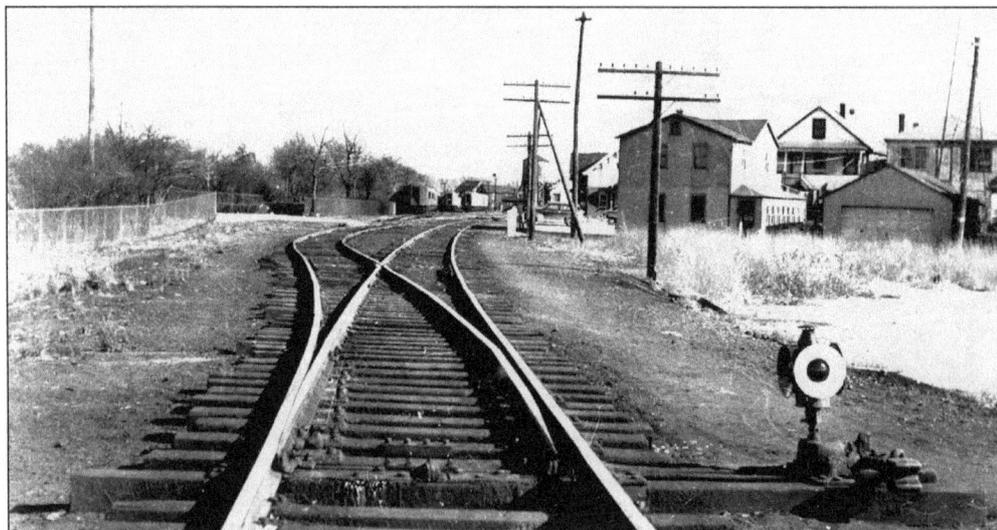

Here is Oyster Bay in a view looking eastward from the first switch west of the depot area. This 1952 scene shows the old kerosene switch target in the right foreground. Visible in the distance, beyond the buildings on the right, are the depot (left), the express house (middle), and the water tower. Passenger cars are laying up in the yard in the distance. (J. P. Sommer photograph.)

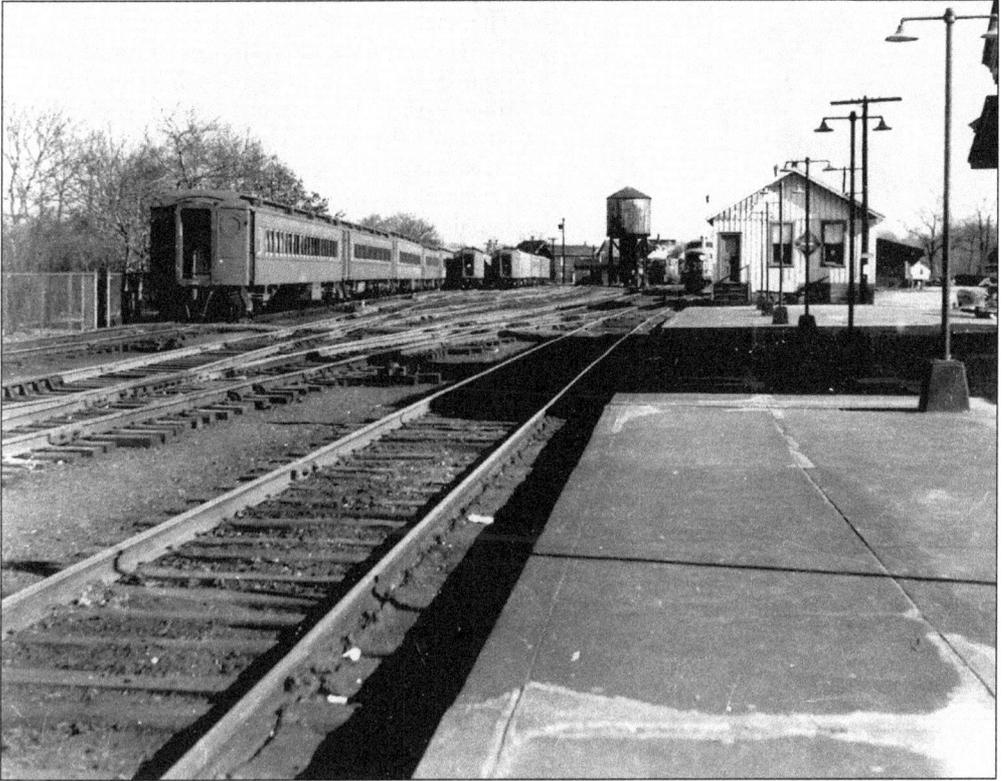

This 1952 photograph, looking eastward from the front of the Oyster Bay depot, shows the yard (including passenger cars) on the left, the old water tower in the center, two Fairbanks-Morse diesels to the right of the tower, and the old Railway Express Agency building. A portion of the freight house is visible behind the REA building. (J. P. Sommer photograph.)

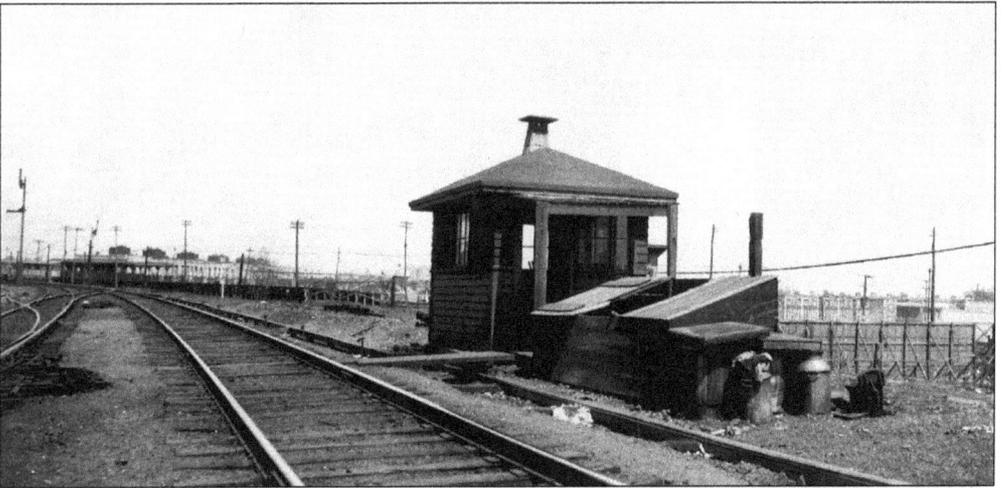

Pictured in 1926 is NU cabin, situated along the Bay Ridge branch at New Utrecht Avenue. The linkage to the right of the tracks has been covered in wood to protect it from freezing in the snow. That linkage extends from strong-arm levers in the cabin to the distant semaphore signals. This little cabin was removed in 1927 during the construction of the 14th Avenue bridge. (James V. Osborne photograph.)

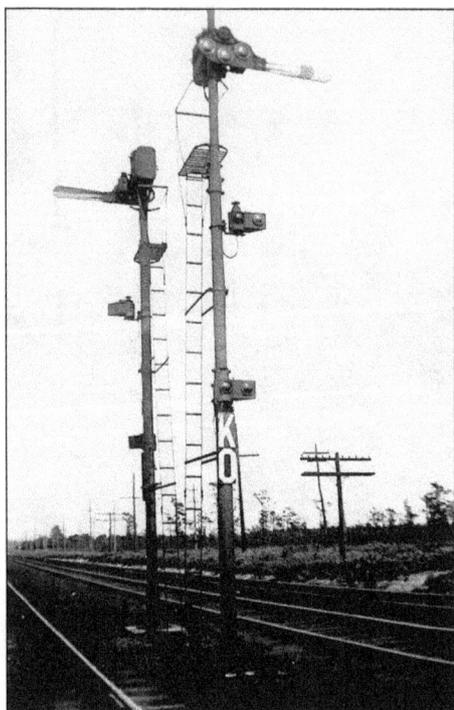

The semaphore-arm block signals at Ronkonkoma are shown in this eastward view from 1940. Identified by the call letters KO, these signals also have unattended block lights affixed to the masts. The semaphore signal aspects indicate "stop" in each direction. Originally controlled from the depot, the signals were later controlled by KO cabin, but then eventually returned to depot control. (T. Sommer photograph.)

An important structure for railroads was the turntable. Operated by air, electric, or even by hand, the turntables were necessary for turning steam locomotives and were located at all the major terminals where there was no space for a wye. Alco C420 No. 208 is spun especially for the camera at Morris Park Shops during a railfan open house in 1966. This turntable also allowed access to the roundhouse. (Norman Keller photograph.)

Here is a nice, clear, wintry view of Ronkonkoma depot and yard, photographed in February 1972 as Alco C420 No. 213 arrives at the station with weekend train No. 4234. This view eastward from the Ronkonkoma Avenue overpass shows an early-morning scene of an almost empty parking lot as well as three passenger trains and one freight minus engine laying up in the distant yard. (David Keller photograph.)

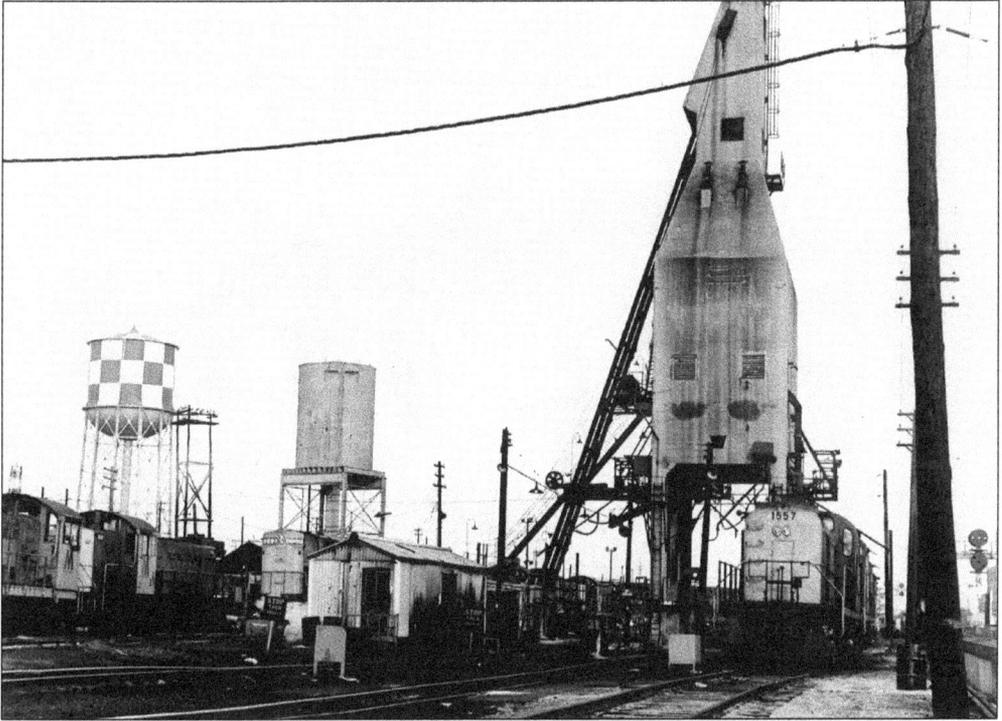

Built as the replacement coaling tower at Morris Park Shops to replace the older, wooden one, the structure at the right was later converted for use as a sandhouse to service the locomotives of the diesel era. The sandhouse is shown here in an eastward view on Christmas Day 1971. Four types of diesels are laying up, and the Atlantic branch is visible on the far right. (David Keller photograph.)

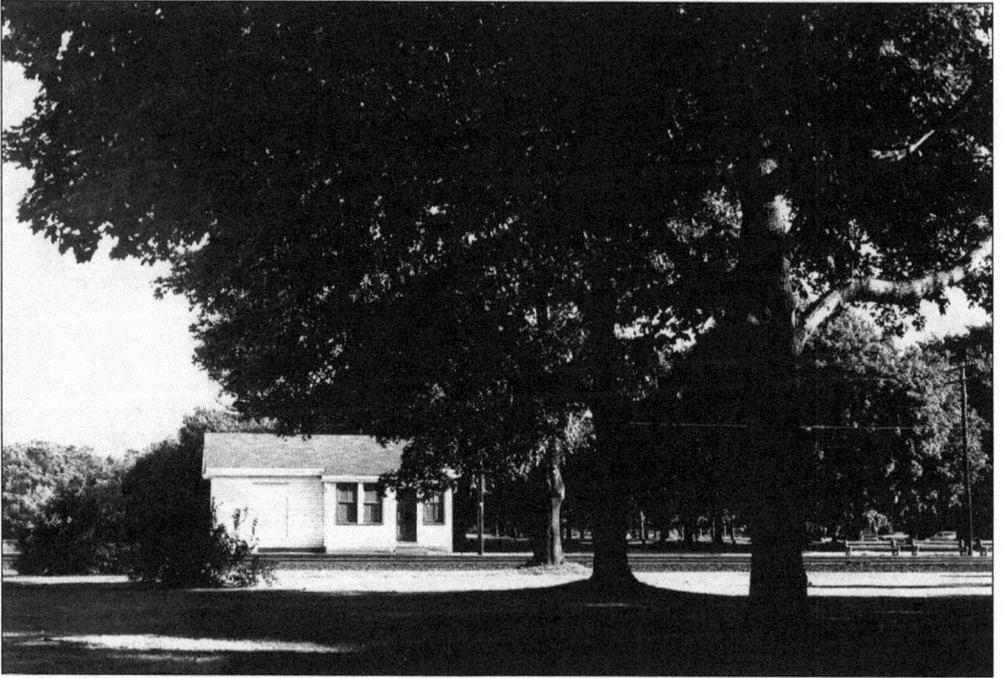

The little Pinelawn station is pictured in this view directly south from the grounds of the Pinelawn Cemetery in August 1970. Originally built in 1915 at the northwest quadrant of the Wellwood Avenue crossing, the station was moved in 1925 to the southeast quadrant. The depot building remained empty for many years after the agency closed and was drastically remodeled c. 1985. (David Keller photograph.)

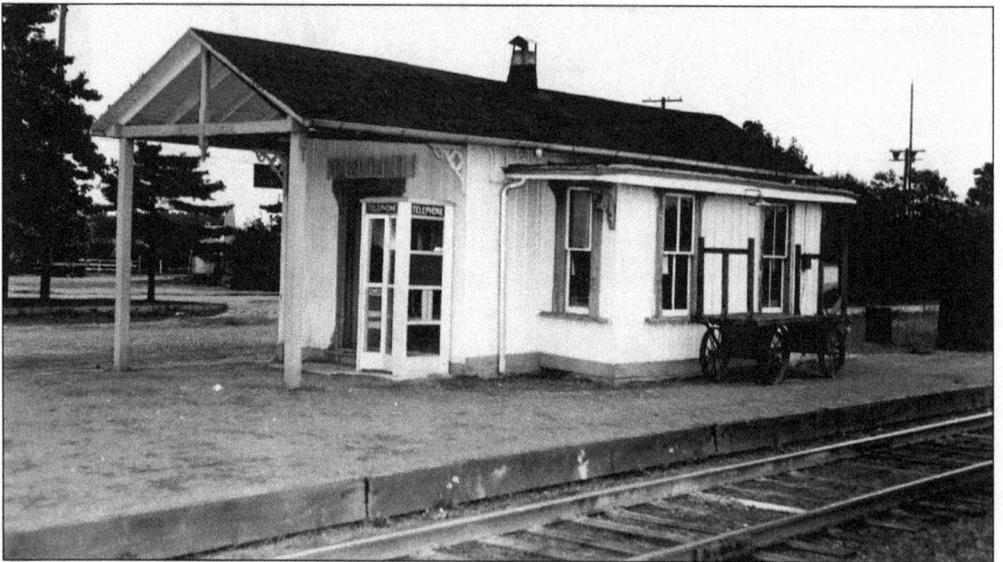

The quaint Yaphank depot is shown here in its twilight years. Built in 1875 and known as Millville, the structure sported fancy decorative woodwork at its eaves and a roof tree along its ridge. Shorn of that detail and its station sign, the depot is pictured on September 20, 1958, with baggage wagon still evident, just about the time the agency closed. The little building was razed in 1961. (Irving Solomon photograph.)

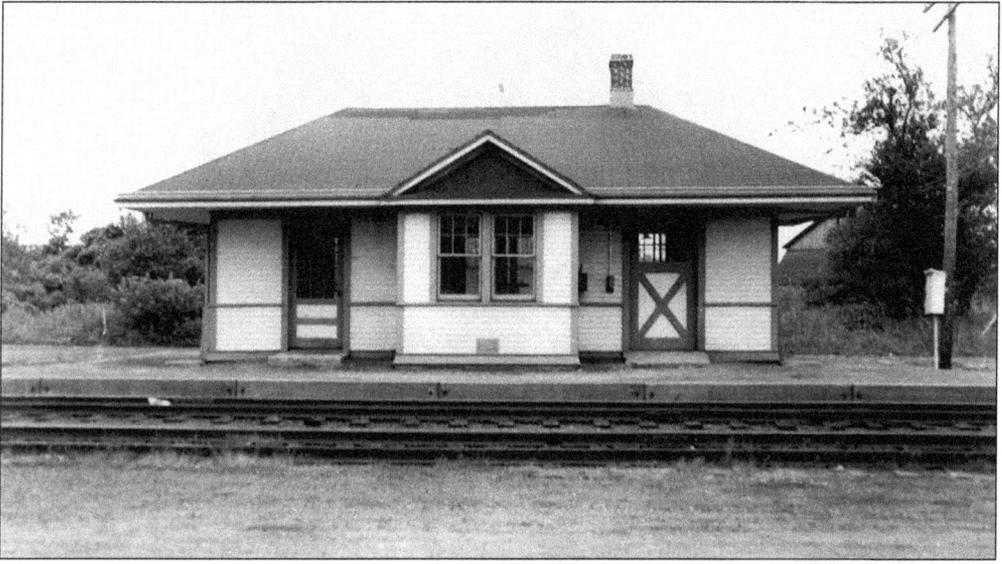

Another cute main line depot was this building at Calverton. The structure was built in 1922 on the south side of the tracks, across from the previous depot. The agency closed about the time this photograph was taken on September 20, 1958, and the building was purchased by Les Magnus, an LIRR signal maintainer who had it moved to his property along Montauk Highway in East Quogue. (Irving Solomon photograph.)

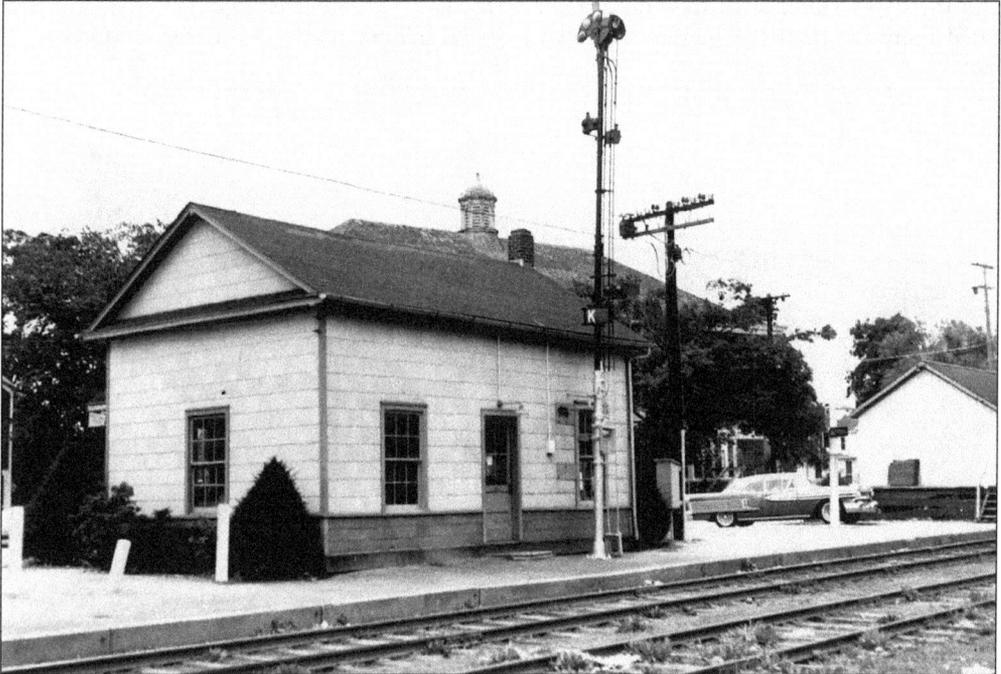

The little Mattituck depot was also photographed on September 20, 1958. Its agency closed in January 1959. Built in 1878 and extensively remodeled in 1944, the depot stood until its destruction in July 1967. In this view, it still displays the semaphore block signal with unattended block station lights and the "K" call letter on the full-sized mast. The express house is on the right. (Irving Solomon photograph.)

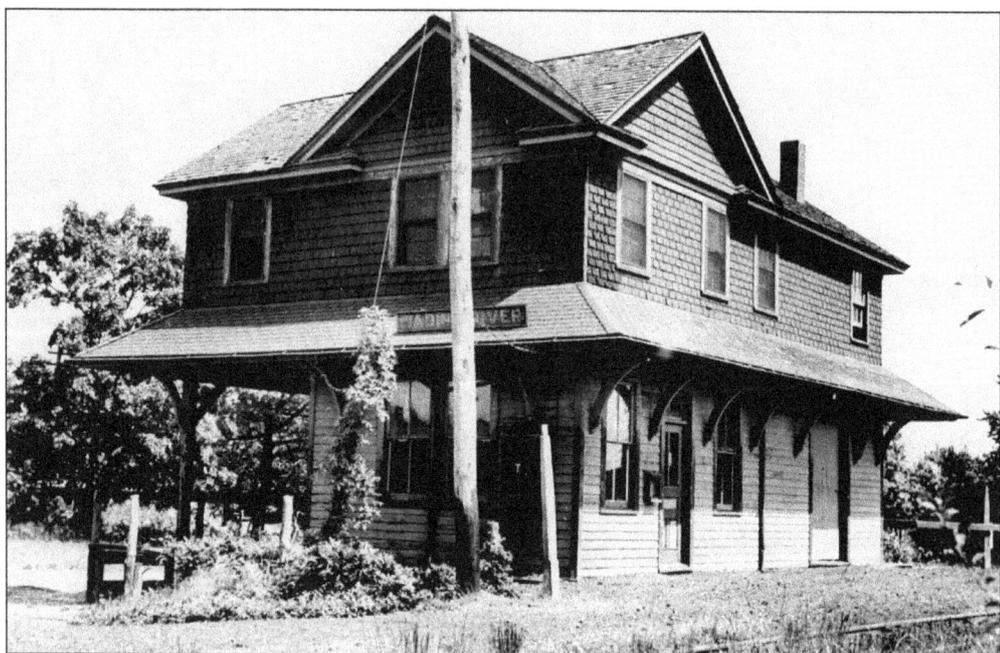

The Wading River depot is shown in September 1937, one year before its demise. Built in 1895, it was enlarged to a two-story structure in 1906 to house the agent. The agency closed c. 1933, and the depot closed with the end of branch service on October 9, 1938. The building was razed thereafter, and the lumber was used to build a store north of the depot. (George E. Votava photograph.)

This 1940 northward view shows the LIRR overpass at North Ocean Avenue, east of Holtsville. Also known as Tunnel Road due to the arched-brick construction, the overpass was built c. 1850 and was identified as bridge No. G530. The little tunnel, which required motorists to yield the right of way quite frequently, was replaced with a larger structure c. 1951. (Albert E. Bayles photograph.)

An eastbound Montauk train leaves the wooden shelter shed at Penny Bridge, in Long Island City, *c.* 1954. At the rear of the train is a large, round marker lamp over the doorway. The marker lamp became required equipment after a horrible wreck at Richmond Hill in 1950, where one passenger train telescoped into the rear of another. Spanning the entire scene is the Kosciusko Bridge. (W. J. Edwards photograph.)

As FM No. 1506 travels eastbound out of Central Islip *c.* 1952, it passes the pole gates that protect the Carleton Avenue crossing. While gates at other locations were wooden slats that were hand cranked, the gates pictured here were constructed from telephone poles that were lowered by pulling a rope. Originally a single pole stood on each side of the tracks at Carleton Avenue. Later the singles were replaced by a double set, which were still lowered by ropes and tied off by the crossing watchman. (George G. Ayling photograph.)

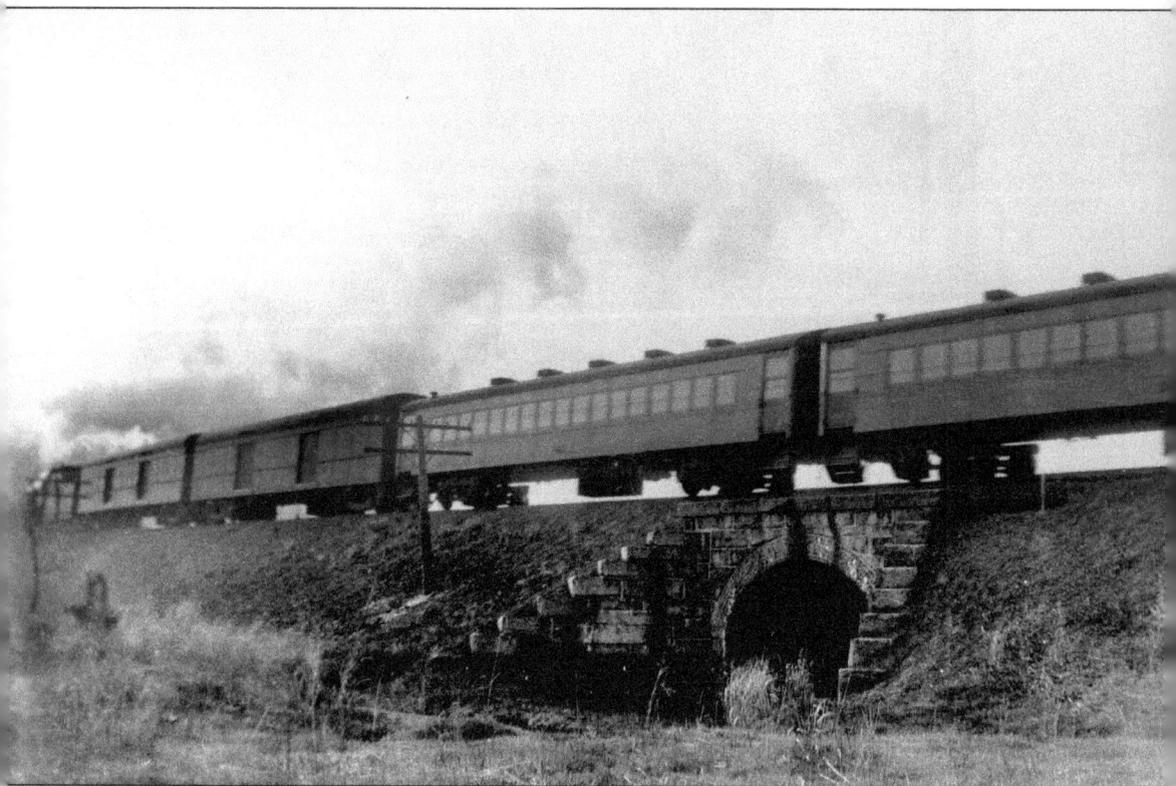

This G5s has just left Oyster Bay as it pulls an early-evening train with double consist of baggage cars. The locomotive is steaming away, blowing its whistle, and leaning into the curve of the tracks as it pulls the train over Mill Creek and heads west into the sunset toward the close of this day in 1940. (T. Sommer photograph.)

www.ingramcontent.com/pod-product-compliance
Lightning Source LLC
Chambersburg PA
CBHW050650110426
42813CB00007B/1963